Copyright © 1988 Xerox Corporation

First published in 1988 in New York by Watson-Guptill Publications, a division of Billboard Publications, Inc., 1515 Broadway, New York, N.Y. 10036, in conjunction with Xerox Press, an imprint of Xerox Corporation.

Library of Congress Cataloging-in-Publication Data

Xerox publishing standards.

 "A Xerox Press book."
 Bibliography: p.
 Includes index.
 1. Corporation reports—Publishing—Data processing—
Standards. 2. Corporations—Publishing—Data
Processing—Standards. 3. Electronic publishing—
Standards. 4. Printing, Practical—Layout—Data
processing—Standards. 5. Business writing—Data
processing—Standards. I. Xerox Corporation.
Z286.C68X47 1988 070.5'0285 88-26078
ISBN 0-8230-5964-2

Distributed in the United Kingdom by Phaidon Press Ltd., Littlegate House, St. Ebbe's St., Oxford

Manufactured in the United States of America

First printing, 1988

1 2 3 4 5 6 7 8 9 10/93 92 91 90 89 88

Xerox® and all Xerox products mentioned in this publication are trademarks of Xerox Corporation.

Excerpt from *The Art of Clear Thinking* by Rudolf Flesch. Copyright 1951 by Rudolf Flesch. Reprinted by permission of Harper & Row.

Project editors: Sue Heinemann and Virginia Croft
Page makeup: Areta Buk
Graphic production: Ellen Greene
Text set in 10-point Optima by Maryland Composition Company

Contents

Preface xiii

| The story behind the publishing standards xiii

| The *Xerox Publishing Standards* manual xiv

| Where the publishing standards are today xv

| Acknowledgments xvi

Introduction xvii

| The need for publishing standards xvii

| Overview of Xerox' publishing standards xviii

| How standards are developed xix

| Communicating publishing standards xx

1. Publishing process

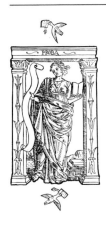

Overview of publishing process 1-3

| The role of electronic tools 1-4

Document planning 1-7

| Plan ahead 1-7

Research and design 1-11

| Collect information 1-11

| Validate research and prepare for writing 1-12

Writing and editing/preparing graphics 1-15

| Tasks of technical writers 1-15

| Tasks of the editor 1-15

| Writing process 1-16

| Editorial process 1-23

| Graphics preparation 1-25

Production 1-27

| Composition 1-27

| Printing 1-30

| Packaging 1-31

Distribution 1-33

Updating and storage 1-35

2. Document organization

Overview of document organization 2-3

Generic document structure 2-5

Visual logic 2-5

Modular content 2-5

Document terminology 2-8

Document access and cross-referencing 2-9

Document title 2-9

Numbering systems 2-11

Headers and footers 2-14

Headings 2-20

Front matter 2-21

Title page (cover) 2-21

Copyright page 2-22

Special information page 2-24

Table of contents 2-24

Foreword 2-25

Preface 2-25

Introduction 2-25

Subject matter 2-27

Parts 2-27

Chapters 2-27

Sections 2-27

Annotation 2-28

Back matter 2-33

Summary/conclusion 2-33

Appendices 2-33

Glossary 2-34

Endnotes page 2-35

Bibliography 2-35

Index 2-39

Response/order form	2-39

Legal considerations — 2-41

Copyrights	2-41
Trademark requirements	2-41
Licensing and warranties	2-42

Revision documents — 2-43

Change bars	2-43
Errata sheet	2-43

3. Writing and style

Overview of writing and style	3-3
The meaning of style	3-5
Useful conventions	3-5
Style versus design	3-6
Content factors	3-7
Put people in your writing	3-7
Use conversational style	3-8
Bias-free writing	3-9
Avoid sexist writing	3-9
Multilingual communication	3-13
Readability	3-15
Sample passages	3-15
Readability formulas	3-16
Fry readability scale	3-17
Kernel distance theory	3-18
Negative effects on readability	3-18
Paragraph construction	3-19
Introductory paragraphs	3-19
Developmental paragraphs	3-22
Concluding paragraphs	3-24
Paragraph coherence	3-24
Sentence structure	3-27
Basic sentence patterns	3-27
Characteristics of clear sentences	3-29

	Active voice	3-31
	Variety	3-32
Technique and form		3-35
	Definition	3-35
	Identification	3-35
	Analogy	3-36
	Classification	3-36
	Comparison and contrast	3-36
	Example	3-36
	Statistics	3-36
	Other writing techniques	3-36
Word choice and usage		3-39
	Use simple words	3-39
	Take care with jargon	3-40
	Be precise	3-41
	Avoid clichés	3-41
	Use transitional words or phrases	3-42
	Provide contextual clues	3-42
	Eliminate redundancy	3-43
	Use company names and trademarks correctly	3-44
Grammar		3-45
	Word order	3-45
	Word position	3-45
	Common grammatical mistakes	3-45
Spelling		3-47
	Using a computer spellcheck program	3-47
	Common misspellings	3-48
	American versus British spelling	3-48
Punctuation		3-51
	Apostrophe	3-51
	Colon	3-52
	Comma	3-53
	Dash	3-54
	Ellipsis points	3-54
	Exclamation point	3-55

Hyphen	3-55
Parentheses	3-55
Period	3-56
Question mark	3-56
Quotation marks and italics	3-57
Semicolon	3-58
Punctuating lists	3-58
Capitalization	3-59
What to capitalize	3-59
Capitalization as a convention	3-60
Abbreviations	3-63
Numerals	3-65
Editorial and proofreading symbols	3-68

4. Visual design

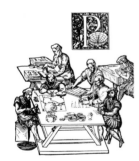

Overview of visual design	4-3
Organization of information	4-3
Measurements and terminology	4-4
Menu of content elements	4-4
Design rationale	4-5
Typography and page layout	4-5
Packaging and binding standards	4-6
Page specifications	4-7
U.S. and international page size standards	4-7
Page orientation	4-8
Live matter	4-9
Summary of page specifications	4-10
Column layouts	4-15
Standard: single text column	4-15
Alternate: multicolumn variations	4-15
Big book, portrait: single text column	4-16
Big book, portrait: double text columns	4-18
Big book, portrait: triple text columns	4-20
Big book, portrait: combination of columns	4-22

Small book, portrait: single text column 4-24

Small book, portrait: double text columns 4-25

Big book, landscape: four columns 4-26

Small book, landscape: single text column 4-28

Typeface 4-29

Typeface selection 4-29

Text 4-31

Body copy 4-31

Emphasis within text 4-33

Downstyle capitalization 4-34

Lists 4-35

Summary of visual conventions 4-36

Graphics and tables 4-39

Artwork size and orientation 4-39

Use of rules (boxing) 4-39

Graphic placement 4-40

The practice of centering 4-41

Text 4-41

Headers and footers 4-45

Header and footer specifications 4-46

Heading options 4-49

Visual logic of the heading options 4-52

Headings for other page sizes and orientations 4-53

Selection of headings 4-53

Placing and spacing elements on the page 4-55

Fixed spacing patterns 4-55

Editorial spacing 4-56

Special spacing problems 4-57

Special pages 4-59

Title page 4-59

Copyright page 4-59

Table of contents 4-60

Subtitle pages 4-60

Appendices 4-60

Glossary 4-61

Bibliography 4-61

Index 4-61

Response/order form 4-61

Blank pages 4-62

Classified pages 4-62

Tabs 4-63

Die-cut tabs 4-63

Bleed tabs 4-64

Binding 4-65

Guidelines for binding selection 4-66

Loose-leaf binders 4-66

Wire-O binding 4-68

Perfect binding 4-68

Saddle-stitch binding 4-68

Packaging accessories 4-68

Paper for text pages 4-69

Ink for text pages 4-69

Cover 4-71

Cover content and organization (anatomy) 4-71

Cover art specifications 4-73

Cover print quality based on premium category 4-73

Master cover art 4-74

Appendices

A. Xerox document categories and contents A-1

Publication types and objectives A-1

Management planning/control A-5

Marketing/sales A-24

Applications/support A-34

Reference A-38

Training A-41

B. Xerox word list B-1

Entries B-1

Legend B-1

C. Standard units of measurement — C-1

Standard international units (SI)	C-1
Standard unit abbreviations	C-4
Point measurement conversion	C-10

Glossary, bibliography, index

Glossary — GLOSSARY-1

Entries	GLOSSARY-1
Legend	GLOSSARY-1
A	GLOSSARY-2
B	GLOSSARY-5
C	GLOSSARY-8
D	GLOSSARY-14
E	GLOSSARY-18
F	GLOSSARY-19
G	GLOSSARY-24
H	GLOSSARY-25
I	GLOSSARY-27
J	GLOSSARY-30
K	GLOSSARY-31
L	GLOSSARY-32
M	GLOSSARY-35
N	GLOSSARY-38
O	GLOSSARY-39
P	GLOSSARY-41
Q	GLOSSARY-47
R	GLOSSARY-47
S	GLOSSARY-50
T	GLOSSARY-56
U	GLOSSARY-59
V	GLOSSARY-60
W	GLOSSARY-62
X	GLOSSARY-63
Y	GLOSSARY-63

Bibliography BIBLIOGRAPHY-1

Index INDEX-1

Figures

1-1. Document publishing process	1-3
1-2. Publication planning/production form	1-10
1-3. Document flow through an EPC	1-28
2-1. Generic document structure	2-6
2-2. Standard sequence of content elements	2-7
2-3. Content and organization of headers and footers	2-15
2-4. Header and footer content variations	2-16
3-1. Fry readibility scale	3-18
3-2. Edited and corrected text	3-72
A-1. Xerox publication categories	A-2

Tables

1-1. Time budget for writing	1-17
2-1. Standard document terms	2-8
2-2. Numbering of major document divisions	2-12
4-1. Specifications for text	4-43
A-1. Publications reference list	A-3
C-1. Point measurement conversion	C-10

Preface

Because of the success of our Xerox Publishing Standards Program, many of our customers have asked that information about the standards be made available to them. Much of what we have learned about publishing standards is contained in this book.

For our customers, Xerox standards establish a consistent editorial and visual design, used throughout our publications. Regardless of the document or the subject, the consistent structure speeds access to needed information.

For our employees, Xerox standards establish a common publishing vocabulary and communication vehicle among many business units. Our program focuses on people and how they are brought into the publishing process in the atmosphere of mutual cooperation and shared goals. This is what renders our standards effort a success.

The story behind the publishing standards

Xerox customers use a variety of Xerox publishing and printing products. The publications that help customers use these products must be accurate, easy to read, and readily available.

The Xerox Publishing Standards Program came about as a response to customer feedback about our publications in the marketplace. They told us the documentation did not meet their needs. The primary goal, therefore, of the publishing standards and related programs was to solve this problem.

Tying in electronic publishing

It was important for our customers to see us successfully using our products. In 1983 Xerox brought together its publishing and printing products to create an in-house electronic publishing center. Our aim was to validate Xerox' publishing product capability and versatility. The fulfillment of the publishing center came when user manuals were published using the products they supported.

We quickly learned the difficulty of preparing a unique application program and maintaining editorial and visual style specifications for so many documents. Over a nine-month period we reviewed more than 2,000 pounds of our customer documentation. Our research revealed inconsistencies in content, organization, visual design, and delivery.

We interviewed Xerox managers, writers, editors, artists, designers, engineers, programmers, and headquarters marketing people. These individuals initially felt that, in the electronic publishing process, they owned the "right" to produce documentation their way. Once the standards program was implemented, however, people began to realize the importance of focusing on the external customer.

Organizing a competency and support center

As more and more people accepted the idea of writing with the customer in mind, we found the need for publishing expertise. Xerox is a decentralized corporation. To gain consensus from everyone involved, we organized a formal competency and support center. We consulted with standards users on documentation and media design and provided the following resources:

— A publishing standards hotline (phone and network)

— Briefing and training sessions

— A library where our users can examine mock-ups, publications, and materials samples

— Standards for documentation organization and writing style

— Cohesive packaging and design strategies

— A page format for documentation that works on all publishing systems

— Guidelines for managing documents through the entire publishing process.

The information that passed through the competency center became the basis for the standards manual.

The *Xerox Publishing Standards* manual

We grouped our research and information gathered from standards users into four areas: publishing process, document organization, writing and style, and visual design. The categories then became the four major parts of the standards manual. The sequence of chapters reflects the document development process.

You can work through the manual from beginning to end to plan your project. Or you can find the specific information you need for a task. The first part of the book is management and process oriented. The next three parts are increasingly technical. The table on the facing page provides an overview of the standards categories.

Visual design

The format you see in *Xerox Publishing Standards* is the Xerox visual look. It is a design created especially for product, customer, service, technical, systems, corporate, and marketing documents.

Special graphics

We want to call your attention to the special graphics on the subtitle pages of the manual. We created original scanned images from our collection of 15th- and 16th-century woodcuts. You will find a description of the electronically produced woodcuts on the reverse of each of the four subtitle pages. Before woodcuts became an art form, they were a practical way to replicate many images, a primitive way of duplicating. The content of the new woodcuts is reminiscent of historical publishing practices.

Publishing standards categories

Publishing process

- Concurrent product and document delivery
—Planning
—Organizing
—Controlling

- Program planning
—International distribution
—Decision control
—Schedule
—Budget

- Research/design
—Writing specification
—Validation

- Writing/editing
—Text
—Graphics

- Composition
—Style specification
—Word processing
—Phototypesetting

- Production
—Laser
—Offset
—Reprographic

- Distribution
—Electronic
—Direct mail

- Maintenance
—Updates
—Revisions

Document organization

- Document type
—Books/manuals
—Promotionals
—Presentations
—Curriculum

- Document access
—Modularity
—Visual logic
—Title
—Numbering
—Headers and footers
—Headings

- Front matter
—Title page
—Copyright page
—Table of contents
—Foreword
—Preface
—Introduction

- Subject matter
—Parts
—Chapters
—Sections
—Paragraphs

- Back matter
—Appendices
—Bibliography
—Index

Writing and style

- Multilingual audience
—Content
—Bias-free writing
—Translation

- Paragraph construction
—Sentence structure
—Readability level
—Syntax
—Consistency
—Clarity
—Logic

- Style
—Grammar
—Spelling
—Punctuation
—Capitalization
—Word usage
—Terminology
—Conventions

Visual design

- Specifications
—Page
—Big/small
—U.S./international
—Portrait/landscape

- Typeface

- Text
—Type size
—Line length
—Leading

- Column layout

- Graphics
—Size
—Placement
—Use of white space
—Use of rules

- Paper
—Weight/finish
—Color

- Printing
—Binding
—Tabs
—Covers
—Wrappings

Where the publishing standards are today

Through the Publishing Standards Program we not only improved Xerox documentation but used the capabilities and productivity of our technology. We now provide documentation that is easy to use. We produce it efficiently, using Xerox publishing and printing products. All text and graphics are created, revised, and maintained in electronic form, so that the documents are available on demand.

The use of electronic technology has speeded things up. But it does not alter the timeless process of communication. In this sense, our publishing standards represent electronic-age implementation of traditional publishing wisdom.

Acknowledgments

It is not possible to credit everyone individually who has contributed to Xerox' publishing standards. We want to acknowledge the many people inside and outside Xerox who implemented and tested the standards and who took the time to communicate with us. They are the ones who ensure that publishing standards work. We will continue to incorporate their ideas into the program.

Special recognition goes to the following:

Carla J. Jeffords and Robert V. Adams, as visionaries of electronic publishing; Jan V. White, as typographic designer of the page architecture for Xerox documentation; Helen Choy Whang, for art direction, presentation, and packaging design; Nancy Sampson, for content analysis, development, and editing; Earlene Kerns, for visual design and editorial support; Lee Marengella, Pat Behenna-Meyer, Virginia Croft, and Sue Heinemann, for developmental writing and editing; Charlene Narita, for graphics and art production; Melinda Broaders and Jeanne Mignacca, for development of the page layout for the Xerox Integrated Composition System (XICS) style specification, Xerox ViewPoint templates, and Xerox Ventura Publisher style sheets; Sharon Harman, for communications, production, proofing, and distribution support; Lisa Huschke, for composition and production support; Elizabeth Duffey and Sandy Jones, for electronic art creation and production; the Xerox Font Center, for electronic typeface development; and the Xerox Electronic Publishing Center, for editorial, composition, and vendor services, and for producing millions of good impressions.

Xerox Publishing Standards Program

Richard M. Lunde

Manager,
Documentation and Font
Services

Business Products and
Systems Group

Brenda Peterson

Manager,
Xerox Publishing
Standards

Business Products and
Systems Group

Introduction

Xerox' publishing standards are a family of principles, requirements, practices, and specifications that guide the preparation and dissemination of publications.

These publishing standards were specifically developed to meet the needs of people who produce documentation with electronic and desktop publishing products. These products include personal computers, workstations, electronic typewriters, printers, computer-aided design systems, facsimile devices, and networks, as well as the multitude of software packages that work with them.

The standards provide guidelines for:

— Processes by which publications are managed, produced, and disseminated

— Types of publications, their organization and content

— Writing and editorial style

— Visual appearance and physical characteristics.

The need for publishing standards

Xerox, like many companies, produces a wide variety of publications that communicate operating policies, practices, data, and other information. Publishing is still the most efficient process for performing this communications task. Although publishing is not the main activity of our business, it consumes major resources.

Our documents are important to management, operational units, and customers. Strategic, operating, and business plans are prepared with as much review and editing as the information in a successful newspaper or magazine. Customer understanding of how to use a product is critical to product success in the marketplace. Good product support documentation is essential.

Much publishing knowledge is shared verbally through on-the-job instruction. In a large international organization, however, informal communications are inadequate to achieve information transfer on a broad scale. You need a disciplined process to manage efficient and cost-effective publishing cycles. You also need standardized publications that share a consistent visual logic and style.

Overview of Xerox' publishing standards

Standards must be maintained in the areas outlined below to ensure quality documentation and improve organizational operations.

Publishing process

— Select management of the highest caliber who have a clear understanding of business and editorial goals and of performance standards.

— Plan documentation at the same levels and with the same attention as you would any other product.

— Incorporate marketing, review, editorial, translation, production, and quality control cycles into the business plan.

— Identify target audience, including education, related skill level, and work environment.

— Prepare a document design specification and packaging plan for every document. Design before you write.

— Utilize the capabilities of technology to maximize productivity.

Document organization

— Title all documents consistently and identify each with a unique publication number.

— Place content in the appropriate front, subject, and back matter sections.

— Accurately number and cross-reference divisions, pages, and illustrations.

— Make headers and footers consistent within a document and across documentation sets.

— Establish a clear heading hierarchy.

— Provide a complete and accurate index.

— Copyright all documents.

Writing and style

— Write graphically. Replace text with visuals wherever possible.

— Write in an unbiased, conversational style using the active voice.

— Write at the appropriate reading level for your audience.

— Keep sentences and paragraphs brief. Pay attention to grammar, syntax, and punctuation.

— Use standard spellings and abbreviations for words and units of measure.

Visual design

— Select page size, orientation, and binding according to how and where the document will be used.

— Follow standards for typography and page layout.

— Reflect content organization and hierarchy in the size, emphasis, and placement of visual elements.

— Prepare text and graphics to facilitate translation and production.

— Coordinate document and media accessory design.

— Use standard materials and buy them in volume.

How standards are developed

Standards grow out of general publishing practices and are adapted and supplemented to fit special environments. Standards must accommodate a range of user needs and applications.

Exceptions

Standards provide a clear framework for document development. Exceptions should receive prior approval based on a business or technical requirement for a nonstandard application.

Additions

Standards are dynamic. They evolve to accommodate new technology. They are never complete and must constantly be developed, refined, and updated. New ideas become Xerox publishing standards if they meet the following criteria.

1. Customer requirements are clearly stated and show a business or technical need for a new standard practice or design.

2. The standard can be implemented by document development groups in centralized and decentralized international organizations and without professional design assistance.

3. The standard accommodates multilingual requirements and multinational production, packaging, and distribution.

4. The standard can be produced:

 a. In word processing, style specification, and typesetting applications

 b. In all electronic (laser, ionographic, and offset) printing environments.

Options

Standards must allow for flexibility and creativity within guidelines. A good example is the vertical line or rule that you see on this page. The rule provides subtle guidance to the eye. However, you can't easily create the rule under all conditions. So it becomes an option to be used when appropriate.

Communicating publishing standards

The *Xerox Publishing Standards* manual is just one vehicle for communicating standards to the Xerox community. We also produce bulletins and communicate daily with our users by electronic mail and over the phone. Councils and task forces meet as needed to address standards issues across organizations.

Most important, users channel feedback and inquiries through the Publishing Standards Program. It makes information and experience available to the whole community and precludes repetitive decisions. This saves time and money in the publishing process and contributes to establishing a consistent process and image for all publications.

If you would like to reach us

We feel that the *Xerox Publishing Standards* manual will be a useful addition to your reference library. If you have questions or comments, we would be delighted to hear from you.

Phone 213-333-6092

Xerox Ethernet address From within Xerox you can access the Publishing Standards Program via electronic mail. Our network address is:

PublishingStandards:ES CP8:Xerox

ARPA Internet address PublishingStandards.ESCP8@Xerox.COM

1. Publishing process

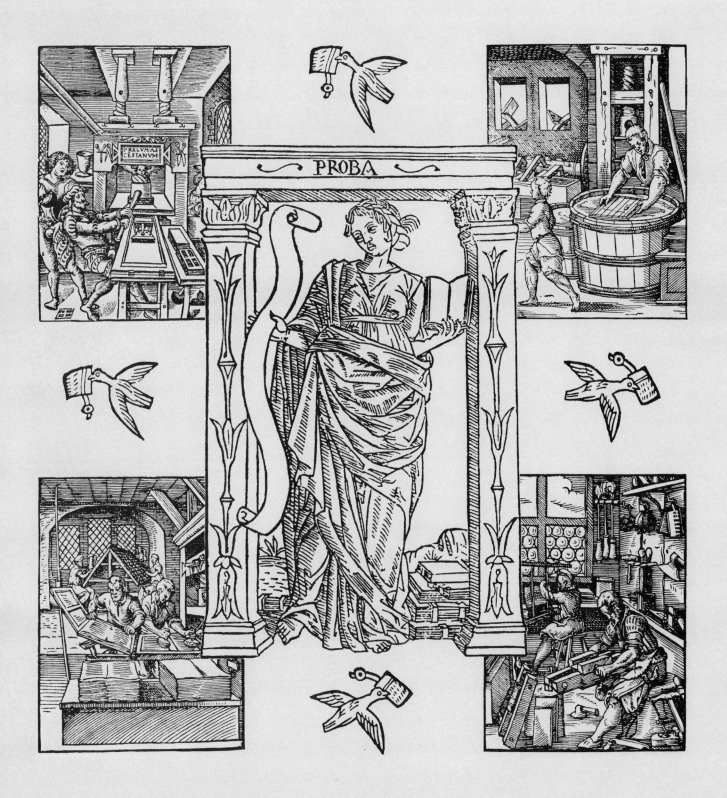

Part 1: Publishing process

The various images shown on the subtitle page for part 1 come from woodcuts produced between 1481 and 1568 in Nurnberg, Paris, and Rome. The bookbinder, the papermaker, the printer, and the typesetter surround the central figure, Proba. Although a minor Roman deity, Proba (or "proof") is a major presence in the publishing realm. She holds a scroll in one hand and a bound treatise in the other. The four birds carrying documents, presumably hurrying to press, are added for balance. As early as 450 BC, carrier pigeons were used for communication between Greek city states. The birds could fly up to 700 miles a day, and were the most efficient means of fast, long-distance communication well before the telegraph, radio, or electronic publishing.

Overview of publishing process

Whether you are publishing a one-page flyer or a 100-page reference manual, there is a specific process you should follow to turn your idea into a successful publication. This overview of the publishing process outlines the steps involved in printed communications and describes how to guide a document through the six main stages (figure 1-1).

Figure 1-1. **Document publishing process**

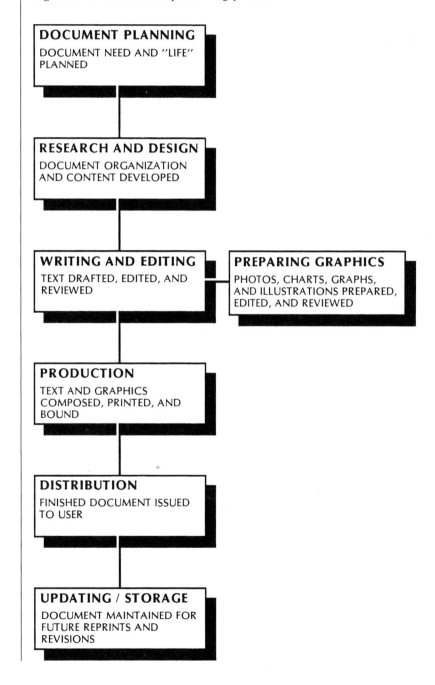

DOCUMENT PLANNING
DOCUMENT NEED AND "LIFE" PLANNED

RESEARCH AND DESIGN
DOCUMENT ORGANIZATION AND CONTENT DEVELOPED

WRITING AND EDITING
TEXT DRAFTED, EDITED, AND REVIEWED

PREPARING GRAPHICS
PHOTOS, CHARTS, GRAPHS, AND ILLUSTRATIONS PREPARED, EDITED, AND REVIEWED

PRODUCTION
TEXT AND GRAPHICS COMPOSED, PRINTED, AND BOUND

DISTRIBUTION
FINISHED DOCUMENT ISSUED TO USER

UPDATING / STORAGE
DOCUMENT MAINTAINED FOR FUTURE REPRINTS AND REVISIONS

After a document is initiated, it is planned, researched and designed, written and edited, produced, distributed, and, when necessary, stored and updated. It ceases to exist when it is no longer needed and no inventory remains. This progression from stage to stage is called the "life" of a document.

Every successful publication follows this progression. Each step has a strong impact on the next and essentially determines its outcome. You must plan carefully at the onset of the project so that the details of each step are anticipated and problems are worked out before they occur. You should review the document's development at each stage to ensure that the document is progressing on schedule and is in compliance with its intended outcome. Skipping steps or jumping randomly from one step to another results in costly and time-consuming backtracking. Following the process logically ensures a steady progression toward a successful publication.

The role of electronic tools

Today we have the advantages of assistance from computerized typesetting and word-processing equipment, printers, scanners, and other electronic devices. New equipment and systems are extremely valuable, but they cannot guarantee publication quality—they are only tools that help writers, editors, copy editors, and proofreaders achieve and maintain quality through sound publishing practices.

Increasing productivity

In an electronic publishing environment, writers and editors format their own text and create or borrow art on-line. Basically this means that writers directly insert formatting commands along with the text. These commands instruct the electronic printer to set margins, paginate, format columns, and place graphics. Writers and editors then submit the preformatted tape or disk to an electronic publishing facility. In other words, they control page makeup, thereby reducing production costs and turnaround time.

The graphics and text in a corporate standards manual, for example, can be created on-line and stored electronically. The book can be printed on demand, one copy or hundreds at a time, eliminating such prepress operations as negative preparation and platemaking. Because each electronic copy is really an "original," the pages can be used as offset masters for high-volume printing. Portions of any of the text or graphics can be borrowed from the electronic library for use in other documents.

Understanding the limitations

In the minds of some people, changing technology has had a blurring effect on the functions of writing, editing, copy editing, and proofreading. Before electronic editing systems came into use, these jobs were widely understood; writers and editors knew style and how to spell, copy editors verified spelling and style, and proofreaders caught mechanical errors generated in the rekeying for typesetting.

Now that technology enables us to capture the writer's and editor's keystrokes for use all down the line, some of these checking functions may seem unnecessary, but they are still needed, even with automation. The quality of publications deteriorates seriously if the less

obvious but more important checking functions of these jobs are lost in the process.

There are also limitations inherent to computer-based devices. A spelling dictionary, for example, is useful, especially if the user can store technical or obscure words that are hard to spell. But consider the following:

> Once up on a time, their was too little kids which live in a tree house they billed them self. . .

The computer dictionary won't reveal the grammatical problems with this sentence.

Also, new methods of document preparation haven't changed the axiom that the later a change is made, the more it costs. An error takes only a moment to fix if it is discovered as the manuscript is being written. If it is found by the editor, there are complications, including discussion with the writer. And so it continues—to the worst case of a serious error requiring destruction of a finished publication ready to distribute. If a serious error is discovered after the publication has been distributed, not only are there major incremental costs, but there may also be serious customer-relations problems.

Standards won't solve all these problems, but they can prevent many of them. As with all managerial tasks, a good publishing process begins with planning.

Document planning

The first step in publishing any document is planning it carefully and in detail. This statement simply cannot be overemphasized since it establishes the foundation for the entire publishing process. Before a single word is written or graphic prepared (and certainly before a single page is printed!), you must cautiously, carefully, even painstakingly anticipate and review each stage of a publication's life.

Planning ensures a smooth, timely, and cost-effective work flow. It also ensures that the finished product is exactly what it was conceived to be and that it is well written, effectively designed, efficiently produced, and successfully distributed without unnecessary and wasteful backtracking.

Plan ahead

You need to set aside time at the outset of the publishing process to plan and organize all aspects of research, design, writing, production, and distribution. Clearly define your objectives for each publication and examine the needs of the readers. Make these decisions before you begin writing or producing the manual, and always keep in mind the specified publishing standards. Careful integration of all these elements at the very beginning of document development can make a success of your publishing venture.

— Is the publication necessary?

— What is its objective?

— Who are its users?

— What is the relationship of the publication to the program?

— What is its relationship to other existing documents?

— What will the general document contents be?

— What publishing standards apply? What other corporate standards apply?

— How much time is required to complete it?

— Will the document require translation?

— What is the anticipated production schedule (complete with start and finish dates for research and design, writing and editing, production, and distribution)?

— What are the estimated costs and resources (labor and others)?

— How many copies are needed?

— Who are the required reviewers?

— How will the publication be produced, distributed, and maintained?

— Will it be reprinted?

— How will it be distributed?

— Where is a document identification number obtained?

— Which organization will package, ship, store, and fulfill orders?

— How will customers obtain copies of documents?

— How and where are orders placed?

— Will the document be marketed?

Establish roles

You must clearly define and establish responsibilities and identify key review stages in the development of the publication. For example:

— What are the roles of the writer, editor, designer, production co-ordinator, and other staff?

— When are costs and scheduling estimates made?

— Where are the critical review points, and how do they relate to the publishing process?

— Who is responsible for reviewing the publication as it progresses from one stage to the next?

— When are planning, budgeting, and review conferences to be held and who must attend?

These questions may seem obvious, but if they are not resolved early enough in the publishing process, they can cause serious problems later.

• If you do not determine during the planning stage who the primary user of the document will be, the text and graphics may be prepared ineffectively and inconsistently. Distribution of the document may be faulty because decisions concerning designing, producing, and issuing the publication were not directed toward a defined audience.

• While you may have good intentions, if you do not anticipate at the start the time and personnel required to complete a project, time and money may be wasted and the publishing objective may not be met because the project is not completed on time.

• If you do not carefully anticipate the overall design of your publication, you may produce a small, saddle-stitched book that was meant to be one of a series of large manuals in D-ring binders.

Many more examples of costly, wasteful, and ineffective documents resulting from poor planning could be given. What is important to remember, however, is that you must weigh many aspects of a document in detail before the project actually begins. Planning ensures that the publishing process flows smoothly and that design, writing, production, and distribution methods work together to achieve the overall publishing objective.

Develop a documentation launch plan

During the planning stage, program and documentation managers should develop a documentation launch plan. This is a management plan containing the documentation objectives, budget, personnel requirements, plans for local or international distribution, and anticipated means of carrying out the project. It is similar to a product launch plan, but its focus is specifically on documentation.

Because planning is so critical to successful communications, a sample publication planning/production form (figure 1-2) has been prepared to help program managers and teams identify the types of concerns they should address on each publishing project. Feel free to make copies of the form and to use it when planning your document. Its benefits are numerous. Recording the data prompts you to take the planning function seriously. It also ensures that the design and production specifications are complete and accurate, and that they are kept in mind as you prepare the text and graphics.

Figure 1-2. **Publication planning/production form**

Purpose - This form is designed to standardize the planning and production requirements for all publications.

Instructions - Complete entries one (1) through twenty-two (22) for all new publications, reprints, and revisions.

1. Identification no.

2. Working title

3. Desired/intended users

4. No. of potential users

5. Is this publication one of a series?

☐ Yes ☐ No

6. Is this publication related to a product?

☐ Yes (Name) _____ ☐ No

7. What is the primary objective?

8. What are the three most important points to be made:

1)

2)

3)

9. How much time is required to complete the publication

_____ yr _____ mo _____ wk _____ days

10. What is the estimated cost?

(Labor and other)

$ _____

11. Who will be the originating author/organization?

Name Organization Office address Telephone number

12. Who will be the required reviewers?

Name Office address Telephone number

13. What is the projected schedule?

Research and design _____ Production _____

Writing and editing/ _____ Distribution _____
graphics

14. What will the media be?

☐ Hardcopy ☐ Tape

☐ Telecommunicated ☐ Disk

15. No. of copies

16. Status

☐ New ☐ Reprint ☐ Revision

17. Output paper size

18. Paper weight

19. Paper color

20. Covers
☐ Offset ☐ Silkscreen

21. Binding requirements ☐ 3-hole, D-ring ☐ Saddle stitch ☐ Wire-O ☐ Other

22. Distribution instructions

Research and design

Once the document is planned, the process moves on to research and design. At this stage additional elements are defined, especially what the specific contents of the document will be and how the information should be designed for maximum usefulness and visual effect.

Collect information

Define your expectations

What are the overall publishing objectives and expected results for the internal and external customer? Answering this may involve considerable research but helps to determine the specific need for the document. (Appendix A provides more detail on document categories, contents, and objectives.)

Identify the user

It is important to identify specifically who will use the publication, as well as how and for what reasons. Researching this aspect of publishing helps to determine how the document should be designed and written. (Appendix A provides more information about primary document users.)

Determine the need for research

It is essential to determine the objective of the publication and the information the user requires. Research may well be needed to update or expand available data. Unique or specialized user needs should also be studied while the publication is being developed. (Appendix A provides more information on document content.)

Evaluate methods of sequencing and presentation

The way in which information is arranged and presented affects the user and, in turn, the usefulness of the document. Your goal is to make the meaning and the appearance of the words work together to reach the user and achieve the document objective. Part 2 provides more information on organizing and cross-referencing documents.

Use a clear writing style

Words are the basic building blocks of all publications. The writing must be clear, concise, and accurate. It should be directed toward a clearly defined audience and presented in a style that catches and holds the reader's attention. It must also be easy to read and comprehend. Part 3 provides guidelines on writing and style, as well as

information on how to measure the readability of your text. It establishes rules for grammar, spelling, punctuation, capitalization, abbreviation, and the use of numerals.

Consider the visual design

The visual aspects of a publication involve its typestyle, graphics, paper, ink, format, binding, and how they interact to form an integrated document. Design is vital to successful communications. It determines how the reader sees and ultimately is able to use the information.

The visual design specifications presented in part 4 are meant to give every document a consistent, professional, and familiar company "look." By following similar standards, you can make each document easily identifiable as your company's product, as well as one that can be relied on for accuracy and ease of use.

Keep these visual design specifications in mind when you are writing a document. They become critically important when the text is formatted.

Anticipate updating needs

In many respects, outdated information can be worse than none. Keeping publications current is essential to maintaining successful communications with customers and employees. Early in a publishing project, research should be conducted on how the text and graphics will be stored for future updating. Furthermore, decisions on binding and pagination techniques should allow updated pages to be inserted in documents, so that you avoid reprinting the entire document.

Validate research and prepare for writing

Test in the user environment

You need to test and retest research in a user environment. When producing an operations reference manual, for example, interview users to find out how they will use the document, as well as how they intend to use the equipment or application. Your documents should be based not only on what the machine or application can do but also on how the customer plans to use it.

Much of this information should be available from marketing research. Obtain a current set of documents and use them as a model to test your own materials.

Write clearly from the start

Avoid unnecessary and complex jargon, especially if you are developing technical specifications. Use standard units of measurement and follow established procedures for information updates and changes. Keep in mind that the next step in the process will be to translate any highly technical information into usable information for the customer.

Write for the average reader

Expect to write at approximately the eighth-grade reading level. Some people have more skill in reading than others. You will not lessen the impact or value of information by aiming for an eighth-grade reading level in most documents. More knowledgeable people are not offended by good, simple writing. They simply read it faster. (Part 3 provides more information on readability scales.)

Use simple, concrete words and relatively short sentences. Follow the Kernel Distance Theory, keeping the noun (subject), verb (predicate), and object of the verb close together. How well you communicate with your readers determines the effectiveness of your document.

Solicit feedback

Solicit feedback from others and share with them what you have found works or doesn't work. Review your research until you are satisfied it is as complete as possible.

Obtain editorial support

One person should provide the final editing for all the documents in a product line. This editor is responsible for ensuring that the terms and structures are consistent and accurate. He or she should also keep the language simple, clear, and readable.

Listen to the users

Let the final test of how the material should look and read rest with the users. If they tell you it can be improved, listen to what they have to say. At this point, you have the opportunity to carefully amend and improve what you have written.

Writing and editing/
preparing graphics

After planning and research and design are completed, writing and editing begin. It is at this point that the exact words must be carefully chosen. The goal is to prepare text that is "user-friendly" and that successfully communicates the objective of the publication.

Working hand in hand with the text are photographs, charts, graphs, and other illustrations. Whether you use electronic or traditional means to prepare the graphics, be sure that your artwork is of the highest quality, that it is current and accurate, and that it complements the text.

Tasks of technical writers

In most organizations, there are two kinds of technical writers. The first are people who are not writers by profession—managers, executives, engineers, and scientists—but spend some daily time writing technical and business documents. The second kind are full-time professional writers and editors whose principal job is to write, edit, and prepare technical documents for publication.

Professional technical writers often head writing teams as managers. It is the writing manager's job to coordinate the writing and production of the document. Usually there are several authors, including the different engineers and technical managers. Each author writes the sections of the document dealing with a particular area of technical expertise. A large publication can have dozens of contributing authors; it is the writing manager's job to mold their work into one clear, coherent text.

Tasks of the editor

While planning and writing, keep in mind what an editor can and cannot do. In general, an editor works only with what you supply. Changes are usually minor. The editor looks for errors of fact, awkward sentences that need rewording, misspellings, misused words, clumsy transitions, and the like. But the editor cannot correct a faulty plan for a document through normal editing. This requires complete reorganization, which nearly always means rewriting from the beginning. Any good piece of writing, from a single paragraph to a chapter in a manual, fits together neatly. If you take out a part, move it somewhere else, then revise another part thoroughly, the structure begins to crumble. It is not the editor's job to redo what the writer should have done in the first place (if so, the editor becomes the new writer). It is the editor's job to point out how serious the problems are and provide direction for changes.

Writing process

Successful writers follow a systematic, step-by-step procedure in developing their copy. For some, this procedure is more formalized than for others. For experienced writers, the process may be so habitual that they no longer think about the individual steps. In fact, they may be so adept at writing that an inexperienced writer does not perceive any visible signs of an orderly and systematic procedure. When pressed to reveal their methods, however, seasoned writers can invariably identify the stages of their writing process.

Successful writers analyze their assignments as well as their readers, conduct necessary research, organize carefully, write, and rewrite. Often they write and rewrite several drafts before they find the best way to say what they have in mind. They search carefully for the right words and the best organization. Only then do they feel their work is ready for publication and distribution.

Observe the four classic stages of writing

There are four classic stages in the art of writing: prewriting, writing, self-editing and revising, and proofreading. Following this systematic approach can help you in a number of ways. First, it can reduce the anxiety you feel about writing. Approaching a document one step at a time is more reassuring than trying to complete it at one sitting. Second, a clear process can help you use your writing time efficiently. Organizing your ideas before you write them out precludes pausing over vague ideas in the middle of a paragraph. Finally, this approach can help you write clearly and logically. Going back over your first draft gives your brain time to consolidate the ideas you have been explaining.

Prewriting

Prewriting is the careful preliminary work. It should take up approximately **55 percent** of your writing time. During this stage, you analyze your purpose and your reader and also research your subject thoroughly. Finally, you decide on an organizational plan.

Conventional wisdom once suggested that writing promotes clear thinking. Just the reverse is true. It is during the prewriting stage that your thinking and planning must occur. Otherwise, you will not produce good copy.

Writing

The actual writing takes only about **20 percent** of your total writing time. Since you researched your subject thoroughly in the prewriting stage, you can now create content out of your notes and ideas. Write quickly, incorporating your research into your first draft. The most important goal during this stage is to get your ideas into sentences and paragraphs. Worry about perfecting them in the next stage.

Self-editing and revising

Self-editing and revising needs **20 percent** of your writing time. When you edit and revise, you correct your habitual writing errors. You also check the content for accuracy and consistency. You search carefully

for the best words and the best organization for your ideas. Carefully editing and revising numerous drafts will help you communicate clearly.

Proofreading

Finally, you should spend **5 percent** of your time proofreading for mechanical errors. At this point you can confidently pass your writing on to other writers for further revision.

Set aside time for each stage

Once you understand the fundamental writing stages, table 1-1 can help you budget your time.

Table 1-1. **Time budget for writing**

Stages in the process	Time spent in each stage (%)
Prewriting	
Analyze your writing assignment and state your purpose	5
Analyze your readers	10
Research your subject Analyze the information Categorize the information into topics	35
Determine your basic approach (inductive or deductive) and arrange your topics in a logical sequence (prepare an outline)	5
Writing	
Write your first draft (save the introduction for last!)	20
Self-editing and revising	
Edit and revise your first draft Check for logic of overall organization Check for appropriate word choice Check for your habitual weaknesses in sentence structure, grammar, and punctuation Prepare your revised draft	10
Edit and revise your second draft Check for eighth-grade level of readability Prepare your revised draft	10
Proofreading	5
Proofread carefully Check for omissions Check for misspellings Check for letter, word, or sentence transpositions Check for incomplete copy	

Do your undercover work: prewrite

Writing requires content. In prewriting, you determine what you have to say and how you are going to say it. In other words, you determine your purpose, analyze your reader, and gather and organize your facts.

Analyze your purpose

Before you begin to write, you must clarify your purpose in writing. Your purpose is as important to clear communication as is your content. Ask the following questions:

— Why am I writing this document?

— What type of information do I want to present?

— What conclusion do I want my readers to reach?

— What recommendation do I want to make?

— What do I want my readers to do, or to be able to do, as a result of this document?

— How do I want my readers to react to this document?

Your written statement of purpose should reflect the answers to these questions.

	I am writing this document
reason	to inform the field that, even though the 5700 is now an Ethernet Print Server option for the 8010 workstation user,
information needed	the 5700 cannot print documents containing complex graphics
	and
result desired	to make sure the field informs customers that they will probably want to keep an 8044/45/46 on site for this purpose.

Such a statement of purpose enables you to determine the kind of information you need to gather during your research. For example, you may need one type of information to persuade a customer to buy a certain product but another type of information to brief field personnel on a new product.

Analyze your readers

After stating your purpose, get to know your audience. Knowing your readers will help you determine your content. Different types of readers need different types of information. Answer the following questions to develop a profile of your readers:

— Who are my readers?

 Headquarters staff?
 Field employees?
 Customers?
 Position or title?

— What do I need to know about them?

 Professional expertise?
 Prior knowledge of the subject?
 Attitude toward the subject?
 Attitude toward the company?
 Native language or nationality?
 Reading level?

— What must I keep in mind about their needs, idiosyncrasies, or prior knowledge of this subject?

Gather your information

Once you understand your purpose and know your readers' needs, you can gather information efficiently. Generally, once you know your topic, you must get information from other sources. Either retrieve it from your own memory or develop it from reading or from other kinds of research, study, and analysis. Ask the following questions:

— What information do I need to communicate the subject as clearly as possible?

— How can I classify the overall subject of this document? Is it, for example, sales or instruction?

— Based on this classification, and based on the reaction or action I want from my readers, what basic approach should I choose for this document (deductive or inductive)?

— What categories does the information fit into? What names can I give these categories? (Use these names later to help you write strong topic sentences for your paragraphs.)

— In what order should I discuss these categories?

Adequate research requires extensive digging and considerable thought. Review your information for balance and objectivity. To feel comfortable about the writing stage ahead, always gather a surplus, or cushion, of information. The information you unearth now will be essential for making intelligent choices during the writing stage.

As you gather information, annotate your research and keep careful records of your sources. Each time you record potentially useful information, make a note explaining why and where it may be useful. And, of course, record your sources, noting the authority or text and page numbers.

Organize your information

Once you have assembled sufficient information about your subject, you are ready for the last step in prewriting: organizing your material into a logical and manageable structure. Having this order or organization to follow keeps you from aimless wandering. It also provides a subtle but perceptible orientation for the reader.

After you have chosen the pertinent material from your research, you should categorize it and then determine some sequence for those categories. Your first decision is whether to use a deductive or inductive approach. Deductive writing moves from the point you are making to a detailed explanation. It is useful for presenting familiar or simple instructional material. Inductive writing works in the opposite way. It moves from details to the point you are making. It is useful for selling a product or for presenting complicated instructional material.

Organizing your material almost always means outlining. Experienced writers use some form of outlining. Some writers make detailed outlines. They use complete sentences and note many specific points for eventual development. Other writers list their major categories or points in a logical sequence, using phrases and shorthand. Whatever the technique, it all comes down to an outline. Outlining prevents mental wandering. It enables you to organize your thoughts before you begin to write.

Get started—write

After outlining, you are ready to begin writing. Getting started is one of the toughest chores in the writing process. It takes self-discipline to sit down and start producing copy. For many writers the act of self-expression is the most difficult. They are not ready to put pen to paper.

Writer's limbo

If you develop a psychological block when you have to start writing, the pressure of an imminent deadline can help push you to action. As the deadline pressure mounts, you produce a few organized sentences. Invariably, the squeezing out of these first few sentences sets up a positive chain reaction. One idea seems to generate another, and the words begin to flow. At last you are off and running.

The secret of getting started is to begin and keep going, knowing that anything you write is at best tentative. You should never feel personally or permanently committed to anything you write in your first draft. **Don't spend time trying to edit as you write.**

A good approach to your first draft is the keep-going-at-all costs method. When you have to interrupt an article for lunch or the end of the workday, write the first sentence of the next paragraph before you stop. You'll be amazed by how easily you can get going again after the interruption.

Don't feel obligated to start writing at the beginning of your outline. Often you can break through a psychological block by working on the section you are most interested in or feel most comfortable with. If this method doesn't work, try talking through your outline to yourself. Informally discussing or writing down your ideas sometimes removes the fear that may accompany more formal kinds of expression.

Ghost writing: writing for others

Authorship is an element of corporate writing that requires open discussion. Although it is assumed that people will do their own writing, there are times when you need professional writing and editing to help prepare the complex and high-quality documents required by a business. Entire writing groups are organized to develop program and product manuals. No individual owns these publications. Rather, authorship is claimed by the corporation.

Ghost writing is done on behalf of another individual who is named as author. Whether the document is a speech, report, presentation, executive summary, or newsletter, there are sound reasons for this type of writing support. There may not be time to prepare a key document. There may be a need for a senior manager's signature to add power or influence. A group may need a single document that describes its work or the results of a meeting. Writing for others in these circumstances is a necessary and acceptable business practice.

If you are asked to write for others, here are some suggestions:

1. Find out as much about the subject as you can in advance. This may prevent your asking unnecessary questions or, worse, letting things pass that you don't understand.

2. Use a tape recorder. This is especially important in reporting on a meeting, where the heat of the moment may cause people to say things that they don't remember later. The tape can then be transcribed into a manuscript that is convenient to edit.

3. Allow at least twice as much time for writing and editing as you would need if you were doing it just for yourself. If a recording is made, you should be present to ask questions, help guide the speaker, and ask for clarification. Then you will need considerable time for editing the transcript, including tracking down errors and clearing up ambiguities. Have your edited version reviewed by those who contributed to it. Edit their comments and changes a second time for coherence and consistency.

4. Make sure that you—and all the others involved—understand the approval procedure in advance. Whenever possible, try to get agreement that a single person will have final authority for approving the document. It can be difficult to get several people to agree to the same facts, much less the wording, and the compromises that are necessary in these cases can lead to vague and inconclusive writing, which may obscure the subject instead of explaining it.

If you are directing or using a ghost writer, here are some suggestions:

1. Clearly define what you want written and what the document will be used for.

2. Be available to answer questions and review developing drafts. Be sure you have scheduled enough time for the project.

3. Help the writer understand your style and personality. If the document is cold or unclear, ask for a rewrite. Don't rewrite it yourself. Ask the writer to revise it, even if it takes many drafts.

4. Use standard editorial marks to communicate precisely what you want.

5. Give credit where credit is due.

Self-edit and revise

One of the most valuable skills to learn in writing is the art of self-editing and revising. All writers make mistakes in their first drafts. Successful writers, however, take the time to go back over their work and correct it. You should spend 20 percent of your total time editing and revising your first and second drafts.

When writing your first draft, you are combining your research notes and your original ideas into the sentences and paragraphs of a document. Often the content of these sentences and paragraphs is quite complex. In most cases, you will need to revise the first draft considerably to arrange the facts logically and choose precise and appropriate words. You will probably require subsequent drafts to express all the ideas clearly and with apparent simplicity.

As a writer, you may become emotionally involved with your own words. You may tend to guard what you create as a personal work of art. It is helpful to remember that nothing you write is sacred. Review your text carefully and develop the art of self-editing. The following suggestions can help you speed up the process.

Adopt a self-critical attitude

Look at your work with an eye toward improving it, but don't try to edit as you write. Once you start, keep going. Just leave plenty of space for revision. Always consider your first draft as tentative.

Develop your ear

Read your copy aloud, to yourself or to someone else. Listening to your own copy is a habit that you can establish quickly. By reading copy aloud, you subject it to two senses—seeing and hearing. In this way, you increase your chances of spotting places where you can improve the wording.

By reading aloud, you can also discern rhythm, pace, and flow more easily than when you read silently. When you listen to what you have written, you can quickly identify words that jolt or jar. You can catch digressions and detect inaccuracies or vagueness.

Cut out verbosity

Wordiness is a common tendency. Read your copy with red pencil poised to see how many words you can delete without changing the meaning. Pounce on adverbs. Get rid of an adjective when you find several in a row. You'll probably find whole phrases that are irrelevant.

Make sure you have enough content

If you find your development is too lean, add an idea or two to beef it up. You may discover that you have missed the point or that your approach is weak. Perhaps you didn't define your purpose clearly during the prewriting stage. Don't let such an experience throw you; scrap your writing and start over.

Keep a list of your own errors

Errors are often habits and keep recurring, regardless of how well you understand them. Check your copy for errors you've made in the past.

Learn from others

The editorial process is a vital part of writing. Always be aggressive when others edit your copy. Be positive. Feel free to question the editorial changes in your copy. The editorial process provides a continuous avenue for learning. You can assimilate what you learn from others into your own self-editing know-how.

Proofread

Proofreading is a neglected art. It deserves more attention because it is the last chance to correct errors of fact and omission as well as typographical errors.

You should spend the final 5 percent of your time proofreading. Proofreading provides a check for omissions; misspellings; letter, word, or sentence transpositions; and incomplete copy—including missing heads, subheads, captions, and any necessary specifications. Proofreading is your responsibility. Clean, accurate, legible copy saves time for everyone who must handle your text once the production process begins.

Proofreading must be done any time new text is entered or existing text is revised. The more inaccurate your writing draft, the higher the cost of the editorial process.

Accurate proofreading requires a different point of view from editing. Rather than evaluating content, you are looking for misspellings and

typos. Proofreading requires looking at the small details of each word on each page. Here are some suggestions for making the process effective:

1. Take the time to enter text accurately. Proof the words of each paragraph.

2. Look at each word separately, rather than as part of a sentence. Sound out long words to make sure all the syllables are there.

3. After you see an error and correct it, look carefully at the preceding and following text. Often when one error catches your attention, you overlook another nearby.

4. Have someone who has never seen the copy proofread it.

5. When comparing marked-up copy to new copy, place a ruler under each line to help the eye jump back and forth between pages.

6. Read technical and statistical material aloud to another proofreader.

Insist on accuracy

Not enough can be said on the importance of accuracy. Once something is in print, it is difficult (sometimes impossible) to retrieve and correct. You may have written a perfectly well-organized and concise document, but one error—a wrong figure or date, a misspelled word, a grammatical error, a misquote, an inaccurate fact, a mixed caption, or a wrong headline—can damage the integrity of the entire document.

Sooner or later we all make errors in our presentations. To lessen the probability, make a habit of using more than one source and checking and double-checking figures, dates, names, captions, heads, quotes, and all other data. Finally, review your document at each stage to catch every possible error.

Editorial process

Writers become so familiar with the text after working on it for a long time that they tend to overlook errors or confusing statements. The quality of any document is enhanced by using the services of an editorial department. The questions below can help you define exactly how many editors and what level of editing your project needs.

— Do you need help organizing the content and planning the document design?

— How long are the documents and how many authors are there?

— Do you need help ensuring consistency among products and across document sets?

— Which level of text editing do you need?

Provide new text or art and transitional material.

Examine the document for correct sentence structure, logical flow of ideas, clear presentation of material, consistency, and concise expression.

Examine the document for adherence to the basic standards of grammatically correct English.

Ensure the document meets corporate publishing standards.

Ensure the final draft of the document is complete and that the front and back matter and the text are in order.

Compare each new draft to the previous hardcopy, ensuring that the author's corrections have been made.

— Which level of graphics editing do you need?

Manage the art log.

Proof callouts, legends, and captions.

Check line weights, perspective, and resolution.

— Do you need help coordinating the production aspects of composition, graphics, printing, or distribution?

Using an editorial checklist

You need to clearly establish from the beginning what is expected of the editorial role. The following checklist is an example of what you might require for checking format and document integrity:

1. Check the levels of headings for type size and font.

2. Check margins and indents.

3. Check the format of entries in illustrations.

4. Edit spacing where necessary to eliminate isolated text and awkward runaround text with illustrations.

5. Check the page numbers for order and position.

6. Keep track of all references in the text, checking to see that they refer to the right pages or figures.

7. Compare the entries in the table of contents, table of illustrations, and index with the corresponding chapters, sections, pages, and figures to see that the page numbers match.

8. Check headers and footers for accuracy.

You can create a checklist to identify any level of edit from developmental writing and editing to proofreading.

Handling review and production cycles

Document production is most efficient when several people can work on various parts and aspects of a document simultaneously. Everyone should agree to an organized system of handling and exchanging drafts during the cycle. The following suggestions will help keep the review process organized:

1. Establish a schedule and communicate it to everyone involved.

2. To ensure that you are working from the latest copy, clearly number all document pages and place a version or draft level and date in the footer and on all media. Keep this information updated.

3. Break large documents into smaller units for efficient handling. Circulate difficult and high-priority sections first.

4. Identify the level of review required and establish a date for the sections to be returned.

5. Mark all changes in red (not pencil or dark ink). If you must distinguish different people's marks, assign different colors. Submit the red lines to the production department, rather than copies.

6. Every time a revision is made that incorporates changes, check that the corrections have been made and that new errors haven't been introduced. Mark the latest version and date on the revised pages.

See page 3-69 for a chart of the standard editorial and proofreading symbols.

Seeing red

It can be disconcerting the first time you encounter an editor's red lines on your copy. Don't take offense. The abundance of red on your copy is a sign that your work is being polished, not criticized or destroyed.

On-line editing

On-line or on-screen editing is an efficient way to write and revise copy because changes are made directly onto the electronic master and you can immediately see the typed result. If your whole department is on-line or on a network, you can take advantage of electronic document management, including document routing, art libraries, and controlled document accessing.

You still need to agree upon conventions for communication, such as using underscoring to identify changes made to the text. If you are working both on-line and with hardcopy, always check the version of the media file to make sure it matches that of the copy in hand.

Graphics preparation

Graphics are an essential component of the publishing process. Illustrations please the eye, guide readers through a document, and enhance the written word. Writers frequently call upon the skills of graphics specialists who can help them plan and process all artwork requirements. In technical documents, for example, a graphics editor reads the associated text and proposes art edits that ensure the clear portrayal of technical concepts.

Since you are responsible for the entire document, including graphics, the following practices will help you process your art requirements smoothly and efficiently.

Organize and number artwork

First, order all your artwork as it appears in the document. When a piece of art is repeated, place it in its first position only.

Your company's graphics specialist can assist you regarding the numbering of your art pieces. He or she may suggest an existing convention, such as an alphanumeric system in which a preassigned block of numbers is given to you.

You then mark these identifiers on the original artwork. Use only non-photo blue pencil or marker if you write on the front surface of the artwork. It is efficient to note all identifiers in the same place (perhaps the lower right corner) on each piece of artwork.

Create a "graphics master" and art log

Next, obtain a copy of the text to use as a "graphics master." Using red ink this time, annotate all graphic identifiers at appropriate locations in the margin of the text. Arrows can be drawn to clarify art location between lines of type. Note duplicates by stating "repeat xxx [graphic identifier]." This master is then given to the graphics specialist. You should retain a copy for reference during document production.

The art log is a list of all the graphics in their order of occurrence in the document. You should include the graphic identifier, figure number or captions where applicable, special size or placement directions, and so forth. Keep this log as simple as possible and include the status of any missing art. If you are using graphics specialists, make sure you provide them with copies.

Precheck original art quality

Is your art of high quality? Check for extra marks or smudges, unclear or feathered line work, breakup of solid gray or black areas. If you cannot correct the problems, consult your graphics specialist. There may be production processes that can alleviate the problems.

Meet with the graphics specialist

Provide the graphics specialist with all the original art, a copy of the graphics master, and an art log. At this meeting you can both review the artwork and supply your final requirements. You also need to:

1. Communicate the publication date and the request date for a proof copy with merged art.

2. Identify the final printing process. The graphics specialist can select art production methods best suited to high-quality output, whether your document is produced electronically or offset printed.

3. Specify the use of technical terms, special hyphenations, and use of acronyms in legends that occur within the graphics.

4. Define legends that occur with graphs.

5. Decide on final sizes, ie, quarter, half, and full pages.

Final review

Use the graphics master and art log to verify the correct placement of all images in the text. Note all changes in red ink.

Production

Document production takes place only after the planning, research and design, writing and editing, and graphics stages have been completed. A manuscript is final when it has successfully been reviewed for accuracy and completeness in text and graphics, and the style and visual design have been approved. Production of that manuscript includes composition, printing, and packaging.

Scheduling your publication through production is a major concern. Workloads often vary in a production center during peak and off-peak periods. Figure 1-3 illustrates the average turnaround time of typical publications within an electronic publishing center (EPC). Make sure to schedule your publication far enough in advance of the desired delivery date.

Composition

There are many ways to format or compose a document and many kinds of hardware on which to do so, including:

— Typewriter

— Word processor

— Personal computer

— Networked workstation

— Host computer

— Host publishing system

— Typesetting system.

Simple devices like typewriters and word processors generate output appropriate for a variety of documentation needs. More complex systems that use software packages designed specifically for composition can generate an even wider range of output. The appropriate composition method for your document is determined by your application.

Factors to consider

There are many factors to consider when choosing a composition method, including the user, your budget, the document size, updating requirements, and the input method.

User

The requirements of your user should be clearly understood. Otherwise it is possible to select a composition method that adds time and expense to the project without providing additional benefit to the user.

Figure 1-3. **Document flow through an Electronic Publishing Center (EPC)**

ACTIVITY	TIMETABLE FOR JOB COMPLETION								
	12 WKS	10 WKS	8 WKS	6 WKS	5 WKS	4 WKS	3 WKS	2 WKS	1 WKS
1. 1st meeting with EPC	───		▪ ▪ ▪ ▪						
2. Mag media and dummy to EPC		───		▪ ▪ ▪ ▪					
3. Media conversion			───		▪ ▪				
4. Forms design begins				───	▪ ▪ ▪ ▪				
5. Composition process			────────		▪ ▪ ▪ ▪ ▪ ▪ ▪ ▪ ▪				
6. Text proof cycle begins					───	▪ ▪ ▪ ▪			
7. Artwork to EPC						─── ▪ ▪ ▪ ▪			
8. Scan art/merge with text						─── ▪ ▪ ▪ ▪			
9. Merge forms with text						───	▪ ▪ ▪ ▪		
10. Final proofing begins							─── ▪ ▪ ▪ ▪		
11. Final editing								─── ▪ ▪ ▪	
12. Printing begins									─── ▪ ▪ ▪

Legend:

───── Job output 200 pages or more ▪ ▪ ▪ ▪ Job output 100 to 200 pages

░░░ EPC work flow only

Budget

If the user will accept a variety of methods, your budget is the next criterion to evaluate. A publishing center or vendor can estimate the costs involved for alternative composition methods.

Document size

The size of the document obviously affects composition costs but is quite often overlooked as affecting the composition method. Large documents can be processed quickly in the host computer environment but may go very slowly in the workstation or personal computer environment.

Updating requirements

If the document will require frequent updating, it is important to maintain its integrity. It is worth the time up front to get the document into an electronic format in order to facilitate the updating process.

Input method

The method of input can determine the composition method, especially if the two are electronically compatible. Compatibility between devices eliminates the need for file conversion or manipulation.

Quality assurance for composition

Regardless of the composition method chosen, there are guidelines for quality assurance that composition must follow. Chief among these are consistency and accuracy.

Consistency

Composition techniques should be executed in a similar fashion throughout the document. Common treatment of the document elements facilitates understanding of the material.

Accuracy

The accuracy of a document is of utmost importance. By the time it gets to the composition step, text accuracy should be a given. However, composition will affect the document in ways like page breaks, headers and footers, numbering, indexing, and references. It is therefore imperative to do a thorough check of the composed document to ensure that these elements are accurate. When that process is complete, your document becomes a master.

Printing

The process of duplicating, or printing, provides you with multiples of your document from a master. A master can simply be a typed manuscript used in a reprographic machine. Or it can be typeset copy with art "cut and pasted" into place. This kind of master is also known as "ready for camera," and refers to the first photographic steps in the offset printing process.

The kind of master used in electronic publishing is an electronic master, not a hardcopy. It can be a file that resides on magnetic media or is communicated directly from an input device to an output device. The electronic master can drive the output device if it is a compatible format, and the output device will generate, or print, a quantity of the document.

Methods of printing

Printing methods include reprographics, electronic or laser printing, and traditional printing, such as offset lithography.

Reprographics

In the realm of copier and duplicator technologies is reprographics, which creates a "second-generation" copy of a master. Optimum results are achieved by using the cleanest and highest resolution master possible. Reprographic technology includes speeds that rival electronic printing capability and can feature on-line finishing, such as stapling, collating, and binding.

Electronic or laser printing

Driven by the power of a computer, the electronic printer creates multiple originals instead of second-generation copies of a master. In other words, every page is a master, and there is no loss of resolution.

Traditional printing

Traditional printing uses a series of photographic and mechanical processes. Masters become negatives, which are assembled and exposed on photosensitive metal plates. When these plates are placed on any one of a number of printing presses, ink adheres to the plate and transfers from roller to paper. The large sheets of paper are folded to create what are called signatures. The signatures are assembled to create the document.

The printing method, like the composition method, should be carefully chosen based on the application and the requirements of the customer. For example, offset printing is most cost-effective in high quantities, not in quantities of a few hundred. Electronic printing is very economical for small runs. You can print one or ten or a hundred copies on demand without having to warehouse large inventories. Some reprographic output is not as legible as laser printer output. However, laser-printed documents can react to extremes in temperature.

Quality assurance for printing

Judging the quality of printing may be subjective, but you can watch for the following possible problems: intermittent spotting, streaking, black areas that are not dense, shaded areas that fade, type that breaks up, fine details that disappear, faulty alignment, and pages that are out of order or missing.

Discuss your quality expectations with your publishing center or vendor. Ask to see sample output from the various methods they use. There is a difference in quality from one method to the next. Avoid both surprises and disappointments by establishing your quality expectations at the start.

Packaging

Once printing is done, several more steps need to take place prior to distribution of the document. These steps can be called packaging, and they involve some of these packaging elements:

— Binding (looseleaf, Wire-O, perfect, or saddle stitch)

— Trimming

— Collating

— Assembling other materials, such as software diskettes, diskette holders, sheet lifters, tabs, and custom elements (rulers, grids, photos, etc)

— Shrink-wrapping

— Boxing

— Labeling.

Planning the packaging requirements of your document is critical. It is usually necessary to manufacture packaging elements while document production is occurring. Monitoring the production of these elements and gearing their completion to coincide with the printed quantity is nothing less than a fine art. The only way to have everything ready at the same time is to know exactly what you need and order it early. Changes will cause delays and cost overruns. Packaging is best accomplished with the help of publishing and procurement experts. Use them.

Quality assurance for packaging

Your supplier should assist in checking the quality of packaging materials. Take care at this stage, because shoddy workmanship can damage materials that will take time to replace. For example, shrink-wrapping can bend the edges of tabs. Since it is a heat process, it may melt plastic items such as grids or rulers. Shrink-wrapping should be smooth and even, and the seal should be secure.

Make it clear to your supplier that your quality expectations do not stop with print quality. Ragged and uneven pages are the sign of a dull knife on a guillotine cutter. Spots or streaks on covers are unacceptable. Dirt or smudges on materials assembled by hand are definitely avoidable.

A good rule of thumb for deciding when to reject shoddy work is: "If you can see it, they should have seen it."

Distribution

Although it is one of the last stages in the publishing process, distribution is a key aspect of communications. A publication is successful only if it gets to the people who need it—when they need it.

For this reason, accurate mailing lists and usage figures should be maintained so that publications can be issued quickly and easily to all intended users. Also, publication updates or revisions should be clearly identified on the document (that is, publication number and date) so that users know exactly which edition of the publication they are using.

Design specifications are also vital to distribution. For example, if your piece is a self-mailer, the address must be placed correctly. Or if your publication is to be inserted for mailing, it must be designed to fit in a standard-size envelope.

Determining the best means for getting a document to its intended audience is critical. Will it be displayed on rack stands, packaged with a product, handed to customers, mailed to employees, or sold? The objective, audience, quantity, quality, and design of a document all have a very significant bearing on distribution.

Updating and storage

The fact that a document is completed, approved, published, and distributed represents the achievement of a milestone. However, unless the document has been designated for "one-time use only," it is just the beginning.

For example, when a company sells a product, it may also offer ongoing service and maintenance. Staff members responsible for documentation development must also be responsible for updating. Publications must be maintained just as customers' equipment is maintained.

Information should be kept accurate and current. Reprints or updates should be distributed promptly to those who need them.

Electronic publishing has greatly simplified the updating and storage process. Information stored electronically can be revised, produced, and distributed easily, economically, and quickly.

Don't treat revisions lightly. When preparing updates, follow the step-by-step publishing process described in this manual.

2. Document organization

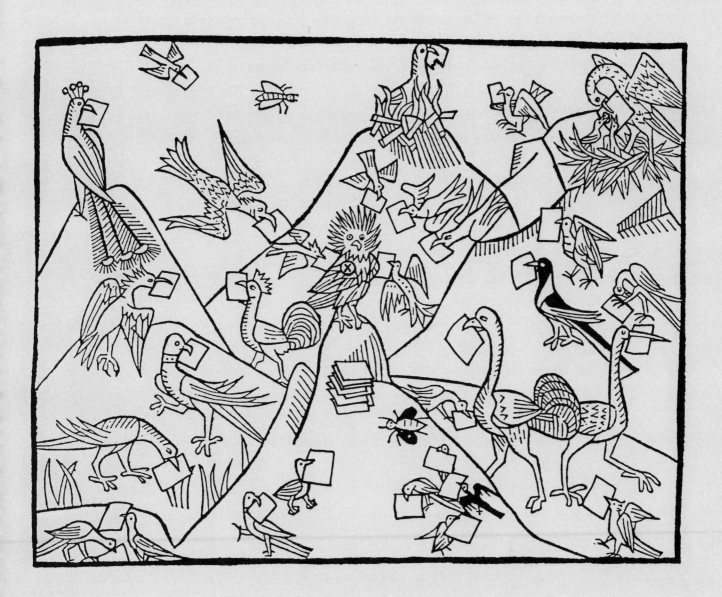

Part 2: Document organization
In part 2 the theme of document delivery is continued, with the emphasis on organization. The image is based on a plate from a French book, "Propriétaire des Choses," published in 1485 by Bartholomeus Anglicus. Prior to adaptation, the many species of birds carried insects and twigs. The birds now carry documents. And if you look closely, you'll see that we left a few bugs in the process.

Overview of document organization

Structure and organization are two essential elements in document planning. Part 2 presents guidelines for piecing together the major elements of your document so that they form a coherent, logical pattern.

You will discover how to construct your document so that readers can access information easily and quickly. You will see how the three major document elements—front matter, subject matter, and back matter—have been broken down into their component parts and their use fully described.

You will also learn that these guidelines are generic and therefore can be applied successfully to virtually any writing project that you may undertake.

Generic document structure

The principal aims of document organization are accessibility and findability. Users do not read technical documents page by page or cover to cover as they do a novel or other running text. They skim the material to find just the information they need at the moment. Consistent organization among related documents is critical.

All documents—whether manuals, procedures, catalogs, reports, or brochures—require a basic skeleton, or structure. This generic structure (figure 2-1) provides the reader with consistent document access, logically organized content, and easy cross-referencing.

Visual logic

Basic organizational elements are used in all presentation styles and communication media. What differentiates them is the variation in visual expression and delivery. In good document design, each structural element is associated with a particular look, size, or placement. This visual logic helps readers to identify information quickly and easily. For details on the visual layout of these elements, refer to part 4, "Visual design."

Modular content

"Modular" means standard, yet flexible, content elements. A modular approach helps you to organize the content of your documents consistently. It aids in relating document structure to computer codes, moving drafts through iterations, "borrowing" like segments of data from one document to build other documents, and exchanging one specific module for another in documents distributed to different countries.

Sequence

Although the subject matter varies in program, marketing, technical, promotional, service, and training publications, all use the same basic organizational elements. Figure 2-2 shows the standard sequence of content elements. Substantive books, manuals, and reports require all of the elements shown. Smaller-scale publications require less activity. If separate page-numbering patterns are used for the front, subject, and back matter, revisions are easy to handle.

Figure 2-1. **Generic document structure**

STANDARD VISUAL ELEMENT | **STANDARD STRUCTURAL ELEMENT**

Cover art
Title page

Division and
page numbering,
headers and
footers

Part title (subtitle)
page

Chapter heading
(level 1)

Section headings
(levels 2 through 10)

Paragraphs
Lists
Figures
Tables

XEROX PUBLISHING STANDARDS

Figure 2-2. **Standard sequence of content elements**

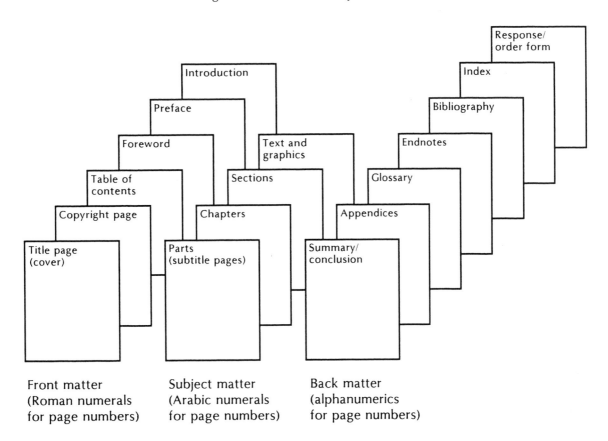

Front matter
(Roman numerals
for page numbers)

Subject matter
(Arabic numerals
for page numbers)

Back matter
(alphanumerics
for page numbers)

Document terminology

When referring to document elements, use the standard terms listed in table 2-1.

Table 2-1. **Standard document terms**

Front matter, subject matter, and back matter	The major conceptual divisions of a document are the front matter, subject matter, and back matter. The front matter introduces the document and outlines how it is used. The chapters in the subject matter present the message. The back matter provides supplemental and reference material.
Part	A part is a main division of subject matter. It groups chapters that seem to belong together. Subtitle pages are used to separate and identify parts.
Chapter	A chapter is a main division of a document. Standard chapter-level segments include the table of contents, preface, introduction, main subject areas, appendices, glossary, bibliography, and index. Each chapter should begin on a new right-hand (recto) page.
Section	A section is a subdivision of a chapter. Numerous heading options can be used to identify and visually arrange sections in the text.
Text	Text is any segment of written or printed words, such as a paragraph, a sentence (complete or fragment), a list, or a table.
Graphics	Graphics are pictorial or diagrammatic representations.
Recto page	Recto means the right-hand, odd-numbered page.
Verso page	Verso means the reverse of the recto page, or left-hand, even-numbered page.
Header	A header is the standard information printed at the top of every page of a document. It usually contains the chapter heading.
Footer	A footer is the standard information printed at the bottom of every page of a document. It usually contains the document title and page number.
Simplex printing	Simplex is one-sided printing on recto pages only.
Duplex printing	Duplex is two-sided printing on both recto and verso pages. Headers and footers reverse on each page.

Document access and cross-referencing

Using correct nomenclature in your document is essential. It enables readers to identify and locate needed information quickly and accurately. Presented below are guidelines that define the elements of document titling, page numbering, and headers and footers.

Document title

☐ Product/program name
☐ Document content

Every document should have a title, which is shown on the title page and on the document cover. The title should include elements that aid readers as they use, reference, order, or search a data base for the document.

Product or program documentation titles should contain two elements:

— Product or program name (primary element)

— Document content (secondary element).

Product name

The product name is the primary element of the document title. Always use the exact, approved name to avoid duplication or trademark infringement. To be effective, a product name must:

— Create customer recall

— Create association with key product attributes

— Position the product in the marketplace with the appropriate competition.

Document content

The document content is the secondary element of the title. It is a succinct description of the document's purpose. Elements to consider when brainstorming the document content include the main concepts of the subject matter, the audience, and the presentation style of the document.

Together, the primary and secondary elements comprise the complete title. For example:

Complete document title	Product/program name (primary element)	Document content (secondary element)
Xerox Computer Printing System Quick Reference	Xerox Computer Printing System	Quick Reference
Xerox Ventura Publisher Applications Workbook	Xerox Ventura Publisher	Applications Workbook
Xerox Typographic Marketing: Font Catalog	Xerox Typographic Marketing	Font Catalog

Guidelines for selecting a document title

Use the following guidelines as you finalize a document title:

1. Choose a brief, straightforward title to clearly communicate the purpose of your document.

2. Identify the document by subject matter and function rather than audience ("installation planning" rather than "customer installation").

3. If it makes sense to identify the audience, avoid possessives (use "programmer" rather than "programmer's").

4. Try different phrasings to clarify the title ("operating the system" or "system operations"). Keep the title brief.

5. Clear all trademarked names with your legal and product nomenclature departments.

6. Use terms familiar to the general public and the industry rather than company-specific words.

7. Generally, do not abbreviate in titles. Spell out acronyms.

8. Use terminology consistent with other corporate documents and sets.

9. Always consistently reference and cross-reference exact titles.

10. If the product name contains an abbreviation or acronym, be sure to spell it out on the title page and in the document (for example, Xerox Network Systems [XNS] or Laser Printing System [LPS]).

Numbering systems

- Pages
- Divisions
- Illustrations
- Annotation

Numbering document elements allows the reader to locate information easily and also makes extensive cross-referencing possible. Numbering systems may be:

a.	Consecutive	1, 2, 3 . . .
	Consecutive numbering is most useful in small publications that are not part of a series.	i, ii, iii . . .
b.	By segment	1-1, 1-2, 1-3 . . .
	In lengthy, technical, reference, or MIL-SPEC material, readers can refer to specific sections more readily if you number by part, chapter, section, or paragraph.	A-1, A-2, A-3 . . . Index-1, Index-2, Index-3 . . . 1.1-1, 1.1-2, 1.1-3 . . .
c.	Limited	1 of 3, 2 of 3, 3 of 3
	Limited numbering is mainly used in contracts and classified documents or in freestanding charts and tables.	

The pattern you select depends on the document size, its complexity, and how often you plan to revise it. Numbering should be organized so you can insert revisions without extensive reprinting.

Page numbers

Every page in a document, beginning with the title page, must be numbered, even if the number is not printed on the page (see table 2-2). This includes blank verso pages in duplex printing. Page numbers are not assigned to covers and tabs. In documents that are frequently revised or referenced, major divisions and parts or chapters are separately numbered so that a change in their size does not affect the numbering in the rest of the document.

Division numbering

Here are the general principles for sequencing and numbering document divisions and other elements.

Front matter

Number front matter pages consecutively with lowercase Roman numerals (i, ii, iii . . .).

Subject matter

Number subject matter pages with Arabic numerals, either consecutively (1, 2, 3 . . .) or by part or chapter (1-1, 1-2, 1-3 . . .). Extremely large sections of technical documents may be numbered by section or subsection (1.1-1, 1.1-2, 1.1-3 . . .).

Table 2-2. **Numbering of major document divisions**

Document division	Page type*	Page number (by segment)
Front matter		Lowercase Roman numerals
Title page	Recto	i (not printed)
Copyright page	Verso	ii (not printed)
Special information	Recto (verso may be blank)	iii
Table of contents	Recto	iii or v
List of figures List of tables	Recto if lengthy Recto if lengthy	Next sequential Roman numeral Next sequential Roman numeral
Foreword	Recto or verso (verso may be blank)	Next sequential Roman numeral
Preface (acknowledgments)	Recto or verso (verso may be blank)	Next sequential Roman numeral
Introduction	Recto	Next sequential Roman numeral
Subject matter		Arabic numerals
Part 1 (subtitle page)	Recto (verso is blank)	1 or 1-1 if numbered by part (not printed)
Chapter 1	Recto	1-3 if follows part; if not, 1 or 1-1 if numbered by chapter
Sections	Recto or verso, as necessary	Next sequential Arabic numeral
Back matter		Alphanumerics
Summary/conclusions	Recto	SUMMARY-1
Appendices	Recto	A-1, B-1, C-1
Glossary	Recto	GLOSSARY-1
Endnotes	Recto or verso	ENDNOTES-1
Bibliography	Recto or verso	BIBLIOGRAPHY-1
Index	Recto	INDEX-1
Reader comment/order form	Recto	None

* Recto (right-hand) page numbers are odd; verso (left-hand) page numbers are even. "Recto" alone indicates that the element should always begin on a right-hand page.

If the pages of the document are numbered by part, number the subtitle page as page 1-1 (not printed). The verso blank is page 1-2 (not printed). If the pages are numbered by chapter, do not number the subtitle page. If the pages are numbered consecutively, subtitle and verso pages take the next sequential page number.

Back matter

Number back matter pages consistently with subject matter pages. If the document is numbered consecutively, continue the numbering sequence through the back matter (45, 46, 47 . . . 90). If the document is numbered by segment, number the back matter using alphanumerics (A-1, B-1, INDEX-1).

Illustrations

Illustrations may be identified by a figure or table number and title. The number should be referenced or "called out" in the text and the illustration placed as close as possible to that reference.

Headings should clearly and specifically identify the purpose and content of the figure or table.

Number figures and tables consistently with consecutive or by-segment page numbering. If pages are numbered consecutively, number illustrations and tables consecutively throughout the document (figure 1, figure 2 . . . figure 25; table 1, table 2 . . . table 25). Similarly, if pages are numbered by segment, number illustrations and tables by segment (figure 1-1 . . . figure 1-10; table 2-1 . . . table 2-10).

Document sets

Document sets may be grouped and volumes numbered within the group (volumes 1 through 6 of set 1, for example). Your distribution plan will guide how you group and number sets or series of documents. The use of a numbering system along with consistent titling and terminology will greatly enhance the usability of your larger documentation packages.

Annotation

Use Arabic numerals to number footnotes and endnotes, as well as bibliography entries.

Tabbed divisions

Tabs allow your readers to access the major parts or chapters in a document. When you are planning the number of tabs and their titles, determine the major user reference points. These reference points can become tabs and are not assigned page numbers. You may use a subtitle page following a tab.

Headers and footers

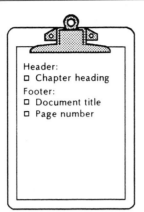

Header:
□ Chapter heading
Footer:
□ Document title
□ Page number

Headers and footers are page signposts that tell readers where they are in the document. Quite simply, a header appears at the top, or head, of a page and a footer appears at the bottom, or foot. The pages in this book contain both headers and footers.

Figure 2-3 shows the standard header and footer content for portrait (vertical) and landscape (horizontal) pages. Portrait pages contain both headers and footers on each page, while small landscape pages alternate headers and footers. Note that on the big landscape pages the standard header and footer information is combined in one place, alternating from top to bottom on verso and recto pages.

Always place page numbers at the outer, unbound edge for easy reference. Keep in mind that the best way to make headers and footers effective is to choose concise chapter headings and document titles.

Headers and footers appear on all document pages except in the following cases:

— No header appears with a chapter heading.

— Only a footer rule appears on title, copyright, and subtitle pages.

— No header or footer appears on order forms, blank pages, or tab dividers.

In addition to citing the chapter heading in the header, you may place a revision notice on each page containing a change. In the footer you may place the following items in addition to the document title and page number:

— Volume or date

— Series name

— Draft level.

Figure 2-4 illustrates how to organize alternate header/footer content and also shows how to handle lengthy titles on small pages without abbreviating.

Figure 2-3. **Content and organization of headers and footers**

A. Big and small portrait

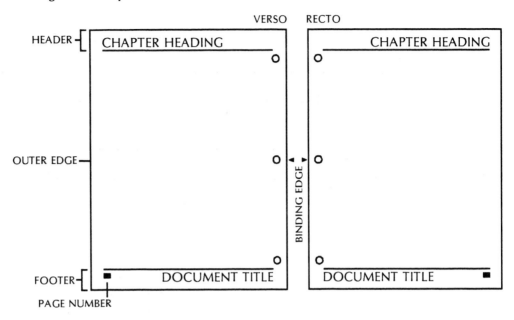

B. Big landscape

C. Small landscape

Figure 2-4. **Header and footer content variations**

A. Revision level

Big and small portrait: Appears flush to the inside edge, opposite the chapter heading on each page containing a change.

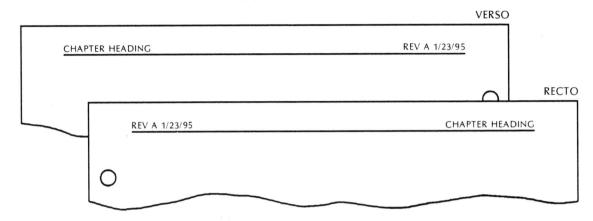

Big and small landscape: Appears below the verso page number or above the recto page number on the page containing the change.

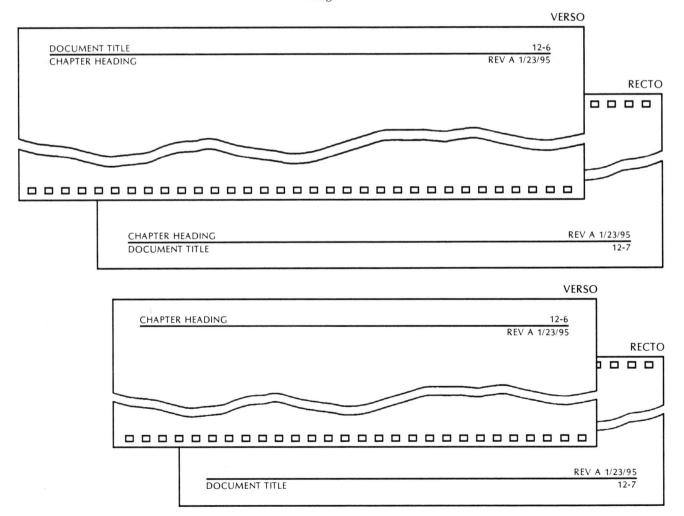

Figure 2-4. **Header and footer content variations (continued)**

B. Volume or date

Big and small portrait: Appears in the footer space on verso pages only.

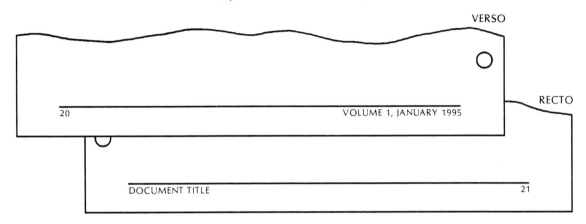

Big landscape: Appears instead of document title on verso pages only.

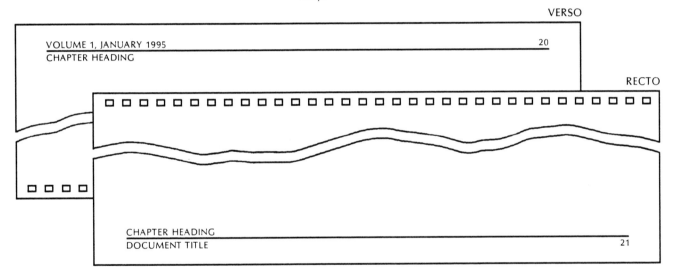

Small landscape: Appears centered in the space between the document title and the page number on recto pages only.

Figure 2-4. **Header and footer content variations (continued)**

C. Series name

Big and small portrait: Appears in the footer space on verso pages only.

Big landscape: Appears instead of the document title on verso pages only.

Small landscape: Appears centered in the space between the document title and the page number on recto pages only.

Figure 2-4. **Header and footer content variations (continued)**

D. Draft level

Big and small portrait: Appears flush right and flush left, below the usual footer on every page. Remove the draft level for final printing.

Big landscape: Appears flush left, above or below the document title on every page.

Small landscape: Appears flush left, above the header or below the footer on every page.

Figure 2-4. **Header and footer content variations (continued)**

E. Lengthy titles (small portrait only)

The primary element of the document title appears in the verso footer space.

The secondary element of the document title appears in the recto footer space. Do not abbreviate.

VERSO

5-14 XEROX SYSTEMS PRODUCTS

RECTO

CUSTOMER DOCUMENTATION CATALOG 5-15

Headings

□ Chapter level
□ Section level
□ Keywords
□ Lead-in

Headings flag segments of text and call attention to the organization and content of a document. In the table of contents, headings express both the hierarchy and the logical flow of ideas. Your readers should be able to scan the major concepts in the table of contents for an overview of the information presented in the document.

The first or highest-level heading is used for chapter-level content. Chapter-level elements include the table of contents, preface, introduction, main subject areas, appendices, glossary, bibliography, and index. Lower-level headings divide chapters into sections. Most publications require three to four well-differentiated heading levels to properly organize the content. The Xerox visual design provides ten heading options to identify and visually arrange chapters and sections. When you're ready to design the look of your heading levels, refer to the chapter on heading options in part 4.

Headings encapsulate and communicate key thoughts quickly and independently of the associated text. They permit readers to reach needed information and skip over other material. Headings also create visual interest. Provide your readers with several headings on each page. Number the headings in material that requires frequent cross-referencing.

The first major division of a document, the front matter, guides readers to the contents and nature of the publication. It also presents the information readers need to use the document properly. The sequence of front matter elements is shown in figure 2-2 on page 2-7.

Title page (cover)

□ Document title
□ Corporate identity (logo)
□ Version
□ Identification number
□ Graphic (optional)

The title page contains basic information identifying the document. It is page i, although the number is not printed.

When you consider the amount and level of information to be placed on a title page, keep in mind that it is used for identification when a document is referenced or entered in a computerized cataloging system. If you want additional descriptive information to appear in the cataloging record, place it on the title page. Always use the title page rather than the cover for data base classification and abstraction. For many internal documents, the title page can also serve as the cover.

Document title

Use the complete document title cleared by the authorizing body in your company—for example, the product/program team.

Corporate identity (author/publisher)

The "author" and "publisher" of a corporate document is the corporation. This is reflected in the logotype that appears on title pages and covers. Recognition for department, editorial, or special contributions is placed with the acknowledgments as part of the preface.

Version

The version identifies the document iteration, volume, edition, software release, revision level, series, or date.

Identification number

Every document should be identified by a unique publication number. This number may also represent a manufacturing or configuration control number for convenience. However, only one document identification (publication) number should be visible to the reader.

Copyright page

- ☐ Publisher's address
- ☐ Copyright notice
- ☐ Impression history
- ☐ List of trademarks
- ☐ Notices
- ☐ Errata statement
- ☐ Colophon

The copyright page carries required legal and special information and appears on the reverse of the title page. It is page ii, although the number is not printed.

Publisher's address

The corporation should appear as the publisher, with the appropriate mailing address.

XYZ Corporation	Corporation (not business unit or division)
Publications	Ordering point for the document (optional)
123 Elm Street	Central mail room
TCXA-456	Building code—mail stop
202-555-4321	Outside phone (optional)
Washington, DC 01010	City, state, zip code

Copyright notice

The copyright notice contains the symbol ©, the year(s) in which the document was published, and the name of the copyright owner. For example:

© 1987, 1989 by Xerox Corporation. All rights reserved.

Include other legal statements in the copyright notice required by the legal department. For example:

Copyright protection includes material generated from the software programs displayed on the screen, such as icons, screen displays, looks, and the like.

Subsequent versions

List the first date of publication and any subsequent editions (not impressions or reprints). For example:

Published 1984. Edition 2 1987.

Country of publication

If the publication is a translation, include the original title and publisher (if different) and the name of the country in which the publication is actually printed. For example:

Printed in the United States of America

Printed in Great Britain

Impression history

Place an inventory of the number of impressions (printings and reprints) below the copyright notice. This inventory can consist of a cumulative number that is increased each time a printing is ordered, or it can be presented as an incremental series of entries. For example:

5000	Cumulative number, three printings
3000, 1500, 500	Incremental series, three printings

The second method provides a way of tracking inventory and could indicate, for example, why one copy of a certain document has typographical errors not found in another copy of the same version.

List of trademarks

List all trademarks discussed or referenced in the document. This is referred to as the trademark mandatory. For example:

Xerox®, 6085, ViewPoint, and VP are trademarks of Xerox Corporation.

DEC and VAX are trademarks of Digital Equipment Corporation.

Lengthy trademarks

If the list of trademarks is lengthy or you cannot verify its completeness, use a generic statement.

1. If the document does not have a specific product name in its title, state:

 Xerox® and all Xerox products mentioned in this publication are trademarks of Xerox Corporation.

2. If the document does have a specific product name in its title (for example, Xerox 4045), state:

 Xerox®, 4045, and all other Xerox products mentioned in this publication are trademarks of Xerox Corporation.

3. List products of other corporations as follows:

 IBM and all IBM products mentioned in this publication are trademarks of International Business Machines, Inc.

Refer to "Legal considerations" on page 2-41 for more information about trademarks.

Notices

Place legally required FCC, warranty, and licensing notices on the copyright page. If the notices are too lengthy for the copyright page, place them on page iii under a minor-level heading titled "Notices." Place lengthy or instructional safety information in the subject matter.

Errata statement

You should include the following brief statement on the copyright page of frequently revised publications:

> Changes are made periodically to this document. Changes, technical inaccuracies, and typographic errors will be corrected in subsequent editions.

Production inscription (colophon)

If your documents are specially designed and produced, you may want to place an inscription with the production facts on the copyright page. For example:

> This book was created using the Xerox Integrated Composition System (XICS) and produced on the Xerox 9790 Laser Printing System. The typeface is Optima.

Special information page

□ Notices
□ Related
 publications
□ Dedication

Certain information—such as lengthy notices, a list of related publications, or a dedication—may be appropriate for a particular product or program. Place this information on page iii, where it will draw the reader's attention. Because this is not a chapter-level division, use a second-level heading. Keep special information brief, no longer than a page.

Table of contents

□ Headings to
 three levels
□ List of figures
□ List of tables

The table of contents, which begins on a recto page, guides readers to the major chapters and sections of the document.

If the document is grouped into parts as well as chapters, each part should be listed. Page numbers are not required for parts. Lower-level headings may be included in the contents but should not be indented beyond the third level.

Lists of figures and tables

In the table of contents you may include a list of figures, tables, exercises, illustrations, or other significant items if you want to give the reader an overview or reference. Lengthy lists may prove more distracting than helpful, however. The titles listed should correspond exactly to the titles printed with the illustrations themselves.

Foreword

☐ Personal comments
☐ Authorization

The foreword is a statement regarding the document or program by someone other than the author or responsible writing group. The name, title, and/or affiliation of the person providing the foreword may appear on the page.

Preface

☐ Purpose of document or revision
☐ Product data
☐ Acknowledgments

The preface contains brief, interesting information concerning the document, as well as acknowledgments for special contributions. If the acknowledgments are lengthy, they may be put on a separate page following the preface.

Substantive information about the document belongs in the introduction. Introductory material that is essential to the text belongs in the subject matter.

Introduction

☐ Document background
☐ List of parts or chapters
☐ Key concepts
☐ Audience
☐ Terminology
☐ Editorial method
☐ Symbols and conventions
☐ How to use this document

The introduction is an unnumbered chapter-level element that gives an overview of the document to readers. This element is appropriately titled "Introduction," but the word "introduction" and similar general terms should not be used alone in other headings. When introductory material surveys something other than the whole document, place it in the subject matter and broaden the heading to include the other concepts presented. For example:

— Introduction to the program

— Overview of the laser printing system

— Overview of operations

This prevents confusion between the document introduction in the front matter and other introductory sections and paragraphs.

Subject matter

Subject matter elements divide the text of the document into meaningful segments for readers. The primary subject matter elements are parts, chapters, and sections. Documentation planners determine the content of these elements for similar programs, products, and document categories. Refer to appendix A for a list of program, operations, and product document categories, as well as their primary objectives, typical contents, and intended audiences.

Parts

□ Part title
□ Part contents (optional)
□ Graphic (optional)

A part is a collection of chapters that have been conceptually grouped together. You may use a subtitle page to visually identify this grouping as a part. The part title, which appears in the table of contents, gives readers an idea of what they will find in the group of chapters that follow. A tab page is often used in front of the subtitle page to provide easy access to that major part of the document.

Chapters

A chapter is a major block of information in a document. The chapter heading is carried in the header on each page.

Sections

A section is a subdivision of a chapter. Different levels of headings can structure the various sections and provide a visual hierarchy.

Annotation

Annotation is brief aside information that adds to or documents the text. The following sections describe each type of annotation.

Notes

Notes are unnumbered comments or explanations that are placed directly in the text. A note is set off from the text as a separate paragraph so that readers can skim over it if they wish. For example:

Note: If you do not select [DISPLAY OPTIONS], the TTY property sheet does not appear.

Warnings and cautions

A warning or caution provides safety information. Warnings are associated with the safety of people, and cautions are associated with equipment safety. Warnings and cautions are set off from the text so that they are immediately visible to readers. For example:

WARNING

To avoid severe shock, make sure the unit is grounded.

CAUTION

Do not turn off the computer without removing the floppy disk from the disk drive. You may lose data.

Illustration and table notes

Use the following guidelines when placing notes in figures and tables:

1. Use symbols or letters to avoid confusion with tabular content. The symbols, in order of appearance, are:

 * (asterisk)
 ** (double asterisk)
 † (dagger)
 ‡ (double dagger)
 a, b, c (lowercase letters)

2. Make sure that notes are consecutive and that they appear horizontally as you read, not vertically down the columns of a table.

3. Either run in notes or set them as separate lines. Do not use both methods in the same illustration or table.

4. Notes may be separated from the body of an illustration or table by a 1 1/2-inch half-point rule set flush left.

Author-date notes

Author-date notes are a method of citing references within the text. From a cost standpoint, author-date notes are preferable to endnotes and footnotes. With author-date notes, changes can be made in either the text or the bibliography without changing the numbering of the notes.

In the text, author-date notes contain:

Last name of author.
Year of publication.

These notes refer to the alphabetical listing of works cited in the bibliography. For example:

Schedules are the most important factor in product development and productivity (Fey and Paraskevopoulos 1986).

"Fey and Paraskevopoulos 1986" refers to a bibliography entry that reads:

Fey, C. F., and D. E. Paraskevopoulos. 1986. "A model of design schedules for application specific ICs." *Journal of Semicustom ICs* 4(1):5-13.

Format and placement of author-date notes

1. Place the author's last name and the date of publication in parentheses. Use no punctuation between the name and the date. For example:

 (Arnold 1981)
 (Chicago Manual 1982)

 "Author's last name" means the name or words under which the work is alphabetized in the bibliography.

2. Place the author-date note at a logical point within the text and before end punctuation. For example:

 The findings show variance with the foregoing (Xerox 1989).

 Various scientists (Chun and Sanger 1986) report findings at variance with the foregoing.

 Brennan (1989) indicates that the findings are at variance.

3. Author-date notes in the text must agree exactly with the list of references in the bibliography.

Sample author-date note entries

The following samples illustrate different kinds of author-date notes. For additional guidance, consult the *Chicago Manual of Style*. If you cannot find a rule, use the example that most closely matches your situation, or present as much information as necessary to help the reader locate the reference.

One author

(Mills 1988)

Group or agency names

(Xerox 1990)
(U.S. Copyright Office 1982)
(U.S. Government Printing Office 1984)

With page numbers	(Gelb 1974, 142) (Xerox 1988, 23-5)
With document division or volume	(Earnst 1983, chap 9) (Frand 1980, vol 2)
With volume and page	(Xerox 1989, 2:114)
Two authors	(Zarno and Zarno 1963) (Weglin and Keywell 1960, 114-16)
More than two authors	For a work by Borgman, Mohgdam, and Corbett: (Borgman et al 1984)
Multiple references	(Xerox 1984, 1981) (Xerox 1984, 17-18; Xerox 1981, 25) (Xerox 1984; Harman 1976, 36)
Similar-date entries	(Xerox 1984a, 1984b, 1986) (Flygare and Mohan 1986f) (Edwards 1896a, 10; Edwards 1896b; Edwards 1907, 3)
New edition of older work	(Flyte [1804] 1963, 72)
Unpublished works	Harlan Smith describes computer networking in his notes for 14 January 1967. The bibliography entry reads: Smith, H. Papers. California Data Bank. Los Angeles.
Citations not listed in bibliography	Zelich indicates that the high input speed and the occurrence of rejects means that quality was met. (Walter Zelich, letter to the author, 1 April 1964). Gulch of the CMOS Society (telephone interview, 28 October 1988) maintained that the process is viable.

Footnotes

Footnotes are numbered notes that are placed at the bottom of text pages. If possible, write comments directly in the text instead of using footnotes. When footnotes are used:

1. Indicate footnotes in the text with superscript Arabic numbers in the order in which they appear on the page (begin with 1 on each new page). Place the number at the end of a clause or sentence, outside end punctuation. For example:

 Repeat the cycle at 2-minute intervals.[1]

2. Place the footnotes under a 1 1/2-inch half-point rule at the bottom of the page in which they are called out, as shown in the example below.[1]

3. Avoid using footnotes in titles or headings.

4. Use the author-date style for footnotes containing cited works.

5. Do not combine endnotes and footnotes in the same document.

Endnotes

Endnotes are a method of listing numbered notes together by chapter at the end of the document.

1. Indicate endnotes in the text by superscript Arabic numbers in the order in which they appear in each chapter (begin with 1 in each new chapter). Place the number at the end of a clause or sentence, outside end punctuation. Avoid using endnotes in titles or in headings.

2. List the endnotes by chapter in the back matter on a page titled "Endnotes."

3. If there is also a bibliography, use the author-date style for endnotes containing cited works. Complete references need only be placed in the bibliography.

4. Do not combine endnotes and footnotes in the same document.

[1] This is an example of how a footnote looks at the bottom of the page.

Back matter

Back matter contains reference material. It includes the following, depending on the needs of your document:

Summary/conclusion
Appendices
Glossary
Endnotes
Bibliography
Index
Response/order form

Summary/conclusion

A summary or conclusion may be a standard chapter in the subject matter. It may be also be a separately numbered back matter element, beginning on a recto page.

Appendices

☐ Reference lists, tables
☐ Elaborations
☐ Company-specific data
☐ Country-specific data
☐ Questionnaires

The appendices house lengthy reference material or important information not essential to the text. They may include regional or frequently updated information, such as names, organization charts, phone numbers, addresses, and forms. Country-specific data that can be substituted in various translations (for example, electrical current specifications) belong in appendices, where the information is easily transported to other documents.

Give each appendix a chapter-level heading describing its content. If you include more than one appendix, designate it with a capital letter (A, B, C). Refer to the appendices in the preface or introduction and where appropriate in the subject matter. Also list them in the table of contents.

Glossary

- □ Key vocabulary
- □ Product nomenclature
- □ Acronyms
- □ Abbreviations

Separate from and following the appendices is the glossary, which defines important terminology contained in the document. A glossary is extremely important for the reader who may not be familiar with company-specific, technical, or application-specific phrases and words.

For technical and instructional material, write the glossary in a telegraphic style, eliminating articles ("a," "an," and "the") and extraneous words.

Alphabetizing and sequencing entries

Arrange entries that require sequence in the following order, which is the order that most computer programs use to sort numerals, letters, and symbols. (The exact sequence may vary with the software. Use automatic sorting rather than manual placement.)

1. Numerals: 0–9

2. Letters: A–Z

 — Full words come before parts of words made up of the same letters.

 — Solid compounds are followed by hyphenated compounds and then open compounds (workup, work-up, work up).

 — Lowercase entries come before entries that begin with capital letters.

3. Symbols and null characters

[, {	left bracket/brace
\, \|	backslash, vertical line
], }	right bracket/brace
^, ~	circumflex, tilde
^	caret
<	less than
>	greater than
†	dagger
‡	double dagger
¶	paragraph sign
#	number or pound sign
↵	return key
@	at
`	grave accent
´	acute accent
—	underline
	space
!	exclamation point
"	quotation mark
#	number sign
$	dollar sign
%	percent sign
&	ampersand
'	apostrophe

(open parenthesis
)	close parenthesis
*	asterisk
+	plus sign
,	comma
-	hyphen or minus sign
—	dash
.	period
/	slash
:	colon
;	semicolon
=	equal sign
?	question mark
	empty or missing fields

Endnotes page

You may use endnotes to cite other documents or to comment further on a point in the text. List the endnotes in numerical order by chapter and include only those entries noted in the text.

Use the author-date style for all works cited if a bibliography is included in the document. Full references need appear only in the bibliography.

Bibliography

☐ Author
☐ Date
☐ Titles
☐ Volumes
☐ Facts of publication

The bibliography lists documents referred to in the text or consulted by the author in preparing a document. It may also provide entries and information on topics beyond the works cited in the document. References to bibliography entries are called out in the text by author-date notes. The bibliography may be structured in several ways:

— A single list of sources, arranged alphabetically by author (preferred)

— A list broken into sections by subject or by type of material

— A discursive essay in which the author discusses useful sources or related publications.

Content

Each bibliography entry should include the elements needed to find it in a library catalog. The major items are: name of author, date of publication, titles, volumes, and other facts of publication. These elements should appear in the following sequence.

All entries

— Name of the author or authors, the editors, or the institution responsible for writing the book, periodical, paper, or software

— Date of publication.

Books	After author and date of publication:
	— Chapter or part title, if applicable
	— Full title of the book, including the subtitle, if any
	— Title of series, if any
	— Volume or number in the series
	— Volume number or total number of volumes in a multivolume work
	— Edition, if not the original
	— City of publication
	— Publisher's name (omitted if same as author).
Periodicals/papers	After author and date of publication:
	— Title of the article or paper
	— Name of the periodical
	— Volume or issue number
	— Pages occupied by the article.
Software	After author and date of publication:
	— Fully spelled-out title of the computer software program, package, language, or system
	— Version, level, or release number
	— City of origin
	— Person, company, or organization having the proprietary rights (publisher).

Format

Names	Use first name initials and last name. The first author is listed last name first. For example: May, B., A. Head, and H. Choo
Date	List the date by day, month, and year. Add lowercase letters to the year to distinguish similar years. 1 January 1990 1988a 1988b nd (meaning no date)
Known information	If information is known but not printed on the document, put it in brackets. [1993] [Forthcoming] [In press]

Titles
Italicize the titles of books, periodicals, and newspapers. Capitalization is upstyle, with initial caps on the first and last words and all other words except articles, prepositions, and short conjunctions.

Chicago Manual of Style
Graphic Arts Monthly
The Los Angeles Times

Set the titles of articles, papers, and chapters in regular type in quotation marks. Capitalization is downstyle (with only the first word capitalized), except for proper nouns and product names.

"Readability formulas play too dominant a role"
"Electronic manuscript preparation and generic tagging"
"Booting the system"

Set the titles of forms and computer programs in regular type, without quotation marks. Capitalization is downstyle, except for proper nouns and product names.

Documentation checklist
Fry readability scale
Xerox List Manager
Xerox ScreenMate
Utilities program

Numerals
Use Arabic rather than Roman numerals.

Pages
List pages without any accompanying abbreviation for the word "page."

49, 53–55

Volumes
Abbreviate volume data. Use a colon between volumes and pages.

vol 1, no 3
ed 2
1: 37–38

Place of publication
Place a colon between the city and the name of the publisher.

If the author is the same as the publishing organization, do not repeat the name a second time.

Los Angeles, CA: Larkspur Press
Rochester, NY: Xerox Corporation

Punctuation
Place a period after each main segment of an entry. Eliminate the periods on most abbreviations.

Sequence
Alphabetize the bibliography by the author's or editor's last name. If no author or editor is named, alphabetize according to the first word of the title (not including "A," "An," or "The" as an initial word). When author-date notes are used, entries may begin with the element most convenient for use in the text reference.

Repeat entries
List the most recent entry first.

Sample entries

The following samples illustrate most of the bibliography entries you will encounter. For additional assistance, consult the *Chicago Manual of Style*. If you cannot find a rule in the *Chicago Manual*, use the example that most closely matches your situation. Present as much information as necessary to help the reader locate the work.

Books

Anderson, J. D. 1971. "Feasibility of determining the mass of an asteroid from a spacecraft flyby." In *Physical Studies of Minor Planets* SP-267, T. Gehrels ed. Washington, DC: NASA.

Borgman, C., D. Mohgdam, and P. K. Corbett. 1984. *Effective Online Searching: A Basic Text*. New York: Marcel Dekker.

Drexler, K. E. 1979. "Design of a high performance solar sail system." In *MIT Space Systems Laboratory Report*. Cambridge, MA: MIT Press.

Frand, S. 1980. *Systems Users Manual 37265-6005-XT-05*. Redondo Beach, CA: TRW.

Gelb, A. ed. 1974. *Applied Optimal Estimation*. Cambridge, MA: MIT Press.

Shampine, L. F., and M. K. Gordon. 1975. *Computer Solution of Ordinary Differential Equations*. San Francisco: W. H. Freeman.

Small, R. [1804] 1963. *An Account of the Astronomical Discoveries of Kepler*. Reprint with foreword by W. D. Stahlman. Madison: University of Wisconsin Press.

U.S. Government Printing Office. 1984. *Style Manual*. Washington, DC.

Xerox Corporation. 1984. *Leadership through Quality: Quality Improvement Training Participant Book* 600P87178. Stamford, CT.

 1981. *Multinational Customer Instructions Specifications* 600P2316. Rochester, NY.

Zarno, A. L., and S. K. Zarno. 1963. *Optics*. New York: Crowell.

Periodicals and papers

Fey, C. F., and D. E. Paraskevopoulos. 1986. "Studies in LSI technology economics II: a comparison of product costs using MSI, gate arrays, standard cells, and full custom VLSI." *IEEE Journal of Solid State Circuits* SC-21: 297–303.

O'Rourke, J. 1981. "A sea-going M-X ICBM?" *Armed Forces Journal* 118:210–17.

Smith, H. Papers. California Data Bank. Los Angeles.

U.S. Copyright Office. 1982. Application for copyright registration, form TX. Washington, DC.

Weglein, R. D., and F. Keywell. 1960. "A low-noise X-band parametric amplifier using a silicon mesa diode." Paper presented at PGMIT National Symposium, 9–11 May. San Diego, CA.

Letters and interviews

Adams, R. 7 July 1989. Letter to author.

Bell, A. 10 March 1876. Telephone conversation with inventor. Boston, MA.

Peters, 1988. Conversations with Lew Peters. Technical Library, Xerox Corporation. Palo Alto, CA.

Ruth, S. 10 October 1979. Interview with author. Customer Documents Library, Xerox Corporation. El Segundo, CA.

Computer programs

Xerox Corporation 1986. Spelling Checker 1.1. El Segundo, CA.

Xerox 1985. Xerox Documentation Management System 1.2. El Segundo, CA.

Xerox 1982. Xerox 860 Information Processing System word processing program H06.300. Dallas, TX.

Index

☐ Topics
☐ Terms
☐ Concepts
☐ Titles and headings
☐ Cross-references

The index is the most important finding tool a publication can provide. It should be extensive, going well beyond the glossary and table of contents. It should present ideas, topics, terms, and other facts, in addition to document titles and headings. Cross-references must be correct and complete.

Response/order form

A self-addressed, postage-paid form at the end of a document may be used to elicit customer feedback. This form may also include a list of related publications and order numbers.

Legal considerations

Possible legal requirements in producing corporate documents include copyright and trademark notices, warranties, contracts, Federal Communications Commission (FCC) information, licensing, and specific legal terminology. Be sure to review your documents in advance with your general counsel.

Copyrights

A notice of copyright consists of three elements. First is the name of the copyright owner. Second is the symbol ©, which notifies the reader that a copyright is claimed. Third is the year of first publication of the work.

A copyright page must appear in key documents, including books, manuals, and brochures. Check with the appropriate company attorney to determine whether you must also register a claim of copyright with the U.S. Copyright Office.

Trademark requirements

A trademark is any word, name, slogan, symbol, design, or combination used by a manufacturer or seller to identify the source of a product and to distinguish that product from others. Trademarks guarantee consistent quality and aid in product advertising and sales. Registered trademarks for suppliers and competitors are identified by the symbol ® following the last letter of the trademark name.

Trademark mandatories

Indicate that a company name is a registered trademark by including a mandatory—an explanatory statement usually placed at the end of printed material or at the bottom of an advertisement. In manuals, the mandatory should appear on the copyright page.

Xerox® is a trademark of Xerox Corporation.

Other company products may also need to be listed as trademarks. For example:

Xerox®, 9700, ViewPoint, and 860 are trademarks of Xerox Corporation.

Trademark references in text

The first time a trademark name occurs, identify the firm to which it is registered with a footnote. Subsequent occurrences of the trademark name do not need a register mark ® or footnote. Trademark names in document titles do not require a register mark.

Licensing and warranties

Licenses and warranties documenting legal responsibilities accompany many products to market. The owner of a product usually provides elements of the following information:

— License (legal agreement)

— List of customer responsibilities

— Guarantees and conditions of sale

— Conditions of use

— Liability statement

— Disclaimers

— Rights under state law

— Conditions of applicability

Seek legal consultation for assistance in the wording of these statements. Although they must be precise, use clear, understandable terms and avoid unnecessary "legalese."

Revision documents

If the changes to a document do not exceed 25 percent of the page count, it is practical to consider issuing a revision package to avoid the cost of reprinting the entire document.

The revision package should contain the following elements:

Cover letter
Changed front matter, text, and back matter pages
Revision level and date in header.

Change bars

Change or revision bars may be required to specifically mark where a revision to copy has been made. On systems with automated revision capability, place a black bar (2-point rule) in the outside page margin to indicate a change. If an entire paragraph or procedure is added or changed, the revision bar should run the entire length of the paragraph or procedure. If text is deleted, a short bar should indicate the location.

For systems without automatic change bar capability, place a vertical slash in the text at the beginning and a double slash at the end of the change.

The following are examples of changes in documents prepared in systems with and without automatic change bar capability:

Original

The spine logo is 24 points. Product name is 80 points. If 80 points are too large, drop to 60 points.

Revision with change bars

The spine logo is 24 points. Product name is 80 points. If 80 points are too large in relation to line length, drop to 60 points.

Revision with bold slashes

Spine logos are 24 points. Product name is 80 points. If 80 points are too large /in relation to line length,// drop to 60 points.

Errata sheet

An errata sheet is an update tool that is used to correct or add important information to a finished document before it is distributed. List the errors and/or additions along with their page numbers. The errata sheet should not be used to correct simple typographical errors, which can be changed in a later printing.

3. Writing and style

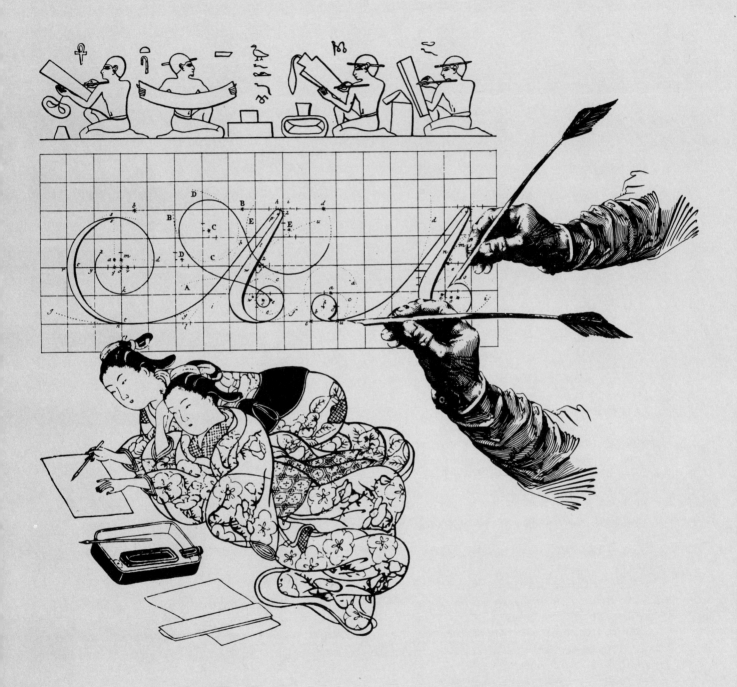

Part 3: Writing and style
The woodcuts for part 3 represent
various forms of multilingual
communication. The harmonious
placement of the images indicates that
art and science really do blend, and
the ancient and ultramodern flourish in
tandem. One woodcut image, taken
from a hieroglyph dated 2500 BC,
shows Egyptian scribes at work.
Another image depicts a writing lesson
in Japan, circa 1780. Calligraphy is as
revered in our age of mechanism as it
was long ago. The pen in hand
(pictured twice) is from a page by Jan
van den Velde of Rotterdam, 1605. It
represents the many artists of the
Renaissance who explored the
mathematics and proportions of the
alphabet. The background image is
from the Dutch writing master Jan Pas'
"Mathematical and Scientific Treatise
on Writing," 1733. The script letter "A"
depicts his early attempts at translating
flowing letterforms into squared raster,
combined with the geometry of curves
based on circles and ellipses. He was
a scant two-and-one-half centuries
ahead of digitized fonts.

Overview of writing and style

The goal of good business writing is to communicate simply and clearly. To make yourself clear to customers and co-workers, you must use the same words and conventions to mean the same things. Each publication should reflect the same high-quality writing.

A few basic principles underlie good writing. Whether you are writing a memo, a newsletter article, a product bulletin, or a customer manual, they are equally appropriate.

The principles are:

1. Know the subject matter.

2. Write in an informal, conversational style.

3. Put people into your writing.

4. Vary the length and complexity of sentences. Keep most sentences short and simple.

5. Write in the active voice.

6. Use simple, familiar words rather than technical or abstract words.

7. Rewrite, rewrite, rewrite.

Adhering to these principles will help make business and technical content accessible to your readers.

The following sections contain guidelines for writing, readability, composition, and usage. There are also rules for punctuation, capitalization, and similar style considerations. Examples, many of which come from Xerox documents, clarify the points.

The meaning of style

Style refers to the basic principles underlying language structure, organization, and presentation. If, for example, ten different employees prepare a report on the same meeting, each document will differ in terms of content (choice of words, perspective, flow of thoughts, and so on). What should not vary, however, is the mechanics of writing (how words are used and spelled, how sentences are arranged and punctuated, how the principles of grammar are applied, when capitalization is used, how abbreviations and numbers are expressed, and so forth).

Style standards exist not to affect the unique expression and individuality of the writer, but to provide the appropriate tone and word usage in technical documentation. They save you the time and trouble of making hundreds of small decisions—and then trying to remember all those decisions in order to achieve consistency. Such matters as which words should be capitalized and when numbers are spelled out don't deserve reconsideration every time the problem comes up.

Many style issues are arbitrary. Once the decisions are made—and the results accepted as conventions—editorial work is simplified at every stage in the preparation of a document. You will find the results of many such decisions in this manual. It's not possible, of course, to include every case. The intent is to provide enough examples for you to recognize the general principles and apply them to similar issues.

Useful conventions

The following paragraph was written without the conventions we have all been taught to use and understand.

> ifyoufindthisparagraphhardtoreaditsbecauseithasab
> solutelynopunctuationthatmeansnoeasywaytotellw
> hereonewordendsandthenextwordbeginsnoeasywa
> ytotellwheresentencesendandbeginnoeasywaytot
> ellwhetherasentenceisaquestionorasta
> tementitishardtogetsenseoutofthelettersisntit

Compare this to:

> If you find this paragraph hard to read, it's because it has absolutely no punctuation. That means no easy way to tell where one word ends and the next word begins, no easy way to tell where sentences end and begin, no easy way to tell whether a sentence is a question or a statement. It is hard to get sense out of the letters, isn't it?

Now try this one:

naoweadmispelengtwothuhprobblumthamispelleen
izpurrfuktleelogacculfrummafoanettikpoyntavyoo
buttduzantuhgreawiththsistmwiryoostewthissmay
kesitevunhorrdurtoogettthecencefrummthuwordz

Now we add misspelling to the problem. This misspelling is perfectly logical from a phonetic point of view but doesn't agree with the system we're used to. This makes it even harder to get the sense from the words.

Our language needs conventions to make it easier to extract the meaning from writing. We all need to understand and be able to accurately use conventions of the English language for spelling, word division, punctuation (sentence style), capitalization (all caps, downstyle, upstyle), and visual emphasis (boldface, italics, underlining).

Style versus design

Although the areas can overlap, we make a clear distinction here between the concepts of "style" and "design." Style refers to the underlying structure and mechanics of writing. It is based on well-established language conventions—for example, capitalizing proper names or placing a period at the end of a sentence.

Don't confuse writing style with the visual characteristics of a document, such as type size, color, graphics, or typeface. While visual formats are updated every 5 to 10 years as fashions and technology change, style generally remains constant. Visual design is explained in part 4.

Content factors

In developing your document, you should choose the content with your readers in mind. Two factors are particularly important because of their potential effect on readability:

Interest

The readers of documentation and similar publications are essentially captive audiences. They may have had little, if any, voice in selecting and ordering their reading materials. Since they have not gone to a newsstand and freely selected what they are reading, they may not be motivated to struggle through the contents. Often, however, they require the information in your documents to do their jobs, so you must provide them with the necessary information or training in a simple, clear, accurate manner. If what they are reading increases productivity and efficiency, they'll be interested.

Experience

Closely allied to the interest factor is the readers' experience. Readers not only get meaning from words, they also bring meaning to them. Consider the readers' level of vocabulary and conceptual understanding, the amount of knowledge they already have, and the skills they've mastered. Then decide what learning increments and information loads are appropriate for your particular audience.

Put people in your writing

Your writing can be warm, personal, alive, and clear. Remember, most readers identify with people, not abstractions.

Ultimately, writers must sell not only their subject matter, but also who they are. It is the personal transaction that is at the heart of good writing. Out of this come the qualities this manual will emphasize: humanity, warmth, accessibility, and brevity. Good writing has vitality that keeps the reader interested from one paragraph to the next.

Whenever possible, direct information to the reader by referring to the reader as "you." This will simplify an explanation by avoiding abstractions. Avoid using "I," except in personal writing or in a section such as a preface.

Use conversational style

Conversational style has the following characteristics:

— Variety of sentence length

— Use of colloquial and idiomatic expressions

— Use of sensory impressions

— Variety of sentence beginnings

— Predominance of common words of one or two syllables

— Good use of connective phrases

— Minimal use of proper nouns, numerals, and abbreviations.

Used where appropriate, a conversational style has the advantage of immediately putting readers at ease and making them feel as if the writer were addressing them personally. Certainly training and instructional materials lend themselves to this approach, as do newsletters, departmental bulletins, operator manuals, and instructor guides.

Bias-free writing

It is possible to eliminate sexist, ethnic, lifestyle, and career stereotypes from the text and illustrations of your publications and to include a positive representation of disabled or handicapped people.

As times change, so do language requirements and the meaning of words. It is a slow process, a steady evolution in the way we think and the way we express ourselves through the written and spoken word. Today we speak a significantly altered tongue from the English-speaking people who came before us. We structure our sentences differently. Our vocabulary has been expanded to include new inventions and discoveries. It has also been revised to reflect changes in word usage and current thought.

Modification to language, like all change, is difficult to accept. This is especially true when the change occurs during our own lives. We tend to resist alterations to our speaking and writing habits. New words and sentence patterns don't "sound right" because they differ from what we are accustomed to hearing. In addition, acknowledging that certain words no longer mean what they used to can be extremely troublesome. As a result, we may use words in their former sense even when they can cause our message to be distorted or misunderstood.

Avoid sexist writing

Among the most vital and important changes taking place in English today is the elimination of sexist language. In the past, words such as "man," "he," "forefathers," and "deity" may have represented both men and women. Through time and use, however, these words have come to infer male persons only. They are no longer widely accepted in a broad, generic sense.

Avoid the generic use of masculine- or feminine-gender nouns, pronouns, and verbs in written and spoken communications. Because such words confuse or ignore the presence of others, they do today's writing (and the people they exclude) a great disservice.

Consider the following examples of sexist writing. If the intent of the sentences is to represent men only, then the original statement is correct. If the intent of the sentences is to include men and women, note how much more clearly and accurately the revised statements convey that message.

Original statement	Revised statement
The man who works hard will be rewarded.	The employee who works hard will be rewarded.
Our forefathers could only dream of the technology we have today.	Our ancestors could only dream of the technology we have today.
The man with the most sales will be named salesman of the year.	The employee with the most sales will be named sales representative of the year.

Original statement	Revised statement
A writer must understand his reader.	Writers must understand their readers.
After a customer receives his equipment, it must be promptly installed.	We must promptly install equipment after a customer receives it.
Electronic technology has made an impact on man's life.	Electronic technology has made an impact on people's lives.
Electronic publishing reduces the man-hours required to produce a document.	Electronic publishing reduces the work time required to produce a document.
The company's image is affected by communications between a serviceman and his customer.	The company's image is affected by communications between the service technician and the customer.
The marketing staff was asked to man the trade show exhibit.	The marketing staff was asked to run the trade show exhibit.
Our manpower shortage will be resolved soon.	Our personnel shortage will be resolved soon.
A corporate spokesman will announce the merger of the two divisions.	A corporate representative will announce the merger of the two divisions.
Every manager must submit his report by Friday.	All managers must submit their reports by Friday.

Sexist stereotypes

Sexist language and connotations can appear in your writing in other ways. This can occur when women are stereotyped, singled out, or patronized. The following examples refer specifically to women. Note, however, the difference in tone and message between the original and revised statements.

Original statement	Revised statement
I'll have my girl type the letter.	I'll ask my secretary (or assistant) to type the letter.
The new gal in the department is Mary Brown.	The new employee (or analyst) in the department is Mary Brown.
Write the instructions so that even a woman can understand them.	Write the instructions in steps that the average person can understand.
She does high-quality work for a woman.	She does high-quality work.
Jeanne Jones is a successful lady executive.	Jeanne Jones is a successful executive.

Learn to edit your writing for sexist language. What you say and how you say it tells a great deal about you. It also has a significant effect on how your readers perceive you and your subject matter. Our goal is to be accurate and to say exactly what we mean. Why say "all men" when the actual idea being expressed is "all people" or "everyone"?

Avoid sexist language by substituting vocabulary that includes rather than excludes ("reporter" instead of "newsman"; "woman" instead of "girl") or by rewording sentences to eliminate the male/female issue entirely, perhaps by using the plural. Sexist language is exclusive. It obscures meaning and hinders understanding.

Multilingual communication

When writing for non-English-speaking populations, it is important to be aware of the cultural nuances inherent in language. Translation usually occurs late in the publishing process, during production. The base copy must be well written, or the translation will reflect similar problems.

Computer software is available to translate English into other languages with a minimum of human editing. An automated language translation system is only a tool, however. The program cannot replace the expertise, judgment, and artistry of the person providing the translation.

If your goal is world-wide communication, you will want a network of systems to support your translation requirements. In evaluating a multilingual translation system, look for the following attributes:

1. Windowing capability on the screen for side-by-side comparison of the original language, the translated copy, and dictionary prompts.

2. A variety of well-designed fonts to support the world's strategic languages, including Arabic, Chinese, Japanese, and Russian.

3. A variety of fonts to support technical language, including mathematical equations and scientific notation.

Readability

Once you have evaluated your document to ensure that it meets the needs of the audience, you should look at it from the standpoint of readability, or what might be called reader-friendly writing. In this section, we'll examine the types of writing that ensure readable copy, as well as the mechanical tests for the readability.

Consider the following examples, taken from several recent Xerox publications.

> Consistent with the announcement of the reduced rate Multiple Use Lease Increment for the concurrent use of Program Products at a single Licensed Location, expanded commission point structure consistent with the new rates is established.

> We have introduced a change in Xerox policy concerning the process of accepting a maintenance contract on equipment not covered by Xerox maintenance immediately prior thereto.

> The financial industry marketing program was started with banks and related institutions such as savings and loans; however, this industry is changing rapidly and we will expand the scope of our efforts to include brokerage services in the near future.

> When alerting a manager to either response or downtime situation, all UMs that would be escalated within 45 minutes (because of either response or outage length) will also be explained to that manager and the subsequent escalations of those calls by WSC will not be necessary.

The authors of the preceding examples did not achieve a high level of readability. After reading what follows, you should be able to improve on their efforts.

Sample passages

The following parallel passages, taken from Rudolf Flesch's book *The Art of Clear Thinking*, illustrate that you can make the readability level of a given passage or article more comprehensible by rewriting it.

Passage from labor union contract

Such grievance shall be submitted to such impartial umpire in writing and he shall promptly afford to the Employee or Employees concerned, the Union and the company, a reasonable opportunity to present evidence and to be heard in support of their respective positions with regard to such grievance.

> Readability level: college graduate

Rewritten passage

The next step is a letter to the umpire. As soon as your complaint is received, the umpire must give you a chance to tell your side of the story and prove it.

> Readability level: fifth grade (can be read and understood by 91 percent of the U.S. adult population)

Passage from insurance policy

If total disability occurs during the grace period for payment of a premium, such premium shall not be waived, nor refunded if paid; provided that failure to pay such premium within the grace period therefore shall not in itself invalidate a claim hereunder for total disability commencing during such grace period if such premium with compound interest at the rate of 5 percent per annum is paid at the time your proof of the claim is furnished to the company.

> Readability level: college graduate

Rewritten passage

You have a 31-day grace period to pay a premium after it is due. Suppose you become disabled during such a period before you have paid the premium. In such a case you can stop paying any more premiums, but you'll still have to pay the one that's already overdue. You have time to pay it (with 5 percent interest) when you furnish us proof that you are totally disabled.

> Readability level: eighth grade (can be read and understood by approximately 85 percent of the U.S. adult population)

As you can see, you can revise writing to raise or lower the readability level. Patient rewriting can simplify and improve the clarity of most writing.

Readability formulas

The concept of readability involves many factors. We can measure, in a quasi-scientific manner, mechanical factors such as sentence structure, sentence length, and the difficulty of words. We can't analyze other factors as objectively—style, usage, typography, and graphics. However, you must understand their effect on readability to prepare good documents.

A readability formula is in many respects like a reading test. Instead of testing the reader, however, it tests the written material. The value of doing this is to test the complexity of your writing. It is merely a guide that may signal a need to reexamine and perhaps revise your work.

Analyzing readability is valuable because it:

— Determines the reading difficulty of the document you are writing

— Evaluates the reading difficulty of material you are considering adopting or using

— Enables a comparison between documents

— Provides empirical data to indicate whether the current or proposed document is appropriate for the reading abilities of the target audience.

A word of caution: Use readability formulas to evaluate a document *after* you've written it. Readability formulas should not dictate what and how you write. Counting words per sentence while you write will seriously impair your progress. If you find you've written your document at too high a grade level for your reader, you can revise it in several ways. For example, you can change long or abstract words, vary sentence length, or edit your writing for conversational style. You will have then used the formula as it is meant to be used—as a quantitative measure and as an indicator of possible modifications.

Fry readability scale

In the 1960s, Edward Fry developed the Fry readability scale. During the last 20 years this formula has had widespread adoption. The following sections explain how to apply it to your writing.

Fry readability range

Elementary through college graduate

Documentation target

Eighth-grade reading level

The Fry readability scale is widely used by publishers, editors, curriculum and manual developers, writers, and educators. Every writer who prepares major documents for your employees or customers should understand and use the graph. Before you complete a document, evaluate it against the scale to ensure it meets eighth-grade reading objectives.

Instructions

1. Randomly select three 100-word passages from near the beginning, middle, and end of the document. Count everything except numbers.

2. Count the total number of sentences in each 100-word passage (estimating to the nearest tenth of a sentence). Average these three numbers.

3. Count the total number of syllables in each 100-word sample. Average the total number of syllables for the three 100-word samples. There is a syllable for each vowel sound. For example: cat (1), blackbird (2), continental (4). Don't be misled by word size. For example, "polio" has three syllables; "through" has one. Endings such as "-y," "-ed," "-el," or "-le" usually make a syllable. For example, "ready" has two; "bottle" has two.

 When counting syllables, Fry suggests that you put a mark above every syllable over one in each word and add 100 to your total count of marks. This technique simplifies the syllable count since one-syllable words are included in the word count of 100, as are the first syllables of the words that have one or more marks.

4. Plot on the accompanying graph (figure 3-1) the average number of sentences per 100 words and the average number of syllables per 100 words. The perpendicular lines mark off approximate grade-level areas.

5. If you find a great deal of variability, use more samples to get a better average.

The Fry readability scale is not copyrighted. Anyone may reproduce it. Edward Fry appreciates being acknowledged if the graph is cited or copied. He has also developed a simple slide-rule measurement tool that you can order from Jamestown Publishers in Providence, Rhode Island.

Figure 3-1. **Fry readability scale**

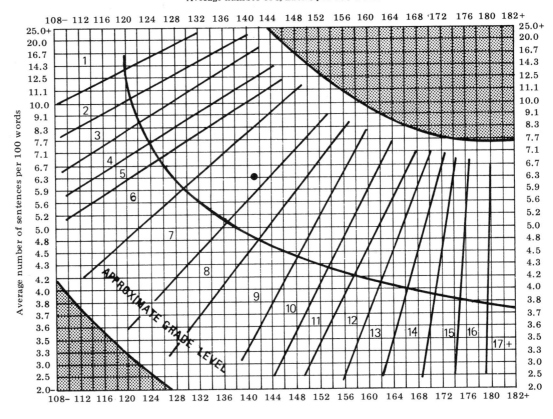

Kernel distance theory

Another test of readability is the "kernel distance theory." It defines the kernel of a sentence as the noun (subject), verb (predicate), and usually the object. According to the theory, the greater the distance between the noun and the verb, the harder the sentence is to read.

Negative effects on readability

The following writing weaknesses have a negative effect on readability:

— Heavy load of proper nouns, abbreviations, and acronyms

— Heavy load of numerals and figures

— Indefinite pronoun antecedents

— Lack of pronunciation guide for new and foreign words

— Overload of closely placed sibilant sounds (she sells sea shells)

— Passive voice

— Lack of parallel construction.

Paragraph construction

The paragraph is the basic organizational unit of written expression. Paragraphs consist of groups of sentences aimed at introducing, developing, and concluding the topic of the section. Paragraphs in corporate documents should be relatively short. As a rule of thumb, plan for no more than six to eight lines of text. Place important information at the beginning of each paragraph, followed by supporting information and detail.

Short paragraphs break up solid blocks of copy into manageable chunks that are less forbidding to sometimes reluctant readers. Short paragraphs add air, or white space, which is aesthetically appealing. They also help give direction and movement to a document, keeping the reader oriented and interested.

The three types of paragraphs discussed in this section have different purposes and organizational patterns. Introductory paragraphs attract readers' attention and announce what they are going to encounter. Developmental paragraphs explain the main points, in unified and coherent detail. And concluding paragraphs give a sense of completion to your explanation.

Introductory paragraphs

Most sections of a document require one or more introductory paragraphs. The first introductory paragraph generally begins with a lead-in sentence or two. This lead-in should capture and keep the reader's attention. At the same time it should point to the subject of the section. Succeeding sentences in the same paragraph or in the next one set the stage for the body of the section. They let the reader know where the text is heading.

Your readers are not leisurely reading a novel, waiting in suspense to find out what is going to happen next. They are busy colleagues or customers who want an overview of the document's content. They also want to be prepared for the order in which the information will appear.

Depending on the subject and audience, you may need to provide some background information in the introductory paragraph. Present it after the lead-in sentences. This background information will prepare readers for your statement of the subject. Be brief and remember your readers' needs.

Write a lead-in and state your subject

Use your lead-in to establish a reader-friendly tone. You might use direct address, a question, a quotation, a series of headlines from other documents on your subject, a simple but dramatic statement, or an unusual or humorous statement. Consider the following lead-in for a sales brochure:

> You may already have a character printer or a line printer. And chances are you wish your high-quality character printer ran faster or your high-speed line printer had higher quality.

The direct address, "you may already have," combined with the simple and dramatic "chances are you wish your high-quality printer ran faster," involves the audience in the message. They become a part of the subject. The lead-in acknowledges their good business sense as well as their needs. And it leads to the next sentence, which states the subject of the brochure.

lead-in	You may already have a character printer or a line printer. And chances are you wish your high-quality character printer ran faster or your high-speed line printer had higher quality.
statement of subject	That's why we think you should look at electronic printing—particularly at the new line of distributed electronic printers.

Any number of approaches will attract attention. Don't, however, try to be clever just for the sake of cleverness. The approach you use should have a justifiable and logical purpose. It should serve as a springboard for the subject of your document. It should lead smoothly and naturally to a statement of your subject. Note this attention-getting lead-in and the following statement of the subject.

lead-in	You've heard the rumors . . . and yes, they're true! The new laser printing system is here!
statement of subject	Our laser printers are located in the new corporate offices at the main site.

Together, this lead-in and statement of subject make up the first introductory paragraph of this document.

You've enticed your readers with a good lead-in and informed them of your subject. Now you want to prepare them for what you have to say about your subject.

Include your key ideas in sequence

The lead-in and statement of subject make up one paragraph. The succeeding paragraphs should touch briefly on the major points of the document. You're telling your audience what they are going to discover. You should also tell them where they will discover these points and the order of their appearance. Introductory material organized in this manner subtly orients your readers to your discussion.

The following introductory paragraphs briefly mention each major point in the document.

lead-in	You've heard the rumors . . . and yes, they're true! The laser printing system (LPS) has arrived at the company's corporate offices. Technically, the two
subject	units being beta tested are located in the Finance Office Building.
major point	Thanks to the hard-working systems group, the Automated Systems Division is experimenting with using the laser printing system in conjunction with different hosts and text application programs. The
major point	results should enable user groups with LPS potential to take full advantage of this productive, efficient, high-quality printer.
major point	The user groups are located throughout the five company sites.
major point	Currently, the company's systems group is developing a three-phase strategy for implementing the LPS for these user groups.

The major points introduced were:

1. The group responsible for this account

2. The data processing activity in operation

3. The potential for this account

4. The implementation strategy.

The body of the document will develop these points in detail. Most important, the writer has prepared the reader for this development.

When do introductory sentences suffice?

If the section is short, you may need only one or two introductory sentences to prepare your readers for the discussion to follow. If your lead-in and statement of subject are only a sentence or two rather than a paragraph, simply dovetail these sentences with your first paragraph of development (see the section on developmental paragraphs).

lead-in	Today we are announcing the introduction of a powerful
subject	new program—the new account Uptime Guarantee Program. The Uptime Guarantee Program provides quarterly credits to those qualifying customers whose
development	LPS performance exceeds 5 percent unscheduled downtime. The program will be presented to all current customers and should be particularly effective in removing reliability and availability concerns of first-install prospects. Field operations personnel have asked for this tool and now we have it.⁻ Let's use the program to our advantage.

The important idea behind introductory paragraphs is usefulness. Use them to entice your readers and to orient them to what follows.

Developmental paragraphs

While introductory paragraphs identify major points, each developmental paragraph takes one major point and explains it in detail. This explanation can take many forms—analysis, definition, illustration, or contrast, for example.

Use facts to support or develop the ideas you are explaining. Never use them as fillers or for the sake of impressing your readers. When you use specific facts, check your sources to make sure they are accurate.

All developmental paragraphs should correspond with the subject of the section.

Use an outline

It helps to sketch an outline of each paragraph before you commit your ideas to ink or the keyboard. Readers, unlike listeners, must have a systematic, primarily deductive presentation of thought to understand some kinds of material easily. Decide how to organize your ideas before you put them together into related sentences.

Promote paragraph unity

All paragraphs of a document develop the single, broad subject of the document. In the same manner, all sentences of a developmental paragraph develop the narrow, limited subject of that paragraph. Sticking to the subject in this way ensures paragraph unity, thus enabling your reader to easily grasp your point or follow your explanation.

Write a strong, specific topic sentence

To create paragraph unity, state the subject in the first or second sentence of the paragraph. This sentence is your topic sentence. It controls the content of the paragraph by dictating the subject matter to follow.

If you discover the ideas of your topic sentence buried in the paragraph, pull them out and organize them into a concise, precise sentence. Then place that sentence at the beginning of the paragraph. Rearrange the succeeding sentences in logical order. The following example illustrates unity between the topic sentence and the body of a paragraph.

topic sentence	We have a problem with the output when making multiple copies on a unit with an automatic document feeder.
development	After we run more than a dozen originals, we begin to get toner buildup. This buildup results in streaks on the copier/duplicator platen and then on the copies.

A strong topic sentence helps you stick to the subject. It also helps the reader determine the subject without having to analyze the entire paragraph.

Express the idea of your topic sentence in specific terms. Revise each topic sentence until you have replaced all general words with concrete ones. Try to make your topic sentence as specific as possible before you write the paragraph. Then check through the paragraph to find ideas you've neglected in the topic sentence.

Note how you can improve the following topic sentence by adding words that point to the actual content of the paragraph.

overly general topic sentence	The company's finance office comprises an elite force of analysts who welcome **more productive computer equipment like the new laser printing system.**
	One of their major charters is to produce budget reports for the U.S.—an all-encompassing project involving high-volume "numbers crunching." For this project, they often need report summaries (15
specific ideas to use in topic sentence	to 20 pages) **immediately available** in their area. The **print quality (number legibility)** afforded by the laser printing system is critical.

The revised topic sentence below states the subject in specific terms and points directly to the development to follow.

specific topic sentence	The company's finance office comprises an elite force of analysts who welcome the **system's efficiency and print quality.**

Precise words in a topic sentence aid both the writer and the reader. Clarity highlights the significance of present material and provides an idea of what is to follow.

Edit for paragraph unity

Check your paragraphs for unity during editing. Keep the facts and details that develop the subject of the paragraph and nothing else. Business writing should not follow the "who, what, where, when, why" news reporting approach. Readers of technical manuals and reports should be able to find facts and details quickly and easily.

With paragraph unity in mind, edit out unnecessary text. Note the irrelevant details in the following paragraph:

destroys unity	The company's finance office comprises an elite force of **extremely knowledgeable, hard-driving, aggressive** analysts who welcome the system's efficiency and print quality. One of their major charters is to produce budget reports for the U.S.—an all-encompassing
destroys unity	project **for the first part of the year,** involving high-
destroys unity	volume "numbers crunching." **Some of their CP reports are too long to make routing to the laser printer practical.** However, they often **have the** need to have **large quantities of** report summaries (15 to 20 pages) immediately available in their area. Print quality (number legibility) is critical for these budget reports.

Keep these factors in mind

Make sure each paragraph is indispensable and builds solidly onto the preceding one. Also watch for consistency in the following elements.

Person | Choose unity of person. Are you going to write in the first person as a participant or in the third person as an observer? You should not start a paragraph in the first person and then switch to the second or third person.

Tense | Whenever possible, use the present tense. Of course, you can switch from one tense to another where appropriate.

Mood | Choose an informal conversational style whenever possible. Do not mix two or three styles in the same document.

Attitude | Are you going to be involved, detached, judgmental, humorous, or ironic? We recommend an involved and warm style. Be consistent in the attitude that appears to achieve your objective most effectively.

Concluding paragraphs

Concluding paragraphs have one major purpose: to alert the reader that the text is coming to an end. Don't leave your reader hanging.

You can signal the end of your document in several ways. If the document is long or complex, summarize your main points. You can also establish proof of your explanation or lead your reader on to further study of the subject. If the document is brief, involve your reader by making a recommendation, by providing encouragement, or by prompting a response.

Note how the authors wrap up their subjects in these examples.

encourages readers | You've had to read quite a bit to get to this point, but I've got one more piece of good news to give you. Every unit placement carries five commission points. I doubt this statement will be hard to digest or will require additional explanation.

arouses readers to action | This future vision is possible thanks to hard-working people like Fritz and Carol. They helped make the system an integral part of this far-reaching plan. You too can achieve these results.

Paragraph coherence

In writing, you must anticipate possible confusion in the reader's mind and provide words and explanations that connect ideas in a logical manner. These words create paragraph coherence. An easy and natural flow, or transition, from one sentence to another marks the well-written paragraph.

Edit for coherence

Editing for coherence is most effective if it is done several hours to a day after you've written your paragraphs. Time away from your writing gives you distance from your ideas. It increases your objectivity and restores your ability to ''hear'' how your text sounds. You can tell whether a reader can follow your material without confusion.

When you edit for coherence, put yourself in the reader's place. Ask yourself if you need help understanding any implied connections between ideas. If you can clarify your subject by providing explicit connections, do so.

Use connective techniques

You can create paragraph coherence by using one or both of two methods. In one method, you repeat keywords or phrases to refer to previously stated ideas. In the other method, you use transitional words and phrases such as ''however'' and ''in other words'' to indicate logical relationships between ideas.

Refer to previously stated ideas

Repeat keywords and phrases to present a clear, logically connected explanation.

	The company's finance office comprises an elite force of analysts who
keywords	welcome the system's efficiency and **print quality.**
keywords	One of their major charters is to produce **budget**
keywords	**reports** for the U.S.—an all-encompassing **project** involving high-volume ''numbers crunching.''
keywords repeated	For this **project,** they often need report summaries (15 to 20 pages) immediately available in their area.
keywords repeated	The **print quality** (number legibility) afforded by
keywords repeated	the laser printer is critical for these **budget reports.**

Show relationships between ideas

Use transitional words to indicate logical connections such as temporal, contrastive, or causal ones.

	We offer the system as a print server option.
time/addition	**Soon** it will **also** be an option for the
contrast	word processing workstation. **Even so,** there are some documents that the net-resident printer can print that other printers cannot.
contrast and addition	**However,** as illustrated in the graph above, a good percentage of these documents cannot be produced on the workstation.

Sentence structure

From the three types of paragraphs,

— introductory, which provide subject lead-ins and attract the reader's attention,

— developmental, which explain the main points, and

— concluding, which bring the explanations to an end,

we move to the building blocks of paragraphs, namely, sentences. What follows is an examination of sentence structure.

Basic sentence patterns

Essentially there are four basic patterns for building sentences: 1) simple, 2) complex, 3) compound, and 4) compound-complex.

Simple

The simple sentence has one independent clause.

The electronic mail arrives.

Next to the complex sentence, the simple sentence is the most widely used pattern in writing. The simple sentence provides variability in rhythm. It can be concisely used to make a point, provide a transition, or summarize preceding ideas.

Complex

The complex sentence has one independent clause and one or more subordinate or dependent clauses.

The electronic mail arrives when the user selects the icon.

The complex sentence is the most widely used writing pattern. It has the greatest flexibility and is the easiest to control. The mobility of its subordinate clause provides variability. By changing its position, you can create a change in emphasis and rhythm. Because readability formulas will limit your use of complex sentences, be aware of the added strength that judiciously placed complex sentences can give to your writing.

Compound

The compound sentence is made up of two independent clauses.

The electronic mail arrives, and the user may route each piece.

Use this type of sentence when you have two related ideas of equal importance, each embedded in its own clause. The interrelationship between the two clauses may be contradictory and joined by "but," collective and joined by "and," or alternative and joined by "or."

Avoid the habit of using "and" as a stringing device for your clauses. In self-editing you can usually change an undeserving compound sentence into two simple sentences or into a complex sentence.

In the following examples, note the illogical use of "and" to string together clauses.

Original	Revised
Compound sentence expressing two unrelated ideas that should be separated	Two simple sentences
We have installed a printer in a research facility within the Department of Computer Sciences, and the account has been working with some very creative applications.	**We have installed a printer in a research facility within the Department of Computer Sciences. The account has been working with some very creative applications.**
Compound sentence expressing two ideas that should be joined in a conditional relationship	Complex sentence that subordinates the condition expressed in the clause beginning with "when" to the number of pages printed a week
With combined usage of all areas, they are reporting a usage of more than 10,000 pages per week, and the printer is in use 24 hours a day, 7 days a week.	**When they combine usage of all areas, using the printer for 24 hours a day, 7 days a week, they print more than 10,000 pages a week.**

Compound-complex

The compound-complex sentence has two or more independent clauses and one or more subordinate clauses.

The work stops when the union sanctions a strike, but the workers keep their tools ready because management may soon give in to their demands.

Here are the individual parts of that sentence:

independent clause	The work stops
subordinate clause	when the union sanctions a strike,
independent clause	but the workers keep their tools ready
subordinate clause	because management may soon give in to their demands.

The compound-complex sentence can be difficult to understand. For example:

The main objective in implementing such a network is to eliminate the need for the dial-up private line telephones that are presently provided, for they are costing us approximately $360K a year and could easily double in cost because of the introduction of fiber-optic cables.

first independent clause	The main objective in implementing such a network is to eliminate the need for the dial-up private line telephones
first subordinate clause	that are presently provided,
second independent clause	for they are costing us approximately $360K a year and could easily double in cost
second subordinate clause	because of the introduction of fiber-optic cables.

Avoid compound-complex sentences in corporate publications. And follow the rule of thumb: "One idea to a sentence."

Characteristics of clear sentences

Every grammatically correct sentence has two key parts: a subject and a predicate. Every sentence answers two questions:

1. What am I talking about (the subject)?

2. What am I saying about it (the predicate)?

Subject close to verb

Here is a short sentence:

Two field engineers visited the customer site.

This sentence is easy to understand. We know what it is about ("two field engineers") and what is being said about them ("visited the customer site").

When the subject and its verb, called the simple predicate, are separated, the meaning grows unclear.

The field engineers, hoping to find the software packages on their desks, since copies had not yet arrived at the customer site due to the late mail, called in at their office.

By the time you get to the predicate, you may have forgotten the subject—what the sentence is about.

A better sentence would be:

The field engineers called in at their office, hoping to find the software packages on their desks, since copies had not yet arrived at the customer site due to the late mail.

Even better is:

The field engineers called in at their office. They were hoping to find the software packages on their desks. Due to the late mail, copies had not yet arrived at the customer site.

Verb close to object

Keep the verb and its object close together. Anything separating the verb and its object makes the sentence harder to read:

> The field engineers collected the software packages after calling the warehouse.

The verb usually has an object, which answers the question what or whom. When the verb and its object are widely separated, the meaning is unclear:

> The field engineers collected, after calling the warehouse, the software packages.

By the time you get to the object ("software packages"), you may have forgotten what the subject is.

Subject close to beginning of sentence

Keep the subject close to the beginning of the sentence. Anything that keeps your reader from quickly learning what you are talking about makes the sentence harder to read. Try to start your sentence with your subject, with a transitional connector, or with brief information about your subject.

We frequently write the way we talk. We suddenly get another idea and interrupt ourselves before we have told our readers what we intended to say. Consider the following example:

> After I saw you yesterday following the dry run for the presentation (the traffic was terrible and I thought I would never get home), my boss called to tell me he wants me to go to a meeting in Los Angeles.

We need to move the subject near the beginning of the sentence.

> After yesterday's dry run, my boss called to say he wants me to go to Los Angeles.

Notice the short phrase at the beginning of the sentence. It gives the time of the event and does not interfere with understanding.

Another example:

> Since the system has not been a complete success but has been successfully used by some select companies in surprising ways, my assignment is to conduct a special study on just how these other companies are able to use the system.

A better sentence is:

> My assignment is to conduct a study of select companies that are using the system successfully.

Modifiers close to modified words

Anything that separates modifiers and the words they modify makes a sentence difficult to read. It may also make it incorrect and humorous. Rearrange your modifier to make the meaning clear. For example:

> Running in diagnostic mode, the managers watched all the terminals they had rented begin operations.

This is awkward because the beginning phrase isn't clear until you finish reading the whole sentence. The sentence should read:

> The managers watched all the terminals they had rented begin operations, running in diagnostic mode.

Another example:

> I purchased some software that was full of bugs **called Ensigs**.

Here's the same sentence with its misplaced modifier moved to the correct spot:

> I purchased some software **called Ensigs** that was full of bugs.

A modifier limits or changes the meaning of a word. Modifiers answer questions like when, where, why, in what manner, what kind, which one, and to what extent. They are either adjectives:

> I purchased **expensive** software.

or adverbs:

> The screen brightened **immediately.**

They can also be phrases or clauses that act like adjectives:

> Use the software **with pull-down menus.**

or adverbs:

> The screen flashed **without stopping.**

Modifiers should always be placed nearest the element they are describing. For example:

> The expensive software, which I purchased yesterday, called Ensigs needs debugging.

This is better written:

> The expensive software called Ensigs, which I purchased yesterday, needs debugging.

Nouns and verbs give power and direction to writing. Use adjectives and adverbs with restraint in business and technical documentation.

Active voice

Your choice of verbs can make a real difference in the force and action of your writing. Passive verbs weaken a sentence; active verbs invigorate it.

For example, the original sentence below indirectly communicates its meaning. The subject ("document format") does not perform the action of the verb ("to use"). In the revision, the understood subject ("you") does perform the action of the verb. This sentence communicates directly.

Original	Revised
Passive relationship between subject and verb	Active relationship between subject and verb
This document format will be used for all internal newsletters in the future.	**In the future, use this document format for all internal newsletters.**

Find active substitutes for the verb "to be" ("am," "is," "are," "was," "were") and other verbs that denote a state of being ("seems," "appears"). Note the conciseness and impact of the active verbs below.

Weak, "to be" verbs	Strong, active verbs
We **are of the opinion** . . .	We **believe** . . .
The new laser printer system **is an illustration of** . . .	The new laser printer system **illustrates** . . .

Also use verbs that communicate positive meaning instead of those that suggest mere probability. For example, the simple present is much more positive than "may," "would," or "should."

The new document about the laser printer **helps** you clearly understand its use.

Variety

Variation in sentence length generally improves sentence rhythm. A series of simple sentences tends to produce more of a rhythm than a series of long, complex sentences.

Monotony results from building a series of sentences that all begin with subjects. Overcome this tendency by watching for the movable elements within your sentences—such as subordinate clauses, phrases, and adverbs. Try shifting them to the beginning of the sentence to achieve better pace and flow.

Note the movable elements in the original paragraph below. The revised paragraph no longer sounds monotonous.

Original

Overuse of subject/verb pattern at the beginning of each sentence	The Electronic Publishing Center uses a network of workstations to gather and disseminate the customer requirements of each job it produces. The Electronic Publishing Center chose a workstation network as its in-house method because of the ease with which its employees can communicate with one another, between departments, and with customers.
movable element	The center **previously** had depended on telephone calls and memo distribution as the way to communicate with
movable element	**everyone in the information loop— employees and customers alike.** Now the Electronic Publishing Center receives customer input and requirements electronically, confirms or queries correspondents via mailnotes, and spreads information to those who need to know by electronic distribution lists. Networked workstations allow the center to do the job faster and better than before.

Revised | Various syntactical patterns at the beginnings of sentences

subject/verb — **The Electronic Publishing Center (EPC) uses** a network of workstations to gather and disseminate customer job requirements.

participle — **Recognizing** a workstation network as an effective time-saver, the EPC chose it for the speed and ease of its communications.

adverb — **Previously,** EPC employees depended on the telephone and the memo pad.

subject/particle — Now **customers and employees,** using electronic workstations,

verb — **communicate** with one another more efficiently than before.

To find out if all your sentences move at the same pace, read them aloud. You may gain variety by reversing the order of a sentence, by substituting a word that is new or unusual, or by altering the sentence length.

Remember, sentence variety is not your primary goal. Communication is still the basic aim of your writing. Determine the final structure of any sentence by what you want to say and by the content of the sentences that precede and follow it.

Technique and form

Much corporate writing is *exposition*—defining or explaining a product, system, or application. You must define countless terms, many of which may be technical. You must explain products and features and how they apply to specific user needs. You must also describe the exact steps the user has to follow to implement a product or system.

There are many techniques that bring life and freshness to expository writing. Brief descriptions of the techniques are listed below, along with examples.

Definition

What exactly is it that you are writing about? Inexperienced readers want to know, and more knowledgeable readers may need to be reminded. Define your subject matter, but don't simply give a dictionary definition. Make your definition pique readers' attention and stimulate interest. For example:

> The electronic printing system is part of a new generation of imaging systems, which are so advanced, they set new standards for flexibility, quality, and effectiveness in computer-generated business communications. Combining computer, laser, xerographic, communications, and microfilming technologies, the system allows images of practically unrestricted size, shape, and orientation to be printed directly from digital information.

Identification

Place your subject matter in context. It is more meaningful, and your readers can better visualize what you are writing about. For example:

> The world of information handling and communications has undergone profound changes in the last decade. Sophisticated word processing systems, digital communication systems, earth satellite systems, advanced facsimile systems, and increasingly complex private and public networks have become commonplace.

> The new printing system operates efficiently in these environments, helping to increase productivity through its speed and flexibility in merging information from a variety of sources and structuring it into attractive reports and displays.

> For those who will make the decisions, present the proposals, develop the products, and pursue the opportunities for growth, the new system is the vital next step in information handling and communications.

Analogy

Show your readers how things are alike or different from one another. If you are describing a difficult or unfamiliar topic, make a simple analogy to a familiar subject. This gives readers a reference point they can understand and brings the writing closer to their own experiences. For example:

> In 1455, Johannes Gutenberg invented movable type. But more than that, he pioneered a revolution in communications. He created works of printed art by controlling the steps in an integrated printing process—a process that helped bring the printed word to millions of people and created an emphasis on communication that continues today.
>
> Xerox Corporation is a modern pioneer in communications and therefore has many potential "Gutenbergs" . . .

or:

> Xerox, although a large corporation, is, like Gutenberg, a communications pioneer.

Classification

Use classification to provide connective tissue between elements that you perceive to be similar. Your readers will see relationships to other things in the same classification. For example:

> The versatile color graphics printer is a full-color printing/plotting system designed to serve a variety of rapidly expanding communications needs.
>
> Process industries use color display systems extensively. Critical process variables, such as temperature, pressure, flow, valve settings, and tank levels, must be monitored constantly. Color hardcopy is also needed for periodic logging and for recording alarm conditions for subsequent analysis.
>
> The petroleum industry has a major need for color displays in three areas: process and pipeline design, seismic plotting, and process monitoring and control.
>
> Government agencies have a variety of needs for color hardcopy. Many statistical studies and reports intended for executive presentation can be simplified through the use of color graphics.

Comparison and contrast

Compare your product or service to something similar or contrast it with something different. Use vivid comparisons and contrasts so that you maintain your readers' interest. For example:

> As you can see, it's the things you won't have to do that make electronic publishing unique.

> Instead of taking weeks to produce business documents conventionally with camera-ready art, you can eliminate the paper wait with on-demand printing. Now you can produce your business documents—catalogs, price lists, proposals, technical manuals—immediately and efficiently.

Example

Use specific examples that explain general topics. Be sure to choose examples that capture the essence of your subject matter. Think of examples that your reader would find useful or enlightening. They should also be clear and uncomplicated. For example:

> At Xerox, we recognize that users of our electronic printing systems need different typefaces for different applications. We develop a wide variety of fonts to meet these needs. For example, if you have a requirement to match the output from line printers, typewriters, or word processors, Xerox offers a line of typefaces designed to match those most often used in data centers and offices. These include monospaced and proportional spaced typefaces in various styles and sizes.

Statistics

Use statistics to support your major points. Statistics can give dimension to your writing. For example:

> One company, a wholesaler of books to school libraries, used our system to offer customized catalogs with a personal choice of sequence and delivery dates. The result was that sales increased by more than 400 percent.

Other writing techniques

The following approaches can add freshness and an interesting change of pace. Use them whenever possible.

Eyewitness account/interview

Using an eyewitness account or interview strengthens authenticity by creating an "I was there" feeling. It also encourages a conversational and personalized writing style.

Letter form	With a letter style, you can easily develop a conversational and personalized tone.
Question and answer	A question-and-answer format lends an up-to-date presence and provides opportunity for dialogue. It also encourages a conversational and personalized style.
Quotation	To reinforce the message, it helps to quote different experts. Keep quotations brief and to the point. Take care to quote accurately.
Author/reader dialogue	Setting up an author/reader dialogue encourages a conversational and personalized style, as well as the use of strong, active verbs and descriptive modifiers.
Step-by-step or listing techniques	Using steps or lists encourages clear organization and aids the recall and summary of the main ideas. It is very effective for listing procedures and sequenced actions. It also allows you to break up copy with numerals, bullets, or dashes. This technique should not, however, be used in place of good sentence structure or effective transitions.
Photo, chart, or graphic essay	Combining photographs, charts, or other graphics with the text can attract the reader and provide visual support for topics that are difficult to clarify. It helps you structure events or steps and encourages clear organization.

Word choice and usage

Words are the nuts and bolts that make a difference in your writing style. In fact, the English satirist Jonathan Swift believed that "proper words in proper places make the true definition of style."

English is richly endowed with words; the choices seem endless. The best writers are the most exact in the choices they make. According to Mark Twain, "The difference between the right word and almost the right word is like that between lightning and the lightning bug."

Note the subtle differences in meaning in the boldface words in the following examples.

Original	Revised
Xerox' major **emphasis** is to meet our users' needs.	Xerox' major **goal** is to meet our users' needs.
Well-chosen modifiers can explain the fine **discrimination** between ideas.	Well-chosen modifiers can explain the fine **distinctions** between ideas.

As a general rule, don't use a new word that you have not learned in context and subsequently checked out in a reliable dictionary. You should have at your fingertips standard references: an up-to-date dictionary, a thesaurus, a dictionary of modern usage, a world almanac, and a style manual.

Use simple words

Often you will have to decide between two words with the same or similar meaning. Choose the shortest, most direct, most natural word or phrase. Words with many syllables or words that are difficult to pronounce slow the reader down and detract from the written message. Sometimes they sound forced or pretentious. Aim for an easy, conversational style.

In choosing words, never deliberately strive to use a complex word when a good simple synonym is readily available.

The most readable English comes from Anglo-Saxon words, not from Latin derivatives. The words of Anglo-Saxon origin below are shorter and more conversational than their counterparts of Latin origin.

Anglo-Saxon	Latin
find out	ascertain
make up	constitute
hand out	distribute

You can't always avoid long words in technical writing, any more than you can get along without technical terms. But you will often have a choice between long and short words. The enormous vocabulary of English provides pairs of words with virtually identical meanings in current usage. Here are some examples:

When you can use	Do not use
therefore; so	accordingly
these	aforementioned
apply to	applicable
aid, help	assistance
try	attempt
due	attributable
by	by means of
pay	compensate
so	consequently
much	considerable
letter	correspondence
used	employed
help; ease	facilitate
this; these	foregoing
also	furthermore
shows	illustrates
first	initial
begin	initiate
because	inasmuch as
debt	indebtedness
show	indicate
to	in order to
if	in the event that
soon	in the near future
now	in this day and age
many	numerous
before	prior to
if	provided that, whether
buy	purchase
rest	remainder
is	serves as
enough	sufficient
end	terminate
send	transmit
use	utilize
see	visualize
about	with regard to

Take care with jargon

Every trade has its own buzzwords and jargon. Some of these words become standard because they meet a need—"software" is an example. Others like "feature-rich" are vague and short-lived.

One way to handle jargon is to identify the intended users of the publication. Be careful in using words that have special meanings that are not obvious to a customer. For example, "landscape orientation" is a familiar phrase to those who use electronic printing. To others, it may suggest a form of art or nothing at all. Either explain such terms or find a substitute that is clear to everyone.

Consider the nature of the document you're working on and its relationship to the reader. For example, if it is an internal document directed only to members of an engineering department, you would expect to use technical terms. Be certain, however, that they are used accurately and express the meaning more clearly or in fewer words than nontechnical terms. If it is an internal document but meant for distribution to both marketing and engineering employees, beware of using the jargon of either group. Also take extra care to explain acronyms or abbreviations the first time they are used.

Be precise

Another category of commonly misused words consists of those that seem to mean something but actually don't. "Functionality" is an example. And then there are words or, more often, phrases that are substituted for standard words because we have fallen into the habit of using them. "In a timely manner" for "promptly" or "on time" are examples. Here are other examples:

Use	Do not use
now	at this point in time
can be used to	has the capability to
study	focus upon
for the reason of	for the purpose of
this is important	this is key
is based on	centers around the notion of
new	advanced or leading edge
did	performed the function of
unique	the most unique
faster	faster speed
said	said verbally
he couldn't	he totally lacked the ability to
except	with the possible exception of
called	referred to as
until	until such time as
this output	these outputs
fact	true fact
complete	finalize
I hope	hopefully
inside	inside of
imagine	conceptualize

Avoid clichés

Rather than adding to the color and cleverness of your material, empty and timeworn phrases deaden it. Keep the use of clichés to a minimum. Don't "explore every avenue," "leave no stone unturned," or "strain every muscle" in your search for a phrase that in the end is tired, trite, or overworked.

Use transitional words or phrases

Effective writing requires transitional words and phrases to connect ideas.

To the right of each group of transitions below, you will find the rhetorical purpose of that group.

Transitions		Uses
and additionally also	indeed in fact first, second	Join ideas of equal weight
for instance for example	for one thing	Illustrate or expand the point
similarly	likewise	Compare points
therefore consequently	so then	Add up results
finally all in all	on the whole in short	Summarize to emphasize a major point
of course no doubt certainly	to be sure granted that	Concede a point to the opposition or recognize a point that diverges from your line of thought
but yet	however	Reverse the line of thought, usually back to your own
still	nevertheless	Return the thought to your own side after a concession
although	though	Attach a concession to one of your points
because for	since	Connect a reason to an assertion
if provided that when	unless in case	Use a condition to qualify and restrict an idea
as if	as though	Consider tentative or hypothetical conditions
when soon before	while after until	Show a temporal relationship

Provide contextual clues

You can provide a subtle explanation for an unfamiliar word in the very sentence or passage in which it appears. You can develop these built-in explanations, or contextual clues, in several ways.

1. By definition:

 Janet needed to **eliminate unnecessary portions**. She *cropped* the photo.

2. By drawing on the reader's experience:

 Traveling **around the large metropolitan area** is usually easier if one uses the *beltway*.

3. By comparison:

 The *CRT display* is like the **screen of a home television set**.

4. By synonym:

 When John opened the box of *standardized documentation*, he was pleased with the **uniform internal and external appearance of the instruction manuals**.

5. By familiar expression:

 The *giant* was as tall as the **Empire State Building**.

6. By summary:

 Cathy sat down at her desk and **turned on the computer**. Then she **inserted the system disk into the disk drive**. Almost instantaneously, the **red light on the controller came on**. After a few minutes, Janet saw the **menu appear on the screen**. Then she knew she had correctly *loaded the software*.

7. By mood:

 The hotel, including her room, had a **sterile, institutional** atmosphere. The food in the coffee shop was **uninspired**. The employees were **unfriendly**. Even though she was an experienced business traveler, Linda realized she was still *homesick*.

Eliminate redundancy

Repetition of a word in close proximity to its first use has a jarring effect on the reader. For example:

The **astronauts** will have new space suits. But the **astronauts** will not wear them on Apollo 13.

There are several ways to correct the example given above:

1. Substitute a synonym (''space explorers'').

2. Substitute a pronoun (''they'').

3. Repeat the noun but use a demonstrative qualifier (''that,'' ''such,'' ''this,'' ''these'').

Avoid being redundant in meaning. For example:

She was elected **unanimously** by the **whole** assembly.

Use company names and trademarks correctly

A company's name is among its most valuable assets. Your company spends a lot of effort building quality into the products and services that bear its name. The way a company is actually perceived is shaped by the collective appearance of the messages it presents. Every advertisement, brochure, and promotional package communicates an impression of your company's character. Every document identifies and determines for the reader its image as a source of high-quality products and services.

Here are some guidelines for the proper use of trademarks.

1. Always spell trademarks correctly. Do not adapt or embellish them.

2. Differentiate trademarks from surrounding words.

3. Show trademarks that appear as a design, logo, or label in the correct format and colors.

Grammar

Grammar is the system of rules of usage in a language. Every language has its own conventions, accumulated and modified for centuries, that are accepted and used. The following are principles of correct English grammar.

Word order

"The marketing manager successful her complimented representative sales" is not a grammatical English sentence. However, when the same eight words are put together in grammatical order, we get a clear and correct sentence. "The successful sales representative complimented her marketing manager." The same words in a different order make another good sentence with an entirely different meaning. "The marketing manager complimented her successful sales representative."

Word position

Subject, verb, object is the most common order of words in English sentences. Other words, such as modifiers, are added to increase and clarify meaning. A simple way to illustrate the importance of word position in English grammar is to observe what happens when the adverb "only" is put in different places:

Only he operated the printer yesterday.
He **only** operated the printer yesterday.
He operated **only** the printer yesterday.
He operated the **only** printer yesterday.
He operated the printer **only** yesterday.
He operated the printer yesterday **only**.

Common grammatical mistakes

Some of the most common grammatical mistakes are listed below, with examples.

	Incorrect	Correct
Agreement of subject and verb	The **number** of workstation users **have** increased ten-fold.	The **number** of workstation users **has** increased ten-fold.
Wrong sequence of tenses	The writer **deposits** the bound text and **departed**.	The writer **deposits** the bound text and **departs**.

	Incorrect	Correct
Dangling participle	This is a participial phrase with no logical noun or pronoun to modify. The bolded phrase below incorrectly modifies "benefits." Benefits cannot examine laser printers.	
	Examining the new laser printers, many cost-effective benefits were discovered.	Examining the new laser printers, the customers discovered many cost-effective benefits.
Misplaced modifiers	Put modifiers next to the word they modify.	
	Here's a new way to access the computer **that everyone's talking about.**	**Everyone's talking about** the new way to access the computer.
Indefinite antecedents	Make sure the referent for a pronoun is clear.	
	In class, **they** followed test procedures.	In class, **the trainees** followed test procedures.
"That" or "which"?	These are both pronouns, but "that" distinguishes its subject from all others, while "which" adds detail about the subject.	
	The word processor, **which** is broken, has been set aside for repairs.	The word processor **that** is broken has been set aside for repairs.
	The new employee's word processor **that** is broken has been set aside for repairs.	The new employee's word processor, **which** is broken, has been set aside for repairs.
"Who" or "whom"?	Use "who" when the pronoun is the subject of the following verb and "whom" when it is the object.	
	Ms. Jones is the person **whom** we think will be company president.	Ms. Jones is the person **who** we think will be company president.
	Ms. Jones is the person **who** the shareholders hope to elect.	Ms. Jones is the person **whom** the shareholders hope to elect.
Split infinitives	In general, avoid splitting infinitives, ie, placing a modifier between "to" and the verb.	
	I wanted **to continuously write** for an hour.	I wanted **to write continuously** for an hour.
	However, you may split infinitives when avoiding them would produce an awkward sentence, as in:	
	My intent was **to pull gently** the disk out of the machine.	My intent was **to gently pull** the disk out of the machine.

Spelling

The most widely accepted authority for spelling is *Webster's Third New International Dictionary (Unabridged)*. *Webster's Ninth New Collegiate* includes nearly all the words in common use and is more convenient to use. In all cases, use the first listed spelling of the word. The spelling of technical terms, acronyms, and words not given in *Webster's* should follow standard usage in the field. Appendix B contains a list of compound words and special terms. Also refer to the glossary.

Using a computer spellcheck program

A computerized spellcheck program can be a valuable tool for detecting spelling errors in electronic copy. Every program has a built-in dictionary to which you can add new words and names. When you use a spellcheck program, there are some limitations you should be aware of:

1. Spellcheck programs do not take into account sentence meaning and context. For example, if you use an inappropriate word that is pronounced the same but spelled differently, such as "pale" for "pail" or "wait" for "weight," the program will not pick that error up.

2. It takes time to run a spellcheck program. Every time the program flags a misspelling, you must provide the correction. If the program has limited dictionary space, you may be constantly stopping at acronyms and unusual terms that don't fit the dictionary.

3. Some programs pass over words that aren't in the dictionary, so you still need to edit for misspellings.

Use a spellcheck program as an adjunct to the editorial process, not as a replacement for it.

Common misspellings

For your immediate attention, please note the following list of most commonly misspelled words.

Incorrect	Correct
capibility	capability
compatability	compatibility
disemble	dissemble
comittee	committee
newmonia	pneumonia
similer	similar
mispel	misspell
rythm	rhythm
embarass	embarrass
fullfil	fulfill
truely	truly
seperate	separate
sofomore	sophomore
diafram	diaphragm
counsil	council
ocasion	occasion
disent	dissent
forein	foreign
nucular	nuclear
efective	effective
paralel	parallel

Take care with words that sound and look similar but have very different meanings, such as:

affect	and	effect
council	and	counsel
compliment	and	complement
comprises	and	is composed of
ensure	and	insure

American versus British spelling

The differences between American and British spelling fall into two main categories: word endings and individual words. Most American dictionaries list both variations, with the preferred American spelling given first.

Word endings

	American	British
-or/-our	color honor valor	colour honour valour
-er/-re	center theater specter	centre theatre spectre
-ize/-ise	criticize specialize deputize	criticise specialise deputise
-ler/-ller	traveler jeweler leveler	traveller jeweller leveller
-se/-ce	defense pretense license	defence pretence licence (although "license" is preferred for the verb)

Note that certain "-ce" words retain the "ce" ending in both American and British spelling. For example:

> evidence
> essence
> concurrence

Individual words

Some individual differences include:

American	British
jail	gaol
aluminum	aluminium
maneuver	manoeuvre
story	storey (referring to a floor of a building)

Punctuation clarifies the relationship of words and ideas in sentences. It can also provide a way to show emphasis or tone.

Generally, there is only one correct way to punctuate a given sentence or passage. When you are in doubt, punctuate according to the rules. Remember that you punctuate to help your readers, not to be different. Make every effort to be consistent and simple.

It is helpful to think about the relationship between the pauses in speaking and the punctuation in writing. When we pause very briefly while saying something, the equivalent in writing is a comma. A longer pause is like a period or a dash. Other punctuation marks are represented in speech by inflection—the natural rise and fall of pitch in our voices. An example is the question mark.

The most important and frequently used punctuation marks are:

Apostrophe	Hyphen
Colon	Parentheses
Comma	Period
Dash	Question mark
Ellipsis points	Quotation marks
Exclamation point	Semicolon

An explanation and example of each of these is provided in this chapter. Some of the rules are arbitrary. You will see publications that follow other conventions, but those listed here should be followed for all documents to ensure consistency.

Apostrophe

1. Do not use the apostrophe to form the plural of numbers or initialisms.

 The mid-1950**s** the early 1930**s**
 9700**s** CLAR**s**

2. In constructions such as "the '90s," use an apostrophe in both the numeric form and the spelled-out version.

 the '30s the 'thirties

 Do not confuse the latter example, which refers to a specific decade in time, with a reference to a person's age, as in "He was in his 30s." The apostrophe is not used in this case.

3. To form the possessive of a singular noun, add an apostrophe and an "s." To form the possessive of plural nouns, add only an apostrophe if the plural ends in "s." Otherwise, add an apostrophe and an "s."

 department**'s** budget
 services**'** allocation
 children**'s** department

The only exception to this rule for common nouns is where tradition and euphony dictate the use of the apostrophe only:

for appearance' (conscience', righteousness') sake

This general rule applies to plural nouns as well, including most names of any length ending in sibilants:

Burns' poems Berlioz's opera
Marx's theories

If, however, the last sibilant is silent, the apostrophe and "s" are added whether the word is monosyllabic or not:

Des Moines's business community

4. In forming the possessive of an underlined or italicized word or title, do not underscore or italicize the apostrophe and "s."

The *Tribune*'s circulation

Colon

1. You can use the colon in two ways: 1) to separate a grammatically complete clause from a second one that contains an illustration or amplification of its meaning; 2) to introduce a formal statement, extract, or speech in a dialogue. A colon often takes the place of an implied "namely," "as follows," or similar expression.

 The solution is simple: prepare the document on a professional workstation.

 Michael: I reported the problem to the customer engineer.

 Separate two independent clauses that have no sequential relationship in thought but are in some way related with a colon.

 To emphasize the sequence in thought between two clauses that form a complete sentence, use a semicolon to separate the clauses.

2. Place a colon outside quotation marks.

3. Do not follow a colon with a dash.

4. Use a colon to separate minutes and hours in most time divisions.

 The sales representative arrived at 8:30 a.m.

5. Use a colon following the salutation in formal correspondence.

 Dear Dr. Payne: To Whom It May Concern:

6. When enumerations or illustrative terms follow a colon, do not capitalize the first word of each term if the terms are part of the sentence.

 Treatment of a cold includes the following: get plenty of rest, drink fluids, and take aspirin.

Comma

The comma indicates the smallest interruption in continuity of thought in sentence structure. Aside from a few rules governing its use that have become almost obligatory, the use of the comma is a matter of good judgment. Ease of reading determines when you should use a comma.

1. When the clauses of a compound sentence are joined by a co-ordinate conjunction, place a comma before the conjunction unless the clauses are short and closely related.

 > The technician quickly turned off the machine, but the wiring had already been burned out.

 > Charles typed the copy and Mary proofread.

2. An adverbial phrase at the beginning of a sentence is frequently followed by a comma.

 > After reading the manual, Henry could operate the new equipment.

 > Because of the unusual circumstance, the president wrote the letter herself.

 Omit the comma after short introductory adverbial phrases.

 > On Tuesday we held the staff meeting.

3. Use commas sparingly, as needed for clarity and to prevent sentences from becoming unwieldy. Never let a comma come between the subject and verb of a sentence.

4. Insert commas to set off the year in a month/day/year date.

 > On October 15, 1985, all yearly budget plans are due.

 Do not use them when only the month and year or the year alone are given unless a figure follows immediately.

 > In June 1977 the company introduced a new copier.

 > In 1984 Mary Evans had the best sales record.

 > In March 1980 we moved into our new building.

5. Use commas to set off terms in geographical expressions such as states following cities. Use a comma on both sides of a state name when combined with a city name in text.

 > Stamford, CT, is the site of corporate headquarters.

 > He attended Yale University, New Haven, CT, and Dartmouth College, Hanover, NH.

6. Use commas to set off nouns or phrases in apposition to a noun.

 > Frank Smith, president of the company, was at the meeting.

7. In a series, use a comma after the next-to-last term.

 > The carton contains a terminal, a keyboard, and a reference manual.

8. Without exception, place commas inside quotation marks.

9. Follow a specific organization's usage in putting commas before ''Inc.'' or ''Ltd.'' A comma does not necessarily follow the period, except for grammatical reasons.

10. Use commas to set off the words "yes" and "no" in the following type of sentence:

> Yes, the report will be ready tomorrow.

11. Use a comma before expressions such as "namely," "for example," and "that is" in most cases and always follow them with a comma.

12. Do not use commas between days, hours, and minutes in a series or between degrees, minutes, and seconds of longitude and latitude.

Dash

1. Use the dash sparingly in copy. Its primary function is to set off a clause or phrase that might otherwise be enclosed in parentheses.

2. To make a dash with typesetting equipment, use an em dash, closed up to the words preceding and following.

> Our latest acquisition—the electronic typewriter—was used to prepare the letter.

To make a dash on a standard typewriter, use two hyphens, closed up to the words preceding and following.

> Our latest acquisition--the electronic typewriter--was used to prepare the letter.

Ellipsis points

Ellipsis points are used to indicate deliberate omissions from quoted material. They consist of three dots (periods).

1. When ellipsis points are used to show omission of a word or phrase within a sentence, they are preceded and followed by a space.

> This applies to all employers . . . and to independent business contractors.

2. When ellipses imply the omission of the end of the quoted sentence, place them after the end punctuation. The first word following the fourth dot should be capitalized.

> The law is given in the collected statutes. . . . The practice is found in the decision.

3. When there is a question mark or an exclamation point in place of the final period in the original, retain this mark and follow it with three dots for the ellipsis.

> Did they send word that the equipment was installed? . . .

4. Use other punctuation on either side of the three ellipsis points if it helps the sense or shows more clearly what has been omitted.

Exclamation point

In general, the exclamation point should be used only where it appears in quotations and titles.

Hyphen

1. Follow *Webster's* for the use of hyphens in compound words. Also refer to appendix B.

2. In most cases, use the hyphen in compound adjectives. Follow *Webster's* where the adjectival form is given.

public-school system	well-known authority
old-age pension	high-level language
joint-stock company	19th-century building

 Exceptions to this rule include proper names having their own fixed meaning, geographical terms when the expression is a geographic entity, foreign phrases used as adjectives, and two-word compounds containing an apostrophe.

New Testament books	South American coffee

3. Do not hyphenate combinations of an adverb and a participle where no ambiguity could result. Do not hyphenate compounds ending in "ly" or combinations including "very."

very high frequency	completely known material
very good quality	ever increasing temperature

4. Do not hyphenate adverbs or compound adjectives that follow the word they modify.

well-known book	the book was well known
12-inch rulers	rulers 12 inches long

5. Use the "suspense" hyphen as illustrated by the following examples:

a fifth- or sixth-grade reading level	2- and 3-year-olds
19th- and 20th-century literature	two-, three-, and fourfold production

6. Be careful about hyphenating compound adjectives in technical articles, since the hyphen can easily change the meaning. If the difficulty cannot be resolved, leave the hyphen out.

Parentheses

1. If the parenthetical expression is part of the sentence, do not use punctuation before the open parenthesis. Place end punctuation after the close parenthesis.

 This process is described in a book by A. A. Smith (published in 1979).

2. Place punctuation marks inside parentheses if the parenthetical expression is a complete sentence in its own right and not part of another sentence.

 (This process is further described in the section below.)

3. Use parentheses to confirm certain statements in legal papers or contracts.

 I promise to pay 9 (nine) dollars.

4. Use brackets for parenthetical expressions inside parentheses. Brackets alone may be used in some mathematical and scientific contexts.

5. Use close parentheses to enclose figures or letters that denote divisions in the enumeration within a sentence.

 Reasons for its success are 1) speed, 2) high-quality output, and 3) price.

Period

1. Without exception, place periods inside quotation marks.

2. Use a period to end a complete sentence unless a question mark or exclamation point is required.

3. Do not use periods after metric abbreviations, chemical symbols, or "percent," except at the end of a sentence.

4. Do not use periods after capital or lowercase Roman numerals except in enumerations where the numeral appears in an outline.

 Henry VIII I. The System Overview
 page vi II. The System Description

5. Omit periods at the end of short captions, unless the caption ends with an abbreviation that takes a period.

Question mark

1. Place the question mark inside the quotation marks if it is an integral part of the quotation. Place it outside the quotation marks if the quotation itself is only part of the question.

 He asked, "Are these products compatible?"

 Why did you say, "The meeting is cancelled"?

2. Use a question mark at the end of an interrogative sentence within another sentence.

 How can this dilemma be resolved? was on everyone's mind.

Quotation marks and italics

1. In general text, use quotation marks and italics as little as possible. Do not quote English words being used in their ordinary sense as given in *Webster's*. Author's quotation marks may be used with slang, obsolete, and other unusual words being used ironically (in the last case, to remove the quotes might alter the author's meaning). Quote technical words given in *Webster's* only if the meaning would otherwise be unclear. Words or phrases being discussed are frequently quoted. However, it is unnecessary to quote them if the author has not done so, unless the sentence is ambiguous.

2. Italicize foreign words and phrases in general, except for common foreign abbreviations (such as "ie" and "eg"). Do not italicize the titles of foreign places and organizations, nor medical and legal terms.

3. Use double quote marks for direct quotations and single quote marks for quotations within quotations. If long passages, such as extracts from documents, are indented left and right and are centered, do not use quote marks.

4. Place the parenthetical translation of a foreign phrase within quotation marks.

 > The motto of Louis XIV was: *L'Etat c'est moi* ("I am the state").

5. Place letters and groups of letters being discussed within quotation marks.

 > The letter "e" sounds best.

 > We use the "ing" suffix to form the participle.

6. Italicize the titles of books, long poems, periodicals, newspapers, motion pictures, ballets, and plays.

7. Put the titles of single short poems, journal articles, short stories (unless they have been published as separate books), essays, comic strips, TV and radio programs, songs, paintings, and statues and the names of ships, airships, airplanes, and trains in quotation marks.

8. Place a period or comma within quotation marks. Place a semicolon or colon outside quotation marks. Place a dash, question mark, or exclamation point within quotation marks when it refers to the quoted matter only; place it outside when it refers to the whole sentence.

9. Use underscoring if italics are unavailable. Underscoring should be uninterrupted: post hoc ergo propter hoc. Do not underscore a punctuation mark when it ends a sentence.

Semicolon

1. Use the semicolon to separate two main clauses of a compound sentence when they are not joined by a conjunction.

 The text was machine readable; it was translated into digital form by the input device.

2. Use a semicolon, not a comma, before the final "and" in a series containing semicolons.

3. Use semicolons to set off a series where members are internally punctuated.

 The program team comprises the following members: engineering, Tom Smith; software, Peter Jones; marketing, Mary Brown; manufacturing, Pat Thomas.

4. Always place the semicolon outside quotation marks and parentheses.

5. Do not use semicolons as final punctuation for items in enumerated lists set off from the rest of the copy. Items should take either a period or no final punctuation.

6. Use a semicolon before such expressions as "namely," "for example," "to wit," "that is," "viz," and "ie" if the break in continuity is greater than that signaled by a comma. (These expressions must always be followed by a comma.)

Punctuating lists

1. Place end punctuation on complete sentences.

2. Place no end punctuation on incomplete sentences.

3. If a paragraph preceding a list ends in a colon, place end punctuation on the last item in the list.

4. Keep list items parallel—either all sentences or all incomplete sentences.

In general, capitalize the first word of any sentence and any proper noun—that is, any word that is a name or trademark, such as California, Boston, or Xerox.

What to capitalize

The trend in most publications is toward less capitalization. In general, do not capitalize unless there is a specific reason or need. The reason may be based on the rules here, or you may have a special purpose. But never capitalize just to make a word look more important. The basic guidelines are as follows:

1. Capitalize components of the names of societies, institutions, companies, conferences, etc.

 American Management Association
 University of Southern California

2. Lowercase the defining term of such names when used alone, even though reference is being made to a specific organization.

 the University of Southern California; the university

3. Lowercase the defining term of proper nouns when used in the plural.

 Xerox and Data General corporations
 Atlantic and Pacific oceans

4. Capitalize the proper names of the components of schools, colleges, and related institutions of universities; lowercase departments.

 Harvard Law School College of Liberal Arts
 the department of history

5. Capitalize general words when they form a special name.

 Xerox Design Integration Office.

6. Lowercase terms that are not actual names but are merely being used descriptively.

 He attended the annual convention of the state computer society.

7. Lowercase terms being used to indicate classes of organizations and the like.

 state medical associations
 the San Diego high schools

8. Capitalize the first and last words in a title. Capitalize all other words in a title except articles, conjunctions, and prepositions of fewer than four letters.

9. Do not capitalize "a," "an," or "the" before a title or name unless it is a specific part of the title or name.

> the *Boston Globe* the *Washington Post*
> *The Time Machine*

10. Do not capitalize "appendix," "chapter," "section," "figure," "table," or similar words when used in a phrase.

> in section 4 see item 5
> in appendix A refer to table 4-3

11. Lowercase common nouns, adjectives, and verbs that were originally derived from proper nouns but have acquired a specialized meaning.

> venetian blind biblical
> portland cement anglicization

12. Capitalize trade names unless they have been integrated into the language; for example, Acrilan, Lucite, Monotype, but rayon, nylon, diesel, dynel.

13. Do not capitalize nouns that follow a product program name unless they are a specific part of the name.

> Chrysler car Volkswagen Dasher
> Doublemint gum General Mills Wheaties
> Xerox Integrated Xerox copier
> Composition System

14. Do not capitalize machine parts, menus, or generic terms.

> font memory Centronics 100 interface
> printer laser printing system
> telephone read-only memory
> pop-up menu product delivery process

Capitalization as a convention

The following sections summarize how capitalization is used as a convention in conjunction with the design described in part 4.

All caps

Capitalize all letters in the word or phrase for:

— Header and footer text

— Emphasis in running text

— Style option in level 10 headings

— Textual callouts in art

— Initialisms and acronyms

— Logo (also use logotype font)

— Network addresses.

Headline style

Use headline style, capitalizing the initial letters, for:

— Document titles (also use italics)

— References to document titles in text

— Trademarked product names.

Downstyle

Use downstyle, capitalizing only the first letter of the first word, for:

— Headings

— Figure and table titles

— Lists

— Text in art

— Legends and captions

— Column headings in tables

— Names of journal articles and papers (also use quotation marks)

— References to headings, chapters, or sections in the text (also use quotation marks).

Sentence style

Use sentence-style capitalization and punctuation for:

— Sentences in running text

— Sentences in lists.

Lowercase

Use lowercase for:

— Glossary and index entries (except proper nouns; also use bold-face type)

— Abbreviations

— Machine parts and assemblies.

Abbreviations that are not associated with numbers or measurements are discussed in this section. Refer to "Numerals" for information on abbreviating numbers and units of measurement.

1. Give the full name the first time it is used in each chapter and follow with its abbreviated form in parentheses. Words normally spelled out in text may be abbreviated in tables to conserve space.

2. Use company initialisms and acronyms, such as S&TD, only in internal documents and only after the complete name—Space and Technology Division—has been used once.

3. Write initialisms and acronyms closed up without periods, unless the periods are part of a geographical area or tradename.

UN	RCA	USAF	ICBM
DAR	AFL-CIO	SAGE	AWOL
NCR	NATO	CHQ	KTTV
TRW	YMCA	PST	CDT
GOP	U.S.S.R.	PhD	BA
U.S.	U.K.	MS	LLD

Acronyms may become lowercase as they are accepted into the language.

radar COBOL

4. Form the plural of abbreviations by adding a lowercase "s."

CLAR**s** PhD**s**

5. Abbreviate countries, U.S. states, and provinces using postal abbreviations when they follow cities and counties. Spell them out when they are combined with geographic features such as mountains or rivers.

CA UT
USA Mississippi River

6. Type the following abbreviations in lowercase, without punctuation, closed up, and followed by a comma. A phrase beginning with the abbreviation should be treated as parenthetical.

cf (*confer*)	compare
et al (*et alii*)	and others
etc (*et cetera*)	and so forth
eg (*exempli gratia*)	for example
et seq (*et sequentes*)	and the following
ibid (*ibidem*)	in the same place
ie (*id est*)	that is
loc cit (*loco citato*)	in the place cited
op cit (*opere citato*)	in the work cited
qv (*quod vide*)	which see
viz (*videlicet*)	namely
vs (*versus*)	against

1. In general text, spell out exact numbers of nine or less that are not units of measurement. Express numbers of 10 or more in figures.

 Fewer than **eight** members were present.

 More than **10,000** people attended the trade fair.

2. Spell out numbers occurring at the beginning of a sentence. If the sentence begins with a long, complicated number and spelling it out would be awkward, reword the sentence.

 One hundred fifty machines were shipped in the first delivery.

3. In paragraphs where several numbers of the same type occur, do not use figures for some and spell out others. If the largest contains two or more digits, use figures for all.

 There were **12** workstations in the publishing department, **8** in the personnel department, and **25** in the finance department.

4. Use numerals for all mixed numbers, serial numbers, part numbers, specification numbers, etc.

 item **4** step **2**
 part number **223-34-568**

5. Use a hyphen between whole numbers and fractions in shilling fractions.

 8-3/4 1-1/2
 12-15/32

 Do not use a hyphen between whole numbers and fractions when the fraction is stacked.

 $3\frac{1}{4}$ $2\frac{1}{2}$

 Do not mix shilling and stacked fractions in the same text.

6. Spell out "number" unless used repeatedly in text. Then abbreviate as "no."

7. In mathematical, technical, and scientific matter, use Arabic numerals, including "1," for all dimensions, weights, and other measures, formulas, mathematical equations, etc.

 Dimensions of the disk drive at **18** by **12** by **9** inches.

 The runners ran more than **7** miles.

8. Type decimals with a cipher (0) preceding the decimal point (0.5). Do not use the decimal point and cipher after whole numbers, except in discussions where it is necessary to establish a particular point or in tables where the cipher is needed to maintain alignment. Do not use the cipher after whole numbers denoting percent (3%; not 3.0%).

9. If a column has mixed decimals of two or more places, do not add zeros. Align the decimals.

0.22347	1.263
4.	2.6

10. Use commas in numbers of 1,000 or more except in years and page numbers. In decimal figures, never use a comma to the right of the decimal point.

11. Spell out "to" and "by" in continuous numbers.

from 6 **to** 16 feet 8 **by** 10 inches

12. In continuous numbers indicating measure or percent, do not repeat the unit.

25 to 30 percent 50 to 60 feet
(not 25 percent to 30 per- (not 50 feet to 60 feet)
cent)

13. Omit the apostrophe in expressions such as "the 1950s" or "the depression of the 1930s." The form "the '80s" or the "roaring '20s" may be used when there can be no confusion about the century.

14. Capitalize Roman numerals except for front matter page numbers. Lowercase terms appearing before numerals.

class **II** railroads	**r**oom 210
section 32	**v**olume 2
figure 5B	**p**age ix
table 7	

15. Use Arabic numerals for all dates. Spell out the names of months when used alone or when followed by the year. Do not use a comma between the month and the year. When both the day and the year are given, use a comma before and after the year. Do not use a comma in military-style dates.

June, July, and August	August and September 1924
May through July 1898	May 22 through July 31
January 22, 1945	September 18
November 1963	from May to June 1936
27 May 1951	

16. Do not state a number twice, except in a legal document.

We ordered 30 units.
 not
We ordered 30 (thirty) units.

17. Use "·" to denote multiplication of numbers. Type out "by" to denote dimensions.

5-1/4 · 4 = 22 8 **by** 10 feet

18. After using an exact date, spell out an elliptical reference to another date in the same month.

On November 5, new products were announced in the marketplace. By the morning of the **sixth,** several newspapers carried the story.

19. In the text spell out single units of measure:

ampere(s)	milliampere(s)
inch(es)	percent
pound(s)	volt(s)
foot (feet)	microsecond(s)

But abbreviate compound units of measure.

in-lb	in/hr
ft/s	V/m

20. Do not punctuate standard units of measurement. Refer to appendix C for abbreviations. Abbreviations use the singular form only. Use the plural form only when units are spelled out in text. Use the singular form with units less than 1.

Editing and proofreading symbols

Use standard editing and proofreading marks to note additions and corrections on your copy. To specify type, you must provide exact directions and measurements. Minimize marks that require judgment in adjusting space or punctuation to accommodate a change.

Below is a set of commonly accepted and useful symbols with a demonstration of their use.

Insert or move

	
∧	Insert missing item—used in text
/	Insert missing item—used in margin
#	Insert space
⌐	Break; start new line
[M]	Insert an em space
[N]	Insert an en space
[Insert a thin space
⊙	Insert a period
▯	Indent
⌐	Move or flush right
⌐	Move or flush left
⌐⌐	Center on line, space, or page
‖	Align vertically
=	Align horizontally
⊓	Move up
⊔	Move down
⊔⊓	Center

Instructions

	
ℰ	Delete
ℰ	Delete and close up
ant	Check pronoun antecedent
awk	Awkwardly expressed; revise
<u>radar</u>	Capitalize
ɌADAR	Make lowercase—used in text
lc	Make lowercase—used in margin
RɅDAR	Caps and lowercase
<u>Radio</u>	Use small caps—used in text
sm	Use small caps—used in margin
comb	Combine into one sentence as you judge best
frag	Sentence fragment
?	Unclear; please clarify
note	Note a suggestion or change (If a note is written on a separate piece of paper and attached to the page, be sure to include the page number in case the note is dislodged.)
¶	Start a new paragraph
no ¶	Do not start a new paragraph here
⌓	Run in; do not start a new paragraph
$\frac{\prime}{m}$	Use an em dash
$\frac{\prime}{n}$	Use an en dash
redun	Awkward repetition (redundant); revise
....	Let it stand—used in text
stet	Let it stand—used in margin

r/o	Run-on sentences; separate sentences or revise
⬯	Something needs to be done; problem area
sp	Spell correctly—used in margin
3⃝**lb**	Spell out
3⃝**yards**	Abbreviate
TO	Text left out; please supply
to⌐pull⌐gently⌐	Transpose order of letters or words; fix punctuation and wording as necessary—used in text
tr	Transpose—used in margin
10/11	Ten-point type set on 11-point leading
New York Times	Use italics—used in text
ital	Use italics—used in margin
New York City	No italics
rom	Roman type
transport	Use boldface—used in text
bf	Use boldface—used in margin
transport	No boldface—used in text
no bf	No boldface—used in margin
⌣	Close up

Table 3-2. **Edited and corrected text**

You save time when everyone use the same Symbols for revisiting,
editing, and proofing.

Their is many ways to use the marks, so learn to use standard
editing and proofreading merks to note additions and errors.
Show where somethings missing by drawing a carrot. Draw
thecorrections above the line of on the margin alongside. Draw
arrows to show location change. Circle the words or letters in
questin to bring attention to the problem area. Write legibly and
use common sense. Rectify any QUESTIONS in the margin with a note.

Learn to use standard editing and proofreading marks to note
additions to and errors on your copy. You save time when
everyone uses the same set of symbols for revising, editing, and
proofing. There are many ways to use the marks. Show where
something is missing by drawing a caret. Write the correction
above the line or in the margin alongside. Draw arrows to show
change of location. To bring attention to a problem area, circle
the words or letters in question. Write legibly and use common
sense. Clarify any questions in the margin with a note.

4. Visual design

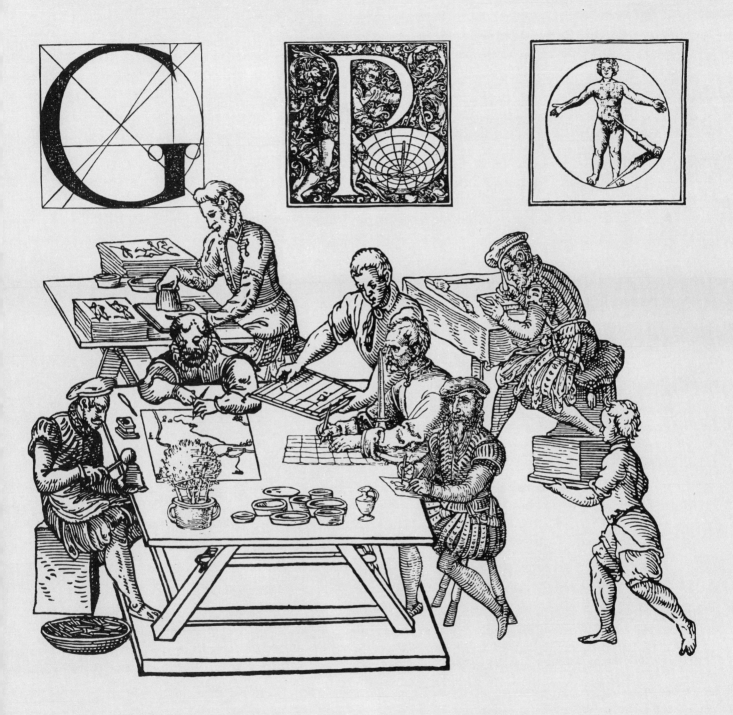

Part 4: Visual design
The images for part 4, taken from 16th-century European woodcuts, depict members of various occupations assembled to plan and produce a product. From left to right sit a typefounder; a cartographer; an illuminator who manually colors and gilds illustrations (what appears to be a mouse in his hand is really a stencil); an apprentice; a grid plotter; the art director designing the product; a woodcut artist; and a courier. The inspirational posters on the wall include (from the left) a Leonardo da Vinci study of a letterform; a Peter Apianus initial P with geometric theme, including a scientist describing the hemisphere with a compass; and a Vitruvius woodcut of Leonardo's man in the circle, illustrating proportions and mathematical relationships.

Overview of visual design

One of the primary objectives of visual design standards is to establish a family resemblance, or corporate "look," throughout all customer documents. At a glance customers should be able to recognize a company publication. An attractive, consistent design stands for reliable, high-quality documentation and, in turn, reliable and high-quality products.

A consistent visual design is particularly important for network systems, which contain a number of interrelated products. Consistent text formatting and presentation assist readers in finding information quickly, even when they must seek the information in more than one document. Consistency and recognition give readers a sense of familiarity and comfort with technical documents.

To show how a consistent corporate look can be achieved, this part details the specifications for the Xerox look. If you take the time to review this part from beginning to end, you will see the evolution of the Xerox design logic and how it is implemented. By studying this specific example, you should gain ideas for developing your own design standards.

Organization of information

This part was written for two audiences:

1. Those who select and plan visual elements of documentation during the planning, research, and design phases of the program

2. Those who create document pages and prepare packaging during the writing and production phases.

The document planner needs criteria for selecting page design and packaging. The document formatter requires brief, exact specifications for implementing the design and producing the visual elements.

For the document planner, the chapters in part 4 have been organized in a design planning sequence. For the formatter and artist, specifications are brief and visual, without lengthy discussion. Each chapter is modular, to allow growth as new specifications are developed.

This part begins with overall page specifications. It then moves to the page interiors with column layout, text, and graphics. Then formats are provided for content elements, including headers and footers, headings, and special pages. Last are standard binding and cover specifications. Design logic is included to guide judgments that must be made along the way.

Measurements and terminology

The illustrations in this part, which are presented at a reduction of actual size, provide examples of possible layout options. Binding edges, recto pages, and verso pages are shown where necessary.

All dimensions are shown in U.S. printer's points, except where noted. (Refer to appendix C for equivalent measurements in picas, inches, millimeters, and pixels.) Page dimensions are shown width by depth. Binding measurements are shown depth by width, as is standard in the binding industry.

If you are not conversant with publishing or graphic design terminology, some of the terms in this part may be unfamiliar. All these terms, however, are defined in the glossary.

Menu of content elements

The page design includes a full visual menu of content elements, from heading options to emphasis in text. It is possible to pick a combination of visual elements to fit the demands of any document. There is no "correct" or "incorrect" way of using these modular elements. Their variety allows you to make information visually clear while also creating visual interest within a coherent format. You can mix and match these elements to express the meaning and hierarchy of your information.

Design rationale

Visual design standards should not be determined arbitrarily, nor should they be based on personal preference or habit (". . . but we've always done it this way!"). They should be determined by analysis of the material and the purposes for which it is being published.

The document purpose and user requirements can be met, in part, through effective page size, margins, text columns, point size, typestyle, leading, graphics, headers, footers, and so on. Every element of the visual design, including paper, color, and binding, must work in concert to achieve a successful, consistent look.

Typography and page layout

The principal goals of page layout are visual recognition and legibility. These goals are accomplished through consistent typography, effective use of white space and graphics, and controlled use of rules.

The page layout described on the following pages can be achieved in both electronic and offset printing environments. The design encourages consistent visual placement of elements, including white space.

Typeface

The establishment of one typeface for all text pages ensures a unified look for all your printed materials. Consistent placement on the page, along with appropriate sizing, spacing, and proportioning, also contributes to the character of your documents and to the primary objective of content findability.

Visual logic

A repeated visual logic guides the eye and helps the reader scan. Each element of document organization is associated with a consistent visual look (refer to figure 2-1, page 2-6). The text is mapped in a hierarchical format, with organization reflected in heading levels and supporting text. Headings are not hidden or centered in surrounding text. To aid legibility, downstyle capitalization is frequently used for titles and headings.

White space

A generous amount of white space is reserved as a blank presentation area, allowing headings to "pop out" and wide graphics to be extended. This space also provides for the possibility of translation. A German text, for example, requires 30 percent more space than a comparable English text.

Validation

Visual design standards and guidelines are determined through extensive evaluation and testing. Temporary fashion and trendiness should be deliberately avoided. The standards presented in the following pages are the result of careful analysis of the needs and purposes of documentation. The Xerox visual design represents a systematic approach that is based on technology but is not technology-dependent.

Packaging and binding standards

Document packaging standards grow out of the desire for marketplace recognition and the need to control production costs. Binding selection depends upon document size and how and where the document will be used.

For a company with many products, there are thousands of documents that can appear in varying combinations on customers' shelves. To establish a consistent image, your company should agree upon a basic, standardized design. Although the documentation may be authored and produced by many people in different locations, they should represent a coherent corporate system.

Page specifications

Selecting a page size has many cost impacts. Because it is more costly to support a variety of sizes, only one big book and one small book page size are specified. The large size accommodates many illustrations and lengthy text. For the same amount of material, using the small size can increase the page count by 56 to 75 percent. The small size is easier to handle, however, and takes up less space when open on a desk.

U.S. and international page size standards

There are two standard page sizes, one for big and one for small books. The U.S. sizes are 8-1/2 by 11 inches (big book) and 5-1/2 by 8-1/2 inches (small book). All design options work in the comparable international (ISO) sizes as well, with slight measurement adjustments for page and binding differences.

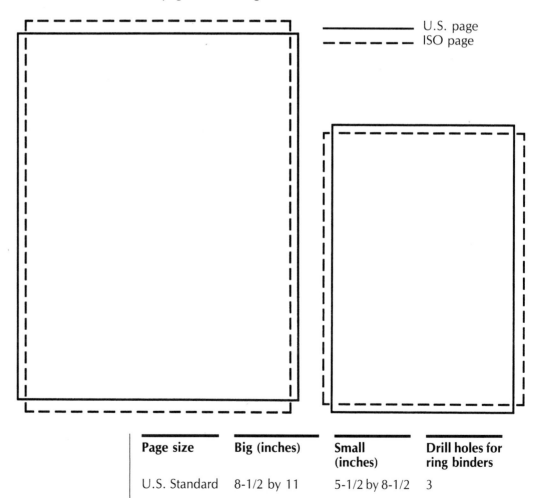

——————— U.S. page
– – – – – – – ISO page

Page size	Big (inches)	Small (inches)	Drill holes for ring binders
U.S. Standard	8-1/2 by 11	5-1/2 by 8-1/2	3
ISO Standard	8-1/4 by 11-3/4 (A4)	5-7/8 by 8-1/4 (A5)	4

Page orientation

STANDARD PORTRAIT ALTERNATE LANDSCAPE

Standard portrait

Portrait is the standard page orientation for all documents. Most text and illustrations can be structured to fit into the portrait mode. Use landscape pages in a portrait document to accommodate the width of a large table or artwork.

Alternate landscape

Landscape is an alternate page orientation. Landscape may be used when most of the document consists of wide tabular data or a multicolumn format that does not fit easily into the portrait mode.

Live matter

Live matter is the usable area of the page between the margins.

STANDARD PORTRAIT ALTERNATE LANDSCAPE

Live matter	Portrait (points)*	Landscape (points)*
Big book	504 by 684	702 by 504
Small book	314 by 504	540 by 303

* Measurements shown width by depth

Summary of page specifications

The ISO page is centered over the U.S. page in both portrait and landscape orientations. The measurements are given in points.

Big book, portrait

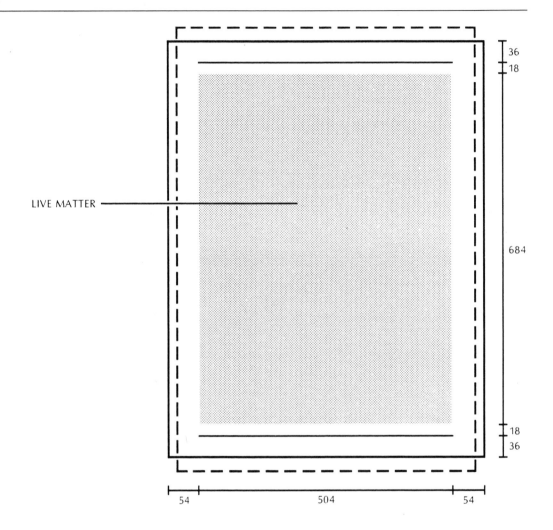

LIVE MATTER

36
18
684
18
36

54 504 54

Small book, portrait

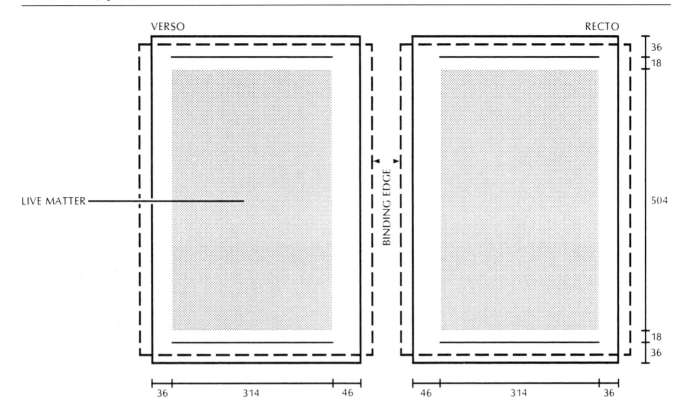

Big book, landscape

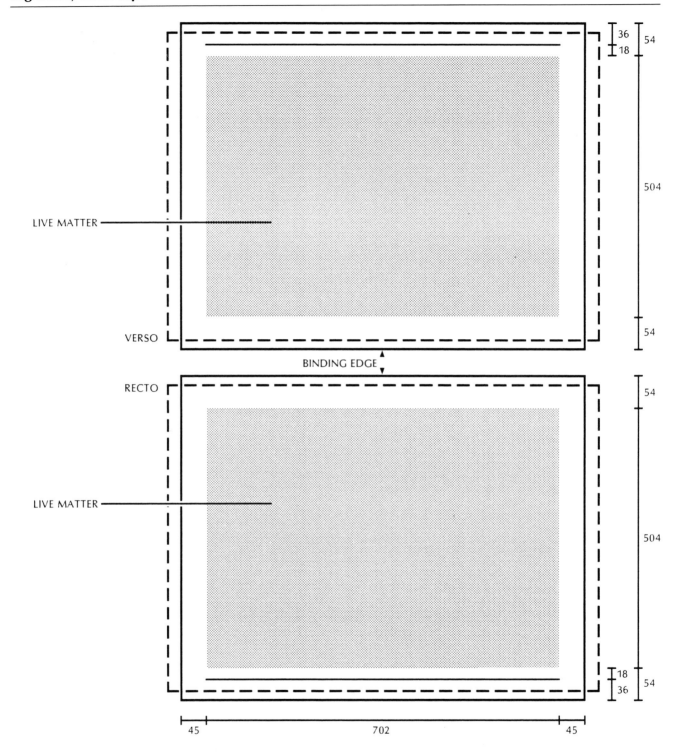

LIVE MATTER

VERSO

BINDING EDGE

RECTO

LIVE MATTER

36
18
54

504

54

54

504

18
36
54

45 702 45

Small book, landscape

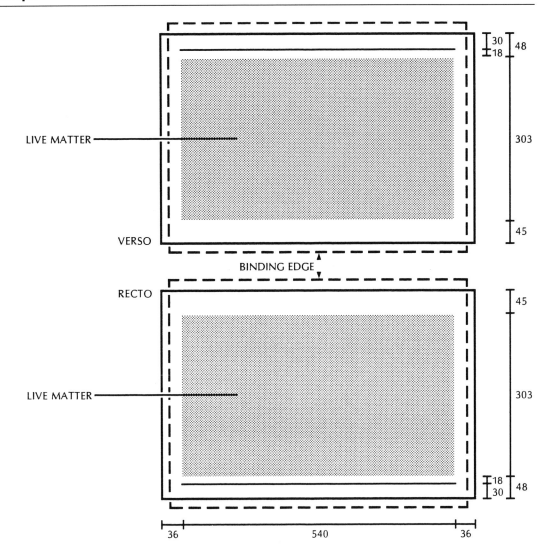

To achieve a common look, it is necessary to control the live matter of the page. At the same time, you need the freedom to present information in a physically varied manner to accommodate a wide array of materials. The Xerox look provides a variety of column layouts to organize text and graphics within the live matter area of the page.

Standard: single text column

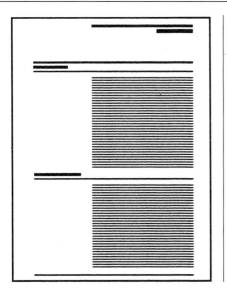

The standard page layout is divided into two unequal parts: a wide text or reading column to the right and a narrower, empty or scanning column to the left. Headings or graphics are made visible by pulling them out from the text column and exposing them to view in a context of empty space. This layout lends itself to the fastest possible scanning by the reader and adds a special character to the document.

Alternate: multicolumn variations

Double-, triple-, and four-column text variations are available as small-scale interruptions of the basic single-column rhythm. They cannot provide the same headline visibility, however, since they use the full width of the live matter area. Only if the single-column format prevents the material from being understood clearly should an entire document be prepared in a multicolumn format.

The following sections contain diagrams and specifications for the various column layouts. Standard portrait layouts for big and small books are followed by landscape alternatives.

Big book, portrait: single text column

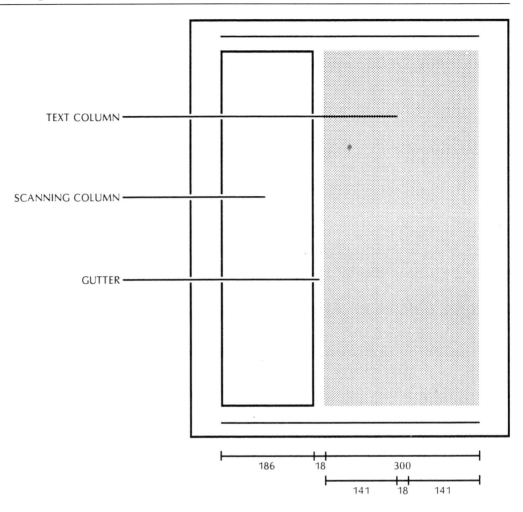

TEXT COLUMN

SCANNING COLUMN

GUTTER

186 18 300
141 18 141

1. Live matter is split into one text column (right) and one scanning column (left), with an 18-point gutter.

2. A vertical half-point rule can be centered in the gutter, 9 points from the text, to organize the material clearly on the page. The rule should end where the lowest column of information ends.

3. Text column measures 300 points wide by 684 points deep.

4. Scanning column is 186 points wide by 684 points deep. Use it as a blank presentation area for headings and wide tables and graphics.

5. Text column can be split into two half-columns measuring 141 points each, with an 18-point gutter.

6. Text column can also be divided into other convenient proportions, depending on the tabular requirements of the material to be displayed.

Single-column page samples

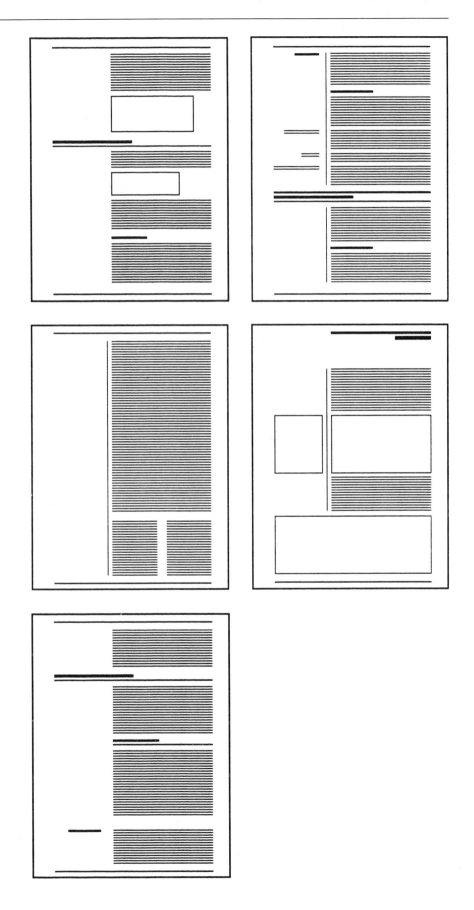

Big book, portrait: double text columns

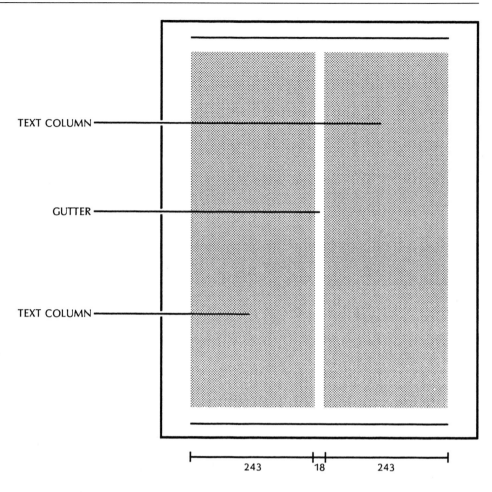

1. Live matter is split into two 243-point text columns, with an 18-point gutter.

2. A vertical half-point rule can be centered in the gutter, 9 points from the text, to organize the material clearly on the page. The rule should end where the lowest column of information ends.

3. Text columns can be split into two half-columns measuring 112.5 points each, with an 18-point gutter.

4. Other parameters are similar to the single-column page.

Double-column page samples

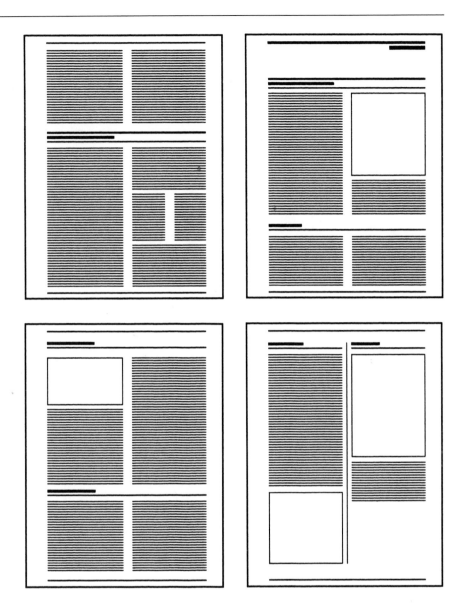

Big book, portrait: triple text columns

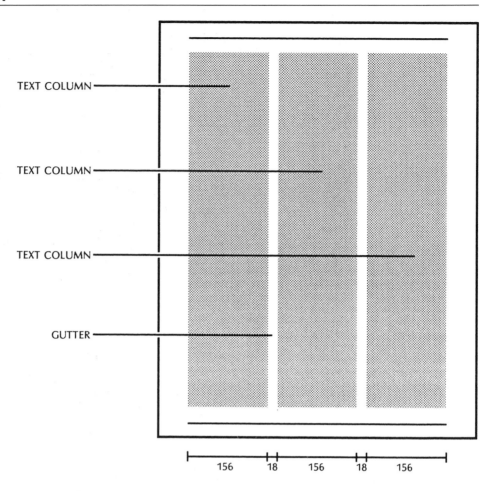

TEXT COLUMN

TEXT COLUMN

TEXT COLUMN

GUTTER

156 18 156 18 156

1. Live matter is split into three 156-point text columns, with 18-point gutters.

2. Vertical half-point rules can be centered in the gutters, 9 points from the text, to organize the material clearly on the page. The rule should end where the lowest column of information ends.

3. Other parameters are similar to the single-column page.

Triple-column page samples

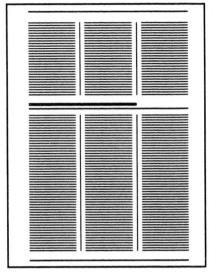
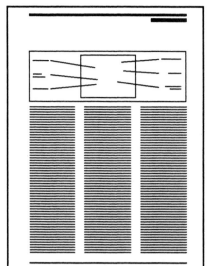
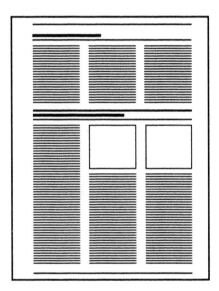
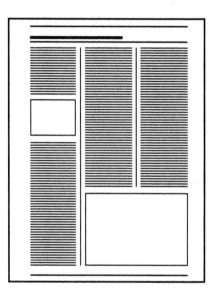

Big book, portrait: combination of columns

You can mix the various column formats on the same page to best display information. Keep in mind the requirements of the text and graphics you are presenting, as well as the capabilities of your publishing system and software. The columns and gutters are coordinated to work together to yield a consistent look while using the space effectively.

Do not distract the reader with excessive variations. Coherent patterning and simplicity result in an easy-to-scan page. Landscape pages should not be mixed with portrait pages within the same document, unless the landscape orientation is required to accommodate the width of large charts, tables, or artwork.

Combined-columns page samples

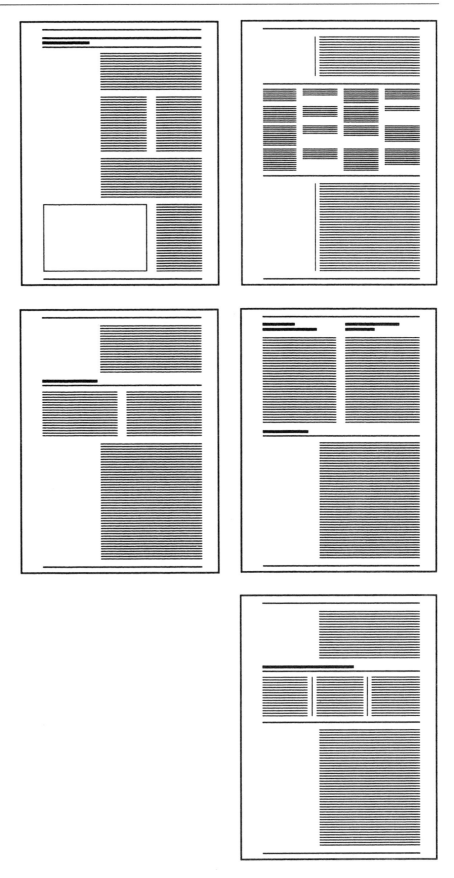

Small book, portrait: single text column

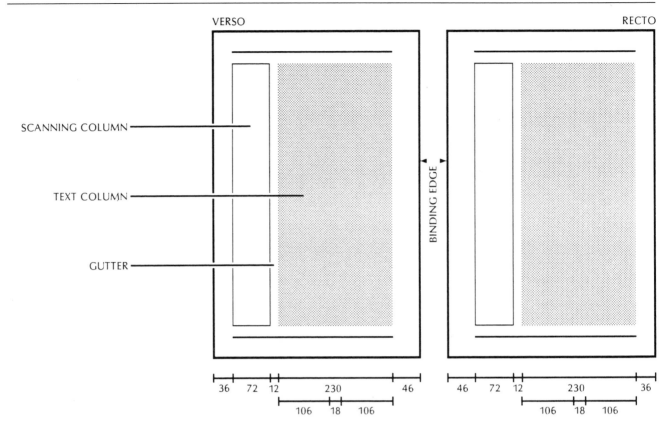

VERSO RECTO

SCANNING COLUMN

TEXT COLUMN

GUTTER

BINDING EDGE

36 72 12 230 46 46 72 12 230 36

106 18 106 106 18 106

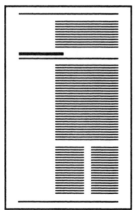

1. Live matter is split into one text column (right) and one scanning column (left), with a 12-point gutter.

2. Text column measures 230 points wide by 504 points deep.

3. Scanning column is 72 points wide by 504 points deep. Use it as a blank presentation area for headings and wide tables and graphics.

4. Text column can be split into two 106-point columns, with an 18-point gutter. Text column can also be divided into other convenient proportions, depending on the tabular requirements of the material to be displayed.

5. Live matter area is offset to allow for binding.

Small book, portrait: double text columns

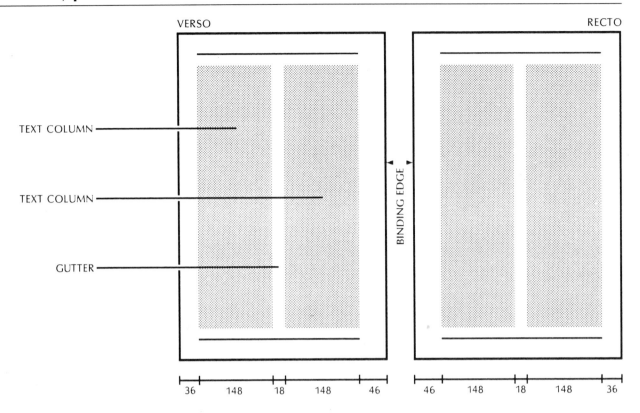

VERSO

RECTO

TEXT COLUMN

TEXT COLUMN

GUTTER

BINDING EDGE

36 148 18 148 46 46 148 18 148 36

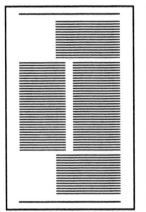

1. Live matter is split into two 148-point text columns, with an 18-point gutter.

2. Vertical half-point rules can be centered in the gutter, 9 points from the text, to organize the material clearly on the page. The rule should end where the lowest column of information ends.

3. Live matter is offset to allow for binding.

4. Other parameters are similar to the single-column page.

Big book, landscape: four columns

The four-column format is complex and is not designed for use with flowing text in most documents. The variety of page arrangements possible with these column structures will accommodate special format requirements.

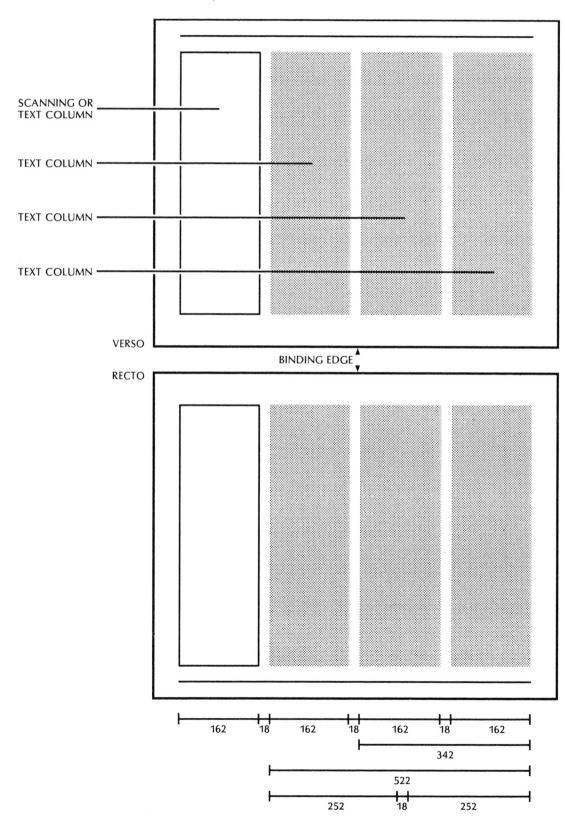

SCANNING OR
TEXT COLUMN

TEXT COLUMN

TEXT COLUMN

TEXT COLUMN

VERSO

BINDING EDGE

RECTO

162 18 162 18 162 18 162

342

522

252 18 252

1. Live matter is split into four 162-point text columns, with 18-point gutters.

2. Vertical half-point rules can be centered in the gutters, 9 points from the text, to organize the material clearly on the page. The rule should end where the lowest column of information ends.

3. The four columns can be combined and utilized in many ways:

 a. Combine two columns and a gutter to yield 342-point columns.

 — Use two 342-point columns to fill the whole page.

 — Use one 342-point column centered on the page.

 — Use one 342-point column off center.

 b. Combine three columns to yield a 522-point text column and a 162-point scanning column (preferably at far left), with an 18-point gutter. This layout is similar to the portrait single-column layout.

 c. Halve the 522-point column into two 252-point text columns, with an 18-point gutter. The scanning column remains 162 points, with an 18-point gutter.

Four-column page samples

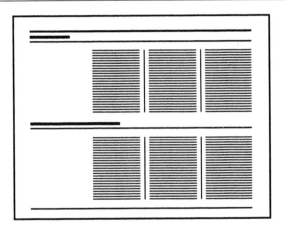

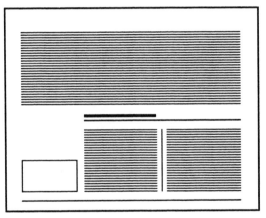

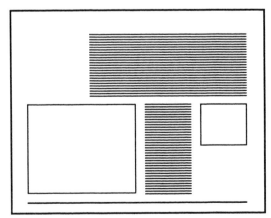

Small book, landscape: single text column

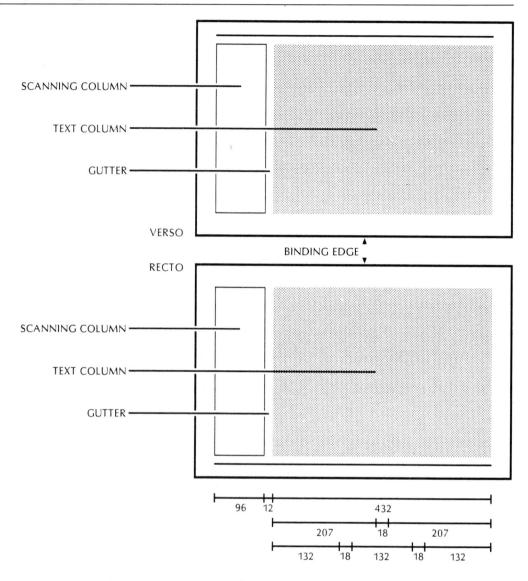

1. Live matter is split into one text column (right) and one scanning column (left), with a 12-point gutter.

2. Text column is 432 points wide by 303 points deep.

3. Scanning column is 96 points wide by 303 points deep.

4. Text column can be split into two 207-point columns, with an 18-point gutter.

5. Text can be split by other convenient proportions depending on the tabular requirements of the material to be displayed.

Typeface

Optima is the standard typeface for text pages produced on or for Xerox electronic publishing systems. It is used for all body copy, lists, tabular matter, diagram callouts, and headings.

Optima is a highly readable sans serif face. It has a spacious appearance and is easy on the eye. It reproduces crisply in conventional printing environments and provides excellent quality on electronic printers. A noticeable typeface without being peculiar, Optima is economical. It accommodates many characters per line. It also displays a strong contrast between regular and bold type.

Typeface selection

When selecting a corporate typeface, you might want to consider:

- The readability of several alternative typefaces

- The various applications that will be supported

- The print production methods involved

- The xerographic reproduction quality expected

- The availability on a variety of products (to assure compatibility)

- The character set available (if you have unusual character requirements)

- The coordination of special font needs (such as logos, signatures, and the like).

For technical publications, you need a typeface that clearly distinguishes between the number 0 and the letter O as well as between the lowercase L, uppercase i, and number 1. Some good alternatives to Optima include Helvetica (a sans serif typeface) and Times (a serif typeface).

In fact, these three typefaces can be mixed and matched to create a variety of design alternatives. For example, you can use Times headers and Optima or Helvetica text, or Helvetica headers and Optima text, or Helvetica headers and Times text.

If you are using an electronic or desktop publishing system, the font combinations available to you will depend on the memory size and quality of your output device.

Text

The selection of text specifications is based on many factors that must be looked at in combination. There are no hard and fast rules to cover every situation.

Carefully analyze the purpose and use of the document before determining text specifications. For example, will the user read the material straight through or skim from one reference to another? Will the book sit in the reader's lap? Will the book be propped up on an easel or a desk? Will the book sit on the floor by a machine being serviced? Is the user a teacher who will carry the book around while instructing a course? All these factors influence size and placement of type.

The specifications that follow were chosen for documentation going to customers of Xerox computer systems products. These publications consist largely of technical, reference, and training materials.

Body copy

Type size

Reference materials	10-point
Student materials	11-point
Instructor materials	12-point

Line length

Text column	Full width of the selected text column, not to exceed 2.5 times the length of the lowercase alphabet.

Leading (line spacing)

Primary leading | Single space in running text (type size plus 1 point)

Secondary leading | Space and a half between paragraphs (primary leading times 1.5)

Other spacing | Spacing around other visual elements in the text (for example, headings, tables, and graphics) is always 1, 1.5, 2, or 3 times the primary leading (see pages 4-55 to 4-57).

Justification of text

Text column | Reference materials: flush left and right
Training materials: flush left, rag right

Scanning column | Flush right, rag left

Emphasis within text

Visual emphasis can be given to important words by making them appear different in some way: darker, paler, larger, smaller, capital-ized, italicized, etc. The change of texture and blackness draws at-tention by contrast to the surroundings. The following techniques may be used.

1. ALL CAPITALS OF THE BODY TYPE (but use with discrimination, as they are hard to read)

2. **Boldface** (to give special emphasis to a full sentence or even a whole paragraph, but reserve such strong means for very special purposes)

3. *Italics of the body type* (to lend a slightly different visual texture to the typography; especially useful for quotations, extracts, breakouts, and the like)

4. Underlined words (for a darker look than the surrounding body copy, though less black than boldface)

Downstyle capitalization

Contrary to the practice of Setting Headings And Display Type In This Initial Cap Upstyle, set all headings, subtitles, figure and table headings, captions, lists, and the like in downstyle.

Guidelines for downstyling

1. Capitalize the first letter of the first word.

2. Capitalize the first letter of proper nouns, such as trademarked product names.

3. Capitalize acronyms.

Note: There is no end punctuation when "downstyle" is used. There is end punctuation when "sentence style" is used.

An exception

Document titles are upstyle; that is, the first letter of each word is capitalized except articles and short prepositions (although these are capitalized if they are the first or last word in the title). For example:

Xerox Production Specifications for Printing and Media

A Schedule of Income and Pass Through

Advantages of downstyle

The use of lowercase letters in downstyle has certain benefits.

1. Faster, smoother reading

2. Simplified word recognition (the profile of lowercase letters is easier to distinguish than all caps or initial caps)

3. Easier cataloging of information (by giving greater visibility to proper names and acronyms)

4. More forthright, contemporary character (by replacing a traditional newspaper technique with a fresh one, more appropriate to technical documentation)

Lists

A list is the simplest kind of table and gives the writer a good, clear way to present information that needs to stand out from the text. Choose a pattern of list conventions and use it consistently throughout the document.

Conventions to signal lists

There are several conventions for signaling the items in a list.

— Numerals (1., 2., 3., etc)

— Lowercase letters (a., b., c., etc)

— Solid 4-point bullets (•)

— Em dash (—)

— En dash (–)

— Indention (2 ems from left or right)

— Outline format (I., A., 1., a., •, —, –)

Format

1. Place list elements flush left in the column or directly under the text above.

2. Indent turnovers (lines after the first) flush left under the text above.

3. Place a 1-em space between the signal and the text.

4. Clear the space before the numerals 1 through 9 so that double-digit numbers will align.

5. In general, use secondary leading before a list and between items. See pages 4-32 and 4-55 through 4-57. Use judgment to make lists appear consistent throughout the document.

6. Use downstyle capitalization.

7. Avoid using bullets. The other conventions provide a lighter look and do not compete with the techniques used for emphasis in the text.

8. Refer to page 3-58 for rules on how to punctuate lists.

Summary of visual conventions

The following sections summarize how visual techniques, such as boldface type, are used in Xerox documents.

Boldface type

Use boldface type for:

— Emphasis in running text

— Document titles on covers (also use italics)

— All heading levels (regular is an option in heading level 9)

— Figure and table titles (use regular for the word ''figure'' and the number)

— Column headings in tables.

Regular type

Use regular type for:

— All body copy

— Style option in heading level 9

— Figure and table numbers.

Italic type

Use italic type for:

— Emphasis in text

— Style option in heading level 10

— Document titles (on covers, also use boldface type).

Underscoring

Use underscoring for:

— Emphasis in text

— Substitute when italic type is not available.

Indention

Use indention for:

— Emphasis in text

— Quotations

— Bibliographic entries.

Arabic numerals

Use Arabic numerals for:

— Page numbering (except for Roman numerals in front matter)

— Footnotes and endnotes

— Bibliographic entries.

Brackets

Use square brackets to indicate the content to be inserted in:

— Boilerplates

— Templates

— Fill-ins

— Variable text strings.

Graphics and tables

Graphic materials include photographs, illustrations, renderings, drawings, charts, graphs, and other forms of artwork printed with the text of a document. They are the visuals supporting, illustrating, and enriching the words.

Take care to prepare graphics of a quality that will complement and enhance the content and support the document's purpose. Be sure that visuals are current, accurate, and professionally drawn.

Pictures contrast clearly against their surrounding typography, but tabular matter is similar in texture and color and thus can blend into its surroundings too easily. Define it for what it is: a self-contained element that interrupts the flow of text on the page. Rules (discussed below) may be helpful in setting off the table.

Artwork size and orientation

The height and the width, that is, the vertical and horizontal dimensions, of any graphic can be as the individual item requires within the live matter. The size should be dictated by the message of the image. Coordinate arbitrary elements, such as leader rules, boxes, and position of callouts, with the column widths of the pages on which the artwork is to appear and use consistent sizing throughout the document.

Illustrations are "read" the same way as text: from left to right and from top to bottom. A drawing showing a flow is followed from start to finish as though it were a sentence. Display graphic elements in a manner that follows our accultured sense of direction (left to right in Western culture).

Use of rules (boxing)

Illustrations, especially those showing realistic physical objects, are easier to look at without a frame. The page also appears lighter and less cluttered. In general, edit out all gratuitous rules.

Rules are most useful when the material is not a picture, but rather a table or other matter that requires reading. Use rules to organize disparate elements that might otherwise float in space or be confused with neighboring material. The decision whether or not to use rules depends upon the situation, as well as the general style of the document as a whole.

If artwork is ruled, use only a half-point rule. The image is the important part, not the rule.

In tables, you can choose from three horizontal rule weights:

_____ Half-point
_____ 1 point
═════════════════════════ 2 points

Graphic placement

The following illustration shows how graphics or tables can be positioned within the scanning and text columns. The guideline is to maintain the integrity of the vertical scanning area (right edge of the scanning column, left edge of the text column) and also the right margin edge.

1. Place a small graphic flush right within the scanning column so it appears to belong to the text to the right (maximum width of the illustration is the total width of the scanning column).

2. Place a graphic that is the same width as the text column flush right and left (justified) within the text column.

3. If the graphic is narrower than the text column, place it flush left within the text column.

4. Limit the width of an illustration to the width of the live matter area.

5. If the graphic is wider than the text column, place it flush right within the text column and let it extend into the scanning column.

The practice of centering

Avoid centering elements within a column or within live matter. Any page element is emphasized when there is a clear contrast between itself and white space. Centered elements become lost below text or within divided areas of white space on either side. It is better to combine white space into one large unit and place it to one side of the element. The contrast of type to white space is emphasized, and the element becomes more visible.

It is also important to repeat the rhythm of returning to the text column edge to read or scan line after line. Faster reading and clearer comprehension result if you don't force the eye to break the vertical scan line to search for floating items.

Use flush left and flush right placement within columns for headings, text, and graphics.

Text

Text is used in illustrations to cross-reference data, to emphasize key points, or to add information not self-evident in the visual element. The following sections contain specifications for text and related elements in graphics, as well as tables.

Illustration titles

Clearly identify each illustration and provide a number for cross-referencing. A visual alternative to titling illustrations is shown in this part of the manual (part 4). We used headings instead of figure titles to identify each grouping of graphics. The headings all appear in the table of contents for reference.

Format Begin with the word "Figure" or "Table" spelled out, with an initial cap, in regular type:

— Followed by Arabic numerals and a period, in regular type

— Followed by a 1-em space

— Followed by the heading in downstyle, in boldface type.

For example:

 Figure 4-1. **Flow chart for payroll application**
 Table 2. **Profit and loss projection, 1978**

Placement Put the title above the illustration or table, flush left in text column.

Note: A title belongs to the figure or table, not the column structure of the page, and needs to be scanned first. Hence, it is placed as the first element to explain the substance of the information beneath.

Callout in text

Reference, or "call out," all figure and table *numbers* in the text. For example:

See table 2 for examples. The flow chart is shown below as figure 4.

Place the illustration or table as close as possible to the text reference. Illustrations and tables may be "sandwiched" between paragraphs or placed at the top of the following page.

Table 4-1 summarizes the specifications for text in graphics and tables.

Table 4-1. **Specifications for text**

Illustration element	Point size, leading, weight, and justification	Capitalization and punctuation	Placement
Figure or table number	10 regular Flush left	Initial cap on ''Figure'' and ''Table'' Period after numeral 2-em space after numeral	Above illustration Flush left within text column
Figure or table title	10/11 bold Flush left, rag right	Downstyle Internal punctuation as needed No end punctuation	Above illustration Flush left within text column or 2-em space after numeral Turnovers align with text above
Number or letter (referring to a legend)	8 bold or regular	All caps No end punctuation	Inside or outside image Thin space* from leader rule Clockwise, on two sides of figure only
Callout	8/8 regular Flush left, rag right	All caps Include essential commas No end punctuation	Thin space* from leader rule Turnovers align with text above
Text (tabular material or flow diagrams)	8 or 10 regular If all caps, set 8/8 or 10/10 If downstyle, set 8/9 or 10/11 Use bold for emphasis Flush left, rag right	All caps or downstyle Punctuate as needed	Flush left, rag right for lines of 150 points or less Flush left and right for longer widths
Column headings	10/11 bold Overscored with 2-point rule cut to width of column beneath	Downstyle	Flush left, rag right on text columns Rag left, flush right on numerical columns
Caption or legend	8/9 or 10/11 regular Flush left, rag right Line length same as illustration	Downstyle Punctuate as needed	Below and flush left with illustration
Leader rule for callouts	1-point continuous (no dots) Vertical or horizontal		Avoid crossing other leader rules. Leave thin white space* on either side of leader where it crosses a solid line. Reverse out when crossing solid area
Arrowhead	Small, not heavy		Use for emphasis
Outline rule around illustration	Half-point		Use only for clarity Avoid boxing
Art control number and credits	6/6	All caps	Flush right below lower right-hand corner of graphic

*Thin space = 2 points

Headers and footers

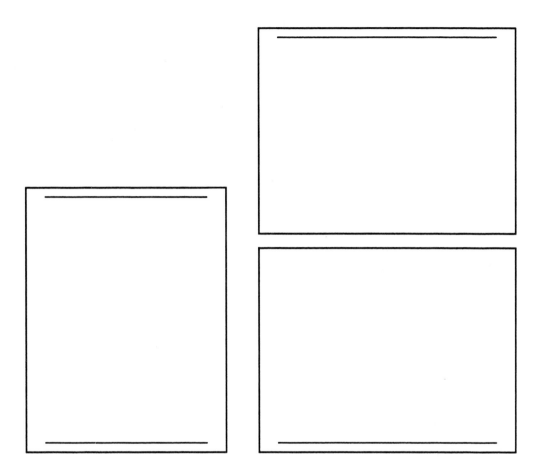

A half-point rule running across the top and bottom of portrait pages defines the correct position for headers, footers, page numbers, and similar reference material. On landscape pages, one rule at each unbound edge saves space for the binding edge. These rules distinctively define the top and bottom of each page. The importance of headers and footers is especially clear on pages without headings and containing only a few lines of information.

Headers and footers appear on all document pages except in the following cases:

1. No header or footer appears on order forms, blank pages, or tab dividers.

2. No header appears with a chapter heading.

3. Only a footer rule appears on title, copyright, and subtitle pages.

Visual specifications for headers and footers follow. For information on the content of headers and footers, refer to part 2, "Document organization."

Header and footer specifications

The following general specifications apply to documents in portrait format. Slight adjustments are made to accommodate landscape orientation.

1. Both the header and the footer are designated by a half-point rule running in the margin above and below the live matter area.

2. Each rule runs the width of the live matter. The rule is 18 points above or below the edge of the live matter.

3. The header and footer text is 8-point type, all capitals, flush with the end of the rule, with 3 points of space between the rule and either the top or the baseline of the type.

4. Allow 3 points of space before other text, such as a draft level, appearing below the baseline of the footer.

5. The page number is always positioned closest to the unbound edge, opposite the footer text.

6. The header text is positioned closest to the unbound edge.

Big and small portrait

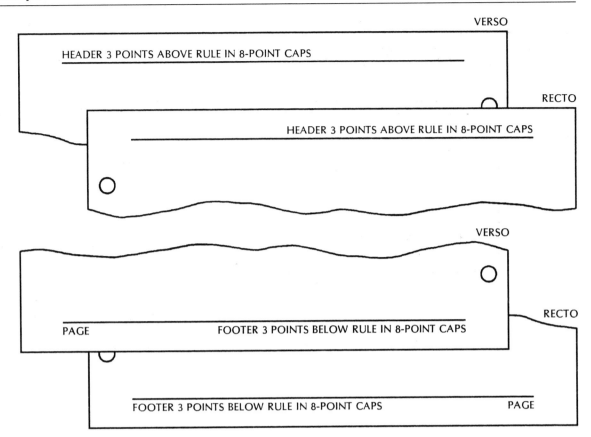

On big and small portrait pages, headers appear above the rule at the top of the page. Footers appear below the rule at the bottom of the page.

Header text: Flush left on verso pages; flush right on recto pages.

Footer text: Flush right on verso pages; flush left on recto pages.

Page number: Flush left on verso pages; flush right on recto pages.

Big landscape

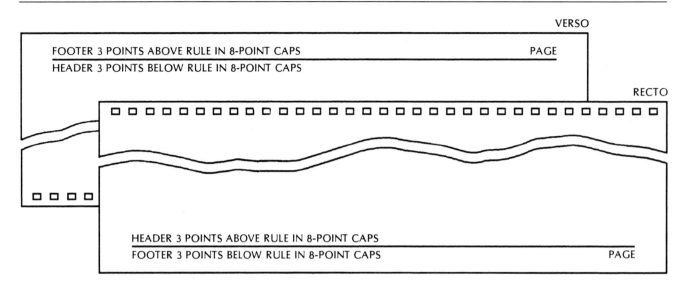

On big landscape pages, the header and footer are combined with one half-point rule at the unbound edge. The header and footer text alternates above and below the rule on recto and verso pages (the footer and the page number are always closest to the unbound edge).

Footer/header text: Flush left at the top on verso pages.

Header/footer text: Flush left at the bottom on recto pages.

Page number: Flush right above the rule on verso pages; flush right below the rule on recto pages.

Small landscape

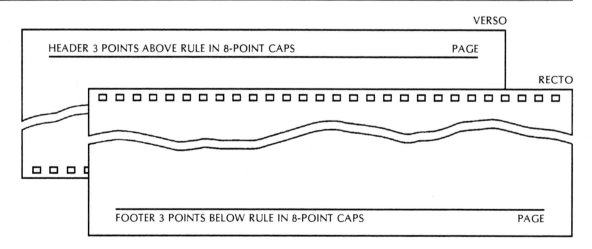

On small landscape pages, only a header appears above the rule on the verso page and only a footer appears below the rule on the recto page, that is, one header and footer per spread.

Header text: Flush left on verso pages.

Footer text: Flush left on recto pages.

Page number: Flush right above the rule on verso pages; flush right below the rule on recto pages.

Heading options

Heading design should include a full range of heading options for chapters, sections, and paragraphs. The placement, size, and blackness of headings reflect the organization of the document.

The two charts on the following pages present the heading options in the Xerox design. The first reduces the heading levels to show the spacing measurements. The second displays the headings exactly as they would appear on a big book portrait page. You would not use all the headings in one document. Some good combinations are suggested for you.

The spacing between headings and text is either two or three times the primary leading and is part of the format. There is a wider space above headings and a narrower space below them to help visually separate topics. The visual logic of each heading level is described in the sections that follow the charts.

All headings are set downstyle, using only an initial capital letter. They may be written as either a phrase or a sentence. They should not, however, exceed a single line in length. Their effectiveness is increased by brevity.

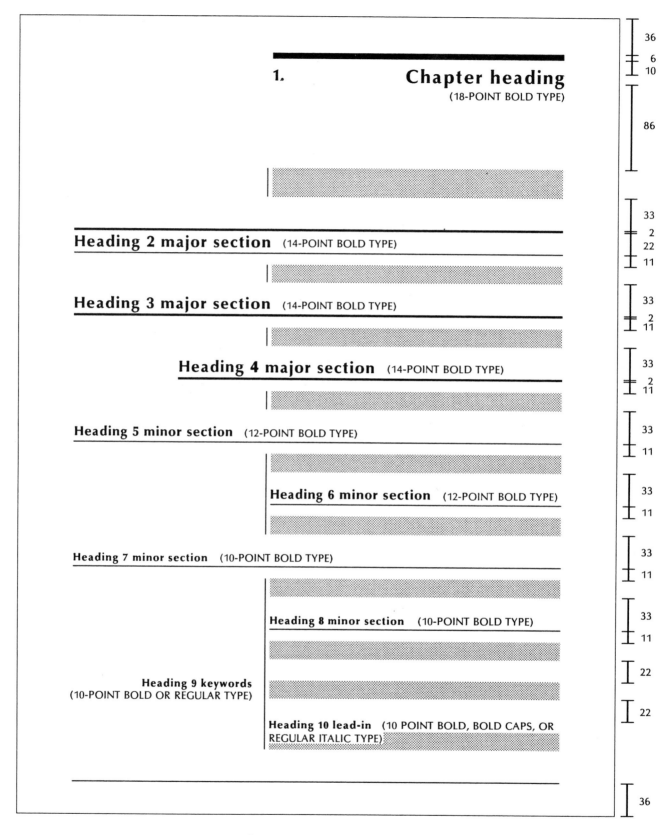

1. **Chapter heading**
(18-POINT BOLD TYPE)

36
6
10
86

Heading 2 major section (14-POINT BOLD TYPE)

33
2
22
11

Heading 3 major section (14-POINT BOLD TYPE)

33
2
11

Heading 4 major section (14-POINT BOLD TYPE)

33
2
11

Heading 5 minor section (12-POINT BOLD TYPE)

33
11

Heading 6 minor section (12-POINT BOLD TYPE)

33
11

Heading 7 minor section (10-POINT BOLD TYPE)

33
11

Heading 8 minor section (10-POINT BOLD TYPE)

33
11

22

Heading 9 keywords
(10-POINT BOLD OR REGULAR TYPE)

22

Heading 10 lead-in (10 POINT BOLD, BOLD CAPS, OR
REGULAR ITALIC TYPE)

36

The headings above have been reduced by 24 percent.

The opposite page is a full-page representation of all heading levels.

1. Chapter heading

A recto page must be used for this heading. The type is 18-point bold, set under a 6-point rule. The number is flush left within the text column, the chapter title flush right at the margin.

Heading 2 (14-point bold type) major section

This heading is 14-point bold, set under a 2-point rule and over a half-point rule. The heading text is flush left at the margin.

Heading 3 (14-point bold type) major section

This heading is 14-point bold, set over a 2-point rule and flush left at the margin.

Heading 4 (14-point bold type) major section

This heading is 14-point bold, set over a 2-point rule, indented 108 points from the left margin.

Heading 5 (12-point bold type) minor section

This heading is 12-point bold, set over a half-point rule and flush left at the margin.

Heading 6 (12-point bold type) minor section

This heading is 12-point bold, set over a half-point rule and flush left within the text column.

Heading 7 (10-point bold type) minor section

This heading is 10-point bold, set over a half-point rule and flush left at the margin.

Heading 8 (10-point bold type) minor section

This heading is 10-point bold, set over a half-point rule and flush left within the text column.

**Heading 9 keywords
(10-point bold or** regular type) This heading is 10-point bold or regular, set flush right within the scanning column. The first line of the heading and the text should align.

Heading 10 lead-in (10-point bold, BOLD CAPS, or *regular italics*). Punctuation following a lead-in may be a period, a colon, or a dash.

Visual logic of the heading options

Chapter heading: level 1

The headings defining the largest blocks of information in a document or within a part of a document are chapter headings.

The name of the chapter and its accompanying 6-point rule preempts the space at the top of the page and replaces the header and its accompanying header rule.

Major section headings: levels 2, 3, and 4 (select one)

Signaling the subdivision of a chapter into its major topics, highly visible major section headings stand out in the scanning column at left in large, 14-point bold type.

Ruled lines add the intensity of blackness and also anchor the heading to the text in the text column at right.

The highest level (level 2) encloses the wording between two rules. The next lower level (level 3) underscores the wording with a single rule. The next lower level (level 4) is indented from the left margin by 108 points.

Minor section headings: levels 5, 6, 7, and 8 (select one or two)

At a degree of importance lower than the preceding major headings are several ranks of minor section headings. The first two levels (5 and 6) are set in a smaller type size (12-point bold) and are underscored by a half-point rule. Level 5 extends to the full live matter width; level 6 is flush left within the text column.

The next two levels (7 and 8) are another degree down the scale of visual importance by virtue of their smaller type size (10-point bold). Ten-point bold is not highly visible on the page, unless it is placed in a swath of white space at the left (level 7).

Level 8 differs from the preceding heading (level 7) only in its placement: flush left within the text column. Its visibility depends on the white space above it, so it is essential that a full 33 points of space between the text and the rule be provided.

Keywords and lead-ins: levels 9 and 10 (use freely)

Level 9 keywords are placed in the scanning column throughout a document. They can be either 10-point bold or regular.

As a paragraph lead-in, level 10 provides emphasis in bold, bold caps, or regular italics.

Headings for other page sizes and orientations

The heading options for small books, landscape, or multicolumn pages are almost identical to those for the big book portrait. The rules are longer (or shorter) to accommodate the different column widths of the page. All the common-sense suggestions outlined for portrait headings apply to landscape headings.

Selection of headings

Although the range of available options is wide, avoid using more than three or four levels of headings in any one document. Subtle hierarchies of rank are not essential to the reader and serve merely to confuse. The following list suggests four possible groupings.

When selecting headings, keep type size in mind. The lowest level of heading should be at least the same point size as the text. If the body copy is 12-point type, for example, you would not want to use a 10-point heading.

Group 1 | Levels 1, 2, 5, 8, 9

Group 2 | Levels 1, 3, 6, 9, 10

Group 3 | Levels 1, 2, 4, 8, 9

Group 4 | Levels 1, 3, 7, 9, 10

Headings should represent a logical hierarchy. Ideally, as in an outline, there should be at least two headings of the same level to provide for solid and parallel structure. For example, each first-level heading should be followed by at least two second-level headings, each second-level heading should be followed by at least two third-level headings, and so forth.

Don't, however, let a strict hierarchy prevent you from freely using minor headings, keywords, and lead-ins to vary the texture and visually clarify the text.

1.1.1 MIL-SPEC numbering in headings

This heading is an example of a numbered heading. Set the number in regular type, one size smaller than the bolded text, as shown in the heading for this section. Your eyes travel directly to the substance of the heading, without being pulled to the number—unless the number is being searched for (in which case it is available).

Placing and spacing elements on the page

This chapter presents the rationale and guidelines for spacing text and graphic elements. By applying good design principles, you can create visibility and movement on the page, which makes the document easier to comprehend. The reader depends on spatial relationships to distinguish the organization of information. The most important factor is the consistency of spacing between items, for it establishes rhythm and visual relationships that are fundamental to recognition.

Most spacing patterns in the Xerox design are automatic. For example, the principle of comparative closeness defines the normal space above and beneath headings. The wider space above each heading helps separate it from the previous topic. The narrower space below each heading connects it to the material that follows. The same rationale applies to other elements placed on the page.

In general, you want to let your system software do as much of your composition work as possible. You want to avoid the manual placement of elements, including space. Sometimes, however, you must edit spatial relationships to visually guide the reader or to make information clearer.

The sections that follow discuss "ideal" spacing patterns in documents using body copy with 10/11 type size and leading. The specified points refer to the space that a ruler would measure if placed over a printed page. They do not refer to the measurements required in the computer to produce the visual effect.

Although your particular software may not be able to achieve ideal measurements in every case, the principles behind the spacing patterns still apply. The term "illustration" here refers to both graphics (figures) and tables.

Fixed spacing patterns

Place the first element on the page flush with the top of the live matter area. You may, however, leave any amount of space below the copy and above the footer. There is no need to spread out page elements to fill up, or "bottom out," the page.

The spacing in the running text and around the headings is fixed. Patterns of 11, 17, 18, 22, and 33 points of space occur regularly on the page.

Use 11 points of space

— From the rule in heading levels 2 through 8 to the top of the next element

— Between the closest related elements of an illustration:

Two pieces of art that belong together
Text and illustrations that belong together.

Use 17 points of space

— From the baseline of running text to the top of an illustration title

— From the baseline of running text to the top of an untitled illustration (such as the rules over a table)

— From the baseline of an illustration to the top of running text.

Use 18 points of space

— From the header rule to the top of the first element on the page

— As the minimum space between the last item on the page to the footer rule.

Use 22 points of space

— From the baseline of text or an illustration to the top of heading levels 9 and 10.

Use 33 points of space

— From the baseline of text or an illustration to the rule in heading levels 2 through 8.

Editorial spacing

The spacing around some visual elements is flexible to allow for the appropriate editing of space. Lay out elements to show clear relationships between and among text and illustrations. Use distance to create separation; use closeness to create the effect of belonging together.

Edit spacing consistently within a document. Use multiples of the primary leading (1, 1.5, 2, or 3 times) as vertical editorial space.

Use 11, 17, 22, or 33 points of vertical space (leading)

— Between an illustration title and the illustration

— Between an illustration (including text) and the next page element, specifically:

17 if text
22 if heading level 9 or 10
33 if heading levels 2 through 8

— Between conceptual units in an illustration.

Use 12 or 18 points of horizontal space

— As a gutter between columns

— Between conceptual units within an illustration.

Special spacing problems

If a heading falls at the top of the page, eliminate the space above the heading and place the heading flush with the top of the live matter area.

Between two consecutive ruled headings, add one additional primary lead to the normal spacing of the second heading.

If one or two lines of isolated text appear at the top of a page:

1. Edit the copy so that the lines move back to the previous page, or

2. Force the entire paragraph to the top of the new page.

If a section begins at the foot of a page, followed by only two or three lines of isolated text, move the entire section with its heading to the top of the next page. If you move a section to a new page for clarity, allow any extra space left on the previous page to fall naturally at the foot of the page.

Special pages

Certain pages in a document are especially important and require special design attention. These include the title, subtitle, and copyright pages, table of contents, glossary, index, and bibliography. Make sure these pages contain the standard content information outlined in part 2. Then work with the page layout options and guidelines in part 4. It helps to look in other books for ideas on how to best design these pages for your content.

Title page

All title pages are recto pages. It is important that titles stand out. The title pages in Xerox documents have the following specifications:

- A 6-point horizontal rule runs across the top of the page.

- A 24-point (large) logo is placed at upper right, above the rule.

- The complete document title in 24-point bold is placed 10 points under the rule, flush left in the live matter, upstyle.

- The version number and identification number are set in 10-point regular, flush left with the live matter, at lower left.

- A half-point footer rule 504 points long is placed 36 points from the page bottom.

- The page number "i" is not printed on the page.

- An optional graphic, maximum width of 504 points, can be placed flush left, 86 points or less below the last line of the title (place more space below the graphic than above).

- The draft level appears in 24-point type, flush left, in the middle of the page.

- The paper stock is 110- to 125-pound, white or light gray (optional).

Copyright page

The copyright page is always the verso of the title page.

- The text is placed at the foot of the page to the extreme left in 8-point type.

- The line length is 315 points.

- The page number "ii" is not printed on the page.

Table of contents

The table of contents lists the headings used in the publication and gives the pages where they can be found. The typography and placement of the elements on the page should mirror the hierarchy of material in the document.

- Use combinations of the heading levels to design the page.

- All headings are downstyle.

- Part subtitles, if any, are listed.

- Show part subtitles and chapter headings in boldface; show section headings in regular. Incorporate type-size modifications and use indenting as necessary.

- Place the word "Appendices" at the highest heading level. List each appendix by its uppercase letter, with the accompanying heading at the next level indent.

- List all back matter elements.

- Lists of figures and tables are optional.

Subtitle pages

The highest level identifiers for the largest blocks of information or parts in a document are subtitle pages. They can also be used as break pages in lengthy documents.

The specifications are the same as for the title page, except no logo, version number, or identification number appears.

Appendices

Appendices are intended as reference material. Pay close attention to clarity and brevity of content.

- Begin each new appendix with a chapter-level heading.

- Identify each appendix by a capital letter and its title.

- Format each appendix with the selected heading levels that were used in the rest of the document.

- Set the text in the same point size as the normal body copy.

- Place multiple appendices in the same order in which they are referred to in the document text.

Glossary

The glossary is a quick-reference tool, designed for ease of use.

- Begin the glossary with a chapter-level heading.

- Format the alphabetized sections with a selected heading option.

- It is recommended that the entry words be specified as heading level 9 (keywords), which are placed visibly in the scan column.

- Set the entries downstyle, in the same point size as the normal body copy.

- Glossaries of only a dozen or fewer entries may be included in the introduction.

- Present the entries in parallel grammatical structure.

Bibliography

Publications often refer to supplementary materials, either as resources or as sources of more information.

- Begin the bibliography with a chapter-level heading.

- Organize all entries consistently in standard bibliography format.

- Set the text within the single text column in the same point size as the normal body copy.

- Indent all lines following the first line of each entry and leave a blank space between each entry.

- Alphabetize but don't number the entries.

- Set titles in italic.

Index

The index, a vital document element meant for frequent and easy reference, is set in the same point size as the normal body copy. This indicates that the index is just as important as the text to which it refers.

Index pages take a chapter-level heading and use a two- or three-column format. Lowercase all entries.

Response/order form

This is the last page in the document. It is designated for customer return by mail. The paper stock is 110- to 125-pound, white or light gray (optional).

Blank pages

Blank pages often occur before chapters that start on a recto page. Print nothing on blank verso pages.

Classified pages

All pages in a document considered to be confidential or controlled by government specification must be visually numbered, classified with the appropriate markings, and secured. On blank classified verso pages, print the usual header and footer elements and the classified markings. Vertically and horizontally center the statement THIS PAGE INTENTIONALLY BLANK in 10-point all caps within the live matter.

Tabs

The use of tabs is optional, depending on the size and requirements of the publication. Die-cut tabs add expense to a document and require hand insertion. Bleed tabs without text do not add expense, but provide less physical accessibility. When tabs are used, the Xerox specifications are as follows.

Die-cut tabs

Tab paper size	8-1/2 by 11 inches (excluding the actual tab) 5-1/2 by 8-1/2 inches (excluding the actual tab)
Tab paper stock	125-pound white or warm white ledger Dull or matte finish
Tab coating	Plain or Mylar; front side only
Mylar color	Clear or gray (PMS 422C coordinated)
Tab print color	Black
Typeface	Optima
Text orientation	Portrait document—reading in, toward binding edge Landscape document—reading out, away from binding edge
Position of type	Centered, reading in Numbered if referring to numbered section
Printing method	Offset
Depth of tab	1/2 inch
Length of tab	Varies according to document size and number of sections

Bleed tabs

Ink color	Black, text reverses out
Placement	Unbound edge Should not interfere with text

The standard binding options for customer documentation include:

— Loose-leaf binders

— Wire-O binding

— Perfect binding

— Saddle-stitch binding.

Binding selection is based on document page size, thickness, updating requirements, and how the document will be used and shelved by the reader. Because most product documentation is frequently revised, it is packaged in loose-leaf binders. Guidelines for selecting bindings are listed below. The following sections contain Xerox specifications for each binding option.

Loose-leaf binder with open-lip vinyl covering. Cover and spine inserts.

Loose-leaf binder with slip-case. Cloth covering.

Wire-O

Perfect

Saddle stitch

Guidelines for binding selection

Document thickness (inches)*	Page size and orientation	Binding option	Rationale
1, 1-1/2	Big or small, portrait only	Loose-leaf binder	Can be updated. Tends to be bulky. Rings pop when overstuffed. Large footprint.
1/4 to 3/4	Big or small, portrait or landscape	Wire-O	Difficult to update. Easy to use open flat or folded in half.
0 to 1/2	Big or small, portrait only	Perfect	Cannot be updated. Does not stay open.
0 to 1/4	Big or small, portrait only	Saddle stitch	Cannot be updated. Not durable.

*Thickness in terms of numbers of pages is dependent on paper thickness, weight, and bulk.

Loose-leaf binders

Rings

Type	D straight, Koloman Handler (or equivalent); 1 or 1-1/2 inches
Number	Three rings U.S.; four rings ISO
Location	Inside back cover
Rivets	Exposed chrome
Drill hole size and position	5/16 inch; 1/4 inch from paper edge to left side of hole (varies with document size)
Sheet lifter	Option

Covering options

Premium	B-cloth
Alternates	Type II reinforced paper (B-cloth equivalent) Vinyl with cover and spine inserts
	The following sections describe specifications for covering options.

B-cloth loose-leaf binders

Size and board	Big book: 11-1/2 by 10-1/2 inches; 140-pound test chipboard Small book: 9 by 8 inches; 100-pound test chipboard
Cover material	Joanna Mills Arrestox "B" 11350 gray (or equivalent); match PMS 422C gray
Lining	80-pound Kraft liner as one piece, black
Ring placement and booster	Big book: 4-1/4 inches center to center with optional booster Small book: 2-3/4 inches center to center, no booster
Print method	Silkscreen

Type II reinforced paper loose-leaf binders

Size and board	Same as B-cloth binders
Cover material	Kivar 9 (or equivalent)
Lining	Same as B-cloth binders
Ring placement and booster	Same as B-cloth binders
Print method	Offset

Vinyl insert loose-leaf binders

Size and board	Big book: 11-1/2 by 10-1/2 inches; 140-pound test chipboard Small book: 9 by 8 inches; 100-pound test chipboard
Cover material	Gray gane, 4590 shoe kid, 0.08 clear vinyl, open lip overlay (or equivalent); match PMS 422C gray
Lining	Same as cover material; nonmigratory to Xerox toner
Ring placement and booster	Big book: 4-1/4 inches center to center with optional booster Small book: 2-3/4 inches center to center, no booster
Print method	Top loading cover and spine inserts only, offset
Insert stock	Coated finish, 90 to 100 pounds

Wire-O binding

Wire color	Silver
Drill hole size and position	Square

Perfect binding

Cover	One piece

Saddle-stitch binding

Staple	Twice, fold center

Packaging accessories

There must be a coordinated design for the covers, slipcase, accessories (such as tray, diskette, label, and shipping packaging).

Slipcases

Slipcases are a packaging option for holding documents and software accessories. Slipcases require considerable purchasing lead time.

Size	Determined by the thickness and size of the contents
Board	Big book: 100-pound or less test chipboard Small book: 80-pound test chipboard
Cover material	Same as B-cloth binder; match binder that goes inside
Print method	Silkscreen; match binder that goes inside

Paper for text pages

Paper for product documentation pages is specified for electronic printers and for offset press.

Electronic printers

Weight	Standard: 60 pounds Alternate: 50 to 70 pounds
Coating classification	No. 3 coating or better
Brightness/color	White or warm white, 80 ±2 Spec consistent color across mill loads
Texture	Smooth or semismooth
Finish	Dull or matte
Opacity	92 (no show-through)

Offset or litho press

Weight	Standard: 60 pounds Alternate: 50 to 70 pounds
Coating classification	No. 1 coating or better
Brightness/color	White or warm white
Texture	Smooth or semismooth
Finish	Dull or matte
Opacity	92 (no show-through)

Ink for text pages

Color	Black only
Toxicity	No lead

A standard cover design should be used on all customer documentation. Exact layout specifications may vary depending on the type of binding used on the document. This chapter details the elements in Xerox document covers.

Cover content and organization (anatomy)

The cover on Xerox publications is designed for visual recognition from a distance. Depending on the binding, covers consist of front, spine, and/or back. The following illustration identifies the 16 items that appear on each.

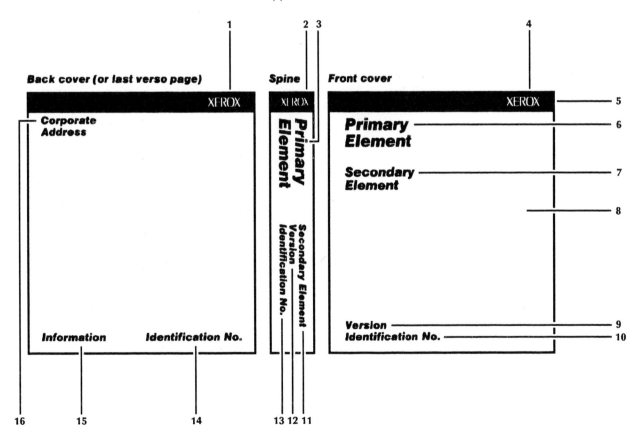

Xerox logotype (1,2,4) | Place the Xerox logotype to the right in the feature stripe on the cover front, spine, and back. The logo is white, reversed out or printed. If binder rivets interfere with the logo on the back, the logo may be placed to the left (on cover and back only). Eliminate the logo on perfect-bound spines under 1/2 inch.

Feature stripe (5) | The feature stripe is PMS 485 red.

Background color (8)	The cover color is PMS 422 gray. All type prints black.
Primary element of title, front (6)	Place the Xerox product name in the primary title position. If the product is a number or software name, precede the title with the word "Xerox" (Xerox 4045 Laser CP, Xerox ViewPoint). Do not add "Xerox" to initialisms or acronyms beginning with "X" (XPS 700, XICS). Trademark symbols (®, ™) are not required on product names on the covers.
Primary element of title, spine (3)	Repeat the primary element as selected in number 6 on the spine. Keep the word "Xerox" in the product name on perfect-bound spines too narrow for the logo. Eliminate "Xerox" in front of product numerals ("Xerox 8700 Laser Printing System" on front cover, but only "8700" on spine).
Secondary element of title, front and spine (7,11)	When a product name is used as the primary title, place the document title in the secondary position on the front and the spine.
Version, front and spine (9,12)	This is an optional item to identify the document version, volume, edition, software release, revision level series, or date. The number may appear on the front cover or on the front and spine, but not on the spine alone. Do not include the word "No." in the phrase (Version 5, Release 10.1, Edition 1). Use "Edition 2" rather than "Second Edition."
Publication identification number (10,13,14)	Every document should be identified by a unique number. It may be placed on the front, spine, and/or back for ordering, manufacturing, or inventory purposes. This number must appear on the title page but is optional on the cover. Do not include "No." in the phrase.
Other information, back (15)	Place brief trademark information, change notice, print location, copyright date, and other information on the back cover as shown here:

> Xerox® and all Xerox products mentioned in this publication are trademarks of Xerox Corporation.
>
> Product appearance and/or specifications subject to change without notice. Printed in U.S.A. 4/87

If there is no printed back cover, you may place back cover information on the last verso page in the text typeface.

Corporate address, back (16)	A corporate address should appear on the back cover as follows:

Xerox Corporation	Corporation (not business unit or division names)
Customer Documents	Ordering point for the document (optional)
701 South Aviation Boulevard	Central mail room
ESXC-123	Building code—mail stop
213-123-4567	Outside phone (optional)
El Segundo, CA 90245	City, state, zip code

Cover art specifications

Typeface

Black type, which varies in size according to line length and spine width, is set solid, flush left, upstyle.

Primary and secondary title elements: Mergenthaler Helvetica Black Italic or comparable typeface. Other manufactured fonts may be referred to as Triumvirate Black Italic or Helvetica Bold Italic.

Version, identification number, and back cover information: Helvetica Regular Italic

Color

PMS 485 red color stripe
PMS 422 gray background
White printed or reversed-out logo
Black type

Spine

Spine widths vary. Pay careful attention to the placement and type size on the spine. It is the most visible element on the customer's shelf.

Cover print quality based on premium category

Register	Three-color process, no apparent variation
Ink density	Across the sheet: uniform Sheet to sheet and throughout the run: no apparent variation
Large solids	Dense, even, no mottling or ghosts
Flaws	Few hickeys, no other flaws such as scumming, set offs, smudges, or wrinkles
Trimming	Trims square, occasional ±1/64 inch
Folding	Accuracy: single folds vary 1/32 inch Alignment: Rarely crooked

Master cover art

Detailed specifications for individual covers are distributed directly to design groups in all Xerox locations. Camera-ready templates are available for the following formats.

Big book portrait, open-lip vinyl *loose-leaf binder*, cover and spine inserts (format 1a for 1-Inch D-ring; format 1b for 1-1/2 inch D-ring)

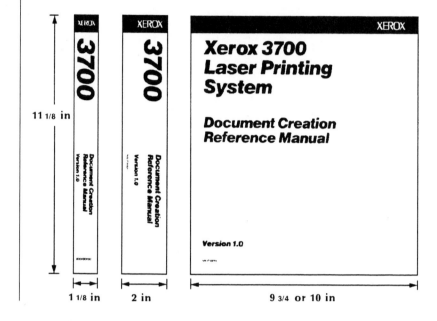

Small book portrait, cloth *loose-leaf binder* (format 3)

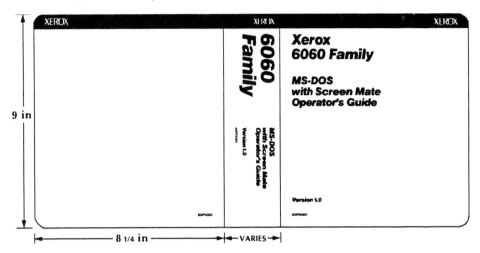

Slipcase for small book loose-leaf binder (format 4)

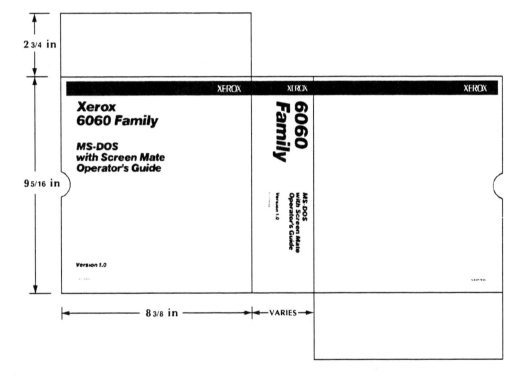

Big book portrait, *Wire-O* binding (format 9)

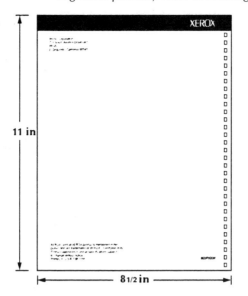

Small book portrait, *Wire-O* binding (format 11)

Big book landscape, *Wire-O* binding (format 10)

Small book landscape, *Wire-O* binding (format 12)

Big book portrait, *perfect* binding (format 5)

Small book portrait, *perfect* binding (format 6)

Big book portrait, *saddle-stitch* binding (format 7)

11 in

8 1/2 in

Small book portrait, *saddle-stitch* binding (format 8)

8 1/2 in

5 1/2 in

Appendices

A. Xerox document categories and contents

Xerox, like many corporations, produces thousands of documents annually and employs as many people in the publishing process as a commercial publisher. Some kind of publication is prepared and issued by virtually every group, division, business unit, and department within the company. A business systems product, for example, may require hundreds of reference, training, and marketing publications to support its use by customers.

Appendix A is a comprehensive list of the major types of program and product documentation produced at Xerox. The list is useful as a model for identifying, categorizing, and planning the content of similar publications. As part of a Publishing Standards Program, various task forces throughout the Xerox Corporation have been standardizing these publications for the company.

The list establishes general subject elements in checklist format to assist managers and staffs in producing complete and well-organized documents. The list:

— Classifies documents by type and purpose

— Describes their audiences

— Outlines their contents

— Identifies who prepares and approves them for publication.

The specific content for each publication is determined individually by the particular needs it must serve:

— Informational requirements of the particular audience

— Audience sophistication in the subject matter and capability to understand

— Conditions under which the information will be read and used.

Publication types and objectives

Xerox documentation is grouped into five categories reflecting the company's method of organizing documentation programs:

— Management planning/control

— Marketing/sales

— Applications/support

— Reference

— Training.

The categories and the publications within them are related in a hierarchy of information flow (see Figure A-1).

Table A-1 summarizes publications under the five major categories. The table indicates whether scheduling and budget forecasts should be made and whether the document user is internal or a customer.

Figure A-1. **Xerox publication categories**

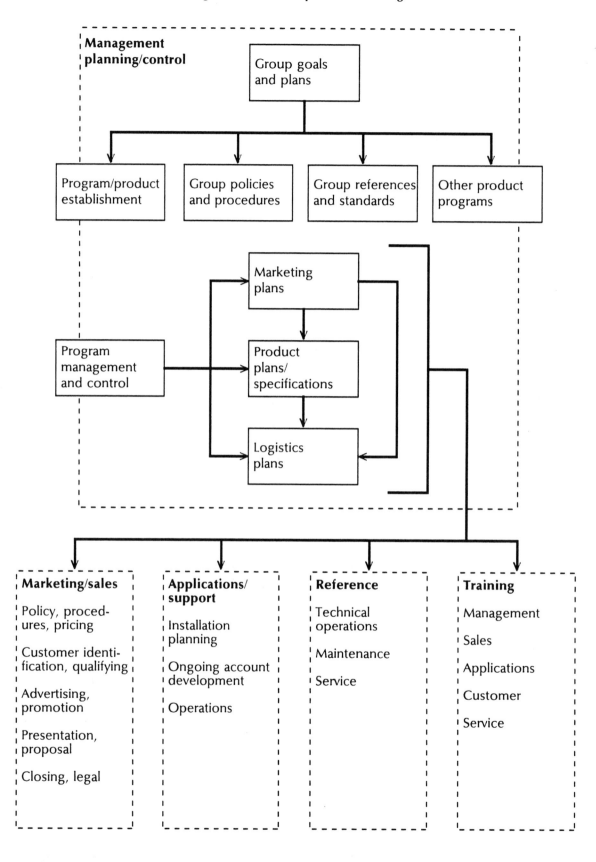

Table A-1. Publications reference list

Publication	Exec. mgmt. approval	Program planning	Budget/ Schedule	Internal users	Customer users
Management planning/control					
Group/division level					
Business opportunity proposal	X	–	–	X	–
Product goals	X	–	–	X	–
System requirements specification	X	X	–	X	–
Product business proposal	X	X	–	X	–
Product program life plan	–	X	–	X	–
Design disclosure	–	X	–	X	–
Support plans	–	X	–	X	–
Launch plan	–	X	–	X	–
Performance assessment report	–	X	–	X	–
Discontinuance plan	–	X	–	X	–
References/standards	–	X	–	X	–
Policies/procedures	–	X	–	X	–
Product planning/development					
Marketing plan	X	X	–	X	–
Product delivery requirements	X	X	–	X	–
Hardware specification	X	X	–	X	–
Functional specification	X	X	–	X	–
Documentation planning and control					
Document design/writing specification	X	X		X	
Printing and media production specification	X	X		X	
Marketing/sales					
Sales guides					
Sales manual	–	X	X	X	–
Prospect data/information lists	–	X	X	X	X
Account profile	–	X	X	X	–
Brochures/general information digest	–	X	X	X	X
Direct mail piece	–	X	X	X	X
Qualifying/info gathering tools					
Application brief	–	X	X	–	X
Product description	–	X	X	–	X
Product fit questionnaire	–	X	X	X	–
Configurator	–	X	X	X	–
Value analysis questionnaire	–	X	X	X	–
Data sheet	–	X	X	X	X
Presentation/proposal tools					
Demonstration kit	–	X	X	X	–
Presentation kit	–	X	X	X	–
Proposal kit	–	X	X	X	–
Closing tools	–	X	X	X	–
Follow-up tools					
Installation checklists	–	X	X	X	–
Account management forms	–	X	X	X	–
Informational publication	–	X	X	X	–

Table A-1. **Publications reference list (continued)**

Publication	Exec. mgmt. approval	Program planning	Budget/ Schedule	Internal users	Customer users
Applications/support					
Installation planning					
Installation planning guide	–	–	X	X	X
Installation manual	–	–	X	X	–
Delivery/removal guide	–	–	X	X	–
Ongoing account development					
Operations guide	–	–	X	–	X
Application guide	–	–	X	–	X
Language application guide	–	–	X	–	X
Operations					
Operations manual	–	–	X	–	X
Job aids/reference cards	–	–	X	X	X
Reference					
Operations					
Hardware reference manual	–	–	X	X	X
Software reference manual	–	–	X	X	X
Service					
Functional manual	–	–	X	X	–
Service manual	–	–	X	X	–
Training					
Sales personnel					
Product and application training	–	X	X	X	–
Sales training	–	X	X	X	–
Systems analysis training	–	X	X	X	–
Technical service					
Systems support training	–	X	X	X	–
Systems management training	–	X	X	X	–
Customer					
Start-up operations training	–	X	X	X	X
Advanced operations training	–	X	X	X	X

Management planning/control

Corporate goals and plans initiate and govern the direction of program and product proposals, plans, and specifications. These documents guide company operations. Group-wide policies, procedures, standards, and reference information are also issued at this level.

At the program/product level, two types of publications are required—documents that present opportunities and proposals and documents that present the detailed plans and specifications for proposals that are accepted. All of these documents are used intimately in the decision-making process and, once published, become the basis for subsequent decisions, activities, and management review and control.

Marketing/sales

Marketing and sales publications assist in getting orders from customers. Some are for internal use; some, for customers. Some materials in the presentation and promotion areas, instead of being printed, are in audiovisual or other media forms.

Applications/support

Applications and support documentation assists operating personnel in installing, organizing, and starting up product operations for customers. These documents are closely allied with training, picking up where formal education activities leave off. In particular, they assist customers in customizing and adapting a product's capabilities to their specific needs.

Reference

Reference publications provide the in-depth information required to use, maintain, and repair products.

Training

Materials in this group assist in the formal education, often in classroom situations, of customer and company personnel. All areas of knowledge are covered, from management, sales, and marketing to applications, maintenance, and service.

Management planning/control

Group/division level publications

This section provides standards for group and division level management publications. These publications become the foundation for all other documentation.

Business opportunity proposal

Purpose

Primary: Information. Used to screen new ideas for best choices to meet business objectives and allocate resources.

Secondary: Motivation. Encourages entrepreneurial spirit by proposing ideas for alternative methods of accomplishing division goals.

Users

Primary: Division headquarters strategic business unit and business planning managers

Secondary: Division headquarters executive management

Typical contents

Market opportunity:

- Summary statement

 — Perceived window
 Market segmentation
 Coverages
 Products systems areas
 — Relationship to existing product/business area strategies
 — Evidence and analysis of need
 — Candidate alternatives
 — Critical determinants for meeting opportunity (eg, timing, features, performance, price, placements, and product mix)

- Current market scenario

 — Performance in target or boundary areas (as applicable)
 Market segment
 Coverage
 Product
 Price
 Activity (sale or lease)
 Revenue contribution
 Service/administration/distribution
 — Competitive scenario
 Reference products/producers
 Presence in opportunity targets or boundary areas
 Perceived present and future strategies
 Current strengths and weaknesses in responding to division opportunity case

- Division resource impact

 — Required technologies (eg, extent of development of new technologies, new design, original equipment manufacturer applications, software development, etc)
 — Timing of introduction/life of opportunity
 — Degree of functional manufacturing/supplier involvement (general estimate)
 — Approximate division dollar investment

- Best/worst case expectations

 — Revenue/profit
 — Opportunity/life
 — Competitive edge
 — Impact/effect on current division products

Technical opportunity:

- Problem definition

 — Evidence/perceptions of problem/technical opportunity
 — Analysis of evidence
 — Problem alternative/opportunity case

- Current state of the art

 — Current performance
 — Design/operations practice
 — Reliability (history and growth)
 — Maintainability
 — Service cost profile
 — Logistics factors

- Technological opportunities

 — Technological projections
 — Alternative solutions and their technological content, cost and time (general estimate)

- Division resource impact

- Recommended alternative

 — Technologies to be pursued
 — Technology goals
 — Design/performance goals to surpass current state of the art

Notes A business opportunity proposal allows management to evaluate opportunities. Only approved proposals will require additional documentation.

Product goals

Purpose **Primary:** Information. Identifies marketplace environment and opportunity; describes hardware/software/application approach; recommends strategic approach to that market. Provides basis for preparation of "system requirements specification" and all supporting functional product program strategies. Provides partial basis for listing of program's critical planning assumptions.

Secondary: Motivation. Ensures clear communication of specific product goals.

Users **Primary:** Management, planning, and division headquarters executive management

Secondary: Executive management

Typical contents
- Introduction

 — Scope (summary of purpose and contents)
 — References

- Market environment

> — Market definition
>> Segmentation/characterization
>> Buyer motivation
>> Profiles
>> Competition
>> Market scoping (industry level)
>> Special OEM markets/requirements
> — Market positioning
>> Specific market need(s) and segment(s)
>> Division plan to satisfy needs
>> Uniqueness of division plan
> — Marketing strategy
>> Merchandising plan
>> Distribution plan
> — Product strategy
>> Architecture/capabilities and features to satisfy market needs/positioning strategy
>> Distribution channel summary
>> Applications

- Product requirements

 — Hardware requirements (components)
 — Software requirements (features/description)
 — Interface requirements (peripherals, special features)
 — Configuration/option summary

- Performance requirements/human factors objectives

 — Key parameters
 — User responses
 — Functional elements

- Reliability, maintainability, availability requirements

 — Reliability/maintainability objectives
 — Maintenance philosophy
 — Availability requirements
 — Product user profiles
 — Environment

- Multinational requirements

- Environmental product safety requirements

 — Compliance standards

- Unit pricing and forecasts

 — Targets
 — Pricing/margin assumptions
 — Forecast/estimate

- Market entry

 — Introduction timing for initial machine observation
 — Configuration/options/features availability
 Timing/location scoping

- Product and economic life

 — Product life
 — Economic life
 — End of life scoping

- Future considerations

 — Other items yet to be determined

- Appendix
 - Provides details/additional information/references, as appropriate.

System requirements specification

Primary: Information. Describes selected product architectural approach. Provides the basis for subsequent design, test, and product development.

Secondary: Motivation. Provides basis for integrated product development and planning across all participating functions and operating units.

Users

Primary: Division headquarters engineering

Secondary: Division headquarters management

Typical contents

- Technical proposal
- Final design concept
 - Function
 - Features
 - Performance
- Operating environments
- Specification change notice control or configuration management
- System performance demonstrations
- Functional specification issued

Product business proposal

Purpose

Primary: Information. Identifies marketplace opportunity and strategic approach. Describes program scope, costs, schedules, primary tasks, participating divisions and operating units, and approximate financial opportunity.

Secondary: Motivation. When approved, provides vehicle for communication of proposed product goals, program plans, and opportunities plans.

Users

Primary: Division headquarters management and program team

Secondary: Headquarters executive management (information only)

Typical contents

- Introduction
 - Purpose and scope of proposal
 - Management decision and/or action requested

- Overview
 - Program summary
 - Description/features
 - Objectives/priorities
 - Simple sketches, line drawings (if available)
 - Summary comparisons with existing/competitive products
 - Reference to systems requirements specification and program goals document

- Strategy
 - Summarize product/system strategy
 - Fit within division, overall group strategy
 - Product positioning
 - Impact on existing or other products
 - Manufacturing forecast summary (worldwide)
 - Marketing strategy
 - Summary of other functional strategies

- Integrated planning baseline
 - Summary chart
 - Program schedule/future reviews
 - Key activities (functional/operating units)
 - Summary narrative interpreting key dates, activities, and confidence level for achievement

- Risks and issues
 - Assessment of program risks, issues, and planned actions

- Functional status
 - Functional assessment (by each functional program manager)
 - Status
 - Issues/risks/actions (not previously identified)

- Multinational status
 - Operating unit assessment (by each operating unit representative)
 - Status
 - Issues/risks/actions (not previously identified)

- Financial summary
 - Minimum set of financial exhibits
 - Key indicators summary
 - Annualized volumes
 - Annualized profit (loss)—program life
 - Annualized cash—program life
 - Program acquisition spending
 - Unit revenue/unit cost/gross margin
 - Incremental analysis
 - Reconciliation

- Transfer criteria assessment
 - Summary of transfer criteria not completed
 - Statement of completion for all other transfer criteria identified in prior proposal
 - Summary of key criteria for next stage transfer

- Opportunities
 - Summary of profit, cost, and upgrade opportunities not included in program plan

- Program recommendation

Notes	The product business proposal must be thorough and comprehensive because it is the basis for product program approval and, later, product planning and development.

Product program life plan

Purpose	**Primary:** Information. Describes plan for the expected life of the product/system and all variants or family upgrades.

Secondary: Motivation. Ensures clear communication of program life plans and supporting functional plans.

Users	**Primary:** Division headquarters management and program team

Secondary: Division headquarters staff

Typical contents

- Introduction
 - Purpose and scope of proposal
 - Management decision and/or action requested
- Overview
 - Program summary
 Description/features
 Objectives/priorities
 Simple sketches, line drawings (if available)
 Summary comparisons with any existing/competitive products
 References to systems requirements specification and program goals document
- Strategy
 - Summarize product/system strategy
 Fit within division, overall group strategy
 Product positioning
 - Impact on existing or other products
 - Manufacturing forecast summary (worldwide)
 - Marketing strategy
 - Summary of other functional strategies
- Integrated planning baseline
 - Summary chart
 Program schedule/future reviews
 Key activities (functional/operating units)
 - Summary narrative interpreting key dates, activities, and confidence level for achievement
- Risks and issues
 - Assessment of program risks, issues, and planned actions
- Functional status
 - Functional assessment (by each functional program manager)
 Status
 Issues/risks/actions (not previously identified)

- Multinational status

 — Operating unit assessment (by each operating unit representative)
 Status
 Issues/risks/actions (not previously identified)

- Financial summary

 — Minimum set of financial exhibits
 Key indicators summary
 Annualized volumes
 Annualized profit (loss)—program life
 Annualized cash—program life
 Program acquisition spending
 Unit revenue/unit cost/gross margin
 Incremental analysis
 — Reconciliation

- Transfer criteria assessment

 — Summary of transfer criteria not completed
 — Statement of completion for all other transfer criteria identified in prior proposal
 — Summary of key criteria for next stage transfer

- Opportunities

 — Summary of profit, cost, and upgrade opportunities not included in program plan

- Program recommendation

Notes

The product program life plan must be thorough and comprehensive. It is one of the most critical documents within the organization. It becomes the basis for product development and delivery. The information included in the product program life plan provides a basis for marketing and product delivery requirements. These documents, when expanded and enhanced, provide input for the technical and promotional/sales sections of other documents.

Design disclosure

Purpose

Primary: Information. Provides detailed plans and specifications for engineering, manufacturing, and service activities required to bring a product to market and make it successful.

Secondary: Motivation. Ensures clear communication of plans and specifications among engineering, manufacturing, and service activities.

Users

Primary: Division headquarters engineering, manufacturing, and service

Secondary: Division headquarters management

Typical contents

- Systems and functional specifications
- Drawings
- Test plans and specifications

- Procurement specifications
- Change notice control

Support plans

Purpose

Primary: Information. Provides functional and participating operating plans as support to the preparation of product business proposals, product program life plans and updates, and launch plans.

Secondary: Motivation. Ensures clear communication of product strategies and plans to allow organizations responsible for planning and for creating other documentation to understand product.

Users

Primary: Division headquarters management, staff, and program team

Secondary: Field management

Typical contents

Engineering plan:

- System and subsystem defined
- Final manufacturing design approach defined
- System requirements specification updated by software change notice
 - Performance ranges defined
 - Operator functional descriptions provided
 - Protocols, media formats, file descriptions defined
- Functional specification released
- Program change management system outlined
- Supplies and associated materials, packages, and safety evaluations completed

Manufacturing and distribution plan:

- Manufacturing site and sourcing strategy completed
- Tooling and process concepts confirmed
- Drawing issue schedule approved
- Production start-up plan developed
- Unit cost estimating system implemented
- Design plan concurred
- Distribution support strategy approved
- Distribution input to logistics support plan developed
- Echelon stocking levels and methods established

Service plan:

- Service strategy approved
- Service cost factors and assumptions established
- Logistics support plan developed

- Level of service target committed
- Design plans approved

Market/operating unit plan:

- Marketing plan developed
- Forecast committed
- Announcement, initial machine observation, and launch plans proposed on manufacturing basis
- User interface descriptions reviewed
- Operating unit pricing, forecasts, and financial analysis committed
- Software category defined
- Sales and support strategy established

Program office plan:

- Program team in place and operational
- Manufacturing working agreements established with participating operating units
- Unique costs identified
- Program critical planning assumptions confirmed
- Integrated product program life plan developed and approved
- Definition stage exit criteria assessed and corrective action plans defined
- Program financial analysis consolidated and issued
- Legal assessment confirmed
 - Patents
 - Licensing
 - Proprietary position
- Management approval of product appearance
- Change management thresholds scoped
- Program issues, risks, and opportunities summarized

Launch plan

Purpose

Primary: Information. Facilitates national and multinational product and branch launch. Identifies required field guidance and divisional support.

Secondary: Motivation. Ensures clear communication of launch plans to field organization.

Users

Primary: Field management and division headquarters staff

Secondary: Division headquarters management and program team

Typical contents

- Introduction
 - Product overview
 - Purpose
 - Launch objectives
 - Scope

- Launch strategy and city openings

- Launch organization and responsibilities
 - Headquarters
 Objectives
 Key responsibilities
 Technical assistance
 - Field
 Key responsibilities
 - Launch milestones
 - Launch readiness reporting
 - Issue management

- Training and documentation
 - Objective
 - Documentation
 Service manual
 Operations guide
 Functional documentation
 - Training requirements strategy
 Purpose
 Tech rep criteria
 Strategy
 Training schedules
 Field service manager training
 Tech rep postschool training
 Customer training

- Installation
 - General
 - Installation phase involvement
 Preinstallation
 Installation
 Postinstallation
 Checklist guide
 - Preinstallation guide
 - Delivery/removal manual
 - Tools
 Basic tools for customer engineer
 Basic tools for product technical support
 Tools for branch
 Supplemental tool kit
 - Spares
 - Order entry procedure
 - Installation status report

- Maintenance and support
 - Maintenance philosophy
 - Service coverage
 - Service call procedure
 - Alert and escalation procedure
 - Parts management and distribution
 - Full service maintenance agreement billing

- Reporting procedure

 — Installation reporting
 — Full service maintenance agreement billing
 — Like for like alert
 — Multinational launch reporting procedures
 — Field reporting

- Software

 — Ordering additional media
 — Patches
 — Software technical bulletins

Performance assessment report (PAR)

Purpose

Primary: Information. Assesses launch preparedness subsequent to beta test and initial machine observation.

Secondary: Isolate areas of performance and preparedness deficiencies requiring correction prior to launch and branch expansion.

Users

Primary: Division headquarters management and field management

Secondary: Division headquarters program team

Typical contents

- Purpose

- Scope

- Product performance summary

 — Qualification test (performance versus specification by block release)
 Ongoing maintenance results/projected growth rate
 Discrepancy reports
 Concessions granted/pending
 Fix effectiveness tests conducted/pending
 Posttest change level increase/decrease
 Major risks/opportunities
 — Beta test (performance versus specification by system configuration)
 Test environments (statistical summary)
 Operations training (response/duration/reaction)
 Operating system software (failure modes/frequency)
 Application systems software (failure modes/frequency)
 Communications software (failure modes/frequency)
 Input/output terminal electronic subsystem performance characteristics
 Installation issues/risks/opportunities
 Technical corrective action measures and field corrective action measures issued
 System analysis activity levels response
 Service factors assessments
 Customer administrative procedures/performance/response
 Customer support system
 Supply support/distribution factors analysis
 Service documentation
 Sales/marketing support documentation

Training documentation/course effectiveness
Customer survey analysis
Cost summary program performance, unit manufacturing cost, service if sold value, etc
Competitive response

- Functional launch readiness

 — Manufacturing status
 Current build rates rolling product program by block configuration
 Change rates
 Sourcing problems/resolutions
 Spares status (build rates, usage adjustments, pipeline problems, etc)
 Performance and reduction projections
 Launch preparedness: risks and opportunities
 — Engineering
 Change control activity versus plan
 Fix effectiveness test program/timing
 Launch impact assessment
 Application/communications software release activity and impact assessment (launch and prelaunch)
 Launch preparedness: risks and opportunities
 — Service
 Support systems assessment
 Level of service factors analysis/costs
 Maturity projections
 National technical support operations analysis
 Training and documentation assessment/verification
 Launch preparedness: risks and opportunities
 — Marketing/sales operating units
 Order status operating units
 Advertising program status spending
 Product support programs assessment
 Sales productivity target revisions
 Sales and customer documentation
 Sales and customer training assessment verification
 National software support operations analysis
 Sales incentive program effectiveness
 Launch preparedness: risks and opportunities
 — Other functions (as appropriate)
 — Exit criteria (performance versus plan by function)
 — Program business manager's assessment

- Action plans and schedules

 — Manufacturing
 — Engineering
 — Service
 — Marketing/sales/operating units
 — Other functions (as applicable)
 — Program office
 — Resource impact assessment

- Recommendations

 — National launch
 — Multinational launch
 — Schedules
 — Resource requirements
 — Variance to launch pad
 — Program risks and confidence factors

Discontinuance plan

Purpose **Primary:** Information. Initiates product market withdrawal process at end of viable economic or strategic life.

Secondary: Defines coordinated functional activities necessary to achieve product withdrawal in an economical and advantageous manner.

Users **Primary:** Division headquarters management

Secondary: Field management and division headquarters staff

Typical contents
- Account reentry strategy
- Holdover demand/inventory (legal requirements)
- Service strategy
- Stop
 - Lease/sales (new or refurb)
 - Refurb
 - Remanufacture
 - Changes
- Replacement strategy
- Trade/secondhand sales programs

References and standards

This class of documents represents a major source of critical guidance for group/division personnel.

Purpose **Primary:** Information. Defines approved guidelines, content, and formats for other documents found in the structure.

Secondary: Motivation. Provides consistency in the development of materials to support division products, applications, and market plans.

Users **Primary:** Division headquarters staff

Secondary: Division headquarters management (except executive) and implementation staff

Typical contents
- Purpose of standard
- What it covers
- What is required
- How to use
- When to use
- Exceptions

Notes

Some typical documents in this category are:

- Standards for hardware and software specifications
- Drafting standards
- Engineering procedures
- Corporate identity
- Configuration management guidelines
- Training standards
- Documentation requirement standards
- Publishing standards
- Promotional material standards
- Library and document control procedures.

Policies and procedures

Purpose

Primary: Information. Defines approved corporate, group, and division policies and procedures for use throughout operating units.

Secondary: Motivation. Provides consistency for management, staff, and field personnel when performing their assignments.

Users

Primary: Field management; division headquarters management (except executive)

Secondary: Field personnel; division headquarters staff and executive management

Typical contents

- Purpose of policy or procedure
- What it covers
- What is required
- How to use
- When to use
- Exceptions

Notes

Some typical documents in this category are:

- Personnel policies and procedures
- Pricing procedures
- Customer service and support procedures
- Equipment ordering procedures
- Problem resolution procedures
- Service administrative policy and procedure manual
- Sales manual
- Cash disbursements manual
- Affirmative action plan
- Compensation manual.

These documents provide important input to management to interpret situations in their daily operations. In addition, they provide important guidance for preparing a new-hire training course as well as subsequent general training requirements.

Product planning/development

The following are definitions of the documents in this section. They are used to organize and support the sales, systems, and service activities required by the field to meet product marketing goals.

Marketing plan

Purpose

Primary: Information. Identifies specific marketplace needs; describes market strategy for achieving product goals; analyzes product's marketplace. Provides a focus for required field sales and systems activities, with an emphasis on implementation.

Secondary: Motivation. Ensures communication of product goals and operating plans and assists division personnel to implement product business proposal and product program life plan.

Users

Primary: Division headquarters program team, management, and staff (sales, systems, and training)

Secondary: Division headquarters service planning and engineering management; field sales and systems management

Typical contents

- Marketplace problem or need defined

 — Origin of the need (market size)
 — Description of the need
 What is the need?
 Who has the need?
 Why does the need exist?
 — Benefits to be derived from meeting the need

- Solution to the problem described

 — Overall goals to be achieved by a proposed solution
 — Users of the proposed solution
 Primary
 Secondary
 — Implementation of the solution
 General approach
 Installation plans
 Other considerations

- Marketplace defined

 — Specific market segment(s)
 Segmentation policy
 Primary and secondary market segments
 Total size
 Expected penetration schedule (6 months, 1 year, 2 years, life cycle)
 Application opportunities
 — Key accounts

- Product impact
 - Position in the product line
 - Cross-product impact (impact on other products)

- Competition
 - Primary
 - Secondary
 - Anticipated competitive advantages
 - Expected competitive response

- Product promotion and introduction
 - Promotion
 - Introduction strategy

- Training needs
 - Internal
 Who needs training?
 How many?
 How often?
 Proposed methodology
 - External
 Who needs training?
 How many?
 How often?
 Proposed methodology

- Sales strategy
 - Channel mix
 - Who should sell the product?
 - Selling strategy

- Ongoing product maintenance
 - Nature of the maintenance need
 - Personnel required
 - Facilities/equipment needed

- Return-on-investment analysis
 - Cost summary
 - Pricing strategy
 Alternatives
 Impact
 - Revenue forecast
 Assumptions
 Consequences

Notes It is important to make the marketing plan document thorough and comprehensive. Similar information was compiled in the "support plans" used as input to the "product program life plan." This information is restated here as a communication vehicle to establish task plans (contracts) with organizations responsible for development of related elements of the documentation set.

Product delivery requirements

Purpose **Primary:** Information. Provides detailed explanations of the product's expected performance characteristics; describes acceptable product limitations; outlines future development plans and schedules.

Secondary: None.

Users | **Primary:** Division headquarters management (except executive and training)

Secondary: Division headquarters engineering staff and training management

Typical contents |
- Hardware/software/application requirements
- Expected performance characteristics
- Acceptable product limitations
- Special considerations

Notes | This document is a restatement of the "product goals" and "system requirements specification." This information is restated here as a communication vehicle to establish task plans (contracts) with organizations responsible for development of related elements of the documentation set.

Hardware specification

Purpose | **Primary:** Information. Provides complete details on all aspects of the product's hardware components.

Secondary: None.

Users | **Primary:** Division headquarters engineering management and staff, sales, systems, service planning, and training staff

Secondary: Division headquarters management (except engineering and executive); outside contractors and suppliers

Typical contents |
- Processor characteristics
- Interface characteristics
 - Channel controls
 - Input and output controls
- Cable requirements
- Performance capabilities and limitations
- Maintenance requirements
- Development schedule
- Implementation plans

Notes | The hardware specification document is written and modified as the product is developed. It provides a picture of the product's operational characteristics. The specifications are the basis for the creation of the technical documentation set. It is also used when developing training materials for customer engineers, system support engineers, systems analysts, and customer personnel. In addition, the document provides a general level of input to the promotional/sales documents.

This information was originally created as a part of the "system requirements specifications." The information is restated here as a communication vehicle to establish task plans (contracts) with organizations responsible for development of related elements of the documentation set.

Functional specification

Purpose | **Primary:** Information. Provides complete detail on all aspects of the software system, eg, functions, features, performance, applications, and protocols. Describes systems software architecture.

Secondary: None.

Users | **Primary:** Division headquarters engineering management and staff, sales, systems analysts, service planning, and training staff

Secondary: Division headquarters management (except engineering and executive); outside contractors and suppliers

Typical contents |
- Features, functions, and applications
- Performance capabilities and limitations
- Interface characteristics (protocols)
- Maintenance requirements
- Development schedule
- Implementation plans
- Functional flow diagrams

Notes | The functional specification document is written and modified as the product is developed. It provides an accurate picture of the product's operational characteristics. The specifications are the basis for the creation of technical documentation. It is used when developing training materials for customer engineers, systems analysts, and customer personnel. In addition, the document provides a general level of input to the promotional/sales documents.

This information was originally created as a part of the "system requirements specifications." The information is restated here as a communication vehicle to establish task plans (contracts) with organizations responsible for development of related elements of the documentation set.

Documentation planning and control

Document design/writing specification

Purpose | **Primary:** Information. Provides complete detail on all aspects of document planning, organization, audience and content, and visual design.

Printing and media production specification

Purpose | **Primary:** Information. Provides complete detail on document, software, and accessory production, binding, packaging, and delivery.

Users | **Primary:** Project management and procurement

Secondary: Production vendors

Marketing/sales

Sales guides

This class of document contains information on sales policies and procedures and provides aids in finding prospects.

Sales manual

Purpose | **Primary:** Information. Provides current information on marketing policies, procedures, guidelines, application and product information, and pricing.

Secondary: Motivation. Encourages sale of the product or the application.

Refresher/reinforcer. Used as a reference tool.

Users | **Primary:** Field sales representatives and management

Secondary: Field systems analysts; division headquarters sales, systems, and training; other groups

Typical contents
- Description of marketing policies
- Application/product's role in meeting customer needs
- Appropriate application/product information
- List of pertinent documentation
- Marketing practices
- Installation and other pertinent policies
- Product pricing
- Business ethics
- Reference section for selling tools and other resources

Notes | The sales manual is the official source of marketing policies, equipment, and software descriptions, product features, specifications, configurations, and prices.

This document may also be used as a textbook during sales training.

In addition, sales guides can be developed to provide more detailed coverage on individual products or market areas. A sales guide is a sales support tool highlighting the market and sales strategy for a specific product or market area. It supplements information and policies in the sales manual.

Prospect data/information lists

Purpose | **Primary:** Information. Provides listings of prospects, prospect characteristics, or market segments for an application or product. Defines prospects in terms of product goals and suggested sales strategies.

Secondary: None.

Users | **Primary:** Field sales representatives and management

Secondary: Division headquarters sales and training

Typical contents |
- List of prospects, prospect classes, or market segments
- Descriptive information, such as:
 — Location
 — Volumes
 — Allied systems/products installed
 — Key contacts

Notes | These lists are developed from existing data bases such as Standard & Poor's.

Account profile

Purpose | **Primary:** Information. Describes successful installations of division products.

Secondary: Motivation. Encourages sales through dissemination of typical solutions.

Users | **Primary:** Field sales representatives and management

Secondary: Field systems analysts; division headquarters sales, systems, and training; other groups

Typical contents |
- Basic description of the account
- Description of the problem or need
- Description of the product application
- Division's unique contributions to this solution
- Benefits realized
- Sources of further information

Notes These account profiles are based on actual "success stories" or selling situations. The type of profile will depend upon the maturity of the product in its life cycle.

Brochure/general information digest

Purpose **Primary:** Motivation. Identifies a problem of concern to a customer organization and encourages the customer to implement or explore the division solution.

Secondary: Information. Provides basic information on the application or product.

Users **Primary:** Customer executive management

Secondary: Customer end user and operations management; suppliers; division headquarters training; other groups

Typical contents
- Attention-getting introduction to identify and address a need or concern of the executive
- Brief description of the problem solved by the division application or product and benefits of solving the problem
- Conclusion to create a compelling reason to seek additional information or take action

Notes Such brochures and general interest digests may be created for an application, a product, or a family of products. Typically, a brochure is at least 8 pages long and may be as large as 20 or 30 pages. A general information digest is similar in content to a brochure but provides a brief description of a product.

Direct mail piece

Purpose **Primary:** Motivation. Identifies a problem of concern to a customer organization and encourages the customer to take action to implement or consider the division's solution.

Secondary: Information. Provides basic information on the application or product.

User **Primary:** Customer end user and operations management

Secondary: Customer executive management

Typical contents
- Attention-getting paragraph to address need or concern of users
- Brief description of the problem solved and benefits of solution
- Additional information customized for the specific prospect
- Conclusion to create compelling reason to seek additional information or take action

Notes | This document can be customized to offer solutions ranging from simple to complex. It is a useful entree to higher levels of management via lower management.

Qualifying/information gathering tools

These documents are intended to help advance the selling effort. They assist in qualifying the customer by facilitating agreement on the proposed division solution to a specific business problem. In addition, they can be used to qualify and gather proposal data.

Application brief

Purpose | **Primary:** Information. Provides detailed information regarding an application or product.

Secondary: Motivation. Encourages additional action, ie, further steps in the sales cycle.

Users | **Primary:** Customer end user or operational management

Secondary: Customer executive management

Typical contents |
- Brief description of the application, including system flow and other relevant information
- Review of a division success story relevant to the application or product

Notes | This item provides an additional level of detail beyond the brochure. It will help both the company and the customer determine potential solutions. Success stories should be based on account profiles.

Product description

Purpose | **Primary:** Information. Provides detailed information regarding the application or related products.

Secondary: Refresher/reinforcer. Functions as a sales aid.

Users | **Primary:** Customer end user and operations management

Secondary: Field sales representatives and systems analysts; division headquarters, sales, systems, and training; other groups; suppliers

Typical contents |
- Description of a product or product set

Notes | These documents can be as broad as a division product line catalog or as specific as a product brochure, data sheet, or font catalog. Information can be more complete and somewhat more technical than the content of an executive brochure.

Product-fit questionnaire

Purpose

Primary: Refresher/reinforcer. Aids in gathering and analyzing information to determine division product fit in customer environment.

Secondary: None.

Users

Primary: Field systems analysts and sales representatives

Secondary: Customer end user and operations personnel; division headquarters systems, sales, and training; other groups; suppliers

Typical contents

- Instructions for use of the document
- Questions, checklists, and other information-gathering devices
- Guidelines for evaluation of information thus gathered, where appropriate

Notes

Customer end user and operational management are not generally considered users of this document. However, sales representatives can use it with current and prospective customers. It may provide an excellent opportunity for:

- Higher-level contacts through key customer executive product discussion meetings
- Clearer understanding of customer needs
- Improved credibility of the company and the sales representative with customers in solving their problems.

Configurator

Purpose

Primary: Refresher/reinforcer. Assists in gathering information for configuring the required hardware and software components for the application targeted by the sales effort.

Secondary: None.

Users

Primary: Field systems analysts and sales representatives

Secondary: Division headquarters systems, sales, and training; customer operations technical personnel; other groups; suppliers

Typical contents

- Guidelines for interpretations of product-fit questionnaire data to allow sensible system configuration decisions
- Examples of typical configurations and environments where they apply

Value analysis questionnaire

Purpose | **Primary:** Refresher/reinforcer. Assists in gathering and interpreting information relevant to the economic justification of the division solution.

Secondary: None.

Users | **Primary:** Field systems analysts and sales representatives

Secondary: Customer end user and operations personnel; division headquarters systems, sales, and training

Typical contents

- Instructions for use
- Questions relevant to costs, timing, and other parameters (both tangible and intangible) associated with current methodologies
- Questions relevant to customer's general methodologies for evaluating investment alternatives
- Provision for merging estimates based on previously determined configuration for the customer's application
- Guidelines for analysis and presentation to customer

Data sheet

Purpose | **Primary:** Information. Provides current information on product, such as prices and specifications.

Secondary: None.

Users | **Primary:** Customer end user and operations management; field sales representatives and systems analysts

Secondary: Customer end user and operations management; division headquarters sales, systems, and training; other groups; suppliers

Typical contents

- Product hardware/software application specifications
- Pricing
- Product description
- Typical applications

Presentation/proposal tools

This classification includes any devices aimed at moving the customer toward the close. They are generally used late in the sales cycle.

Demonstration kit

Purpose | **Primary:** Refresher/reinforcer. Provides a model and experience for preparing and giving an effective demonstration.

Secondary: Motivation. Simplifies preparation and presentation of an effective demonstration.

Users | **Primary:** Field systems analysts

Secondary: Field sales representatives; division headquarters systems, sales, and training; other groups

Typical contents
- Value of demonstration
- How to evaluate demonstration needs
- Preparation for demonstration
- How to conduct the demonstration
- Techniques for effective demonstrations
- Sample demonstration materials
- Appropriate support materials

Notes | Depending on the nature of the application or product to be demonstrated, this document could have as its primary user either field sales representatives or systems analysts.

Presentation kit

Purpose | **Primary:** Refresher/reinforcer. Provides a model for preparing and giving an effective stand-up presentation.

Secondary: Motivation. Simplifies preparing and giving an effective presentation.

Users | **Primary:** Field sales representatives

Secondary: Field systems analysts; division headquarters sales, systems, and training; other groups

Typical contents
- Value of presentation
- How to evaluate presentation needs
- Preparation of a presentation
- How to conduct a presentation
- Techniques for effective presentations
- Sample presentation materials
- Appropriate support materials

Notes | Depending on the content or topic of the presentation, this document may be aimed at systems analysts or sales representatives.

Proposal kit

Purpose

Primary: Refresher/reinforcer. Provides a model for preparing and giving an effective proposal.

Secondary: Motivation. Simplifies the preparation and presentation of an effective proposal.

Users

Primary: Field sales representatives

Secondary: Field systems analysts; division headquarters sales, systems, and training; other groups

Typical contents

- Sample proposal outline
- Sample/standard sections of a proposal
- Techniques for customizing
- Sample executive overview
- Policy/legal considerations affecting proposals
- Techniques for proposal presentation
- Common objections and answers
- Follow-up suggestions

Notes

This kit should be a proposal generator based on current products. It must be accompanied with directions on how to use the kit.

Closing tools

Purpose

Primary: Information. This category includes agreements necessary to obtain the order. Although other documents may be used in "closing," they are covered in previous categories. The tools here are used when the order is ready to be signed.

Secondary: None.

Users

Primary: Field sales representatives

Secondary: Division headquarters sales and training

Typical contents

- Lease agreement
- Rental agreement
- Purchase agreement
- Maintenance agreement
- Licenses

Follow-up tools

This class of documents includes items that are required after an order is received. They are used mainly during the installation and postsale phases of the sales cycle. The overall purpose of these documents is to ensure account satisfaction and growth.

Installation checklists

Purpose

Primary: Refresher/reinforcer. Helps sales representatives ensure proper installation planning techniques are followed.

Secondary: Motivation. Simplifies monitoring of installation planning. Increases the likelihood of continued account involvement by sales representatives during this crucial period.

Users

Primary: Field sales representatives

Secondary: Field systems analysts; customer end user and operations management; division headquarters sales, systems, and training; other groups

Typical contents

- Instructions for use
- Checklist of key events in the installation planning process
- Suggested roles and responsibilities
- List of required action items
- Sample equipment layouts
- Related documentation

Notes

There may be one or more of these documents, depending on the complexity of the installation. They are derived from the installation planning materials in technical documentation but are designed for ease of use by essentially nontechnical people. Customer management use ensures their continued involvement in the installation.

Account management forms

Purpose

Primary: Refresher/reinforcer. Assists in systematic information gathering to maintain account control and assure account growth.

Secondary: Motivation. Simplifies gathering of account information. Encourages an appropriate level of sales representative involvement in the account after sale.

Users

Primary: Field sales representatives

Secondary: Field systems analysts; division headquarters sales, systems, and training

Typical contents

- Instructions for use
- Questions, checklists, and other devices for gathering information on:
 - Status
 - Growth
 - Problems
 - Special situations
 - Account dynamics
 - Other activities.

Notes

Information gathered using these tools is useful in:

- Maintaining complete account records
- Preparing periodic briefings or letters to senior customer personnel regarding application benefits
- Providing suggestions for improvements and new applications.

Informational publication

Purpose

Primary: Information. Provides information on product use, innovations in applications, and other general, nontechnical facts.

Secondary: Motivation. Demonstrates effective use of products and applications in a broad variety of environments, frequently making use of "expert" opinion.

Users

Primary: Customer management (level depends upon topic)

Secondary: Customer staff personnel (depending upon topic); field sales representatives and systems analysts; division headquarters management and training

Typical contents

- Attention getters, such as headlines, illustrations, etc
- Content information
- Sample success stories
- Copies of articles on division products
- Indication of appropriate follow-up action the user might wish to take

Notes

This category is similar to brochures and application briefs. It includes reprints, newsletters, and other documents to sustain communications with customers. These documents may also be used in the sales cycle.

Applications/support

Installation planning

This class of document includes any item that is primarily used from the time the order is signed until the product and/or application is up and operating. This time span can be viewed as installation planning and actual installation. These documents may also be used by prospective customers to determine if their proposed facility can accommodate equipment.

Installation planning guide

Purpose **Primary:** Information. Provides basic information required for installing the application, hardware, or software product.

Secondary: Refresher/reinforcer. Supports repetitive applications and product installations by a given customer.

Users **Primary:** Customer end user management and operations management

Secondary: Customer end user personnel and operations personnel; systems analysts and sales representatives; division headquarters systems and training; other groups; suppliers

Typical contents
- Space requirements
- Installation planning procedure
- Interface with current systems
- Job responsibilities
- Training needs
- Supplies needed
- User acceptance procedures

Notes Depending on the application or product, this item could be one guide or a master guide with several planning guides. Each guide is targeted at a different audience depending on specific user responsibilities.

Installation manual

Purpose **Primary:** Information. Provides the technical information for physical installation of the product.

Secondary: Refresher/reinforcer when product is to be moved.

Users **Primary:** Field customer engineers

Secondary: Division headquarters service planning; other groups; suppliers

Typical contents

- Instructions for packing/unpacking
- Installation instructions
- Summary of pertinent specifications
- Pertinent schematics

Notes This document is typically for the use of customer engineers. The user audience may change or expand with the introduction of user-installable products.

Delivery/removal manual

Purpose **Primary:** Information. Provides instructions for safe transport and delivery of products.

Secondary: Refresher/reinforcer. Assists those with experience in handling the product.

Users **Primary:** Outside contractors/suppliers

Secondary: Field service; division headquarters service planning

Typical contents

- Physical specifications (eg, weight, turning radius, codes)
- Instructions for packing/unpacking
- Instructions for handling during transport
- Instructions for warehousing and stocking
- Notes, such as warnings and potential hazard messages

Ongoing account development

These documents are used after the application/product is properly installed. They provide information for the effective and efficient use of the application or product.

Operations guide

Purpose **Primary:** Information. Provides information required for successful operation of the application/product. Ensures that customers can successfully operate and maintain their equipment.

Secondary: Refresher/reinforcer. Allows review of specific information acquired from earlier training.

Users **Primary:** Customer operations personnel

Secondary: Other customer end user personnel; field systems analysts; division headquarters systems and training; other groups; suppliers

Typical contents

- Overview
- Getting to know the equipment
- Steps before printing
- Operating procedures
- Applications or special jobs
- Paper flow management
- Clearing paper path
- Machine care and maintenance
- Problem solving
- Status codes (if applicable)
- Specification

Notes

This document covers the "physical" operation. It is one of a series. The guide is to be used as an aid only after the completion of training.

Application guide

Purpose

Primary: Information. Provides basic information regarding an application.

Secondary: Refresher/reinforcer. Supports previous training or study.

Users

Primary: Customer end user and operations applications personnel

Secondary: Other customer end user and operations personnel; field systems analysts; division headquarters systems and training; other groups

Typical contents

- Overview of the application
- Data input and output
- Interface with other systems
- Schedules
- Error handling
- Personnel requirements
- Customer and company responsibilities

Notes

This may be one of a series needed for a large or involved division application.

Language application guide

Purpose

Primary: Information. Provides basic information regarding languages, such as print description language (PDL) or forms description language (FDL).

Secondary: Refresher/reinforcer. Supports review of previously studied information.

Users

Primary: Customer end user applications personnel, operations and technical personnel

Secondary: Other customer end user and operations personnel; division field systems analysts; division headquarters systems and training; other groups; suppliers

Typical contents

- Overview of the language
- Typical applications
- Commands and syntax
- Procedures for debugging
- Worksheets
- Examples/illustrations

Notes

May be one of a series in a library of such guides for a division application or product.

Operations

Documents under this category are aimed at those who operate the equipment and tend to be the procedural, "how-to" documents.

Operations manual

Purpose

Primary: Information. Provides basic information needed to run the customer's products, applications, and special procedures.

Secondary: Refresher/reinforcer. Supports review of previously acquired skills.

Users

Primary: Customer end user and operations personnel

Secondary: Other customer end user and operations personnel; field systems analysts; division headquarters systems and training; other groups; suppliers

Typical contents

- Overview of jobs
 - Run procedures
 - Error messages
 - Recovery procedures
 - Equipment maintenance procedures

Notes | This document is supplemented by operator training. Operator training provides for practice, feedback, and reinforcement. This document is an information vehicle, although it can be used as training material.

Job aids/reference cards

Purpose | **Primary:** Refresher/reinforcer. Assists a document user in doing a specific task; supports tasks and procedures covered in other documentation.

Secondary: Information. Provides quick reference to procedures that are to be performed.

Users | Depends on the user of the primary document or the training being supported

Typical contents |
- Brief instructions for use of aid, as appropriate
- Brief procedural instructions
- Illustrations, other graphics as required

Notes | This category includes reference cards, procedural checklists, font gauges, and forms design rulers or aids. Summarizes keys, functions, and most common procedures. Job aids are packaged with the documents they support.

Reference

The reference category includes basic systems documentation and describes the capabilities of a specific product. It is general purpose, using similar data base information required for other special purpose documents.

It is important to distinguish between reference documentation and other types. A reference document is intended to be a complete source of information, used like a dictionary or encyclopedia, and is organized to meet that need. The objective of a reference manual is to put everything anyone needs to know about a product in one accessible place. The document must be readily available to those who need it.

Other documents, such as applications or training, typically contain a subset of the information found in a reference document and are task-oriented. The information is arranged to facilitate the execution of a procedure, such as installation or forms design. These documents can be used as a reference for a task on a refresher/reinforcer basis, but that is not their primary purpose.

Operations

The documents in this category are referenced during normal system use and for troubleshooting.

Hardware reference manual

Purpose | **Primary:** Information. Provides a basic reference source of information on hardware.

Secondary: Refresher/reinforcer. Supports review of information acquired earlier.

Users | **Primary:** Customer operations technical personnel; customer engineers, systems analysts, system support engineers

Secondary: Other customer operations personnel; operations systems and service support personnel; division headquarters systems and training; other groups; suppliers

Typical contents
- System overview
- System performance specifications
- System operations
- Input/output processing
- Problem detection and resolution
- Materials requirements
- Precautions/hazards
- Appendices (eg, error messages)
- Index

Notes | Reference manuals should be a complete source of information. They must be organized in a way to allow quick access to areas of interest.

Software reference manual

Purpose | **Primary:** Information. Provides basic software information on the product.

Secondary: Refresher/reinforcer. Supports review of material acquired previously from this document, other documents, or training.

Users | **Primary:** Customer operations technical personnel; systems analysts, system support engineers

Secondary: Other customer end user and operations personnel; division headquarters systems and training; other groups; suppliers

Typical contents
- System overview
- Software system specification

- Program documentation

 — Software system operations
 — Program flow charts
 — Source program glossary
 — Source program listing
 — Object code listing
 — Data dictionary

- Indices

Notes Reference manuals should be a complete source of information. They must be organized to allow quick access to areas of interest.

Service

This class generally includes documents required to make hardware repairs. Software problems typically are resolved through use of reference documentation and version release documentation.

To ensure that current service documentation and training materials are available to most Xerox non-English-speaking service representatives, Xerox has developed a computerized translation system. This system works in conjunction with a writing style called Multinational Customized English (MCE). The system translates English into a number of other languages. As with all computer systems, the input must be precise to ensure speed and accurate output.

Functional manual

Purpose **Primary:** Information. Provides basic diagnostic procedures for problem isolation.

Secondary: Motivation/refresher/reinforcer. Simplifies problem solving on technologically complex equipment. Supports review of material previously studied.

Users **Primary:** Field customer engineers

Secondary: Division headquarters service planning and training; other groups; suppliers

Typical contents

- Instructions for use

- General procedures

- Diagnostic procedures

- Trouble shooting

 — Fault isolation procedures (FIPs)
 — Block system diagrams (BSDs)

- Indices, other reference devices

- Comment sheets

- Test data

- Schematics

- Wire nets

Notes Such documentation is eventually directed to customers when certain items are serviced by the customer.

Service manual

Purpose **Primary:** Information. Provides information on basic servicing procedures once a fault has been isolated.

Secondary: Refresher/reinforcer. Allows review of material previously studied or seldom used.

Users **Primary:** Field customer engineers

Secondary: Division headquarters service planning and training; other groups; suppliers

Typical contents
- Introduction
- Instructions for use
- Repair procedures
- Precautions/hazards, etc
- Indices and other reference devices
- Adjustment and service notes
- Change tag index
- Product specifications
- Supplemental tools and supplies
- Spare parts index and master locator
- General information
 — Preventive maintenance
 — Consumables
 — Expendables
 — Specifications
 — Remove/repair procedures
 — Parts explain diagrams (illustrated parts breakdown)
 — Adjustments
 — Parts lists
 — Service notes
 — Spare parts index
 — Retrofit tags
 — Reconfiguration

Notes Much of this information should eventually be directed to customers.

Training

While training is closely related to the other document categories, there are some important differences. Training is designed specifically to maximize the effectiveness and efficiency of learning. Of course, you can learn from documents in any category. But training materials incorporate a special variety of presentation techniques including:

— Sequential, task-oriented exposition
— Visualization
— Practice
— Feedback
— Reinforcement.

While reference materials attempt to cover 80 to 100 percent of the information available on a topic, training is designed to teach the 20 to 40 percent of the most important or necessary concepts and skills. Training usually comprises a grouping of documents, media, and supplementary materials.

Classroom

For classroom courses, you must develop:

• Standard course support documentation (agenda, objectives, and modules)

• Instruction and administrative materials

• Classroom hand-outs and student workbooks

• Media, such as tapes, overheads, computer-based instruction, and the like.

Self-paced study

For self-paced study, you must develop:

• Standard course support documentation

• Instructions to

— Direct student use of the document as a text
— Provide practice, feedback, and reinforcement
— Recommend optional media as appropriate.

A critical goal of any training design is to minimize redundancy in documentation. Whenever possible, other documents should be used as student texts. And the training itself should be usable as a reference long after formal training is accomplished. There are several benefits from this approach:

• Reduced redundancy in preparing documents saves labor cost and time.

• Reduced redundancy saves document production, reproduction, and maintenance cost and time.

• Use of existing documents during training:

— Familiarizes the trainee with the document
— Increases the probability of future use of the document as a reference
— Reduces reliance on others for customer support.

The following sections cover general product training documents for field employees and customers. (Management, clerical, and professional training are not covered here.)

Sales personnel

Product and application training

Purpose

Primary: Education. Learning is based on the division products and applications available to customers.

Secondary: Motivation. Encourages sales by providing a thorough understanding of product and application offerings.

Users

Primary: New-hire sales representatives and system analysts

Secondary: Systems support engineers, division headquarters sales and systems; other groups

Typical contents

- Introduction
- Market needs
- Application offerings
- Product capabilities and limitations
- Competition
- Service strategy
- Product fit
- Pricing
- Demonstrations/hands-on experience

Notes

This training utilizes selected documentation, described in other portions of these standards as supporting materials. The specific documentation adopted varies depending upon new product announcements, competition, and marketplace changes. In addition, these documents are supplemented by specific materials designed to support the performance objectives of the program.

Sales training

Purpose

Primary: Education. Learning is based on the necessary market, product, and sales information required to facilitate the sale.

Secondary: Motivation. Encourages sales by simulating solid, real-life situations.

Users

Primary: New-hire sales representatives and systems analysts

Secondary: Field sales management; division headquarters sales and systems; other groups

Typical contents

- Review of the sales guide
- Reinforcement of experiences; blending of information from the sales guide and various tools with previous sales training on topics such as:
 — Locating prospects
 — Using qualifying criteria
 — Collecting and analyzing account knowledge
 — Integrating account knowledge with product information
 — Planning the use of marketing tools
 — Handling objections
 — Preparing proposals
 — Closing.

Notes | This training utilizes selected documentation as supporting materials. In addition, it is supplemented by specific materials designed to support the performance objectives of the individual program.

Systems analysis training

Purpose | **Primary:** Education. Provides learning based on the product, need, and sales information to assure effective support and contribute to the overall selling effort.

Secondary: Motivation. Encourages activity in the product area by simulating solid, real-life situations.

Users | **Primary:** Systems analysts

Secondary: Systems support engineers; sales representatives; division headquarters systems and sales; other groups

Typical contents |
- Review of the various reference materials
- Reinforcement of experiences; blending of new information with previous experience in such topics as:
 — Introduction
 — Conducting demonstration
 — Qualifying product fit
 — Preparing configurations
 — Data gathering
 — Preparing sample application runs
 — Handling objections
 — Contributing to proposals
 — Confirmation
 — Software.

Notes | This training utilizes selected documentation as supporting materials. In addition, these documents are supplemented by specific materials designed to support the performance objectives of the program.

Technical service

This area of training prepares technical support/service personnel for the task of maintaining customer systems in good operating condition.

Systems support training

Purpose | **Primary:** Education. Provides learning based upon the latest hardware and software information required to ensure advanced technical support for current customers.

Secondary: Motivation. Provides assistance in developing procedures to resolve complex customer support problems.

Users | **Primary:** Systems support engineers

Secondary: Systems analysts, customer engineers, headquarters systems and service planning; other groups

Typical contents

- Principles of operations
- Technical use of service and systems documentation
- Review of the various reference materials
- Hardware problem diagnosis
- Software problem diagnosis and resolution
- New operating system/release
- Product test procedures

Notes

Employees in this position are responsible for handling the most difficult hardware technical support problems and for the identification, documentation, and resolution of customers' systems software problems. They are responsible for continuing software maintenance through new releases and patch coordinations. They receive extensive classroom training, plus several weeks of on-the-job training.

Systems management training

Purpose

Primary: Education. Provides information needed to maintain products effectively.

Secondary: Motivation. Provides assistance in making the task as easy and rewarding as possible.

Users

Primary: Field customer engineers and regional technical specialists; technical representatives

Secondary: Division headquarters service planning and systems; field systems analysts; other groups; suppliers

Typical contents

- Introduction
- Theory of operation
- Revision level and prerequisites
- Discussion of roles and responsibilities
- Technical use of service documentation
- Discussion, exercises, and other learning for:
 - Principles of operation
 - Module objectives overview
 - Skill development and knowledge
 - Problem diagnosis
 - Problem resolution
 - Product tests (performance-based)
 - Feedback sheets
 - Additional resources
 - System operation and knowledge
 - Operator training know-how.
- Hands-on troubleshooting activities

Customer

This area is critically important to help achieve customer self-sufficiency. It currently includes training in several traditional areas, such as technical training, operations training, and management training.

Start-up operations training

Purpose

Primary: Education. Provides primary information needed to install and use the application or product.

Secondary: Motivation. Demonstrates a well-organized approach to installation and operations to encourage efficiency.

Users

Primary: Customer end users, systems analysts, operations employees and management

Secondary: Systems analysts and sales representatives; headquarters systems and sales; other groups

Typical contents

- Review of appropriate information from installation planning through implementation documentation
- Discussion, exercises, and applied learning activities related to one or more of the following:
 — Installation planning
 — Application design
 — Daily operations
 — Problem resolution
 — Monitoring and evaluation of the operation
 — Effective customer end user and operator training
 — New system applications
 — Management of systems
 — Customer maintenance and operations.

Notes

There will typically be many training programs, targeted at a variety of needs and audiences, including:

- Executive management overview
- Installation planning
- Application training
- Language training
- New software packages
- New or revised operating systems.

The principal audience will vary by training package. The training will use a variety of job aids, packaged together or separately.

Advanced operations training

Purpose

Primary: Education/motivation. Provides basic and advanced information on selected aspects of the application or product. Encourages a high level of job performance as well as effective and efficient use of the application or product.

	Secondary: Refresher/reinforcer. A back-up reference to information acquired earlier, either from this source or others.
Users	**Primary:** Customer operator personnel
	Secondary: Other customer end user personnel; systems analysts and sales representatives; headquarters systems and sales; other groups
Typical contents	• Introduction to product
	• Product components
	• System overview
	• System operations
	• System practice
	• Operator maintenance
	• Exceptions/error recovery discussion and practice
	• Operator evaluation
Notes	Training in this category will take a variety of forms, such as straight-forward job aids for simple tasks, simple operator training packages for more involved tasks, and complete packages. The material utilizes other documentation for complex tasks.

The word list is a quick reference for the correct spelling of compound words and Xerox-specific terms. Existing authorities disagree about many spellings (for example, setup, set-up, set up). This list presents the Xerox standard choice of spelling. You can base style for words not found on the list by using the analogy of parallel compounds.

Entries

Sequence

The entries on the list are alphabetic, without regard to intervening spaces or hyphens. Solid compounds are followed by hyphenated compounds and then open compounds (for example, workup, work-up, work up).

Capitalization

Most entries begin with lowercase letters, indicating that they are not ordinarily capitalized. If an entry begins with an uppercase letter, the word is usually capitalized.

Prefixes

The following prefixes are generally closed up (not hyphenated) when combined with other words.

anti	mini	proto
bi	mis	re
co	multi	sub
counter	non	super
demi	out	ultra
epi	over	un
hyper	post	
inter	pre	

The prefix "self-" is hyphenated when it is combined with other words.

Legend

g *Government Printing Office Style Manual* and the *Supplement to the GPO Style Manual*

m *McGraw-Hill Dictionary of Scientific and Technical Terms*

o Other

r *Random House Dictionary of New Information Technology*

w	Current version of *Webster's Collegiate Dictionary*
x	Xerox vocabulary or Xerox-approved spelling

Where grammar affects compound style, the following abbreviations are listed:

(adj)	adjective
(adv)	adverb
(n)	noun
(pl)	plural
(prep)	preposition
(s)	singular
(v)	verb

A
absorptance w
absorption w
ac x
accommodate w
ADA w
adsorption w
A-frame w
agreed to x
air bag w
air conditioner w
airflow w
air lock w
alongside w
along-track w
a.m. x
ammeter w
ampere-hour x
analyze w
ancillary w
anechoic w
antennas w
antijam x
antistatic x
a priori w
arcminute o
arcsecond o
arc sine w
as run x
auto-answer x
auto-calling x
autocollimate w
auxiliary w
Avery x
axial w

axillary w
axisymmetric w
azimuth w

B
backdrive (v) x
backorder (v) x
back order (n) x
back room (n) w
backscatter w
backseat (n) w
backshell x
backtrack x
backup (adj, n) w
back up (v) w
ball-lock pins o
ballscrew o
bandedge x
bandpass x
bandwidth r
baseband r
baseline x
baseload o
baseplate o
BASIC w
benchmark (computer) x
bench mark (survey) w
beryl w
bibliography w
bicrystal o
bidirectional x
bilateral w
bilevel x
billet w
binary w

bionics w
biphase g
bipolar w
bipropellant w
bit location r
bit map x
bit pattern x
bit rate r
bitstock w
biweekly x
blockhouse w
blow-by-blow w
blowdown (adj, n) g
blown out (adj) x
blowoff (n) g
blow off (v) w
blowout (n) w
blow out (v) w
blowoutproof g
blow over (v) w
blowtorch w
blowtube w
blowup (n) w
blow up (v) w
boattail g
boiling point w
boiloff (adj, n) g
boldface x
boltcutter g
bond check (v) x
bondstrap o
Boolean w
bootstrap w
breadboard w
breakaway (adj, n) w

breakdown (n) w
break-in (n) w
break in (v) w
break off (v) w
breakout (n) w
break out (v) w
breakthrough (n) w
break through (v) w
breakup (n) w
break up (v) w
breakwire x
broadband w
broadbeam x
broad-beamed (adj) g
brushfire w
bubble packing x
build in (v) w
buildup (n) w
build up (v) w
built-in (adj) w
built-up (adj) w
bulkhead w
burned-out (adj) w
burned-over (adj) g
burn-in (adj, n) g
burn in (v) w
burnout (adj, n) g
burn out (v) x
burnover (adj, n) g
burnup (adj, n) g
burn up (v) x
burnt-out (adj) g
burnt-up (adj) g
bus (buses) w
buy-in (n) w
buy off (v) w
bypass w
by-product w

C

callout (n) x
cam lock x
canister or cannister w
cannot w
catalytic w
cathode ray w
cathode-ray tube w
catwalk w
C-band x
centerline w
centre (Xerox Centre) x
centrifugal w
centrifuge w
centripetal w
changeable w
changeout w
changeover w
charge back x
chargeout (v) x
chargeup x
chassis (s and pl) w
checklist w
checkout (adj) w

check out (v) w
checkpoint w
cipher w
circuit breaker w
clear cut x
clearinghouse w
closeout (n) w
close out (v) w
close-up (n) w
co-author x
coaxial (not coax) w
coaxially w
COBOL x
codebook x
codeword (adj) x
code word (n) x
coefficient w
coelostat o
coldbox x
cold plate x
colinear w
collimate w
collocate w
colocate (facilities) w
commitment w
committed w
committing w
common-sense (adj) x
compatibility w
conceivable w
conductance w
conscan x
consistent w
consumable w
contaminant w
contaminate w
contour-forming x
contractor-furnished x
cooldown (n) x
cool down (v) x
coordinate w
copyedit x
copyfit x
Coriolis w
correspondence w
cosecant w
cosine w
cost-effective (adj) w
cost effective (adv) x
countdown (n) w
count down (v) w
counterbalance w
counterclockwise w
counterinsurgency w
countermeasure w
counterweight (n, v) w
co-worker x
crewmember x
criterion (criteria pl) w
cross arm x
crossbar (n) w
crossbarred (adj) g

crossbeam o
cross-check (n, v) w
crosscouple x
crosscut (n, v) w
cross-link (n, v) w
crossrange x
cross-reference (n, v) w
cross section w
cross-sectional w
cross-strap x
cross-switch x
crosstalk (n) r
crosstrack g
crypto- w
cutdown (adj) x
cut down (v) w
cutoff (n) g
cut off (v) x
cutout (n) g
cut-up x

D

daisywheel x
data (s, pl) w
data bank w
data base w
data file x
data set w
deadband x
debug w
dc x
deceleration w
decipher w
decision-making x
decryption w
decryptor x
de-emphasize w
defuel o
degauss w
degradation w
deinterleave x
deionize w
delineate w
dependence w
desiccant w
desktop x
dew point w
dielectric w
dioctyl x
diode w
diplexer w
dipole w
dipout x
disk w
diskette w
disposition (v) x
diurnal w
Doppler w
dosimeter w
dot-matrix printer x
double-back x
double-density x
double-faced w

double-folded x
doubly-balanced x
 (not double-balanced)
downconverter x
downlink x
downmode x
downstyle x
downtime w
drawback (n) w
draw back (v) w
drive shaft g
drive-to-drive (adj) x
dryout x

E
earth shield o
echo-back o
echo-check r
eg w
e-gun o
electrochemistry w
electroform w
electrolyte w
electrolytic w
electromagnetic w
electromechanical w
electro-optical w
electropyrotechnic g
encryptor x
end game w
endothermic w
end-to-end (adj) x
end to end x
end user x
en route w
ensure w
ephemeris w
equiangular w
equiaxial o
equilibrium w
equivalent w
et al w
etc x
Ethernet x
eyebolt w
eyeglasses w

F
face mask o
facesheet x
Fahrenheit w
fail-safe w
falloff (n) w
fall off (v) w
fax x
feedback (n) w
feed back (v) x
feedthrough (n) w
feed through (v) x
ferroelectric w
fiberglass (brand Fiberglass) w
field of force w
field of view w

field of vision w
field-test (v) x
field test (n) x
file drawer x
filename x
first-out x
flameproof w
flashover w
flash point w
flashtube w
flatbed w
flat-out (adj) w
flat out (adv) w
flatpack x
flat-rolled g
flat-top x
flip-flop w
floodlight g
floppy disk w
flowchart w
flow diagram w
flowmeter w
flowoff g
fluorocarbon w
fluoride w
fly-by-night (n, adj) w
fly-by-wire (adj) w
focus (pl focuses or foci) w
follow-on (adj) g
follow out (v) w
follow-through (n) w
follow through (v) w
follow-up (n, adj) w
follow up (v) w
footcandle (n) w
footer x
footpad w
foot-pound (n) w
foot-pound-second (adj) w
foot-ton g
foreign w
foreword (preface) w
forklift w
FORTRAN w
forward (direction) w
Fourier w
free-fall w
free-flying x
free-lance w
free-running x
freezing point w
French fold x
Freon w
front-end g
front line w
front matter w
front room (n) w
fulfill w
full-length (adj) w
full-scale (adj) w
full-size (adj) w
fulltime (n) x

full-time (adj) w
function key x
fusing (fuse) w

G
galley w
galley proof w
gauge w
gauss w
Gaussian distribution w
geodesic w
geodetic w
geophysical w
geosynchronous w
go-ahead w
go/no-go x
government-bonded o
government-furnished (adj) o
government-owned o
graphic w
graphical w
graphics w
ground rule w
guarantee w
guidebook w
guideline w
guide pin x
guide rail x
gyro- w

H
half-hourly w
half-length w
half-life w
half line x
halftone w
halfway
handbook w
handshake w
hands-off w
hands-on w
handtool x
handwheel x
handwritten w
hardbound (adj) w
hardcopy (n) x
hardcover (adj) w
hard disk x
hard-down x
hard hat (n) w
hard-line (adj) w
hardstand (n) w
hard-surface (v) w
hardware w
header x
heading x
heat shield w
heat sink w
helical w
heliocentric w
hermeticity w
hermetic seal w
hexadecimal w

high bay o
high-energy w
high-gain x
high-impedance m
high-level w
high-powered w
hinged out x
holdback (n) w
hold back (v) w
hold-down (n) w
hold down (v) w
hold off w
hold on (v) w
holdup (n) w
hooked up (v) w
hookup (n) w
hook up (v) x
horsepower w
hundredweight w
hydrometer w
hydrostation o

I

I beam w
ibid w
ie x
in-between (n, adj, adv) w
in between (prep) w
inadvertent w
inclinometer w
in-date x
in-depth (adj) w
in-house w
inland w
in-line w
in-plant (adj) x
in-print w
in-process w
input/output w
inputted w
inputting w
inrush w
insoluble w
insolvable w
intercepter or interceptor w
interchangeable w
interface w
interferer w
interferometer w
interior w
interpolation w
interrelate w
isothermal w
isotropic w

J

jack casters o
jack stand x
jamnut g
jewel w
joule w
judgment w

K

kelvin (temperature) w
key cap x
keyliner x
keyword x
kilohm m
kilometer w
kilovar (kvar) m
kilovolt w
kilowatt w
klystron w
know-how w
krypton w

L

ladder adder o
last in m
layout (n, adj) w
lay out (v) x
lead wire m
leak detector x
leak rate m
leak test m
left-hand (adj) w
leg stat x
letdown w
letter-quality x
letter spacing x
level shift gate x
Lexan x
lifetime w
lift-drag (ratio) m
lightweight w
light-year w
line-of-sight (adj) x
line of sight (n) w
line printer w
line-shim-plumb x
lineup (n) w
line up (v) w
linkedit x
loadbank x
lockon w
lock on (v) x
lockout (n) w
lock out (v) w
lockpin x
lockup w
lockwire (v) x
long-distance (adj, adv) w
long distance (n) w
long-lead (adj) x
long-life g
long-range (adj) w
long run (n) w
long-term (adj) w
longtime (adj) w
longwave g
look-angle m
lookup (n) w
look up (v) w
low-cost x
lowercase (n, v, adj) x

lower-tier x
low-gain x
low impedance m

M

macrophotographic g
macroscopic w
Mactac (brand name) x
mailbox x
mainbody (adj) x
mainframe w
main line w
maintenance w
maker-up g
makeup (n) w
make up (v) w
manageable w
(man-hour) use person-hour w
(manload) use person-load x
man-made w
(man-month) use person-month x
manpower w
(man-week) use person-week x
mapping w
markup (n, adj) w
mark up (v) x
matchmark g
material w
materiel w
matrix (pl matrices) w
medium-gain megohm o
memorandum (pl -dums or -da) w
Memorywriter x
Mergenthaler x
meridian w
meridional w
metalize w
mho (pl mhos) w
microampere g
microcircuitry w
microdiscrete g
microelectronics w
microhm g
microinch w
microinstruction w
microminiaturization w
micron w
microorganism w
microphotography w
microprocessor g
microradiometer g
microstructure w
microwave w
mid-April x
midcourse m
mid-latitude m
midrib w
midsection w
mid-sixties x
midterm g
midzone g
milliammeter o
millicurie g

milliliter g
millisecond g
millivolt g
millivoltmeter g
milliwatt g
minicomputer w
minitrack w
mismate w
missile w
misuse w
mnemonic w
mockup (n) g
mock up (v) x
molydisulphide o
moment of inertia w
monocoque w
monolithic w
month-end (adj) x
movable w
multicard g
multichip g
multicopy form x
multidirectional w
multilayer w
multilevel w
multinational x
multiple-choice (adj) w
multiple-valved (adj) o
multiplexer w
multistage w
Mylar (brand) w

N

nameplate w
nanosecond w
narrow-band m
near term x
network w
nichrome x
nighttime x
no-access x
nodal w
no-electrical switching x
no-load w
nomenclature x
noncurrent-carrying x
non-DOD o
nongovernment w
nonhazardous w
nonimaging x
nonlinear w
nonnominal x
nonnormal w
nonnuclear w
nonoperative w
nonpyrotechnic g
nonreproducing x
nonstock x
nonsymmetric w
nonuniformity w
nonword g
nonzero x
nose cone w

no-switching x
no-voltage (n-v) x
nth w
nucleosynthesis w
nutation w

O

occur w
occurred w
occurrence w
occurring w
off limits w
off-line w
off-loading (v) w
off-pointing x
offsetting w
ohm w
ohmeter w
ohms-per-square o
omniantenna g
omnidirectional w
on and off (adv) g
onboard (adj) g
on board (prep) x
one-and-a-half x
one-dimensional w
one-half g
onetime w
one-way w
ongoing w
onhand (adj) g
on hand (adv) x
onionskin w
on-line w
on-order x
onsite g
onstand (adj) g
op cit w
open-circuit w
operational check chart x
ordinance w
ordnance w
orifice w
O-ring w
outboard w
outgassing w
out-of-bounds w
out-of-tolerance x
output (n, v) w
outputted w
outputting w
outriggered w
overall w
overcharge x
overhead w
overlimit g
overnight w
overpressure w
override w
oversize x
overstress x
overtape g
overtemperature x

overtighter g
overtime w
overtravel g
overvoltage w
oxidizer w

P

page proof x
parameter w
passband w
pasteup g
patch cord w
pathfinder w
payload w
peak-to-peak (adj) x
peak to peak (p-p)(n) x
peak-to-valley (p-v) x
pedestal-mounting x
pent-up (adj) g
performance check chart x
perihelion w
perimeter w
peripheral w
permissible w
personal w
person-hour x
person-load x
person-month x
personnel w
person-week x
pertinence w
phase lock m
phaseout (n) w
phase out (v) w
phase-stable m
phenolic w
photoconductive w
photodetector w
photoelectron w
photoengrave w
photomicrograph w
photosensitivity w
photostat x
phototypeset x
pickoff (n) w
pick off (v) w
pickup (n, adj) w
pick up (v) w
picofarad w
piezoelectric w
pinlock g
pinpoint (adj, v) w
pin pull x
pin puller x
pin-to-case x
playback x
plug-in (n, adj) w
plug in (v) w
plug mold x
plumb bob w
plumb line w
p.m. x
P/N 10000 x

pocket fold x
point-to-point x
polyamide w
polycrystalline w
polyester w
polyether g
polyethylene w
polymer w
polymerize w
polynomial w
polyolefin g
polypropylene w
polystyrene w
polyurethane w
polyvinylchloride g
polyvinylidene g
posigrade w
postattack g
postenvironmental g
postmidseason x
post-1985 x
poststorage g
posttest g
potential w
potentiometer w
power down (n, v) x
powerhouse w
power-off (v) x
powerline g
power on x
powerplant x
power up (n, v) x
powerwise x
preamplifier w
precede w
preemphasize g
pre-engineered w
preenvironmental g
preliminary w
premate g
preset w
press-on type x
pressrun w
pressurant o
pretest w
printhead x
printout (n) w
print out (v) w
print queue x
printwheel x
proceed w
proof-load (adj) x
proof load (n, v) m
proofread w
proof tag x
proportional spacing x
prorate w
proton w
protoqual x
pseudorandom w
psychophysics w
pullout (n) w

pull out (v) w
pulse load x
pulse mode x
pulse modulation x
pulse train m
pulse width m
pulsometer w
pumpdown o
pump-down time m
pushover w,g
pushpin w
pyrolytic g
pyrometer w
pyroshock o
pyrotechnic w

Q
quadrant w
quadriphase g
quantitative w
quantize w
quarter-inch x
quasi-static x

R
radioactive w
radiosonde w
radiotracer w
ragged left x
ragged right x
Rapidfax x
read-back m
readout (n) w,g,m
read out (v) w
read/write driver m
read/write switch m
real-time (adj) w,m
real time (n) w
re-create (v) x
recur w
recurrence w
recycle w
red-line (adj) x
red line (v) x
reemphasize g
reenable g
reestablish g
reexamine g
refrasil x
reinform g
reinstall g
reinterleave g
relayout g
remate g
removable w
rendezvous w
reoptimize x
reorder x
replaceable w
report-back x
re-recover (v) x
resistance w
resister (a person) w

resistor (a device) w
resource w
reusable w
reuse w
rework x
rib tip x
right-hand (adj) w
right hand (n) w
rise time m
roentgen w
rollout w
rolltop (n) w
rollup (n) g
roll up (v) w
Roman type x
rotab (rotary table) x
RS232 (cable) x
RS232C (cable) x
rubdowns w,g
rub-in x
rub in (v) w
runaway (n) w
run away (v) w
rundown (n) w
run-down (adj) w
run down (v) w
runout g,m
run out (v) w
run-out time m
run time x
run-up x

S
sans serif x
S band m
sawtooth w
saw-toothed w
scale-up w
scatter band m
selenocentric w
semiannual w
semiautomatic w
semiconductor w
semi-omnidirectional x
semirigid w
serial number (S/N) w
serif x
setback x
setdown x
set down (v) w
setscrew w
setup (n) w
set up (v) w
shelf life (n) w
shockloads x
short-circuit (adj, v) w
short circuit (n) w
short-circuited (adj) w
short-range (adj) w
short-term w
shutdown (n) w
shut down (v) w
shutoff (n) w

shut off (v) w
shutout w
sideband w
sidelobe x
sidereal w
sidewall w
signal-to-noise (adj) x
silica w
silicon w
silicone w
sine wave (n) w
single access x
single-density x
single-point x
sinusoidal w
sizable w
slabline x
slidewire x
slip ring w
slowdown w
Snopake x
soakback (n) w
softcopy x
soft-switch (v, adj) x
software w
spaceborne o
spectrometer w
spectrophotometer w
speed up (n) w
spin-off w
spin ring x
spinup (n) x
spin-up (n, adj) x
spin up (v) x
spotbond (v) x
spot-check w
spot ties x
spreadsheet x
spring load (v) w
square root w
square wave w
squib w
stand-alone x
standby (n, adj) w
stand by (v) w
standoff (n, adj) w
stand off (v) w
standpoint w
start-up (n, adj) w
state-of-the-art (adj) x
state of the art (n) w
static-free x
stationkeeping x
steady state (adj) w
step-by-step w
stochiometric x
stopwatch w
storyboard x
straightforward w
string tie (v) x
strike-on type x
stripchart x

strip in x
strongback (n) x
style-book x
subassembly w
subatomic w
subcarrier w
subcommutator x
subconnect x
subcontractor w
subframe x
subroutine w
subset w
substrate w
subsystem x
subtask x
subterfuge w
subtitle w
subtotal x
sun-in-bay w
sunline x
sunspot w
superconductive w
supersede w
support stand x
swingout x
switchgear x
switchover x
symmetrical w
sync w
synchronous w

T

tachometer w
tag line (n) w
tag up (v) w
takeoff (n) w
take off (v) w
talk back x
targetable x
T-connectors x
teardown (n) w
tear down (v) w
Teflon w
telemeter w
telemetry w
test crew x
test jack x
test-operated x
test stand x
theodolite w
thermal vacuum x
thermocouple w
thermodynamic w
thermoelectric w
thermonuclear w
thin film x
three-hole drill x
three-hole-drilled pages x
throughput w
thru-bolt (adj) x
tie-down x
tie-in (n) w
tie in (v) w

tie-off x
tie-wire x
tilt table x
time clock w
time code x
time consuming x
timeframe x
timeline x
time-out w
time-sharing (n) w
time tagged x
tip-off (n) w
tip up x
titrimeter o
titrimetric w
torobar x
torque angle o
torr w
tow bar o
trade-off (n) w
trade off (v) x
T-rail o
tran code x
transattack x
triagency x
triaxial (n) w
tricenter x
trickle charge x
trilevel x
tristate x
trouble free x
troubleshooting w
trunnion w
turnaround (adj, n) w
turn around (v) x
turnbuckle w
turnoff (n) w
turn off (v) w
turn-on (n) w
turn on (v) x
twofold w
Tychebycheff o
type-ahead x
typeface w
typeset x
type size x
type style x
type weight x

U

U-boat w
ultrasonic w
ultraviolet w
underside w
undertemperature x
undervoltage x
underway (adj) w
under way (adj) w
unilateral w
un-ionized x
unjustified x
upconverter x
update (n, v) w

upgrade w
uplink x
uppercase (adj, n, v) w
upstyle x
usable w
useful life x
U.S. Government x
U-shape(d) x

V
V-band x
V-clamp x
varactor w
variacs x
Velcro w
vernier w
versed-sine (adj) w
viewgraph x
ViewPoint (product) x
video amplifier o
videoconferencing x
Visicorder x
voltameter w
voltammeter w
voltmeter w
volt-ampere w
volt-peak (Vpk) x
volumetric w

W
walkaround x
walkout (n) w
walk out (v) w
walk-through w
warm-up (n) w
warm up (v) w
waterproof w
wattmeter w
wave band w
waveform w
wave front (n) w
waveguide (W/G) w
wavelength w
waveshape w
weatherproof x
well-being (n) w
wholesale w
wideband x
widebeam x
widerange (adj) x
wipe off x
wire-like x
wire-wrap x
word processing x
word processor x
word spacing x
workbench w

work force x
work off (v) w
work order x
workroom w
workshop w
work space x
work stand x
workstation x
wraparound x
wristwatch w
write-up (n) w
write up (v) w

X
x-band x
xenon w
Xerox' (possessive) x
x height w
x-ray (v) w
X ray (n) w

Z
zener w
zeroing x
zeroize x
zero-th x
Z-time (GMT) (Zulu time) o
Zulu w

C. Standard units of measurement

Standard international units (SI)

The international system of units (Système International d'Unités, SI) is roughly equivalent to the metric system.

Basic SI units

Quantity	Unit	Symbol
time	second	s
mass	kilogram	kg
length	meter	m
electric current	ampere	A
thermodynamic temperature	kelvin	K
amount of substance	mole	mol
luminous intensity	candela	cd
plane angle	radian	rad
solid angle	steradian	sr

Special SI-derived units

Quantity	Unit	Symbol	Formula
frequency (of a periodic phenomenon)	hertz	Hz	1/s
force	newton	N	$(kg \cdot m)/s^2$
pressure, stress	pascal	Pa	N/m^2
energy, work, quantity of heat	joule	J	$N \cdot m$
power, radiant flux	watt	W	J/s
quantity of electricity, electric charge	coulomb	C	$A \cdot s$
electric potential, potential difference, electromotive force	volt	V	W/A
capacitance	farad	F	C/V
electric resistance	ohm	Ω	V/A
conductance	siemens	S	A/V
magnetic flux	weber	Wb	$V \cdot s$
magnetic flux density	tesla	T	Wb/m^2
inductance	henry	H	Wb/A
luminous flux	lumen	lm	$cd \cdot sr$
illuminance	lux	lx	lm/m^2
activity (of radio-nuclides)	becquerel	Bq	1/s
absorbed dose	gray	Gy	J/kg

Common SI-derived units

Quantity	Unit	Symbol
acceleration	meter per second squared	m/s²
angular acceleration	radian per second squared	rad/s²
angular velocity	radian per second	rad/s
area	square meter	m²
concentration (of amount of substance)	mole per cubic meter	mol/m³
current density	ampere per square meter	A/m²
density, mass	kilogram per cubic meter	kg/m³
electric charge density	coulomb per cubic meter	C/m³
electric field strength	volt per meter	V/m
electric flux density	coulomb per square meter	C/m²
energy density	joule per cubic meter	J/m³
entropy	joule per kelvin	J/K
heat capacity	joule per kelvin	J/K
heat flux density	watt per square meter	W/m²
irradiance	watt per square meter	W/m²
luminance	candela per square meter	cd/m²
magnetic field strength	ampere per meter	A/m
molar energy	joule per mole	J/mol
molar entropy	joule per mole kelvin	J/(mol · K)
molar heat capacity	joule per mole kelvin	J(mol · K)
moment of force	newton meter	N · m
permeability	henry per meter	H/m
permittivity	farad per meter	F/m
radiance	watt per square meter-steradian	W/(m² · sr)
radiant intensity	watt per steradian	W/sr
specific energy	joule per kilogram	J/kg
specific entropy	joule per kilogram-kelvin	J/(kg · K)
specific heat capacity	joule per kilogram-kelvin	J/(kg · K)
specific volume	cubic meter per kilogram	m³/kg
surface tension	newton per meter	N/m
thermal conductivity	watt per meter-kelvin	W/(m · K)
velocity	meter per second	m/s
viscosity, dynamic	pascal-second	Pa · s
viscosity, kinematic	square meter per second	m²/s
volume	cubic meter	m³
wavenumber	one per meter	1/m

Standard unit abbreviations

1,000 (thousand or kilo or 10^3)	k
1,024 ("about a thousand" or 2^{10})	K (computer)
1,000,000 (million or mega or 10^6)	M
1,048,576 ("about a million" or 2^{20})	M (computer)
ampere	A
ampere-hour	Ah
ampere per meter (oersted)	A/m
angstrom	Å
arc	arc
arc per second	arc/s
atmosphere (normal)	atm
atmosphere (technical)	at
azimuth	Az
baud	Bd
bel	B
bit	b
bit per second	b/s
British thermal unit	Btu
byte	B (computer)
kilobyte (1,024 or 2^{10} bytes)	KB (computer)
"about a thousand"	
megabyte (1,048,576 or 2^{20} bytes)	MB (computer)
"about a million"	
candela (obs, candle)	cd
candela per square foot (obs, footlambert)	cd/ft^2
candela per square meter (obs, lambert)	cd/m^2
center of gravity, centigram	cg
centimeter	cm
character per second	char/s (computer)
circular mil	cmil
coulomb	C
cubic centimeter	cm^3
cubic foot	ft^3
cubic foot per minute	ft^3/min
cubic foot per second	ft^3/s
cubic inch	in^3
cubic meter	m^3
cubic meter per second	m^3/s

cubic yard	yd³
curie	ci
current (alternating, direct)	ac, dc
decibel	dB
decibel referred to 1 milliwatt	dBm
decimeter	dm
degree Celsius	°C
degree Fahrenheit	°F
degree Kelvin	K
degree rankine or reaumur	°R
degree (plane angle)	°
degree (temperature deg interval)	deg
dots per inch	dots/in (computer)
electronvolt	eV
erg	erg
farad	F
foot	ft
foot per minute	ft/min
foot per second	ft/s
foot-pound	ft-lb
foot pound-force	ft-lbf
gal	Gal
gallon	gal
gauss	G
gigaelectronvolt	GeV
gigahertz	GHz
gilbert	Gb
gram	g
gravity	g's
henry	H
hertz (obs, cycle per second)	Hz
horsepower	hp
hour	h
hydrogen-ion concentration	pH
inch	in
inch per hour	in/h
inch per second	in/s
inch-pound	in-lb
joule (calorie)	J
joule per degree	J/deg
joule per degree Kelvin	J/K
kilo (1,000 or 10³)	k

kilobyte	KB (computer)
kilocharacters per second	kchar/s
kiloelectronvolt	keV
kilogauss	kG
kilogram	kg
kilogram-force	kgf
kilohertz	kHz
kilohm	kΩ
kilojoule	kJ
kilometer	km
kilometer per hour	km/h
kilovolt	kV
kilovoltampere	kVA
kilowatt	kW
kilowatthour	kWh
liter	l
liter per second	l/s
lumen	lm
lumen per square foot (obs, footcandle)	lm/ft^2
lumen per square meter	lm/m^2
lumen per watt	lm/W
lumen second	lm·s
mega (1,000,000 or 10^6)	M
megabit per second	Mb/s
megabyte	MB (computer)
megaelectronvolt	MeV
megahertz	MHz
megavolt	MV
megawatt	MW
megohm	MΩ
meter	m
microampere	μA
microbar	μbar
microfarad	μF
microgram	μg
microhenry	μH
micrometer (obs, micron)	μm
microsecond	μs
microsiemens (micromho)	μS
microwatt	W
mil	mil
mile (nautical)	nmi

mile (statute)	mi
mile per hour	mi/h
milli-	m (prefix)
milliampere	mA
millibar	mbar
milligal	mGal
milligram	mg
millihenry	mH
milliliter	ml
millimeter	mm
millimeter of mercury	mm Hg
milliohm	mΩ
million (mega)	M
millisecond	ms
millisiemens	mS
millivolt	mV
milliwatt	mw
minute (plane angle)	
minute (time) (also gh46m30s)	min
nanoampere	nA
nanofarad	nF
nanometer (obs, millimicron)	nm
nanosecond	ns
nanowatt	nW
nautical mile	nmi
neper	Np
newton	N
newton meter	N·m
newton per square meter	N/m^2
ohm	Ω
ounce	oz
parts per million	p/m
pascal	Pa
peak to peak	p-p
per	/
percent	%
phase	ϕ
pica	pi (publishing)
picoampere	pA
picofarad	pF

picosecond	ps
picowatt	pW
pint	pt
point	pt (publishing)
pound	lb
pound-force	lbf
pound-force foot	lbf/ft
pound-force per square inch (psi)	lbf/in²
quart	qt
rad	rd
radian	rad
revolution per minute	r/min
revolution per second	r/s
roentgen or rankine	R
root mean square	rms
second (plane angle)	″
second (time)	s
siemens (mho)	S
spots per inch	spi
square foot	ft²
square inch	in²
square meter	m²
square yard	yd²
steradian	sr
tesla (gauss)	T
thousand (kilo)	k
thousand (Roman numeral)	M
ton	ton
tonne	t
torr	torr
ultra high frequency	uhf
very high frequency	vhf
volt	V
voltampere	VA
volt-peak	Vpk
volt per meter	V/m
volts ac	Vac
volts dc	Vdc
watt	W
watthour	Wh

watt per steradian	W/sr
watt per steradian square meter	W(sr·m²)
weber (obs, maxwell)	Wb
word	word (computer)
yard	yd
year	yr

Point measurement conversion

The point sizes in this table are measurements on the various Xerox page layouts. Equivalent measurements were calculated using the automatic conversion feature available in Xerox ViewPoint and Xerox Publishing Illustrator's Workstation (XPIW) software. Because measurements have been rounded off, always convert forward from the base unit. To convert measurements manually, use the following equivalents:

pica = points \div 12
inch = points \div 72
millimeter = inches \cdot 25.4
pixel = inches \cdot dots/in

Pixel measurement is equal to inches times the number of dots per inch. Pixel calculation for this table is based upon a resolution of 75 dots or spots per inch.

Table C-1. **Point measurement conversion**

Points	Picas	Inches		Millimeters	Pixels (75 dots/in)
		Decimal	**Fraction**		
846	70.51	11.75	11-3/4	298.5	881.4
792	66	11	11	279.4	825
702	58.51	9.75	9-3/4	247.7	731.4
684	57	9.5	9-1/2	241.3	712.5
612	51	8.5	8-1/2	215.9	637.5
594	49.51	8.25	8-1/4	209.6	618.9
540	45	7.5	7-1/2	190.5	562.5
522	43.51	7.25	7-1/4	184.2	543.9
516	42.99	7.17	7-1/8	182	537.4
504	42	7	7	177.8	525
498	41.5	6.92	6-29/32	175.7	518.8
446	37.16	6.19	6-3/16	157.3	464.47
432	36	6	6	152.4	450
423	35.24	5.875	5-7/8	149.2	440.55
396	32.58	5.5	5-1/2	139.7	407.19
373.5	31.16	5.19	5-3/16	131.9	389.47
342	28.51	4.75	4-3/4	120.7	356.4
330	27.5	4.58	4-9/16	116.4	343.7
318	26.5	4.42	4-13/32	112.2	331.3
315	26.29	4.38	4-3/8	111.3	328.64
314	26.15	4.36	4-11/32	110.7	326.87
312	26.01	4.33	4-5/16	110.1	325.1
303	25.25	4.21	4-3/16	106.9	315.65
300	24.99	4.17	4-1/8	105.8	312.
252	21	3.5	3-1/2	88.9	262.5
243	20.24	3.38	3-3/8	85.7	253.05
234	19.51	3.25	3-1/4	82.6	243.9
231	19.25	3.21	3-3/16	81.5	240.65
230	19.14	3.19	3-3/16	81.03	239.26
216	18	3	3	76.2	225
207	17.24	2.88	2-7/8	73	215.55
186	15.5	2.58	2-9/16	65.6	193.7
162	13.51	2.25	2-1/4	57.2	168.9
156	12.99	2.17	2-5/32	55	162.4
150	12.5	2.08	2-1/16	52.9	156.2
148	12.35	2.06	2-1/16	52.3	154.43
144	12	2	2	50.8	150

Points	Picas	Inches		Millimeters	Pixels (75 dots/in)
		Decimal	Fraction		
141	11.76	1.96	1-5/8	49.8	147.05
132	11.01	1.83	1-13/16	46.6	137.6
120	9.99	1.67	1-21/32	42.3	124.9
112.5	9.45	1.57	1-1/2	39.9	118.08
108	9	1.5	1-1/2	38.1	112.5
106	8.82	1.47	1-1/2	37.34	110.26
100	8.34	1.39	1-3/8	35.3	104.23
96	8.01	1.33	1-11/32	33.9	100.01
86	7.16	1.19	1-3/16	30.3	89.47
84	6.99	1.17	1-5/32	29.6	87.4
72	6	1	1	25.4	75
60	5.01	0.83	13/16	21.2	62.6
54	4.51	0.75	3/4	19.1	56.4
48	3.99	0.67	21/32	16.9	49.9
46	3.84	0.64	5/8	16.26	48.01
45	3.78	0.63	5/8	16	47.24
44	3.66	0.61	19/32	15.5	45.77
42	3.5	0.58	9/16	14.8	43.7
36	3	0.5	1/2	12.7	37.5
33	2.76	0.46	15/32	11.68	34.49
30	2.53	0.42	13/32	10.7	31.59
24	2.01	0.33	11/32	8.5	25.1
22	1.86	0.31	5/16	7.87	23.24
18	1.51	0.25	1/4	6.4	18.9
17	1.44	0.24	1/4	6.1	18.01
14	1.14	0.19	3/16	4.83	14.26
12	1	0.17	5/32	4.2	12.4
11	0.9	0.15	1/8	3.81	11.25
10	0.84	0.14	1/8	3.56	10.51
9	0.78	0.13	1/8	3.33	9.74
8	0.66	0.11	1/8	2.79	8.24
6	0.5	0.08	1/16	2.1	5.99
3	0.25	0.04	1/32	1.02	3.01
2	0.17	0.03	-	0.7	2.24
1	0.08	0.01	-	0.4	1
0.5	-	-	-	-	-

Glossary
Bibliography
Index

Glossary

The glossary consists of standard definitions of terms that are commonly used in publishing and computer systems.

Entries

Sequence
Glossary entries are alphabetic, following the rules for sequencing on page 2-34. In cases of duplicate entries varying only in punctuation, the sequence is closed, hyphenated, then open (for example, workup, work-up, work up).

Abbreviations
Initialisms and acronyms are spelled out and defined. Generally, the abbreviation is used as the main entry.

Capitalization
Most entries begin with lowercase letters, indicating that they are not ordinarily capitalized. If an entry begins with an uppercase letter, the word is usually capitalized.

Legend

pub	publishing related
sys	systems related
adj	adjective
adv	adverb
n	noun
prep	preposition
v	verb

A

AA	Author addition (n, pub). Any change or correction made by the author after type has been composed or set.
abort	(n, sys). Command to delete a job that is currently printing.
absolute placement	(n, sys). Specification of the exact place where line of text is to start.
access	(v, sys). To find the area of memory or auxiliary storage for retrieving or storing information.
access list	(n, sys). List of users and/or groups of users who have been granted specific access to a particular object.
access time	(n, sys). Interval between initiating storage or retrieval action and its completion.
acoustic coupler	(n, sys). Data communications device used with conventional telephone handset to convert signals for transmission over telephone lines.
acronym	(n, pub). Word formed from the initial letters of a word or by combining the initial letters or parts of series of words. An example is laser (light amplification by simulated emission of radiation). *See also* initialism.
A/D (or D/A) converter	(n, sys). Unit to convert analog signals to digital (and vice versa).
address	(n, sys). Specific, unique location in memory or auxiliary storage.
adjective	(n). Word (one of the eight parts of speech) used to modify (describe or limit) a noun or pronoun.

1. Descriptive: **long** day, **blue** sky, **waving** flag.
2. Possessive: **my** hat, **its** nest; **his**, **her**, **our**, **your**, **their** book.
3. Demonstrative: **that**, **this** house; **these**, **those** apples.
4. Interrogative: **whose** cap? **which** coat? **what** dress?
5. Numerical: **one** pear, **three** pears, **first** robin, **third** sparrow.
6. Article: **a** street, **an** avenue, **the** park.

adverb	(n). Word (one of the eight parts of speech) used to modify (qualify or limit) a verb, an adjective, or another adverb. An adverb indicates:

— Time: **now, then, today**

— Place: **here, there, outside**

— Manner: **calmly, quickly, clearly**

— Degree: **very, somewhat, only**.

Some examples are:

Stand **here**. ("Here" modifies the verb "stand.")

Stand beside the **very** old clock. ("Very" modifies the adjective "old.")

Stand **very quietly**. ("Very" modifies the adjective "quietly," which modifies the verb "stand.")

AI artificial intelligence (n, sys). Computer science concerned with the ability of machines to imitate the thinking of people, such as reasoning and learning. An example is the machine's ability to interpret commands by examining the words in their context to determine their meaning and arrive at the appropriate next step. Also includes concept of "expert systems," which store and manipulate the knowledge of human specialists.

algorithm (n, sys). Set of rules for solution of a problem, represented by the sequence of stored instructions.

alias (n, sys). Shorthand name for the user, service, or other registered entry in a clearinghouse data base. "Alias" stands for the first component of a three-part name and may need to be fully qualified (alias:domain:organization) if the domain and organization components cannot be inferred from the context.

all caps (n, pub). Term designating that all letters in a word or phrase should be capitalized. *See also* capitalization.

alley (n, pub). Space between the columns of tabular copy. *See* gutter.

alphanumeric (adj, sys). Mixture of alphabetic and numeric characters in any combination.

ambient humidity (n, sys). Degree of humidity in a surrounding area.

analog (adj, sys). Varying continuously along a scale, as opposed to fixed increments or steps.

analog transmission (n, sys). Transmission of data in which information content is modulated by a continuously varying signal. Ordinary voice-grade telephone lines use analog transmission.

antecedent (n). Word or group of words to which a pronoun refers.

This is the **visitor** who came to the house. ("Visitor" is the antecedent of the relative pronoun "who.")

When **John** and **Mary** came, they told us the facts in the case. ("John and Mary" is the antecedent of the personal pronoun "they.")

application (n, sys). Job to be performed by a computer program or system. The specific program or task, such as sorting employee records, to which a computer solution can be applied.

application program (n, sys). Computer program designed to meet specific user needs, such as controlling inventory or monitoring the manufacturing process.

application software (n, sys). Programs for doing actual jobs, as opposed to systems programs, which manage equipment operation.

architecture (n, sys). Design or organization of the central processing unit (CPU).

archive (v, sys). To store data off-line in storage medium for long-term storage.

array (n, sys). Data structure storing location of points by coordinates or some other group of related variables; matrix.

art (n, pub). All illustrative material used in a printing job. *See also* line art *and* halftone.

ascender (n, pub). That portion of an alphabetic character that rises higher than the body of the character (usually the x-height portion). The tall part of letters (such as b, d, or h) that extends above the main body. The portion of a lowercase letter that rises above its x height.

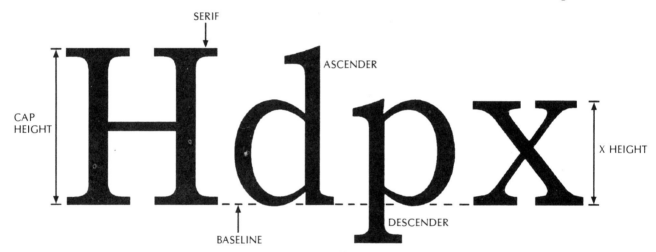

ASCII American Standard Code for Information Interchange (n, sys). Digital code set that represents a character as a 7-bit digital code. It is used for information interchange among data processing systems, data communication systems, and associated equipment, covering 128 possible characters. The code in which a binary number is assigned to each alphanumeric character and several nonprinting characters. This coding system is used to control printers and communication devices.

assembler (n, sys). Software that converts higher-level (English-like) programming language into machine-readable instructions.

asynchronous (adj, sys). Transmission of data in which time intervals between transmissions can be unequal. Transmission is character by character and is controlled by start and stop elements at the beginning and end of each character.

automatic carriage return	(n, sys). Capability of a workstation to move or "wrap" to the next line as necessary, without operator intervention. Increases input speed because the operator does not usually slow down or have to decide when to move to next line.
automatic centering	(v, sys). To center a word or text segment between margins or at a designated point with one or a few operator keystrokes.
automatic job recovery	(n, sys). Procedure that allows the system to function when a piece of equipment has failed.
auxiliary storage	(n, sys). Any peripheral device, such as a disk or tape drive, as opposed to the computer's internal storage capacity.

B

background processing	(n, sys). Automatic execution of print or other functions without disturbing computer processing.
backup	(n, sys). Procedure by which a copy of important information is saved in case of later loss or damage to original.
backup file	(n, sys). One or more files copied onto the storage medium for safekeeping in case the original gets damaged or lost.
band	(n, sys). Grouping of 32 successive scan lines of video data.
band buffer	(n, sys). Area of storage used to transfer a band (32 scan lines) of video data to laser-based scanner.
bandwidth	(n, sys). Range of frequencies that can pass through the circuit, determining the rate of information transfer.
baseline	(n, pub). Imaginary line on which all letters without descenders (particularly capitals) appear to rest. (Imaginary rule running under each line of type.) *See also* ascender.
BASIC	beginner's all-purpose symbolic instruction code (n, sys). High-level, English-like computer programming language, considered one of the easiest to learn.
batch processing	(n, sys). Type of computer processing in which similar tasks are grouped and handled sequentially to simplify operations.
baud	(n, sys). Measurement of the data rate in bits per second. This term is used to describe the information flow between two devices. A unit of data transmitting/receiving speed roughly equal to a single bit per second. Common baud rates are 110, 300, 1200, 2400, 4800, and 9600.

Baudot code	(n, sys). Data transmission code in which five bits represent one character.
bibliography	(n, pub). List of works consulted by an author in putting together a document.
bidirectional printer	(n, sys). Prints both left to right and right to left, increasing the printing speed by avoiding the print head return.
binary	(adj, sys). Numbering system based on 2 rather than 10. Uses only 0 and 1 when written.
binary code	(n, sys). Code that makes use of only two distinct characters, 1 and 0 or on and off.
Binary Synchronous Communications	*See* BSC.
bisynchronous	(adj, sys). Operating procedures for synchronous transmission of binary coded data.
bit	(n, sys). Abbreviation for "binary digit," the smallest unit of information recognized by a computer, represented by 1 or 0. Multipliers are as follows:

> If 1 or 0 byte equals 8 bits
> then 1 kilobyte or KB (1,024 bytes) equals 8,192 bits
> and 1 megabyte or MB (1,048,576) bytes equals 8,388,608 bits.

Space equivalents are:

— 1.5 KB of computer space is about one single-spaced typewritten page (in main memory on a disk).

— 30 KB of computer space is about 20 typewritten pages.

— 150 KB of computer space is about 100 typewritten pages.

A typical personal computer disk stores between 150 and 160 KB of information (about 100 to 105 pages).

bit map	(adj, sys). Visual representation of a graphic image in which each bit defines a pixel. If the bit is 0, the pixel it corresponds to is printed.
bit-map graphics	(n, sys). Technology that allows the control of individual pixels on a display screen to produce graphic elements of superior resolution, permitting accurate reproduction of arcs, circles, sine waves, or other curved images that block-addressing technology cannot accurately display.
bit mapped	(adj, sys). Display screen image generated by bit for each point, or dot, on the screen. Resolution is very high because any point on the screen can be addressed. The scanner is directed by software to create characters and/or graphics.
bit rate	(n, sys). Speed at which bits are transmitted, usually expressed in bits per second.

bit synchronous	(adj, sys). Form of synchronous transmission in which single symbols are transmitted in a continuous stream.
blank	(v, pub). To omit printing on a specified area of a page.
bleed	(n, pub). Copy that continues flush to the edge of a page.
block	(n, sys). Group of words, characters, or digits that is treated as a single unit.
block check character	(n, sys). Eight-bit code calculated according to the algorithm shared by a pair of devices, whereby the integrity of information passed between them is checked.
block length	(n, sys). Number of records grouped together into a discrete unit that the destination computer can understand.
block schematic diagram	See BSD.
blocked	(n, sys). Method of writing files to tape.
blowup	(n, pub). Enlargement of text or graphics.
body copy	(n, pub). 1. Copy set in text type. 2. Text of a document, not including display type for headings or subheadings.
body type	(n, pub). Type used for text, as opposed to larger display type used for headings.
boilerplate	(n, pub). Standard text that can be rearranged to create a new document. Variable information, either prerecorded or keyboarded, may be combined with boilerplate.
boldface	(adj, pub). Heavy-faced type, as opposed to the standard face for text.
boot	(v, sys). To start or restart the processor.
bootstrap	(adj, sys). Program that causes the system program to be read into memory for operation. Once the system program is operative, the bootstrap program gives control of the computer to that program.
BSC	Binary Synchronous Communications (n, sys). A widely used data link protocol comprising Binary Synchronous Communications procedures defined by IBM. These procedures are usually abbreviated as BSC or BiSync, and only allow for data link operation in one direction at a time.
BSD	block schematic diagram (n, sys). Deductive job aid that shows functional flow of data from input to output in symbolic form. See also deductive job aid.

buffer	(n, sys). Intermediate storage area or device that holds data being transferred between elements of a computer system. It usually is an area of memory, but it may be a disk or tape.
bullet	(n, pub). Bold dot (●) used for emphasis.
byte	(n, sys). Set of eight contiguous bits, which represent a character, symbol, or operation. *See also* bit.
byte synchronous	(adj, sys). Form of synchronous transmission in which the sequence of successive bits (characters), most often a group of eight, is handled as a unit and transmitted.

C

CAD/CAM	computer assisted design/computer assisted manufacturing (n, sys). Acronym for a computer system used to create and manage complex graphic output.
CAI	computer assisted instruction (n, sys). Training program designed for self-study of a subject. The program is interactive, providing feedback to the student. Often it is designed so that any instruction module may be chosen for study, according to user requirements.
callout	(n, pub). 1. Reference in text to a particular part of a document, such as "See table 5." 2. Descriptive word in an illustration.
cap height	(n, pub). Height of the capital letters of a typeface. *See also* ascender.
capitalization	(n, pub). Practice of using uppercase letters. Examples of capitalization style:
	— All caps: Every letter in a word or phrase is capitalized (TRAINING MANUAL).
	— Headline style (initial caps, upstyle): First letter of each word in a phrase, except articles and prepositions, is capitalized (Training Manual for a Beginner).
	— Downstyle: First letter of the first word in a phrase is capitalized (Training manual).
	— Sentence style (downstyle with end punctuation): First letter of the first word in a sentence is capitalized; normal end punctuation (This is a training manual.).
	— All lowercase: No letters are capitalized (training manual).
	— Small capitals: Capital letters approximately the height of lowercase letters (TRAINING MANUAL).
caption	(n, pub). Identifying or descriptive text accompanying a photograph or other visual element. Captions provide self-contained background information or further explanation of facts.

carriage return	(n, sys). Control character that (unless set to be interpreted as line end) causes a printer to begin printing at the left margin of a current line.
cathode ray tube	*See* CRT.
caution	(n, pub, sys). Operation or maintenance procedure, practice, condition, or statement that, if not strictly observed, could result in damage to equipment or software.
center	(v, pub). To automatically position alignment so that it is equidistant from defined right and left margins.
centered text	(n, pub). Text that is equidistant from the right and left margins of the page. The middle of each line of text is at the midline of the column.
central processing unit	*See* CPU.
channel selection	(n, pub). Manner of controlling the vertical positioning of characters on a page, in emulation of mechanical printers whose form-feed mechanism is controlled by holes punched in a tape. The tape is divided into channels, each channel having its own set of punched holes that controls a unique pattern of vertical movement.
character	(n, sys). Single printable letter (A-Z), numeral (0-9), symbol (& % #), or punctuation mark (, . ! ?) used to represent data. Characters can also be nonprinting, such as space or tab.
character cell	(n, pub). Digitized space containing a single character within a font set. Space on a page occupied by one character.
character code	(n, sys). Code that assigns numerical values to characters, such as ASCII.
character count	(n, pub, sys). Number of characters in a pica, inch, line, column, or page. It differs for each typeface and size and varies with extended or condensed text. Number of characters in a line, paragraph, or manuscript.
character dispatcher	(n, sys). Computer program that forms characters for printing.
character generation	(n, sys). Production of images on the face of a CRT by moving an electron beam.
character generator	(n, sys). Device or software that converts data to corresponding character images on a screen.
character printer	(n, sys). Machine that prints one character at a time, such as a typewriter. *See also* line printer.
character set	(n, sys). Number of different characters used by a particular device, including alphabetic, numeric, and special characters such as symbols.

char/s | characters per second (n, sys). Unit of measurement for the number of characters an output device is capable of producing in one second.

chip | (n, sys). Small, complete semiconductor device. Silicon crystals yield a wafer that becomes the base for chips.

CIU | computer interface unit (n, sys). Used as a general term to describe a connecting link between two systems. It frequently refers to hardware and software required to join together two processing elements in a computer system.

clause | (n). A group of words that contains a verb and its subject. A clause may be main (independent, principal) or subordinate (dependent).

1. A main (independent, principal) clause expresses within itself a complete thought and can stand by itself as a simple sentence.

 The moon rose and **the stars came out**. (Two main clauses, either of which can stand by itself as a simple sentence.)

2. A subordinate (dependent) clause is not complete within itself and cannot stand alone. It is used as a noun, an adjective, or an adverb.

 That they will run for office is doubtful. (Noun clause: a subordinate clause used as the subject of the sentence.)

 Please lock the door **when you leave**. (Adverbial clause: a subordinate clause that modifies the verb "lock.")

 Give the corrected manual back to the person **who wrote it**. (Adjective or relative clause: a subordinate clause that modifies the noun "person.")

clearinghouse service | (n, sys). "Directory" of registered users, services, and other resources, allowing relevant information about each item to be looked up by name. Internetwork can contain any number of clearinghouse services, each holding a single domain of overall data base.

cluster workstation | (n, sys). One of a small group of workstations, containing its own memory, directed by a master workstation or controller.

coaxial cable | (n, sys). PVC or Teflon-shielded 50-ohm cable. It is designed to accommodate a transmission rate of 10 megabits per second. It comes in three lengths: 77, 230, and 384 feet.

COBOL | common business oriented language (n, sys). High-level programming language designed primarily for business or commercial use.

code | (n, sys). Set of symbols used to represent data or instructions to a computer.

(v, sys). To write a list of instructions (software) to cause a product or system to perform specified operations. These instructions translate detailed design specification requirements to "computer" language.

code conversion | (n, sys). Translation from one type of character or symbol code to another.

coded text	(n, pub). Author-inserted generic tags keyed into raw text. These tags are then machine translated into typographic codes for composition.
cold type	(n, pub). Images of characters created without the use of metal.
	(v, pub). Strike-on typesetting or phototypesetting.
collate	(v, pub). To assemble or gather in sequence. To assemble and arrange pages for binding.
colloquial	(adj). Informal or characteristic of informal writing or conversation.
	Example: plenty of white space
color display	(n, sys). CRT or other display that can show images in more than one color.
column	(n, pub). Vertical subdivision of a line. A column of characters is a vertical line of characters.
COM	computer output microfilm (adj, sys). Conversion of output to microforms by a device that replaces the printer. The COM unit produces high-quality output at 5,000 or more lines per minute, with rapid access to data and reduction of storage space.
command	(n, sys). User instruction to a computer, generally through a keyboard. Commands are words, mnemonics, or characters that cause the computer to perform predefined operations. Coded instruction to a computer or computer-based system.
common	(adj, sys). Applicable to two or more products.
common business oriented language	*See* COBOL.
communication link	(n, sys). Physical means of connecting one location to another for the purpose of transmitting and receiving information.
communication port	(n, sys). Physical outlet used for asynchronous, synchronous, and parallel sending and receiving of information from a remote location.
communications	(n, sys). Ability of two machines to "talk" to each other.
compatibility	(n, sys). Characteristic of computer equipment that permits one machine to use the same information or programs as another machine without conversion or code modification.
compiler	(n, sys). Software that translates instructions written in high-level language into machine-level language for execution by the system.
complexity	(n, pub). Negative effects created by attempting to print too many characters, rules, or graphics.

compose	(v, pub). 1. To set and arrange type by hand, by Linotype, or with electronic equipment. 2. To merge text and graphics.
computer graphics	(n, sys). Diagrams, drawings, and other pictorial representations that are computer-generated.
computer output microfilm	*See* COM.
concept	(n). Abstract or generalized idea, the product of reflective thinking.
condensed type	(n, pub). Typeface with characters narrow in proportion to their height, thus seeming tall and tightly spaced.
confirmation prompt	(n, sys). Message displayed on a controller screen requiring a yes/no response and used to verify certain commands entered by the user.
conjunction	(n). A word (one of the eight parts of speech) that connects words, phrases, or clauses. There are three kinds—coordinating, correlative, and subordinating.
	1. Coordinating conjunctions connect words, phrases, and clauses of equal rank: **and, or, but, for.**
	2. Correlative conjunctions are used in pairs: **either...or, both...and.**
	3. Subordinating conjunctions connect subordinate clauses with main clauses: **if, although, since, in order that, as, because, unless, after, before, until, when, whenever, where, while, wherever,** etc.
conjunctive adverb	(n). An adverb that also serves as a conjunction to connect main clauses and thus form compound sentences: **however, therefore, nevertheless, hence, then, too, besides, also, further, moreover, indeed, still, thus, otherwise, consequently, accordingly,** etc.
content	(n, pub). 1. Topics or matter treated in a written work. 2. Internal subject matter in a written work (in comparison to front and back matter).
contrast	(n, sys). Ratio of the brightness of an image to its background.
controller	(n, sys). 1. Major component of a system, consisting of a rigid disk, floppy disk drive, menu screen, and keyboard. 2. Equipment that houses a microcomputer and its power system.
convention	(n, pub). Accepted syntax or visual pattern.
conventional line printer	(n, pub). Mechanical computer printer.
coordinate	(n, sys). Point on the X and Y axis that determines the position of a grid.
coordinates	(n, sys). Set of numbers specified to determine the exact position of a line of text, graphic window, or horizontal or vertical rule on a page.

copy	(n, pub). 1. Text that is created, edited, and manipulated. 2. All work to be printed: type, photographs, and illustrations. 3. Duplication of original text. 4. All written material needing to be typeset. 5. Material reproduced or printed for convenience or internal use.
copy edit	(v, pub). To correct and prepare a document for composition or typesetting and printing production.
copyfit	(v, pub). To use character counts and editing to fit type into the space allotted by the layout.
corotron	(n, sys). In an electrostatic copier or printer, the charging device, usually wire, which charges the photoconductor to produce images in the printing process.
CP/M	Control Program for Microcomputers (n, sys). Operating system developed by Digital Research Corporation and used in personal computers.
CPS	computer printing system (n, sys).
CPU	central processing unit (n, sys). Main section of a computer that handles arithmetic and logic operations.
critical dimension	(n, pub). Measurement that requires the most reduction to reach a necessary size.
crop	(v, pub). To eliminate portions of a photo or plate. To mask off unnecessary portions of a page.
crop marks	(n, pub). Marks indicating size limits.
CRT	cathode ray tube (n, sys). Evacuated glass tube in which a beam of electrons is emitted and focused onto a phosphor-coated surface to create images.
current graphic position	(n, sys). Point maintained for future reference when a graphic command is complete.
current text position	(n, sys). Point at which the next character would be printed on a page.
cursor	(n, sys). Lighted movable indicator that marks the current working position on a display and can be moved to any point by keys, a mouse, or other means.
customer documentation	(n, pub). Material that accompanies a product and is required for the operation of a product or system.
CWP	communications word processing (n, sys). Software function that controls communications jobs.

D

daisywheel	(n, sys). Small, removable metal or plastic disk with typewriter characters on spokes radiating from its center. The printhead is shaped like a wheel with many spokes. The end of each spoke contains a letter, numeral, or symbol. The daisywheel was developed by Diablo and is now in widespread use in small printers. The print method is similar to that of a regular typewriter. A daisywheel forms full characters, rather than characters made of dots. *See also* dot-matrix printer.
dangling participle	(n). A participial phrase with no logical noun or pronoun to modify. **Examining documents**, many cost-effective benefits were discovered. (The participial phrase incorrectly modifies "benefits." Benefits cannot examine documents.)
data base	(n, sys). Information to meet specific processing and retrieval needs. Generally applies to an integrated file of data, arranged for access by many subsystems.
data base management system	(n, sys). Set of programs for storing, updating, and retrieving information. Increases operational efficiency of large systems with complex and massive data storage requirements.
data communications	(n, sys). Transmission and reception of encoded information over telecommunication lines.
data structure	(n, sys). File organization designed so that relationships between data elements are preserved.
data transmission	(n, sys). Transmission of coded data over telephone or other communication links.
DCLIB	document component library (n, sys). Library used to store text and graphics of a document, which may be merged to form a complete publishable unit. Also called merge library.
debug	(v, sys). To detect and correct errors in a program.
debug testing	(n, sys). A software test sequence performed to check the logic of a software program and to isolate and remove mistakes and/or problems from the program or other software.
dedicated line	(n, sys). Communication line whose use is restricted to data transfer between two specific devices.
deductive job aid	(n, sys). Graphically presented job aid requiring the deductive process to select observation/test points, identify suspect elements, and interpret symbols. These job aids rely on the user's own knowledge to select the appropriate repair activity. *See also* BSD.

default parameters	(n, sys). Format parameters automatically used when others are not specified from the host.
defaults	(n, sys). Preset values used by a system unless the operator specifies otherwise. They may be document formats, menu selections, filled-in fields, and the like.
demand printing	(n, pub). Immediate production of documents that are prepared, stored, and distributed totally in electronic form.
density	(n, sys). Amount of thickness or crowding in a given area.
departmental publishing	(n, pub). Concept of connecting a shared data base or networked system into a departmental printer.
descender	(n, pub). That portion of an alphabetic character that extends below the baseline. *See also* ascender.
desktop	(n, sys). Space on a display screen in which users store icons that represent documents, folders, file drawers, printers, in-baskets, out-baskets, and the like. Similar to a standard office desk, it is used to create, edit, and store documents.
desktop publishing	(n, pub). Use of a personal computer as the front end to a printer.
deviation	(n, sys). Change from a specification that does not permanently affect the specification.
diagnostics	(n, sys). Software tests that can be used to test the correct operation of various elements of a system.
diction	(n). Choice of words.
	Good diction: For business documents, words should be precise in meaning and concrete rather than abstract. Well-chosen words convey the message or attitude of the writer.
	Poor diction: Slang and jargon are examples of poor diction. Imprecise words and words with highly connotative meanings can obscure the message of the writer.
digital	(adj, sys). Information represented by a code of discrete elements, as opposed to a continuous scale of analog representation.
digital type	(n, sys). Characters, such as those from a laser printer or phototypesetter, composed of thousands of lines or dots that are positioned by a computer.
digitize	(v, sys). To break an image down into individual dots.
digitized	(v, sys). Encoded electronically in digital form.

dingbat (n, pub). Symbol used for emphasis or decoration.

disk, diskette (n, sys). Flat, circular plate with magnetic coating for storing data; may be "floppy" (flexible) or "hard" (rigid). Floppy diskettes are housed in a thick paper sleeve for protection. Physical size and storage capacity of disks can vary.

disk drive (n, sys). Device that houses a disk and reads information from it or transmits information to it.

dispatch code (n, sys). Also called SAN code; a code used to identify problem areas. *See* SAN code.

display (n, sys). Visual representation of computer information, as on the face of a CRT.

display highlighting (n, sys). Ability to intensify, blink, or otherwise select certain portions of an image on a display screen. Typically done for some special activity such as deleting or moving text.

display type (n, pub). Large, specially designed typefaces used for emphasis in headlines and the like. Type of 14 points or more.

distinguished name (n, sys). Fundamental name of a user, service, or other registered entry in a clearinghouse data base. One or more aliases may be defined as the shorthand for a distinguished name. Distinguished name can appear in a fully qualified form (name:domain:organization), but can usually be shortened when domain and organization components are clear from the context.

distributed processing (n, sys). Use of intelligent programmable terminals or small computers at sites remote (or separate) from the main computer facility. These terminals communicate with one another via a network, as opposed to centralized processing.

distribution list (n, sys). List of recipients for electronic mail represented by a user group registered in a clearinghouse data base.

DJDE dynamic job descriptor entry (n, sys). One of a set of commands embedded in a stream of data being sent. Can be used to specify a feature of a job, such as form used, number of copies, job entry table, and so forth.

document (n, pub). One or more recorded or printed pages forming a logical whole. Written or printed official paper that conveys information and can be used to provide decisive information or proof.

(v, pub). To gather, collate, summarize, and code printed material for reference purposes.

document organization (n, pub). Traditional or commonly accepted framework for the organization of printed pieces. Users expect to see various elements in consistent places and sequence for fast and efficient reading. Basic elements include front, subject, and back matter.

documentation (n, pub). All information and training in any medium (for example, hardcopy, VCR, film, CRT displays, self-study text, and classroom instruction).

domain (n, sys). Group of registered items in a clearinghouse data base. Domain describes the community of users of a given network, servers, and other resources connected to that network and administered by the local system administrator.

dot (n, sys). Unit of measurement representing a fraction of an inch (also called "pixel" or "spot"). For example, 300 dots per inch.

dot matrix (adj, sys). Method of character generation in which each character is formed by a grid or matrix pattern of dots, as opposed to fully formed characters, such as those produced by a daisywheel.

dot-matrix printer (n, sys). Printer that forms characters from a two-dimensional array of dots. More dots in a given space produce characters that are more legible. *See also* daisywheel.

double-density (adj, sys). Special recording method for diskettes that allows them to store twice as much data as single-density diskettes.

double-density diskette (n, sys). Floppy disk with double the capacity of a standard disk. It can have double the number of tracks per inch, double the bit density, or a combination of both.

download (v, sys). To load information from the host into memory or disk storage.

downstyle (adj, pub). Initial capital letter on only the first word of a phrase (with the exception of proper nouns, which are always capitalized). *See also* capitalization.

downtime (n, sys). Interval when a system is malfunctioning or not operating because of mechanical or electronic failure. Period of time when a device is not working.

draft (n or adj, pub). Document that is in a preliminary, interim, or final stage of development. *See also* master.

draft-quality printer (n, sys). Printer, usually high-speed, that produces characters that are very readable but of less than typewriter quality. Typically used for internal documents for which type quality is not a major factor. *See also* letter-quality printer.

drain (v, sys). To print all pages without ending the job in progress.

drop cable	(n, sys). PVC or Teflon-coated cable that is connected to each workstation. It comes in three standard lengths: 15, 30, and 60 feet.
dry imager	(n, sys). Fine powder (also called toner). Used to print images.
dummy	(n, pub). Mock-up or other representation of the final form of a publication to be produced.
	(adj, pub). Preliminary sample or setup of a book, cover, or layout.
duplex	(adj, sys). Ability to send and receive information simultaneously.
duplex printing	(n, pub). Printing on two sides of the page. Use of both sides of the paper. *See also* simplex printing.
dynamic check	(n, sys). Check, test, or observation made on equipment in running (print) mode.

E

EBCDIC	extended binary coded decimal interchange code (n, sys). Eight-bit code that can accommodate 256 characters.
ECS	external communication service (n, sys). Service that provides terminal emulation and controls RS232C port of communication interface unit.
editorial marks	(n, sys). Standard symbols and abbreviations used to mark up manuscripts and proofs.
electronic mail	(n, sys). Generation, transfer, and display of correspondence in a network system.
electronic page assembly	(n, pub). Pages fully composed on a screen rather than pasted up by hand.
electronic printer	(n, sys). Printer that uses a nonimpact technique similar to the technology of typical office copiers. Toner particles are attracted to a static charge on the surface of a photoconductor, then the toner image is transferred to a sheet of paper. Instead of using reflected light, as a copier does, the electronic printer uses a laser to form an image according to input data.
electronic typewriter	(n, sys). Typewriter controlled by electronic rather than electromechanical means and having some memory facilities. It offers a range of features that facilitate text input and has some text editing capabilities.
elite	(adj, pub). Smallest size standard typewriter type: 12 characters per horizontal inch.

em	(n, pub). In foundry type and phototypesetting, the square of the body of any type size. Em is named for the width of the M, which is usually the widest letter in a typeface's character set. The size of an em is always equal to the current point size. When you're setting a line in 12-point type, an em is 12 points wide. *See also* en *and* thin space.
em dash	(n, pub). Long dash whose size is equal to one em.
embedded commands	(n, pub). Control codes within the text of a document.
emulation	(n, sys). A software program that causes a system or component to act like a different system or component.
en	(n, pub). Width equal to one-half em or the size of the letter N. *See also* em *and* thin space.
en dash	(n, pub). Short dash (hyphen) whose size is equal to one-half em.
ergonomics	(n, sys). Study of equipment design intended to improve convenience, ease of use, and operator comfort.
escape character	(n, sys). A nongraphic (unimaged) code that signals the transmission of control information. Control key available on some host keyboards. It is used to signal the beginning of a command sequence.
escape sequence	(n, sys). Sequence of characters beginning with the escape key.
exit reference	(n, pub). Directive reference from one job aid into either another job aid or to a repair activity.
expanded or extended type	(n, pub). Characters wide in proportion to their height, thus seeming oversized and loosely spaced.
external mail gateway	(n, sys). Option of mail service that allows separate internal users to exchange mail.

F

FAA	fault analysis algorithm (n, sys). Directive job aid, in diagram form, using a set of symbols to show an ordered sequence of checks and yes/no decisions based on the results of checks.
facsimile	*See* fax.
family	(n, pub). Set of fonts sharing the same type style but differing in height, weight, and posture.

fax (n, sys). System of communication in which a document, photograph, map, or other fixed material is converted into signal waves for transmission and receipt at a remote point. An image is scanned at a transmitter, reconstructed at a receiving station, and duplicated onto plain or treated paper.

FDL forms description language (n, sys). Utility that puts new forms onto a system disk.

feedback (n, sys). That portion of an output signal that is returned, directly or indirectly, to be compared to a reference signal in order to maintain the output signal.

(n, mgt). Return of data about the result or effectiveness of a process.

field (n, sys). 1. Part of a record that serves a similar function in all records of that group (for example, name field or address field). 2. An area or setting of practical activity or application.

file (n, sys). Set of records or text that can be stored and retrieved. In data processing applications, an organized, named collection of records treated as a unit.

file drawer (n, sys). Logical storage compartment on file server that holds information associated with a single user, project, group, etc.

file maintenance (n, sys). Keeping a file up to date by adding, changing, or deleting part of its contents.

file server (n, sys). Network device that allows shared storage of files.

file service (n, sys). Software that provides storage services to users connected to a network.

firmware (n, sys). A set of programmed instructions similar to software but stored in hardware and not loadable by the user.

fixed disk (n, sys). Magnetic disk, usually of large capacity, that is not regularly removed, as opposed to floppy disks and disk packs. *See also* disk.

fixed font (n, pub). Font containing characters with fixed spacing.

fixed pitch (n, pub). Font set in which every character cell has the same width. In reference to character sets, this term describes a typeface in which all character cells are of equal width. Monospaced as opposed to proportionally spaced.

fixed spacing (n, pub). Arrangement of characters on a line so that all characters occupy the same amount of horizontal space.

flat text/raw text (n, pub). Uncoded text to be communicated to another system. *See also* uncoded text.

flexible disk	*See* disk.
floating accent	(n, pub). Nonspacing accent character that can be combined with spacing characters and printed as a composite.
floppy disk	(n, sys). Removable, flexible plastic disk used for such purposes as software installation, data base backup, document archiving, word processing, and data storage. *See also* disk.
flowchart	(n, sys). Diagrammatic representation in which symbols are used to represent operations, data flow, and equipment.
flush	(v, pub). To be even in one plane or aligned with a margin. *See also* flush left or right.
flush-cut tab dividers	(n, pub). Separator pages that are the size of a standard page but differ in the type of material and/or color.
flush left or right	(n, pub). 1. Type vertically aligned along the left or right side of a column. 2. Composition style in which each line begins near or at the left or right margin and aligns with the lines above and below it. In typography, type set to line up at the left or right margin. The text you see here is flush right and left. *See also* justification.

The text you see here is flush left with an unjustified right.

The text you see here is flush right with an unjustified left.

foldout	(n, pub). Oversized page that is folded to fit into a book.
folio	(n, pub). 1. Page number. 2. Large sheet of paper folded in the middle, making two leaves or four pages of document. Low folio is a left-hand page, and high folio is a right-hand page.
font	(n, pub). 1. Set of images, usually characters and symbols, having common visual characteristics such as style, width, height, and weight. 2. Complete set of letters, numerals, and symbols of the same type style of a given typeface. Examples of typefaces are Baskerville, Century, and Helvetica. Examples of fonts are Baskerville Italic, Baskerville Bold, and Baskerville Bold Italic. 3. Complete assortment of uppercase and lowercase characters of one typeface. Complete assortment of any one size and style of type containing all the characters needed for ordinary composition.
font data	(n, sys). Encoded bit maps that, when stored on a rigid disk, enable the printing of characters in various fonts.
font data base	(n, sys). Area in software files that maintains and stores fonts.
footer	(n, pub). Information printed consistently at the bottom of each page of a multipage document, usually for document identification and access.

footprint | (n, pub). The area covered by a bound document when it is spread open and lying flat.

8-1/2 by 11 inch page

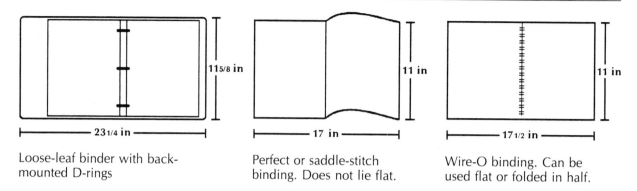

Loose-leaf binder with back-mounted D-rings

11 5/8 in
23 1/4 in

Perfect or saddle-stitch binding. Does not lie flat.

11 in
17 in

Wire-O binding. Can be used flat or folded in half.

11 in
17 1/2 in

5-1/2 by 8-1/2 inch page

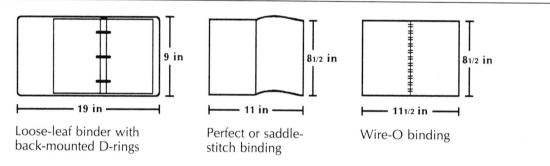

Loose-leaf binder with back-mounted D-rings

9 in
19 in

Perfect or saddle-stitch binding

8 1/2 in
11 in

Wire-O binding

8 1/2 in
11 1/2 in

11 by 8-1/2 inch page

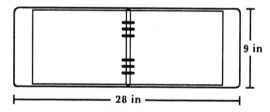

Loose-leaf binder. Special landscape format for service manuals

9 in
28 in

foreground processing | (n, sys). Operation with the system dedicated to performing that function so it cannot be used for another task, as opposed to background processing.

form | (n, sys). 1. Part made from an FSL file. 2. Printed or typed document with blank spaces for the insertion of information. 3. Specific arrangement of lines, text, and graphics stored in a computer under an identifying name. Page of data that, when preceded by the proper command, is stored on a rigid disk as a permanent file and may be combined with subsequent data by means of a form start command.

format	(n, pub). 1. Form and layout of a publication. 2. General shape, size, type area, margins, and overall appearance of a page. (v, sys). 1. To design the distribution of printed information on a page. 2. To initialize a disk.
form feed	(n, sys). Control character that causes a printer to terminate a current page.
form origin	(n, sys). Upper left corner of a form.
forms data	(n, sys). Lines, text, and logos that are part of a form design and are the same on every page.
forms-element character set	(n, sys). Set of characters, including corner, straight-line segments, and line intersections, used to design forms.
forms feeder	(n, sys). Printer component or attachment for handling continuous paper for automatic printout.
forms source language file	*See* FSL.
FPS	formatting print service (n, sys). Software service that converts diagonal and curved line graphics to a format understandable by a high-speed laser printer.
FRM	form file (n, sys). Form file that is in the print spec format.
front matter	(n, pub). 1. All the material page numbered with Roman numerals between the front cover and the beginning of the text. 2. Predetermined arrangement of data. It may refer, for example, to the layout of a printed document, the arrangement of data in a file, or the order of instructions in a program. It can also mean a set of typographical commands available at a keyboard.
FSL	forms source language (n, sys). Programming language used to design forms.
full-duplex	(adj, sys). Circuit or a protocol that permits the transmission of signals in two directions simultaneously.
fully formed characters	(n, pub). Characters formed all at once, upon impact, through a ribbon onto paper. This category includes daisywheel, typebail, and thimble printers.
fully qualified name	(n, sys). Full three-part name of a user, service, or other registered entry in a clearinghouse data base. The three components are written as NAME: DOMAIN:ORGANIZATION. In many cases, the fully qualified name is not needed and can be shortened to NAME:DOMAIN or just NAME.
function code	(n, pub). Computer code that controls machine operations other than the output of typographic characters.

function keys	(n, sys). Keys on a keyboard or a control panel that initiate a particular machine function. Key that instructs the computer to perform specific operations, ranging from executing a program to clearing a computer screen.
functional specification	(n, sys). Internal engineering specification that describes a product or system from the perspective of its operation, features, and functionality and contains all the available commands and user options.
fuser	(n, sys). Printer component that permanently affixes dry imager to paper through the application of heat.

G

galley	(n, pub). 1. Column of type, usually narrower than a regular page. 2. Tray used to hold metal type assembled for printing.
galley proof	(n, pub). Printer's proof taken from composed type before the page composition stage in order to allow detection and correction of errors.
gateway service	(n, sys). Service that allows communicating word processors to utilize electronic mail facility provided by mail service.
gateways	(n, sys). Services that provide compatibility between systems of differing architectures. They transform communication protocols and information formats so that incompatible systems can communicate with one another.
generic	(adj). General; not bearing a product name.
global search and replace	(n, sys). Facility of a word processing system or properly programmed computer system to search for repeated occurrences of an information unit and replace or modify each with a few initial keystrokes.
gothic type	(n, pub). Type without serifs. *See also* sans serif.
graphic	(adj, pub). Pictorial or drawn.
graphic input unit	(n, sys). Device capable of digitizing graphics for input to a computer or network system.
graphic window	(n, sys). User-defined raster grid within which each pixel can be specified as black or white.
graphics	(n, pub). Use of lines and figures to display data, as opposed to use of printed characters. *See also* bit-map graphics.
graphics scanner	(n, sys). Piece of hardware that converts a graphic image (line art or halftone) into a digitized format.

grid	(n, pub). Imaginary pattern of evenly spaced horizontal and vertical lines on a page.
grid unit	(n, pub). Smallest rectangle enclosed by the horizontal and vertical lines of a grid. The size of a grid unit is expressed as the length of one side.
group	(n, sys). Named collection of users who can be granted access rights to file drawers. The group can contain individual users and/or entire other groups. Alternatively, the group can contain a pattern, in which case it implicitly contains all users whose names match that pattern.
guide	(n, pub). 1. Device that regulates or directs motion or operation. 2. Sheet or card with a projecting tab inserted in a card index to facilitate reference. 3. Handbook of information.
gutter	(n, pub). White space along the margins between facing pages and/or white space between the columns of text on a single page.

H

half-duplex	(adj, sys). Circuit or protocol that permits the transmission of a signal in two directions, but not both directions at the same time.
halftone	(n, pub). Picture in which gradation of tone is reproduced by gradation of dots, produced by interposition of a screen during exposure. Gray tones of a photograph or artwork accomplished with a dot pattern.
handbook	(n, pub). Book capable of being conveniently carried as a ready reference tool; manual; concise reference book covering a particular subject.
handshake	(n, sys). Exchange of signals between modems or terminals to verify compatibility and establish that transmission can begin.
hard disk	(n, sys). Inflexible disk, as compared to a diskette. It is more expensive than a diskette but is capable of storing much more data. *See also* disk *and* Winchester disk.
hardcopy	(n, sys). Machine output in a permanent form, such as printed reports, listings, etc. Output in a permanent form (usually on paper or paper tape) rather than temporary form, as on a display screen. Contains readable printed copy of the machine output.
hardware	(n, sys). Mechanical, magnetic, electronic, and electrical devices that make up a computer. The physical equipment that makes up a computer system.
hardwiring	(n, sys). Circuitry to implement system functions or connect certain classes of terminals.

header	(n, pub). Information printed consistently at the top of each page of a multipage document, usually to help the reader locate information.
headings	(n, pub). Lines set in a larger type than body copy to break up the text and emphasize main points.
headline style	(n, pub). First letter of each word in a phrase capitalized. *See also* capitalization.
headliner	(n, pub). Machine that sets display type positioned individually by hand.
head-to-head	(adj, pub). In duplex printing, when the page top is printed in the same position on both recto and verso pages. This usually indicates a portrait document, bound on the left. *See also* head-to-toe.
head-to-toe	(adj, pub). In duplex printing, when the recto page top is printed in the same position as the verso page bottom. This usually indicates a landscape document bound at the top. *See also* head-to-head.
held art	(n, sys). Graphics or images stored in a merge library.
hexidecimal	(adj, sys). Numbering system with a base of 16. In this system, 10 through 15 are represented by A through F, respectively.
high-level language	(n, sys). English-like language whose statements must be compiled in a program to be run on a computer. BASIC and FORTRAN are high-level languages.
highlighting	*See* display highlighting.
horizontal	(adj, pub). Across the page in line with zero slope.
horizontal page	*See* landscape page orientation.
horizontal scrolling	(v, sys). Facility to move a line of text horizontally on a screen to access more characters than may be shown on a screen at one time.
horizontal tap	(n, sys). Horizontal skip in spacing across a page to a predesignated location.
host	(n, sys). Any computer that is accessed by users and serves as a source of high-speed data processing for workstations with less computer power. Commonly referred to as mainframe, as opposed to workstation or service.
host interface	(n, sys). Hardware and software at a common boundary between a central computer and the units with which it communicates.
hot type	(n, pub). Type made from metal.

hot zone | (v, pub). Area near the right-hand margin, controlling placement of the last word on a line of text or activating automatic carriage return.

I

ID | identification (n, sys). Identifier consisting of 1-8 or 1-20 alphanumeric characters (0...9, A...x, "-").

idiom | (n). An expression that is peculiar to a language. (Idioms sometimes violate established rules of grammar but are, nevertheless, sanctioned by common use.)

 Look me up the next time you need a printer.

 I have known them for **many a year**.

image area | (n, sys). Area on a physical page that may contain text or graphics.

(n, pub). Area occupied by all printed information on a page. The portion of a page on which copy is placed. The page number is placed outside the image area, in the margin.

image generating module | (n, sys). That portion of operating system software that receives formatted pages with font data and converts it to video stream for output to laser scanner.

impact printer | (n, sys). Printer that produces characters by impact through a ribbon. This category includes fully formed character printers as well as many dot-matrix printers.

impact printing | (n, sys). Conventional means of printing, in which hard die hammer inked ribbon onto paper. It is used in typewriters, many dot-matrix printers, and line printers.

imposition | (n, pub). 1. Placement of several pages together on a sheet with correct margins, so that, when the sheet is folded, pages appear printed in correct sequence and position. 2. Correct positioning of individual pasteup pages so they fall in proper sequence when signatures are folded. Usually responsibility of the commercial printer.

inbound data | (n, sys). In SNA environment, data that is sent from a remote device to the host.

indicia | (n, pub). Identifying marks; guidelines for the placement of copy on a page.

infinitive | (n). A verb form (verbal) usually identified by "to" plus the present tense of a verb: **to write**. The infinitive is used as a noun, an adjective, or an adverb.

1. Noun: I tried **to run** five miles. (The infinitive phrase is the direct object of the verb "tried.")

2. Adjective: I have a document **to write**. (The infinitive "to write" modifies the noun "document.")

3.	Adverb: **To complete** the project, you will need . . . (The infinitive phrase modifies the verb "will need.")

Before some verbs, the "to" is omitted:

Phil helped me (to) **edit** my copy.

The important rule to remember is to avoid splitting the infinitive. Occasionally you will have to. Generally, however, do not place a modifier between the "to" and the verb.

1.	Incorrect: My intent was **to** continuously **write** for an hour.

2.	Correct: My intent was **to write** continuously for an hour.

information processing	(n, sys). Generic term that encompasses both word processing and data processing and is used to describe the entire scope of operations performed by computer.
information system	(n, sys). Group of computer-based systems and data required to support businesses and other organizations.
initial caps	(n, pub). First letter of each word except articles and short prepositions is capitalized. *See also* capitalization, headline style.
initial machine observation	*See* IMO.
initialism	(n, pub). An abbreviation that is formed from initial letters but does not constitute a separate word. *See also* acronym.
initialize	(n, sys). 1. Procedure that causes an operating system to begin operation. 2. Preparation of a disk for use by naming and formatting it.
ink-jet printer	(n, sys). Nonimpact printer that utilizes droplets of ink. As the print-head moves across the surface of paper, it shoots a stream of tiny, electrostatically charged ink drops at the page, placing them to form characters.
input	(n, sys). Data or text introduced into a computer-based system.
input devices	(n, sys). Keyboards, magnetic media, or any device used to give a computer alphanumeric or graphic information.
input media	(n, sys). Various forms of material, such as tape or disks, used to provide input.
input processing	(n, sys). Control of formatting for the pages of a report.
insert	(v, pub). To place additional text or art in copy.
instruction	(n, sys). 1. Command that tells a computer what operation to perform next. Direction to the computer to perform some operation on specified data. 2. Precept; direction calling for compliance; outline or manual of technical procedure; directions.

instructor	(n). One who instructs; teacher. *See also* trainer.
integration	(n, sys). Combination of computer-based functions, such as word processing, data processing, and telecommunications, to operate as a single system. Allows cooperation among users and the sharing of resources.
integration test	(n, sys). Software test sequence used to test a product as "whole" after each part has been individually tested (developmental tests) and all interfaces verified (integration testing). It ensures that each part of the product and/or software will function and interface properly.
intelligent terminal	(n, sys). Terminal with logic and memory facilities.
interactive	(adj, sys). Reactions and responses between systems and users affecting the progress of operations.
interactive terminal service	*See* ITS.
interface	(n, sys). Common boundary between systems or parts of systems. Often refers to an electronic device that enables one kind of equipment to communicate with or control another.
interface specification	(n, sys). Internal engineering specification that describes a product or system from the perspective of its interfaces.
interlock	(n, sys). Part that controls a machine by electronically linking devices together in order to assure continuity of power.
internal fonts	(n, sys). Font data embedded in the system; these fonts are neither downloaded nor loaded from a diskette.
international paper sizes	(n, pub). Common paper sizes used in Europe and Japan. They are designated as sizes A3 (11.7 by 16.5 inches), A4 (8.3 by 11.7 inches), A5 (5.8 by 8.3 inches), B4 (10.1 by 14.3 inches), B5 (7.2 by 10.1 inches), and B6 (5.1 by 7.2 inches).

SIZE	IN MILLIMETERS	APPROX. INCHES
A1	594 x 841	23 $\frac{3}{8}$ x 33 $\frac{1}{8}$
A2	420 x 594	16 $\frac{1}{2}$ x 23 $\frac{3}{8}$
A3	297 x 420	11 $\frac{3}{4}$ x 16 $\frac{1}{2}$
A4	210 x 297	8 $\frac{1}{4}$ x 11 $\frac{3}{4}$
A5	148 x 210	5 $\frac{7}{8}$ x 8 $\frac{1}{4}$
A6	105 x 148	4 $\frac{1}{8}$ x 5 $\frac{7}{8}$
A7	74 x 105	2 $\frac{7}{8}$ x 4 $\frac{1}{8}$

International Organization for Standardization	*See* ISO.
internetwork	(n, sys). Compound, multisite, store-and-forward communication network comprising networks, point-to-point links, and routing services.
inverse video	(n, sys). Mode of displaying characters on a CRT screen opposite of that screen's normal display.
IRS	internetwork routing service (n, sys). Service that routes communication traffic among multiple networks and point-to-point links to create a single unified internetwork.
ISO	International Standards Organization (n, pub). Organization that develops and publishes international standards for a variety of technical applications, including data processing communications.
isolated text	(n, pub). 1. One or two lines at the end of a paragraph carried over to the top of the next page or column. 2. Partial word appearing as the final line in a paragraph.
italic typeface	(n, pub). Light, slanting typeface, often used for emphasis in text or calling out names of publications.
italics	(n, pub). Characters that slant to the right.
ITS	interactive terminal service (n, sys). Software that permits teletypewriter-like terminals to send mail to or receive mail from other users on a network.

J

JDE	job descriptor entry (n, sys). Collection of specifications that describe a particular job.
JDL	job descriptor library (n, sys). Collection of JDEs stored in a file on the disk.
job	(n, sys). Sequence of operations performed to result in a desired product or service.
job delimiter	(n, sys). Electronic printing command that marks the beginning or end of a job and invokes certain printing functions, such as page offsetting, printing status sheet, or resetting document format parameters.

job specification	(n, sys). Document that defines what kind of computer creates the job to be printed, what forms to use, what fonts to use, whether or not the job is to be collated, where to start printing on the page, and so forth.
justification	(n, sys). Spacing of words within a line so that even or ragged margins are created on both sides of the column. *See also* flush left.

K

k	(n, sys). Standard abbreviation for the quantity 10^3 or kilo, denoting 1,000.
K	(n, sys). Standard abbreviation for the computer quantity 2^{10}, or 1,024.
kchar/s	(n, sys). Symbol for 1,000 characters per second (for example, 50 kchar/s equals 50,000 characters per second).
kern	(n, pub). 1. In hot metal typesetting, any part of the type that extends beyond the main body. 2. In phototypesetting, the overhang between adjacent characters that must be correctly overlapped. This process is called either "kerning" or "mortising." Typographers adjust the space by the shapes of the adjacent letters.
kerning	(n, pub). Negative letterspacing that makes certain letters appear better fitted together. *See also* kern.
keyboard	(v, sys). To enter information via the keyboard for any use, including immediate typing or transferring to computer storage for later processing or reproduction.
	(n, sys). Equipment from which data is input to a computer.
keyliners	(n, pub). 1. Pasteup artists. 2. Production artists or production editors.
keyword	(n, sys). Significant word that identifies the function of a command and must always be expressed in a specified way.
	(n, pub). Substantive word in a document title (or other item within a data base). Used to classify content. Such words provide access to an item when they are used as search terms. For example, keywords in the title "The Impact of Computers on Copyright Law" would be "Computers," "Copyright," and "Law." *See also* KWIC *and* KWOC.
kilo	*See* K *and* k.
kilobaud	(n, sys). Measure of data transmission speed: 1,000 bits per second. *See also* baud.

KWIC | keyword in context (n, pub). Form of automatic indexing. As items are added to a data base, keywords are extracted from their titles (or from abstracts or portions of the text). Common words that are not indicative of content (for example, and, of, the, etc) are eliminated by means of a stop list. For each keyword, a list can then be generated showing the context within which it appears in each item. An entry in a KWIC index normally consists of lines of text printed so that the keyword appears in a central column in alphabetical order, with context to the left and right. A document reference number is entered for each line. *See also* KWOC.

KWOC | keyword out of context (n, pub). Indexing system in which titles are printed in full under as many keywords as the indexer considers useful.

L

LAN | local area network (n, sys). Communication network that interconnects a variety of office equipment and computers within a fairly small area, such as an office building. Xerox Ethernet is an example of a LAN.

landscape page orientation | (n, pub). Orientation of the lines of type or the top of an illustration parallel to the long edge of the paper.

large scale integration | *See* LSI.

laser | light amplification by simulated emission of radiation (n, sys). Device that transmits an extremely narrow and coherent beam of light. Used in communications, facsimile, storage, and electronic printing.

laser printing | (n, pub). Technology that uses a laser to transfer character forms to the page by direct or indirect means.

latent image | (n, pub). Static charge present on a photoconductor before contact with toner particles.

layout | (n, pub). 1. Drawing containing the complete specifications of a printing job. 2. Preliminary sketch or arrangement showing the position, size, and color of illustrations and text.

leader dots | (n, pub). Also called leaders. Row of dots guiding the eye across a page. They are evenly spaced to provide continuity between information on the left to information on the right.

leading | Pronounced "ledding" (n, pub). 1. Vertical distance between lines (also called line space). It is measured from the baseline of one line to the baseline of the next. 2. Extra spacing between lines of type. 3. In typography, the spacing between lines and paragraphs, which is expressed in point and half-point values.

The specification for leading is often written as the denominator (bottom number) of a fraction, with type size as the numerator (top number). For example, type specified as 10/11 is set at point size 10 with leading of 11 points. Ten-point type to be "set solid," ie, with no leading, is specified as 10/10. If the typeface is small or all caps, it can be set "minus leaded," as in 10/9.

Leading may be specified as primary or secondary. Primary leading is the line spacing between lines of type in running text. Secondary leading is the line spacing between paragraphs in running text.

Leading may be specified as "spacing" and the following formulas applied:

Primary lead = type size + 1 or 2 points
Single space = primary lead
Space and a half = primary lead · 1-1/2
Double space = primary lead · 2
Triple space = primary lead · 3

LED light emitting diode (n, sys). Form of display lighting employed on many different office, reprographic, and consumer products.

leftovers (n, sys). Portions of character images not processed within the same band as previous portions and reserved for processing within succeeding bands.

letter-quality printer (n, pub). Printer that generates output suitable for high-quality business correspondence, matching the quality of electric typewriter printing. It is used to produce the final copies of documents. The output of a letter-quality printer is comparable in quality to that of a typewriter. *See also* draft-quality printer.

letterspacing (n, pub). Amount of space between letters. Letterspacing is usually adjustable. Additional space between characters to help justify line.

library (n, sys). Collection of complete programs or data written for a particular computer.

ligature (n, pub). Two letters that, because of their design, may be typeset as one character. "Fi" and "fl" form ligatures in many typefaces.

light emitting diode *See* LED.

light pen (n, sys). Stylus that detects light generation on a CRT and is used to create and move elements on a CRT.

line (n, pub). Horizontal or vertical rule of a specified thickness extending a specified length from a selected point.

line ending (n, sys). Code sequence denoting the end of a print line or command. Line endings can vary from system to system according to the interface and protocol used.

line-ending decision	(n, sys). Function found in many word processors, in which printing is automatically returned to the left margin of the next successive line without a command from the input operator.
line feed	(n, sys). Control character that (unless set to be interpreted as a line end) causes the printer to begin printing in the current character position of the next line.
line guide	(n, pub). Line-spacing device.
line length	(n, pub). Distance right and left between two margins.
line measure	(n, pub). Width of a line of type.
line printer	(n, sys). High-speed printer that prints an entire line of characters at once.
line tables	(n, sys). Internal data structures providing a record in memory of lines to be drawn on a page.
line width	*See* line length.
live matter	(n, pub). Area on a page where body text and graphics appear.
load	(v, sys). To insert a disk into a computer so the computer will enter software into its memory in order to run program(s).
load fonts	(v, pub). To supply a system with digitized font information that can be used in printing documents.
local area network	*See* LAN.
log	(v, pub). To record the sequence and status of copy.
logic level	(n, sys). Either of two voltage levels, corresponding roughly to +5 or 0 volts, that designate the presence of 1s and 0s in a data stream.
log on and log off	(v, sys). To sign onto a terminal before using its functions and to sign off again when finished.
logo or logotype	(n, pub). Trademark or signature of a company.
	(n, pub). Two or more characters set as single unit.
look-up table	(n, sys). Table of stored values that do not have to be computed each time they are required.
lowercase	(adj, pub). Small letters, in contrast to capital or uppercase letters. Of or relating to small letters, as distinguished from capitals. *See also* capitalization.

LSI	large scale integration (n, sys). Chip containing 500 to 20,000 electronic devices. At 100,000 units, it is referred to as VLSI (very large scale integration).
LST	(n, sys). File extension of a listing file that contains the results of form compilation.

M

M	(n, sys). Standard abbreviation for the quantity 10^6 or mega, denoting 1,000,000.
machine language	(n, sys). Coded language used directly by a computer, in which all commands are expressed as a series of 1s and 0s; binary code.
machine readable	(n, sys). Text encoded in a digital format or, in the case of optical character recognition, translatable to digital form by an appropriate input device.
magnetic media	(n, sys). Magnetically coated materials used for text, data, or program storage. Magnetic media include cassettes, computer tape, floppy disks, and rigid disks.
magnetic tape	(n, sys). Data storage device consisting of metal or plastic tape coated with magnetic material such as iron oxide. Data is stored as small magnetized spots, read by read/write head. It is used as a mass storage medium and packaged on reels. Since data stored on magnetic tape can only be accessed serially, it is not practical for use with personal computers. It is often used as a backup device on larger computer systems.
magnification	(n, sys). Enlargement of space covered by a graphic image. This is performed by repeating pixels.
mail folder	(n, sys). Logical electronic container that holds mail addressed to a particular recipient. The mail folder serves as the user's post office box, holding mail until it is examined from the user's workstation.
mail service	(n, sys). Software that permits network users to exchange mail. Should reside on its own server. In order for users to exchange mail, they must have mailboxes created for them. Electronic mail service delivers mail by placing it in the recipient's electronic mail folder, where it can be retrieved and read.
main line	(n, sys). Base horizontal line of an equation.
mainframe	(n, sys). Central processing unit of a computer; usually used to refer to large-scale computers. Computer that is physically large and provides capability to perform applications requiring large amounts of data (for example, a large-scale payroll system).

make up	(v, pub). To arrange type and graphics into their proper pattern, using the layout as a guide. To assemble typeset matter and art into finished pages.
mandatory	(n). Required legal statement.
manual	(adj, pub). Worked or done by hand and not by machine.
	(n, pub). A book that is conveniently handled, a handbook.
map	(v, sys). To translate received codes to designated font characters according to menu- or command-selected tables.
margins	(n, pub). White space on each side of printed text.
mark up	(v, pub). To use standard symbols and proofreader marks to write instructions on copy or proof regarding how it should be prepared or corrected.
master	(n, pub). Hard or electronic copy of a document, which is approved for printing. When a master enters revision or boilerplate process, it then reverts to draft status.
matrix printer	(n, sys). Printer that produces images formed from dots that conform to a matrix unit. For example, 5- to 7-dot character size is frequently used for low-resolution output.
Mbyte	(n, sys). 1,048,576 bytes. *See also* bit.
mechanicals	(n, pub). Camera-ready pages or boards. Mechanicals are also called keylines, artboards, or pasteups.
medium	(n, sys). Physical substance upon which data is recorded (for example, magnetic disks, magnetic tape, or punched cards).
memory	(n, sys). Space in a device where information is kept, or the ability of a device to keep information until needed.
menu	(n, sys). Display of the control program; used to present options or choices for the user.
menu driven	(adj, sys). Program that allows the user to direct operations by a series of hierarchical choices.
menu tree	(n, sys). Set of menus available on a menu screen, portrayed in a manner that illustrates their hierarchical organization.
merge	(v, sys). To superimpose a constant page or one or more forms from memory over a page of data currently being received.
merge page	(n, sys). Page of data, either graphics or text, that is stored in working memory and may be merged with information contained in subsequent pages.

microcomputer	(n, sys). Small computer containing microprocessor, input and display devices, and memory. Also called personal computer or PC.
microfiche	(n, sys). Sheet of microfilm with highly reduced images for storage of large records. Usually 105 millimeters by 148 millimeters (4.1 by 5.8 inches) formatted to hold 98 8-1/2 by 11-inch pages at 24X reduction (7 rows by 14 columns).
microprocessor	(n, sys). Single chip or integrated circuit containing the entire central processing unit for a personal computer or computer-based device.
MIL-SPEC	military specification (adj, pub). A highly structured page format specified for the documentation produced for certain government contracts.
mock-up	(n, pub, sys). A full-sized structural model built accurately to scale and incorporating such visual details as color, texture, finish, and graphics, chiefly for study, testing, or display.
mode	(n, sys). Method of operations or set of conditions under which operations are performed. Designed sequence of equipment operation from a main initiating condition to a terminal observable condition.
modem	modulator/demodulator (n, sys). Converts digital information into an analog signal suitable for sending over analog phone lines. Also converts an analog signal from phone lines into digital information.
modifier	(n). Any word or group of words that describes or qualifies another word or group of words. *See also* modify.
modify	(v). To describe or qualify the meaning of a word or group of words. In a diagram modifiers are attached to the words they modify. A very old man hobbled slowly along the road. ("A" and "old" modify "man"; "very" modifies "old"; "slowly" and "along the road" modify "hobbled"; "the" modifies "road.")
modulation	(n, sys). Process by which a characteristic of one wave is varied in accordance with a signal. Used for the transmission of data, voice, or image information on a carrier.
modulator/demodulator	*See* modem.
monospace	*See* fixed width.
mortise	(n, pub). Method of correcting or revising, in which a portion of copy is cut out and replaced with corrected copy of the same size. *See also* kerning.
mosaic graphics	(n, pub). Graphic designs digitized and used like fonts. In mosaic graphics, pictures often are divided into pieces that must be put together in order to create the desired effect.

mouse	(n, sys). Palm-sized device connected to a workstation. When it is moved, it provides a corresponding movement of a cursor on screen.
multicopy form	(n, pub). Preprinted multipage form that contains carbon paper between its pages (for example, W-2 forms and credit card receipts).
multilith master	(n, pub). Paper master that goes directly to the printing press.
multinational	(adj, sys). Capabilities designed to reflect the requirements of various nations, such as printing requirements.
	(n). A corporation with operating units located in foreign locations.
multiplex	(v, sys). To interleave or simultaneously perform more than one operation.
multiplexer	(n, sys). Device that allows the transmission of a number of different signals simultaneously over a single channel.
multi-reel job	(n, sys). Job that is printed from more than one tape.
multi-report tape	(n, sys). Tape that contains more than one report.
Mylar	(n). Trade name (DuPont) of a polyester film used for film positives.

N

network	(n, sys). Group of computers that are connected to each other by communications lines to share information and resources.
network architecture	(n, sys). Organizational concept for enabling devices at multiple locations to communicate over common carrier transmission facilities. The network architecture specifies processors, workstations, and terminals, and it defines protocols and software that must be used to accomplish accurate data communication.
network holding area	*See* file server.
network number	(n, sys). Unique numeric code that identifies a given network in an internetwork. It is used in conjunction with a processor number to route data among the machines in the internetwork.
nomenclature	(n, pub). Set of terms or symbols and their definitions.
noncollate	(n, sys). Not to arrange in order.
nonimpact printer	(n, pub). Class of printers that form images without striking the page, such as thermal, ink jet, or electrostatic.

nonreproducing	(n, pub). Marks on copy not picked up in the reproduction process.
nontextual data	(n, sys). Data in which binary codes are not intended to invoke the printing of font characters.
note	(n, pub, sys). Operating or maintenance procedure, condition, or statement that is essential to highlight.
noun	(n). The name of a person, place, thing, or quality (one of the eight parts of speech). Nouns are classified as:

1. Common: A common noun is the name applied to any one of a class of persons, places, or things: **adult, child, city, state, chair, bed.**

2. Proper: A proper noun is the name applied to a specific person, place, or thing: **Henry Ford, Jane Addams, New Orleans, California,** the **Parthenon,** the **Washington Monument.**

3. Concrete: A concrete noun names something that can be perceived by one or more of the senses: **water, trees, flower, river.**

4. Abstract: An abstract noun names a quality or general idea: **love, ambition, hate, pity, freedom.**

numeric character	(n, sys). Character that belongs to one of the set of digits 0 through 9.

O

object	(n). A noun or pronoun (or a phrase clause used as a noun) that receives the action of a transitive verb or follows a preposition.

1. Direct object: Any noun (or its equivalent) that receives the action of a transitive verb.

> We raked **leaves**. (noun)

> They supplied **whatever was needed**. (clause used as a noun)

2. Indirect object: Any noun (or its equivalent) that indirectly receives the action of the verb.

> She gave **me** an apple. (''Apple'' is the direct object; ''me'' the indirect object of the verb ''gave.'' You can usually substitute a prepositional phrase for the indirect object.)

3. Object of a preposition: Any noun (or its equivalent) following a preposition. *See also* preposition.

> I walked into the **house**. (''House'' is the object of the preposition ''into.'')

OCR	optical character recognition (n, sys). Electronic means of scanning (reading) copy and then converting the scanned image to a digital equivalent.
off-line	(adj, sys). Equipment that is not in direct communication, as opposed to on-line.

offset	(v, pub). To place pages currently being printed in a slightly different position from previous pages.
	(n, pub). Common term used for the offset-lithography printing method.
on-line	(adj, sys). Equipment that is in direct communication or available for immediate use.
operating system	(n, sys). Master programs that keep all computer components working together, including application programs.
operation	(n, sys). 1. Performance of practical work or something involving the practical application of principles or processes. 2. Single step performed by a computer in execution of a program.
operational check chart	(n, sys). Directive job aid in chart form depicting normal equipment operation in sequence, from power-on through cycle-out, and associated observable indications of normal operation. It includes instructions and references to other job aids or repair activities to be followed if correct indications are not observed.
operator	(n, sys). 1. One who operates a machine or device. 2. Mathematical function.
optical centering	(n, sys). Positioning of an object slightly above center.
Optima	(n, pub). Widely used typeface.
orientation	(n, sys). 1. In reference to an image area, describes whether printed lines are parallel to the long edge of the paper or the short edge. Font and page orientation may not match. 2. Choice of printing portrait (vertically) or landscape (horizontally).
origin	(n, pub, sys). 1. On a page, this is the bottom left corner in portrait orientation and the top left corner in landscape orientation. 2. In a graphic window, origin is the top left corner, which is given the value 0.,0. 3. Zero point of X-Y coordinate system. 4. Upper left corner of a page, line, box, or cell containing a logo.
orphan	(n, pub, obsolete). *See* isolated text.
orthographic projection	(n, sys). Drawing method used to show an object in two dimensions.
outbound data	(n, sys). In an SNA environment, data that is sent from a host to a remote device.
output	(n, sys). 1. Material produced by a peripheral device of a computer, such as a printout or magnetic tape. 2. Result of completed operations.
overhead	(n, pub). Clear acetate page used for projecting copy on a screen. *See* transparency.

overlay	(v, sys). To repeatedly use the same area of internal memory for bringing routines into memory from bulk storage. Used when the available main memory is smaller than the total storage requirements necessary for all program instructions. (n, pub). Transparent sheet used in preparing for multicolor printing.
overstrike characters	(n, sys). Characters printed over each other. *This is an overstrike*

P

PABX	private automatic branch exchange. (n, sys). Exchange that handles the transmission of calls to and from a public telephone network. *See also* PBX.
packet	(n, sys). Collection of data to be transmitted. Packets typically contain routing and error-correction information. Large amounts of data are often broken into smaller packets to be transmitted.
packet switching	(n, sys). Mode of transmission in which a message is divided into fixed-length packets rather than being sent in its entirety. Used to increase the overall speed of transmission and reception.
packing	(n, sys). Instructions used to reduce the size of a graphic file.
page	*See* physical page.
page end	(n, sys). Command character (form feed) to terminate a current page.
page number	*See* folio.
page printer	(n, sys). Electronic printer that produces a page at a time. *See also* line printer.
page proof	(n, pub). Typed output in page format, complete with headings, rules, and numbers.
page scrolling	(n, sys). The ability of a system to "flip" through document pages, usually both forward and backward, allowing the display of all the text in a multipage document.
pagination	(n, sys). Process of putting page numbers in place. Process of separating text into pages.
pallet	(n, sys). Portable platform on which the container for paper in output bins rests.
paper sensing switch	(n, sys). Switch that "tells" the printer where the paper is located.

paper source (n, sys). One of four paper input trays: main tray, two paper cassettes, or large paper feeder.

paragraph (n, pub). A group of sentences expressing a complete thought.

(n, sys). A line or group of lines set off from other sets of lines by extra space above and below.

parallel interface (n, sys). 1. Type of interface between a printer and its host in which data is transmitted and received in bytes rather than bits. Used for local printing over short distances (25 feet, 7.63 meters, or less). 2. Type of connection of one device to another that uses eight data wires in a cable. This allows eight bits (one byte) of data to be sent at the same time.

parallel structure (n). Parallel structure exists when two or more elements of equal rank in a sentence, list, or outline are similarly expressed. Like elements are expressed in like grammatical form.

1. Nonparallel: These documents are **appropriate** and **written in a clear organizational style**.

2. Parallel: These documents are **appropriate** and **well organized**.

parameter (n, sys). Character that describes an item in command. Quantity in command format. It may be given different values in different commands.

parenthetical (adj). A qualifying or amplifying phrase occurring within a sentence. It gives additional and interesting, but grammatically unnecessary, information.

You know, **of course**, to edit your own writing.

parity bit (n, sys). Extra bit used to ensure that data has been transmitted accurately by providing the receiving device with a means of checking odd or even parity.

participle (n). A verb form that can be used as an adjective. In the present tense, it ends in "ing." In the past tense, it usually ends in "ed" or "en."

1. Present: the **swimming** team.

2. Past: **unfinished** business.

In addition to being used as a single-word modifier, it can introduce a phrase:

Examining the documents, the customers discovered many cost-effective benefits. (The participial phrase logically modifies "customer.")

password (n, sys). Required code in addition to a user's name or number that allows him or her to log on.

pasteup (v, pub). To assemble camera-ready elements with adhesives to be photographed for printing. *See also* electronic page assembly.

patch (n, sys). Temporary "fix" of an error in coding.

pathnames	(n, sys). Means for specifying a route to objects that are nested within other objects, such as elements of a data base.
PBX	private branch exchange (n, sys). Manual exchange connecting a public telephone network to a user's equipment.
PC	personal computer (n, sys). *See microcomputer.*
PC-FDL	(n, sys). Version of an FDL compiler that runs on a personal computer.
PDL	print description language (n, sys). A utility that puts new JDLs onto a system disk.
perfect binding	(n, pub). Method of binding in which the pages are held together and fixed to the cover with flexible adhesive.
performance check chart	(n, sys). Directive job aid, in chart or column form, containing instructions to operate equipment in any normal or diagnostic mode(s); perform checks and test the normal observations that should result from these actions; and exit to provide references to other job aids or repair activities to be followed if normal indications are not observed.
peripheral equipment	(n, sys). Input/output units and secondary storage units of a computer or computer-based system. The central processor and its associated storage and control units are the only parts of a computer system that are not considered peripheral equipment.
permanent internal font	(n, sys). One of five fonts always resident in memory.
photoconductor	(n, pub). Metallic substance, such as selenium or cadmium sulfide, which conducts and retains electrical charges until exposed to light. Used in electrostatic copies and printers.
photoreceptor	(n, sys). Receptor that transfers information in the form of an image onto paper.
Photostat	(n, pub). Trademark for a device that makes quick, direct-reading negative or positive copies. Also referred to as a "stat."
phototype	(n, pub). Type created by projecting light onto photosensitive paper.
phototypesetting	(n, pub). Photographic production of composition using a keyboard. Images created by electronic or optical systems on photographic paper or film. Input can be direct keyboard entry or magnetic media.
physical device	(n, sys). Hardware piece associated with a computer.
physical page	(n, sys). Sheet of paper on which printing is done.
pi font	(n, sys). Font with math symbols, dingbats, and/or other special characters to meet specific needs.

pica	(n, pub). Unit of measurement equal to 0.166 inch. Picas are often used to express line measure or column width. There are about 6 picas in an inch. *See also* point.
pitch	(n, pub). Horizontal character spacing; 10-pitch (10 characters per inch) spacing is termed pica, and 12-pitch (12 characters per inch) spacing is termed elite.
pixel	(n, pub). Acronym for "picture elements." Smallest addressable point of a bit-mapped screen that can be independently assigned color and intensity. Pixels are definable locations on a display screen that are used to form images on screen. For graphics displays, screens with more pixels generally provide higher resolution. *See also* bit-map graphics.
platen	(n, pub). Typewriter or impact printer roller.
plotter	(n, sys). Hardcopy output device that can use any of a number of technologies to form an image. Used when the output is primarily graphic rather than text or statistics.
PMS color	(n, pub). Pantone Matching System for ink colors. The PMS book is available commercially.
pocket fold	(n, pub). Oversized page folded so that it can be inserted in an envelope or pocket.
point	(n, pub). Unit of type measurement equal to 0.0139 inch. Points are always used to express type size and leading. There are 12 points in a pica and about 72 points in an inch. (Every 4 inches you must add 1 extra point to be accurate). *See also* pica.
point size	(n, pub). Height of a character set from the top of its ascenders to bottom of its descenders in units (points). Point size does not always include leading.
point-to-point	(n, sys). Feature that allows one or more stations of a communicating system to check with other systems to see if a message is ready to be sent.
polygon	(n, sys). Rotating, many-sided disk whose function is to deflect beams of light at regular intervals across the surface of a xerographic drum.
port	(n, sys). Connecting point between a piece of equipment and the means of data transmission.
portrait page orientation	(n, pub). Orientation of the lines of type or the top of an illustration parallel to the short edge of the paper.
posture	(n, sys). Vertical inclination of font characters.

predicate	(n). The part of a sentence or clause that expresses something about the subject. It consists of a verb and its objects, modifiers, or complements.
	The printer **is quiet**. The key **hit the page**.
preposition	(n). A word (one of the eight parts of speech) used to show the relationship of a noun or pronoun to some other word in the sentence.
	She ran **with** the team. (The preposition shows the relationship between the noun "team" and the verb "ran.")
	The bird is **in** the tree.
	They walked **into** the house.
	The owner **of** the house is absent.
preprint	(n, pub). Page with resource information set up in final form and reproduced. This can be tipped (inserted) into many different documents as required.
press-on type	*See* transfer type.
primary code set	(n, sys). First half of an 8-bit code set; that is, codes X'00' through X'7F'.
print	(v, pub, sys). To produce a paper document from data sent from a host. To produce hardcopy.
print file	(n, sys). Portion of a rigid disk memory reserved for the temporary storage of formatted pages for printing. Pages are retained in the print file until they are delivered to an output tray.
print job	*See* job.
printer	(n, sys). Device that produces the paper copy of a document, also known as hardcopy.
	(n, pub). The person or vendor who supplies printing as a service.
printing system files	(n, sys). Master software programs (sysgen files) that keep all printer components working together.
printout	(n, sys). Hardcopy record of a computer's computations and processing.
	(n, pub). Informal expression referring to almost anything printed by a computer peripheral device.
print service	(n, sys). Service that provides hardcopy printing using an electronic printer connected to the server on which it runs.
print suppression	(n, pub). Control codes to prevent the printing of designated portions of the output.
processor	(n, sys). A computer.

product delivery process	*See* PDP.
production editing	(n, pub). Pasteup of copy and liaison with the printer.
program	(n, sys). Complete set of instructions in a language compatible with the machine to be used. Program directs the computer to perform each operation at the right time in proper sequence.
PROM	programmable read-only memory (n, sys). Solid-state memory for storing programs provided by the vendor to customize a system before delivery to the user.
promotional publications	(n, pub). Materials that are generally used to attract prospective customers and to advertise and sell products. Promotional materials include brochures, data sheets, information digests, and audiovisual sales tools. They are not intended to be retained by the reader and require high visibility on first glance. They have special requirements, such as attention-getting color, glossy paper, special type styles, high-quality artwork, various page layouts, and a number of binding options.
prompt	(n, sys). "Hint" provided by a system and displayed when a choice is to be made or information entered.
pronoun	(n). Word (one of the eight parts of speech) used instead of a noun.

	Nominative case	Objective case
Personal pronouns:	I	me
	you	you
	he	him
	she	her
	it	it
	we	us
	you	you
	they	them
Interrogative pronouns:	who	whom

The nominative case is used for subjects and complements.

She is responsible for the film. (subject)

That was **he** on the phone. (complement)

Who shall I say is calling? (subject of "is calling")

The objective case is used for objects of verbs, verbals (participle, infinitive), and prepositions.

Have you told **them** about the change in plans? (object of the verb "have told")

Mr. Carlyle refused to see **me**. (object of the infinitive "to see")

The supervisor divided the projects between Sid and **me**. (object of the preposition "between")

To **whom** does this book belong? (object of the preposition "to")

Indefinite pronouns: **each, either, any, anyone, some, someone, one, no one, few, all, everyone,** etc.

proof draft	(n, pub). Document that is in the process of being proofed or checked for accuracy and completeness.
proofreader marks	*See* editorial marks.
proportional font	(n, pub). Font containing characters with proportional spacing.
proportional spacing	(n, pub). Text in which each alphanumeric character is given a weighted amount of space. Such output has a printlike appearance. Proportional spacing allows more space for wide characters and less space for narrow characters and punctuation. The text you are reading contains proportional spacing. *See also* fixed pitch.
proportional type	(n, pub). Letters that vary in width.
protocol	(n, sys). Formal set of conventions governing the format of data and the control of information exchange between two communication devices.

Q

queue	(n, sys). Waiting line, such as a sequence of documents to be printed in turn.
QWERTY keyboard	(n, pub). Standard typewriter keyboard, named for first six keys of the third row from the bottom left.

R

ragged	*See* unjustified.
ragged right and left	(n, pub). Type that is not justified on either the right or left margin. *See also* unjustified *and* centering.
RAM	random access memory. (n, sys). Storage that allows data (such as documents) to be stored and retrieved directly by address location, without reading through any other data.
random access memory	*See* RAM.
RAP	repair analysis procedure (n, sys). Formatted chart, table, algorithm, or column of text that defines a set procedure to be used for troubleshooting.
raster data	(n, sys). Binary data, usually comprising dots of a graphic image, that have been arranged in scan lines according to the order in which the dots are to be printed.

raster graphics	(n, pub). Pictures sent to the printer as bit maps (each element of the picture is dot defined as black or white).
raw text	*See* uncoded text.
read-only memory	*See* ROM.
read/write head	(n, sys). Mechanism that writes data to or reads data from a magnetic recording medium.
real time	(n, sys). Performance of an operation that gives the impression of instantaneous response.
receive only	*See* RO.
recirculating signal	(n, sys). Output signal that is returned to an earlier point in the functional flow to modify the operation of a function or to signify completion of the event, but not to have the self-modifying effect of a feedback signal.
record	(n, sys). Collection of related data or words, treated as a unit.
record type	(n, sys). Method of determining how information will be written to tape, designated in number of bytes per record.
records processing	(n, sys). Workstation software package that allows the user to create reports that can be sorted, filtered, and reformatted for report purposes.
redline	(v, pub). To mark corrections on hardcopy. So called because of the customary use of red pencil.
redundancy check	(n, sys). Electronic method of verifying that data received is in same form as that in which it was sent.
reference	(n, pub). 1. Note in a publication guiding the reader either to another passage in the publication or to a source. 2. The passage or source itself. 3. Work containing useful facts or information.
refresh rate	(n, sys). Rate, measured in hertz, of rewriting a screen image.
register	(v, pub). To adjust forms or plates so that they will print in correct position over another form or plate, as in color printing.
registration	(n, pub). Accurate alignment of images with the shape of the paper they are printed on.
registration marks	(n, pub). Set of marks or symbols that are placed to coincide for the alignment of copy in printing. Registration marks are used for overlays and color setups.

remote batch	(n, sys). Method of entering jobs into a computer from a remote terminal for processing later in batch processing or sequential mode. Used when small branches of organization are far away from a central computer system.
remote job entry	*See* RJE.
remote terminal	(n, sys). Computer terminal that communicates with a larger computer. It may or may not have local processing capability.
repeat window	(n, sys). Command that allows any graphic window to be echoed at another position on a page without requiring additional memory or recalls a graphic file from storage on a disk for printing on a current page.
repeater	(n, sys). Device used to extend a network service area beyond one segment (1,640 feet) of cable length. It regenerates the signal between two segments of cable.
repro	(n, pub). Typeset copy with corrections made and elements in position, ready to reproduce by printing.
residual conditions	(n, sys). Conditions that remain after equipment returns from the dynamic (print) to the static (standby or power off) state.
resolution	(n, sys). Number of pixels per unit. For instance, when the number of pixels per inch is decreased as a result of magnification, the resolution is decreased and the look of the graphic image is coarsened. (n, pub). Fidelity of reproduction.
response time	(n, sys). Time a system requires to respond to a command for transferring stored data or completing a processing cycle.
restore	(v, sys). To bring the backup copy of a program or data into service in order to recover from loss or damage of the original copy.
reverse video	(n, sys). Mode of displaying characters on a CRT screen opposite of that screen's normal display. For example, on a screen with light characters against a dark background, the reverse video would show dark characters against a light background.
rework	(v, sys). Fixing, redesigning, or recoding.
rigid disk	(n, sys). Disk memory unit housed within a controller. Large-capacity nonremovable magnetic disk.
ring network	(n, sys). Continuous loop of regenerative signal repeaters with cable links connecting each pair of repeaters. There is a single, closed circuit path between all nodes, or stations, in the loop.
river	(n, pub). Distracting pattern of white space running through text type.

RJE	remote job entry (n, sys). Input of a batch job from a remote site and receipt of output via a printer or other output device at a remote site. Allows systems to share the resources of a batch-oriented computer.
RO	receive only (n, sys). Communicating device that operates in receive mode only.
rollover	(v, sys). To reload software when a piece of equipment or software has failed.
ROM	read only memory (n, sys). Solid-state memory for programs. It cannot be rewritten.
roman type	(n, pub). Type with serifs. Also, type that is upright, not italic.
rotation	(n, sys). Orientation of an image or fonts on a page.
rough draft	*See* working draft.
routine	(n, sys). Sequence of instructions that carry out a well-defined function. Set of instructions to a computer to perform certain functions, often a subset of a major program.
row	(n, sys). Horizontal subdivision along the vertical axis of a page. A row of characters is a horizontal line of characters.
RS232C	(adj, sys). Industry standard specification for data communications.
RS232C port	(n, sys). Physical interface to connect data communication equipment (usually a modem).
rules	(n, pub). Lines of various standard widths.
runaround	(adj, pub). Type set to fit around an illustration, box, or irregular shape. *See also* wraparound.
run-length packing	(n, sys). Method of numbering consecutive repetitions to reduce overhead.

S

saddle stitching	(n, pub). Type of binding.
sample file	(n, sys). Printed page showing all the characters in a font or a sample of a form.
sample tray	(n, sys). Output tray to which sample copies, sample files, and test patterns (25 pages or less) are delivered.

SAN code software analysis number code (n, sys). Six-digit identification code number that appears immediately preceding an error or warning message on a display screen.

sans serif (adj, pub). Class of typefaces without upper or lower strokes. *See also* serif.

(n, pub). Plain type without serifs.

Optima is a sans serif typeface.

scale (v, pub). To calculate the proportions of artwork for enlargement or reduction to fit into an area of specific size.

scan direction (n, sys). 1. On a page, the "y" direction, parallel with the longest edges of the page. 2. In a graphic window, scan direction is always horizontal, regardless of the page orientation, and is considered to be the "x" direction.

scan line (n, sys). Line of video data printed in one pass of a laser beam across the length of a xerographic drum.

scanned art (n, sys). Digitized art that has been placed on a data base using a graphics scanner.

scratchpad memory (n, sys). Storage area in the main memory reserved as an intermediate working area.

screen (n, sys). 1. Display surface of a video monitor. 2. Number of dots per square inch. 3. Pattern or information displayed on a screen.

(v, pub). To darken or shade designated areas. To create a halftone by adding a screen.

scribble sheet (n, pub). Author's worksheet, used in organizing subject matter.

scroll (v, sys). To move an image or block of text up, down, or to one side of a screen, revealing new parts of the image or text at the top, bottom, or opposite side of the screen.

SDLC synchronous data link control (n, sys). IBM communications line discipline or protocol associated with SNA.

secondary code set (n, sys). Second half of an 8-bit code set, codes X'80' through X'FF'.

see-through ruler (n, pub). Clear, lined ruler.

select (v, sys). To choose a menu option or command from a screen.

sentence (n). A group of words expressing a complete thought and containing a verb (predicate) and its subject, with or without modifiers. Sentences are classified structurally as 1) simple, 2) compound, 3) complex, or 4) compound-complex.

1. Simple sentence: A sentence containing one main clause but no subordinate clauses.

 Birds fly. (simple sentence)

 Birds and bats fly. (simple sentence with compound subject)

 Birds and bats swoop and fly. (simple sentence with compound subject and compound predicate)

2. Compound sentence: A sentence containing two or more main clauses but no subordinate clauses.

 The moon rose and the stars came out.

3. Complex sentence: A sentence containing one main clause and one or more subordinate clauses.

 Birds fly when they are startled.

4. Compound-complex sentences: A sentence containing two or more main clauses and one or more subordinate clauses.

 Engines roared overhead, and a bomb fell where we had stood.

sentence style (n, pub). All letters are lowercase except the first letter of the first word in a phrase; a phrase takes end punctuation. *See also* capitalization.

serial interface (n, sys). Method of sending codes from a computer to a printer or other device, one bit of information at a time.

serial printer (n, sys). Printer that prints out successive characters one at a time, either from left to right or bidirectionally for increased speed, as opposed to a line or page printer.

series comma (n, pub). Comma placed before the words ''and,'' ''or,'' and ''nor'' to connect the last two items of a set of three or more.

 . . . bell, book, and candle.

serif (n, pub). 1. Short light line or stroke projecting horizontally from the ends of the main vertical stroke of a roman letter. 2. Type with serifs. *See also* sans serif.

Times Roman is a serif typeface.

server (n, sys). Shared device on a network that any user can access.

set solid (v, pub). To set type with no leading between the lines.

shading (n, pub). Selected ink for drawing a rule. Choices are black, white, or gray.

sheet feeder (n, sys). Microprocessor-controlled device mounted on top of a printer that automatically inserts cut sheets into it and receives the ejected paper in a hopper.

shilling fraction (n, pub). Fraction in which the numerator and denominator are horizontally aligned (for example, 1/2). *See also* stacked fraction.

SI	Système International d'Unités.
signature	(n, pub). Sheet of a book, folded and ready for binding. It is usually 16 pages, but may be only 8 pages if the paper stock is heavy. It can be 32 or 64 pages if the paper is thin and the press is large.
simplex printing	(n, pub). Printing on one side of the page. Uses one side of the paper. *See also* duplex printing.
sixel encode	(v, sys). To code raster data so that it is not mistaken for control codes.
size	(n, pub). Measurement of a graphic window horizontally (size in the x direction) and vertically (size in the y direction).
slipcase	(n, pub). Box to hold a publication without covering the spine.
small caps	(n, pub). Capital letters approximately the height of lowercase letters. *See also* capitalization.
SNA	system network architecture (n, sys). Total description of the logical structure, formats, and protocols of operation sequences for transmitting information units through a communication system. Developed by IBM for distributed processing networks. *See also* network architecture.
softcopy	(n, sys). Copy in electronic memory.
software	(n, sys). Term coined to contrast with "hardware"; represents a program contained on user-loadable media (floppy disk or stored set of instructions), which govern the system operation and make the hardware run.
software exerciser	(n, sys). Software program that causes a system or component to artificially emulate the user.
source language	(n, sys). Computer instructions used to write a program. They are converted by the computer into object or machine language for interpretation within the computer.
spec type	(v, sys). To write type specifications, such as type size, leading, line length, typeface, and font. *See also* type specifications.
specification change notice	*See* SCN.
spine	(n, pub). Bound edge of a book.
spot	*See* dot.
spot carbon	(v, pub). To omit printing on a specified area of a page on specified copies.
stack	(n, pub). Collection of prints.

stacked fraction	(n, pub). Fraction in which the numerator and denominator are vertically aligned (for example, ½). *See also* shilling fraction.
stacked words	(n, sys). Parameters arranged one above another to denote choice.
stacker	(n, sys). Printer component that holds output sheets. Section of the printer in which printed reports are delivered.
standalone system	(n, sys). Single-station word processor or personal computer that neither communicates with others nor shares resources.
stat	*See* Photostat.
static check	(n, sys). Check, test, or observation made on equipment in power-off, test mode, or standby (nonprint) mode.
static data	(n, sys). Information usually found on preprinted forms or overlays.
status sheet	(n, sys). A one-page printout generated by a system in response to a parameter within a job control command. It presents information about the system interface, encoding, fonts, and errors.
storage	(n, sys). Space in memory where information is held for later use.
store and forward	(adj, sys). Handling of messages or packets in a network by accepting them, then sending them forward to the next station.
storyboard	(n, pub). Combination of text and related illustrations (for example, in a book or on a proposal wallboard).
straight copy	(n, pub). Copy that contains no charts, tables, formulas, or other elements that make typesetting complicated and time-consuming.
strike-on type	(n, pub). Characters, such as those from a typewriter, made when a key or needle hits a ribbon coated with ink or carbon.
string	*See* text string.
strip in	(v, pub). To paste up copy for reproduction.
structure (document)	(n, pub). Front matter, back matter, parts, chapters, sections, captions, and text elements that form the foundation of any document. These entities and their relationships (for example, parts contain chapters, which contain sections, which contain subsections, which in turn contain paragraphs) constitute the document structure.
style	(n, pub). Distinctive quality, form, and manner of oral or written expression, related to spelling, punctuation, capitalization, and typographic arrangement and display.

style specification	(n, sys). Group of computer instructions that define the typographic meaning of coded text.
subscript	(n, pub). Small symbol, numeral, or letter that prints below and to the side of another character; for example, H_2O.
substantive editing	(n, pub). Editing that involves changing word choices.
superscript	(n, pub). Small character that prints above and to the side of another character; for example CO^2.
swash letter	(n, pub). An ornamental italic letter with elaborate flowing flourishes and tails.
switched line	(n, sys). Phone line connection in which points of termination can be changed through dialing. It allows sharing of resources and switching from one resource to another.
switched network	(n, sys). Multipoint network with circuit switching capabilities, such as TWX.
symptom-fault table	(n, sys). Directive job aid, in chart or table form, containing observable symptoms, possible causes, and related corrective actions.
synchronous	(adj, sys). Efficient encoding of data suitable for high-speed block-oriented data transmission by using equal time elements. Used by SDLC.
synonym	(n). A word that has a meaning similar to that of another word. A word or expression accepted as a substitute for another word.
syntax	(n, sys). Rules governing the structure of commands; for example, spelling and placement of keywords.
	(n, pub). Arrangement or grouping of words for clarity.
sysgen	system generation (n, sys). Process whereby a system is made ready to operate. Typically involves the selection of operative parameters and the activation of relevant software.
system	(n, sys). Organized combination of hardware components and software, working together to perform some logical process in a systematic manner.
system architecture	(n, sys). Design or configuration for attaching various hardware components of a system so that they interact with one another to fulfill the purposes for which the system was designed.
system files	(n, sys). Master software program that keeps all components working together.
system page	(n, sys). Maximum area on a page on which a system will print.

system utilities	(n, sys). Set of routines for organizing and maintaining files on a rigid disk or any diskette.
systems product	(n, sys). Software, hardware, and documentation related to a system.

T

TA	typesetter alteration (n, pub). Any change made because of a typesetter error.
tape	(n, sys). Recording media for data or computer programs. Tape can be in permanent form, such as perforated paper tape. Generally, tape is used as a mass storage medium in magnetic form and has far higher storage capacity than disk storage, but it takes much longer to write or recover data from tape than from disk.
tape drive	(n, sys). Physical mechanism used to drive tape through a read/write head at high speed.
target population	(n, sys). "User" population to which a document should be written (that is, user skill level assumptions to be used by a writer when developing manuals).
technical error	(n, sys). Data that is omitted, stated incorrectly, labeled incorrectly, incomplete, or out of sequence, causing service or operator personnel to make incorrect decisions or preventing them from completing a task. Technical errors can result in one or more of the following: personal injury, damage to equipment, increase in equipment downtime, increase in service.
Teletype	(n, sys). Trademark of Teletype Corporation, usually referring to a series of different types of teleprinter equipment.
Teletype emulation	(n, sys). Optional software feature of external communication service allowing workstations to access host computers that connect to "Teletype-compatible" terminals.
tense	(n, pub). Change in the form of the verb to indicate the time of the action. There are six tenses.

1. Present: he **sees**, she **uses**.
2. Past: she **saw**, he **used**.
3. Future: he **will see**, she **will use**.
4. Present perfect: she **has seen**, he **has used**.
5. Past perfect: he **had seen**, she **had used**.
6. Future perfect: she **will have seen**, he **will have used**.

terminal	(n, sys). Device equipped with a keyboard. A terminal is connected to a computer or network.

terminator	(n, sys). Character or sequence of characters (such as a line ending) used to mark the end of a command whose length is variable.
test data	(n, sys). Signal measurement procedures containing specifications, tolerances, amplitude, duration, operational mode, or conditions under which a signal is available and test equipment is required.
test pattern	(n, sys). Page of lines or characters used to check print quality.
test point	(n, sys). Any point at which a test, check, or observation is to be made.
text	(n, pub). Ideas housed in character streams. Text can consist of words or numbers (calculations).
text editing	(n, pub). Any rearrangement or change of textual material, such as adding, deleting, or reformatting.
text string	(n, sys). Consecutive series of characters to be printed exactly as specified in a command.
text type	(n, pub). Type size that is less than 14 points.
thermal printer	(n, sys). Nonimpact printer that uses special heat-sensitive paper. Paper passes over a matrix of heating elements to change the color of paper at that point to produce characters.
thin space	(n, pub). User-definable unit, usually half an en. *See also* em *and* en.
timesharing	(n, sys). Utilization of a main computer facility by many users, each of whom has a remote terminal. Processing time is "shared" so that users are unaware of one another.
toggle	(n, sys). Symbol that specifies a shift between two predefined states in a print line, such as from uppercase to lowercase and vice versa. Each appearance of a toggle shifts printing to the opposite state.
toner	(n, pub). Minute, dry particles of resin and carbon black that are used to create images. Toner is capable of accepting an electrical charge.
topology	(n, sys). Spatial pattern formed by nodes of a network and connecting links that make up a network structure.
touch sensitive	(adj, sys). Technology that allows control of a system by sensing the coordinates of a point touched.
trace	(n, sys). Capture utility in which every byte of data involved in a file transfer between two devices is captured in readable form. All data, including communications control codes, text, and unencoded data (for example, graphics), are captured.
tractor feed	(n, pub). Mechanism for feeding paper by means of pins revolving on a tractor tread.

transceiver	(n, sys). Single device that can function as both a transmitter and receiver.
transceiver/tap	(n, sys). Device that connects directly to coaxial cable and provides both the electronics to send and receive encoded signals on cable and the required electrical isolation. One network will support up to 1,024 transceivers.
transfer sheet	(n, pub). Sheet containing letters or symbols that can be moved from the printed sheet to another sheet by rubbing.
transfer type	(n, pub). Type that can be rubbed off its backing sheet onto another surface.
transient conditions	(n, sys). Conditions that do not remain after equipment is returned from the dynamic (print) to the static (standby or power-off) state.
transmission medium	(n, sys). Physical facility used for communication, such as coaxial cable or optical fiber.
transparency	(n, sys). Manner of transmitting electronic data in which bit patterns are not interpreted, acted upon, or transformed by transmitting or receiving device or by intervening devices.
transport skis	(n, sys). Equipment that keeps paper moving through a feed path.
tray	(n, sys). One of four input paper sources or a printed output stacker.
tree network	(n, sys). Cable that has been split into smaller independent subsections so there is only one path between any two nodes, or stations, in the network.
trimetric projection	(n, sys). Drawing method using three different angles at coordinate axis. This type of drawing requires three different scales for foreshortening measurements, and all angles add up to 360 degrees.
truncate	(v, sys). 1. To cut off a decimal point and number to its right. Does not include rounding to nearest integer. 2. To shorten or abbreviate by cutting off at the end.
turnaround time	(n, sys). The elapsed time between submission of a job and the return of the results.
turnkey system	(n, sys). System containing all the hardware and software needed to perform a given application.
turnover	(n, pub). Second and following lines of text that align at the left with the first line. *See also* word wrap.
TWX	teletypewriter exchange service (n, sys). Public teletypewriter exchange (switched) service in the United States and Canada, formerly owned by AT&T but now belonging to Western Union. Both Baudot and ASCII-coded machines are used.

typeface	(n, pub). 1. All the type of a single design, such as Optima or Helvetica. 2. Set of characters with design features that make them similar to one another.
type family	(n, pub). All the styles of a specific typeface design, such as Optima or Helvetica. *See also* font.
type shop	(n, pub). Typesetting business.
type size	(n, pub). Height of a typeface, measured from the bottom of its descenders to the top of its ascenders, expressed in points.
type specifications	(n, pub). Instructions about typeface and size, line measure, indentations, headlines, and the like. Type size and leading are expressed as the upper and lower numerals in a fraction, with points for leading measured baseline to baseline. Type 10/12 means 10-point type set on 12 points of leading.
type specimen book	(n, pub). Book showing examples of all typefaces available from one type shop.
type style	(n, pub). Italic, condensed, bold, and other variations that form a type family.
typesetter	(n, pub). Machine or person that sets type.
typesetter alteration	*See* TA.
typo	(n, pub). Abbreviation for typographical error.
typographic composition	(n, pub). Typographically composed text that resembles typeset or phototypeset text found in high-quality publications and promotional pieces. Typographic flexibility includes the ability to size type, create (or scan) and merge graphics, and control leading, ruling, and kerning.
typography	(n, pub). Art and science of setting type. Also, the style and arrangement of type on a printed piece.

U

UDK	*See* user-defined key.
unbundled	(adj, sys). Programs, training, and other services sold independently of the system hardware by the manufacturer.
uncoded text	(n, pub). Rough text without formatting codes.
unique	(adj, sys). Applicable to only one product.

unjustified	(adj, pub). Text set with an irregular appearance on either or both margins. *See* ragged right and left.
uppercase	(adj, pub). Capital letters.
upstyle	(adj, pub). Initial capital letter placed on all words in a phrase, except articles, conjunctions, and short prepositions. *See also* capitalization.
US ASCII	United States of America standard code for information interchange (n, sys).
usage	(n, pub). Language in use. The level of vocabulary, grammar, punctuation, and sentence construction the writer uses. The choice of level determines the writer's style and tone—formal or informal. The style and tone must be appropriate for the purpose of the written document. Xerox usage is informal and conversational. The writer should choose precise, concrete words that are known by the document's general audience. Sentences should be short, simple, and constructed without interrupting phrases. Verbs should be in the active rather than the passive voice.
USASI	United States of America Standards Institute (n, sys).
user-defined key (UDK)	(n, sys). Key with the capacity to remember and store a series of keystrokes. It allows the user to save the keystrokes needed to perform specific operations and then initiate them in proper sequence by pressing one key.
user group	(n, sys). Any organization made up of system users (as opposed to vendors) that gives users an opportunity to share knowledge of a particular system, to exchange programs, and to jointly influence vendor policy.
utilities	(n, sys). Routines for service or housekeeping tasks that support application usage indirectly. Examples are system usage, file maintenance, information recovery from damaged disks, disk initializing, disk copying, and the like.

V

validate	(v, sys). 1. To launch new products and achieve performance, quality, production, and market objectives. 2. To conduct performance sampling of all areas of deliverables to evaluate their usability.
variable data	(n, sys). Data that is not part of the form design and varies from page to page of the form.
variable text	(n, sys). Text of a changing nature (for example, various names and addresses combined with a form letter to make a complete document).

Velox	(n, pub). Screened print ready to strip into final copy.
verb	(n). A word (one of the eight parts of speech) or words used to assert action, being, or a state of being.

1. Action: Robert **demanded** another chance. Or: The horse **was galloping** along the beach.
2. State of being: Harriet **was** glad to be included. Or: Ted **appears** tired.

vertical	(n, pub). Down the page in line with a slope of 90 degrees.
vertical format control	(n, sys). Manner of controlling the vertical positioning of characters on a page, in emulation of mechanical printers whose form-feed mechanism is controlled by holes punched in a tape. The tape is divided into channels, each channel having its own set of punched holes that controls a unique pattern of vertical movement.
vertical page	*See* portrait page orientation.
vertical spacing	(n, pub). Number of lines per inch from the top of a page to the bottom.
vertical tab	(n, pub). Vertical skip in spacing down a page to a predesignated location.
video data	(n, sys). Stream of bits, wherein each corresponds to one printed dot (pixel) on a page.
viewgraph	*See* overhead.
virtual memory	(n, sys). Mechanism (hardware and software) that provides the illusion of large memory by relating small memory to a large disk. This technique permits the user to treat secondary storage as an extension of main memory, thus giving the appearance of larger main memory.
virtual page	(n, sys). Area on a page that has been selected by the forms designer for printing.
VLSI	*See* LSI.
voice	(n, pub). Distinction in the form of the verb to indicate whether the subject of the sentence acts (active voice) or is acted upon (passive voice).

1. Active voice: I **wrote** the documents in the active voice. (The subject, "I" is performing the action of writing.)
2. Passive voice: The documents **were written** in the passive voice. (The subject, "documents," is not performing the action of writing but is being acted upon.)

W

walking copy	(v, pub). To move copy from page to page.
warning	(n, pub, sys). Operation or maintenance procedure, practice, condition, or statement, which, if not strictly observed, could result in personal injury.
warning message	(n, sys). Message appearing on a display terminal screen describing an existing condition that will require attention soon. Warning messages appear highlighted.
wash up	(v, pub). To clean off a press after using another color ink.
weight	(n, pub). Characteristic of type determined by how light or dark it appears.
widow, widower	(n, pub, obsolete). *See* isolated text.
Winchester disk	(n, sys). Hard disk permanently sealed in a drive unit to prevent contaminants from affecting the read/write head; this virtually eliminates the need for head adjustment by field service personnel. The Winchester disk is capable of storing larger amounts of data than a diskette.
window	(n, sys). 1. User-defined area on the page within which graphics can be imaged. 2. Sections of display screen, provided by programming, that allow the user to deal with several applications, such as comparing documents or files.
word	(n, sys). Largest number of bits a computer is capable of handling in any one operation; usually subdivided into bytes. One storage location in memory or on a peripheral device. Usually 8, 12, 16, or 32 bits make up a word, and these may be organized as bytes.
word processed text	(n, pub). Text that is similar to that produced on a typewriter. It is limited in typographic and graphic flexibility.
word processing	(n, sys). Manipulation of text by a specialized or general-purpose system to reduce repetitive typing.
word processing system	(n, pub). System that performs such functions as paragraphing, paging, left and right justification, rearrangement of lines, and printing of text.
word spacing	(n, pub). Amount of space between words; usually adjustable.
word wrap	(v, sys). To automatically shift words from a line that is too long to the next line.
working draft	(n, pub). Document that is in the process of being written.

workstation	(n, sys). Hardware unit developed for use by a single user at any one time, capable of local processing and/or access to various network services available in an internetwork.
wraparound	(adj, pub). Type arranged around an illustration or box that is narrower than the page width.
write enable ring	(n, sys). Ring that, when inserted, allows the printer to write data on a tape. When it is removed, it prevents the printer from writing data on the tape.

X

X-Acto knife	(n, pub). Trade name for a knife with a very sharp blade for cutting paper.
x axis	(n, sys). Horizontal axis on a forms grid.
x height	(n, pub). Height of lowercase letters without their ascenders or descenders (height of the letter "x"). *See also* ascender.
xerographic drum	(n, sys). Rotating drum coated with a photoreceptor, which may be electrostatically charged and whose charge may be dissipated as the result of the incidence of light.
xerographic engine	(n, sys). Component of a printer that develops the image, transfers it to paper, and fuses it for output as hardcopy.
X.25 circuits	(n, sys). International standard protocol for accessing packet switching networks. These networks support virtual circuits between network access points.

Y

y axis	(n, sys). Vertical axis on a forms grid.

Bibliography

Beach, M., S. Shepro, and K. Russon. 1986. *Getting It Printed*. Portland, OR: Coast to Coast.

Bell, P. 1985. *High-tech Writing: How to Write for the Electronics Industry*. New York: John Wiley.

Bly, R. M., and G. Blake. 1982. *Technical Writing: Structure, Standards, and Style*. New York: McGraw-Hill.

Borgman, C., D. Mohgdam, and P. K. Corbett. 1984. *Effective Online Searching: A Basic Text*. New York: Marcel Dekker.

Brennan, E. R. 1987. *Development of the Publishing Environment*. Los Angeles: Larkspur Press.

Brogan, J. A. 1973. *Clear Technical Writing*. New York: McGraw-Hill.

The Chicago Manual of Style ed 13. [1906] 1982. Chicago: University of Chicago Press.

Christopher, R. 1985. "Electronic manuscript preparation and generic tagging." Study conducted for Association of American Publishers.

Danielson, et al, ed. 1980. *Reading in English*. Englewood Cliffs, NJ: Prentice-Hall.

Deford, B. April 1986. "A nontechnical guide to technical documentation." *EP&P* 27-32.

Digital Equipment Corporation. 1982. *Guide to Personal Computing*. Maynard, MA.

Eisley, L. 1976. "How natural is natural?" In *The McGraw-Hill Reader*. G. H. Mueller ed. New York: McGraw-Hill.

Fitzgerald, S. 1985. "Readability formulas play too dominant a role." *Instructor* 18: 84-86.

Flesch, R. 1974. *On Business Communications*. New York: Barnes and Noble.

Fowler, H. W. 1949. *The King's English*. London: Oxford University Press.

Fry, E. B. nd. Fry readability scale. Providence, RI: Jamestown Publishers.

Harper, W. L. 1980. *Data Processing Documentation: Standards, Procedures and Applications* ed 2. Englewood Cliffs, NJ: Prentice-Hall.

Johnson, E. W. 1980. *How to Achieve Competence in English*. New York: Bantam Books.

Jordan L. ed. 1976. *The New York Times Manual of Style and Usage* rev ed. New York: Times Book.

Joseph, A. 1979. *Put It in Writing*. Ohio: International Writing Institute.

Kerighan, B. W., and P. J. Plauger. 1974. *The Elements of Programming Style*. New York: McGraw-Hill.

Lamphear, L. 1982. *Shortcuts to On-the-Job Writing*. Englewood Cliffs, NJ: Prentice-Hall.

Learn, Inc. 1979. *Power Writing*. New Jersey.

Leggett, G., C. D. Mead, W. Charvat. 1970. *Prentice-Hall Handbook for Writers*. Englewood Cliffs, NJ: Prentice-Hall.

Marangella, L. 1984. Documentation checklist. Phoenix: The Write Component.

McGraw-Hill. 1984. *Guide for Handbook Contributors*.

Mechtly, E. A. 1973. *The International System of Units* 3300-00482. Washington, DC: NASA.

Miller, C., and K. Swift. 1980. *The Handbook of Nonsexist Writing for Writers, Editors and Speakers*. New York: Lippincott and Crowell.

Mish, F. C. ed. 1983. *Webster's New Collegiate Dictionary* ed 9. Springfield, MA: Merriam-Webster.

Modley, R. 1976. *Handbook of Pictorial Symbols*. New York: Dover.

Mueller, G. H. ed. 1976. *Reader*. New York: McGraw-Hill.

Nicholson, M. 1958. *American-English Usage*. New York: New American Library.

Palmer, C. P. 1982. "Making tabular matter easier to read." *Graphic Arts Monthly* 104-105.

Paris Publishing Ltd. nd. *The Print Buyer's First Aid*. London.

Skil-Set Typographers. 1982. *Submitting and Spec'ing Copy*. Los Angeles.

Stone, W., and J. G. Bell. 1977. *Prose Style, A Handbook for Writers*. New York: McGraw-Hill.

Strunk, W. Jr., and E. B. White. [1932] 1979. *The Elements of Style*. New York: Macmillan.

Temple, M. 1982. *A Pocket Guide to Correct English*. New York: Barron's Educational Series.

Typographers Association of New York. nd. *In-house Typesetting—The Real Story*. New York.

U. S. Copyright Office. 1982. Application for Copyright Registration form TX. Washington, DC.

U. S. Government Printing Office. 1984. *Style Manual*. Washington, DC.

Van Buren, R., and M. F. Buehler. 1980. *The Levels of Edit* ed 2. Pasadena, CA: Jet Propulsion Laboratory.

White, J. V. 1988. *Graphic Design for the Electronic Age*. A Xerox Press Book. New York: Watson-Guptill.

1984. *Editing by Design*. New York: R. R. Bowker.

1982. *Designing for Magazines*. New York: R. R. Bowker.

1980. *Graphic Idea Notebook*. New York: Watson-Guptill.

nd. *Grids*. National Composition Association.

White, W. nd. *Laser Printing: The Fundamentals*. Madison, NJ: Carnegie Press.

Wright, P. 1983. "Manual dexterity, a user-oriented approach to creating computer documentation." In *CHI '83 Proceedings*. Cambridge, England: MRC Applied Psychology Unit.

Xerox Corporation. 1987. *Xerox Publishing Standards: Customer Documents for Systems Products* ed 2. El Segundo, CA.

1984. *Xerox Publishing Standards* ed 1. El Segundo, CA.

Zinsser, W. 1980. *On Writing Well*. New York: Harper and Row.

Index

A

abbreviation, 3-63
 measurement, C-4—9
account development, A-4, A-35—37
 application guide, A-36
 language application guide, A-37
 operations guide, A-35—37
account management forms, A-3, A-32—33
account profile, A-3, A-25—26
acknowledgments, 2-25
acronyms, 3-63, GL-2
adjective, 3-31, GL-2
adverb, 3-31, GL-2—3, GL-12
all caps, 3-60, GL-3, GL-8
 for emphasis, 4-33
alphabetization, see sequencing
analogy, 3-36
Anglicus, Bartholomeus, 2-2
annotation
 content, 2-28—31
 numbering, 2-13
antecedents, 3-46, GL-3
Apianus, Peter, 4-2
apostrophe, 3-51—52
appendices, 2-12, 2-33, 4-60
application brief, A-3, A-27
application guide, A-4, A-36
applications/support documents, A-4, A-5, A-34—38
 account development, A-35—37
 installation planning, A-34—35
 operations, A-37—38
Arabic numerals, 2-11, 2-12, 3-66, 4-37
 with lists, 4-35, 4-36
art log, 1-26
author-date notes, 2-29—30

B

back matter
 defined, 2-8
 design, 4-60—61
 numbering, 2-12, 2-13
 organization, 2-33—39
bias-free writing, 3-9—11
bibliography, 2-35—39, GL-6
 content, 2-35—36
 design, 4-61
 format, 2-36—37
 notes and, 2-29
 numbering, 2-12
big book, landscape, 4-12
 column layouts, 4-26—27
 cover, 4-76
 headers and footers, 2-15—20, 4-48

big book, portrait, 4-10
 column layouts, 4-16—23
 combined columns, 4-22—23
 cover, 4-74, 4-76, 4-77, 4-78
 double text columns, 4-18—19
 headers and footers, 2-15—20, 4-47
 single text column, 4-16—17
 triple text column, 4-20—21
binding, 1-31, 4-6
 footprint, GL-22
 loose-leaf, 4-65, 4-66—67
 perfect, 4-65, 4-66, 4-68, GL-43
 saddle-stitch, 4-65, 4-66, 4-68, GL-50
 selection, 4-66
 specifications, 4-65—70
 Wire-O, 4-65, 4-66, 4-68
bit, GL-6
blank pages, 4-62, GL-7
body copy, see text
boilerplate, 4-37, GL-7
boldface, 4-36, GL-7
 editing symbol for, 3-71
 emphasis, 4-33
 headings, 4-57
boxing, 4-39
brackets, 4-37
brochure/general information digest, A-3, A-26
bullet, 4-35, 4-36, GL-8
business opportunity proposal, A-3, A-6

C

callout, 4-43, GL-8
capitalization, 3-59—61, GL-8
 all caps, 3-60, 4-33, GL-3, GL-8
 design and, 3-60—61
 downstyle, 3-61, 4-34, 4-49, GL-8, GL-17
 editing symbol for, 3-70
 emphasis and, 4-33
 headline style, 3-61, GL-8, GL-26
 sentence style, 3-61, GL-8
 small caps, 3-70, GL-8, GL-53
caption, 4-43, GL-8
caution, 2-28, GL-9
centering, 4-41, GL-9
change bar, 2-43
chapter, 2-8, 2-27
 heading, 4-50, 4-51, 4-52
classification, in writing, 3-36
classified pages, 4-62
clause, 3-27—29, GL-10
cliché, 3-41
closing tools, A-3, A-31
colon, 3-52

colophon, 2-24
column layouts, 4-15—28
 big book, landscape, 4-26—27
 big book, portrait, 4-16—23
 single, 4-15, 4-16—17
 small book, landscape, 4-28
 small book, portrait, 4-24—25
comma, 3-53—54
 series, GL-52
comparison, 3-37, 3-43
composition, 1-27, 1-29
 quality assurance, 1-29
conclusion, *see* summary
configurator, A-3, A-28
conjunction, GL-12
conversational style, 3-8, 3-24
copyright notice, 2-41
copyright page
 content, 2-22—24
 design, 4-59
 numbering, 2-12
cover, 4-71—78
 color, 4-73
 content, 4-71—72
 print quality, 4-73
 spine, 4-73
 typeface, 4-73
credits, 4-43
customer training documents, A-4, A-46—47

D
dangling participle, 3-46, GL-14
dash, 3-54, 3-70, 4-35, GL-19
data sheet, A-3, A-29
date, 3-53, 3-66
definition, in writing, 3-35, 3-42
delivery/removal manual, A-4, A-35
demonstration kit, A-3, A-29—30
design, xiv, xv, xix, 1-3, 2-5, 4-1—78
 binding, 4-65—70
 column layouts, 4-15—27
 cover, 4-71—78
 graphics, 4-39—43
 headers and footers, 4-45—48
 headings, 4-49—53
 page specifications, 4-7—13
 planning, 1-14
 rationale, 4-5—6
 special pages, 4-59—62
 style and, 3-6
 tabs, 4-63—64
 text, 4-31—37
 typeface, 4-29
design disclosure, A-3, A-12—13
dialogue, 3-38
diction, GL-15
dingbat, GL-15
direct mail piece, A-3, A-26—27
discontinuance plan, A-3, A-18
distribution, 1-3, 1-33
document categories, A-1—47
 applications/support, A-4, A-5, A-34—38
 information flow, A-2

management planning/control, A-3, A-5—24
marketing/sales, A-3, A-5, A-24—33
reference, A-4, A-5, A-38—41
training, A-4, A-5, A-41—47
document organization, xv, xviii, 2-1—43, GL-17
 access, 2-9—20
 generic structure, 2-5—7
 terminology, 2-8
document sets, 2-13
documentation launch plan, 1-8—9
documentation planning and control materials, A-3,
 A-23—24
double text columns, 4-15
 big book, portrait, 4-18—19
 small book, portrait, 4-25
downstyle capitalization, 3-61, 4-34, 4-49, GL-8,
 GL-17
duplex printing, 2-8, GL-18

E
editing, 1-3, 1-4, 1-15, 1-23—25
 checklist, 1-24
 on-line, 1-25
 -self, 1-16—17, 1-21—22
 symbols, 3-69—72
editor, 1-13, 1-15
electronic printing, 1-30, GL-18, *see also* printer
electronic publishing
 limitations, 1-4—5
 role, 1-4
 standards and, xiii
 storage and, 1-35
electronic publishing center, 1-27, 1-28
ellipsis points, 3-54
em, GL-19
emphasis, 4-33, 4-36, 4-37
endnotes, 2-12, 2-13, 2-31, 2-35
errata sheet, 2-43
errata statement, 2-24
examples, in writing, 3-37
exclamation point, 3-55
eyewitness account, 3-37

F
FCC notice, 2-23
figure
 list, 2-12, 2-24
 notes, 2-28
 numbering, 2-13
 see also graphics
Flesch, Rudolf, 3-15
folio, *see* page number
follow-up tools, A-3, A-32—33
 account management forms, A-32—33
 informational publication, A-33
 installation checklists, A-32
footer
 content, 2-14—20
 defined, 2-8, 2-14, GL-21
 design, 4-45—48
footnote, 2-13, 2-31
footprint, GL-22
foreign words, 3-57

foreword, 2-12, 2-25
four-column format, 4-26—27
fraction, 3-65, GL-52, GL-54
front matter
 defined, 2-8, GL-23
 design, 4-59—60
 numbering, 2-11, 2-12
 organization, 2-21—25
Fry, Edward, 3-17
Fry readability scale, 3-17—18
functional manual, A-4, A-40—41
functional specification, A-3, A-23

G
ghost writing, 1-20—21
glossary, 2-12, 2-34, 4-61
grammar, 3-45—46
graphics, 2-8, 4-39
 centering and, 4-39
 design of, 4-39—43
 mosaic, GL-37
 organization, 1-25
 orientation, 4-39
 placement, 4-40
 preparation, 1-3, 1-25—26
 rules in, 4-39
 size, 4-39
 spacing, 4-55—56
 text for, 4-41—43
 text reference to, 4-42
 writing and, 3-38
graphics master, 1-26
graphics specialist, 1-25, 1-26
group/division level documents, A-3, A-5—20
 business opportunity proposal, A-6—7
 design disclosure, A-12—13
 discontinuance plan, A-18
 launch plan, A-14—15
 performance assessment report, A-16—17
 policies and procedures, A-19—20
 product business proposal, A-9—11
 product goals, A-7—9
 product program life plan, A-11—12
 references and standards, A-18—19
 support plans, A-13—14
 systems requirements specifications, A-9—11

H
hardware reference manual, A-4, A-39
header
 content, 2-14—20
 defined, 2-8, 2-14, GL-26
 design, 4-45—48
heading, 2-20, 4-49—53, GL-26
 capitalization, 3-61, 4-34, 4-49
 selection, 4-53
 spacing, 4-49, 4-50, 4-57
 specifications, 4-50, 4-51
headline-style capitalization, 3-61, GL-8, GL-26
hyphen, 3-55

I
identification, in writing, 3-35
identification number, 2-21

illustrations, see graphics
impression history, 2-23
indention, 4-35, 4-37
index, 2-12, 2-39, 4-61
infinitive, 3-46, GL-27—28
informational publication, A-3, A-33
initialism, 3-63, GL-28
ink, text, 4-69
installation checklists, A-3, A-32
installation manual, A-4, A-34—35
installation planning guide, A-4, A-34
international paper sizes, 4-7, GL-29
introduction, 2-12, 2-25
italics, 3-57, 3-71, 4-33, 4-36, GL-30

J
jargon, 3-40—41
job aids, A-4, A-38
justification, 4-32, GL-31

K
kernel distance theory, 1-13, 3-18
keyword heading, 4-50, 4-51, 4-52

L
landscape orientation, 4-8, GL-32
 big book, 4-12, 4-26—27
 headers and footers, 2-14, 2-15, 4-47
 small book, 4-13, 4-28
language application guide, A-4, A-37
launch plan, A-3, A-14—15, see also documentation
 launch plan
leader, 4-43, GL-32
lead-in headings, 4-50, 4-51, 4-52
leading, 4-32, GL-32—33
legal considerations, 2-41
letter form, 3-38
licenses, 2-42
line length, 4-31, GL-34, see also column layouts
line spacing, see leading
list, 4-34—36
 figure, 2-12, 2-24
 format, 4-36
 punctuation, 3-58
 signal for, 4-35
 table, 2-12, 2-24
 trademark, 2-23
live matter, 4-9, GL-34
logotype, 2-21, 3-60, 4-71
loose-leaf binder, 4-65
 cover designs, 4-74—75
 covering options, 4-66—67
 footprint, GL-22
 rings, 4-66
 specifications, 4-66—67
lowercase, 3-61, GL-8, GL-34

M
management planning/control documents, A-3,
 A-5—24
 documentation, A-23—24
 group/division level, A-3, A-5—20
 product planning/development, A-3, A-20—23
mandatory, 2-41, GL-36

marketing plan, A-3, A-20—21
marketing/sales documents, A-3, A-5, A-24—33
 follow-up tools, A-32—33
 presentation/proposal tools, A-29—31
 qualifying/information gathering tools, A-27—29
 sales guides, A-24—27
measurement
 abbreviations, C-4—9
 conversion table, C-10—11
 units, 3-67, C-1—3
modifier, 3-30—31, 3-46, GL-37, *see also* adjective,
 adverb
modular approach, 2-5
multilingual communication, 3-13

N
note
 author-date, 2-29—30
 illustration, 2-28
 in text, 2-28
 see also endnote, footnote
notice, 2-23
noun, GL-39
numbering systems, 2-11—13
numeral
 in bibliography, 2-37
 handling of, 3-65—67
 with list, 4-35, 4-36
 see also Arabic numeral, Roman numeral

O
object, 3-30, GL-39
operations guide, A-4, A-35—36
operations manual, A-4, A-37—38
Optima, 4-29, GL-40, GL-51
order form, 2-39, 4-61

P
packaging, 1-31, 4-6
 accessories, 4-68
page layout, 4-5, *see also* column layout
page number, 2-11—13, 4-46, 4-47, 4-48
page size, 1-29, 4-7—13
 big book, landscape, 4-12
 big book, portrait, 4-10
 international, 4-7, GL-29
 small book, landscape, 4-13
 small book, portrait, 4-11
paper, text, 4-69
paragraph, 3-19—25
 coherence, 3-24—25
 concluding, 3-19, 3-24
 connective techniques, 3-25
 developmental, 3-19, 3-22—24
 introductory, 3-19—21
 lead-in, 3-20
 unity, 3-22—24
parentheses, 3-55—56
part, 2-8, 2-27
 numbering by, 2-11, 2-12
 see also subtitle page
participle, GL-42, *see also* dangling participle
Pas, Jan, 3-2
percent, 3-65, 3-66

perfect binding, 4-65, 4-66, 4-68, GL-43
 covers, 4-77
 footprint, GL-22
performance assessment report, A-3, A-16—17
pica, C-7, C-10—11, GL-44
pixel, C-10—11, GL-44
period, 3-56
person, consistency of, 3-24
planning, document, 1-3, 1-7—10
 form, 1-10
 launch, 1-8—9
 review stages, 1-8
point, C-8, C-10—11, GL-44
policy/procedure documents, A-3, A-19—20
portrait orientation, 4-8, GL-44
 big book, 4-10, 4-16—23
 headers and footers, 2-14, 2-15, 4-47
 small book, 4-11, 4-24—25
possessive, 3-51—52
predicate, 3-29, GL-45
preface, 2-12, 2-25
preposition, GL-45
presentation kit, A-3, A-30
presentation/proposal tools, A-3, A-29—31
 closing tools, A-31
 demonstration kit, A-29
 presentation kit, A-30
 proposal kit, A-31
prewriting, 1-16, 1-17—19
 analysis, 1-18
 organization, 1-19
 research, 1-19
 time budget, 1-17
printer, GL-45
 character, GL-9
 dot-matrix, GL-17
 draft-quality, GL-17
 electronic, GL-18
 impact, GL-27
 ink-jet, GL-28
 laser, GL-32
 letter-quality, GL-33
 line, GL-12, GL-34
 matrix, GL-36
 nonimpact, GL-38
 page, GL-41
 paper for, 4-69
 thermal, GL-57
printing
 methods, 1-30
 quality assurance, 1-31
 see also duplex printing, simplex printing
Proba, 1-2
product business proposal, A-3, A-9—11
product delivery requirements, A-3, A-21—23
product description, A-3, A-27
product-fit questionnaire, A-3, A-28
product goals document, A-3, A-7—9
product name, 2-9
product planning/developing documents, A-3,
 A-20—23
 functional specifications, A-23

hardware specifications, A-22—23
marketing plan, A-20—21
product delivery requirements, A-21—22
product program life plan, A-3, A-11—12
production, 1-3, 1-27—31
composition, 1-27, 1-29
form, 1-10
packaging, 1-31
printing, 1-30—31
promotional publications, GL-46, *see also* marketing/
sales documents
pronouns, 3-46, GL-46
proofreading, 1-17
marks, 3-69—72
time budget, 1-17, 1-22—23
proposal kit, A-3, A-31
prospect data/information lists, A-3, A-25
publication number, 2-21
publishing process, xv, xviii, 1-3—35
distribution, 1-33
editing, 1-15, 1-23—25, *see also* editing
graphics preparation, 1-25—26
planning stage, 1-7—10
production, 1-27—31
research and design stage, 1-11—13
updating, 1-35
writing, 1-15—23, *see also* writing
publishing standards, xiii—xx
categories, xv
communication, xix
development, xix
electronic publishing and, xiii
need for, xvii
overview, xviii—xix
punctuation, 3-51—58
bibliography, 2-37
list, 3-58
see also specific punctuation marks

Q

qualifying/information gathering tools, A-3, A-27—29
application brief, A-27
configuarator, A-28
data sheet, A-29
product description, A-27
product fit questionnaire, A-28
value analysis questionnaire, A-29
quality assurance
composition, 1-29
packaging, 1-31
printing, 1-31, 4-73
question and answer format, 3-38
question mark, 3-56
quotation, 3-38
quotation marks, 3-57

R

readability, 1-13, 3-15—18
formulas, 3-16
Fry scale, 3-17—18
kernel distance theory, 1-13, 3-18
negative effects on, 3-18
samples, 3-15—16

word choice and, 3-39—40
recto, 2-8
redundancy, 3-43
reference documents, A-4, A-5, A-38—41
operations, A-38—40
service, A-41
references and standards documents, A-3, A-18—19
reprographics, 1-30
research, 1-3, 1-11—13
collecting information, 1-11—12, 1-19
validation, 1-12—13
response/order form, 2-39, 4-61
revising, 1-16—17, 1-21, 1-22
time budget, 1-17
revision document, 2-43
revision notice, 2-14, 2-16
Roman numeral, 2-11, 2-12, 3-66
rule, 4-39
header and footer, 4-45, 4-46
heading, 4-51

S

saddle-stitch binding, 4-65, 4-66, 4-68, GL-50
covers, 4-78
footprint, GL-22
sales guides, A-3, A-24—27
account profile, A-26—27
brochure, A-26
direct mail piece, A-26
prospect data/information lists, A-25
sales manual, A-24—25
sales personnel training documents, A-4, A-42—44
scanning column, 4-15
section, 2-8, 2-12, 2-27
self-editing, 1-16—17
time budget, 1-17
semicolon, 3-58
sentence, 3-27—33, GL-51—52
active voice in, 3-31—32
clarity, 3-29—31
complex, 3-27, GL-52
compound, 3-28, GL-52
compound-complex, 3-28—29, GL-52
simple, 3-27, GL-52
variety, 3-32—33
sentence-style capitalization, 3-61, GL-8
sequencing, 2-34—35
bibliography, 2-37
service documents, A-4, A-40—41
sexist writing, 3-9—11
shrink wrapping, 1-31
simplex printing, 2-8, GL-53
single text column, 4-15
big book, portrait, 4-16, 4-17
small book, landscape, 4-28
small book, portrait, 4-24
slipcase, 4-68, 4-75, GL-53
small book, landscape, 4-13
column layout, 4-28
cover, 4-77
headers and footers, 2-15—20, 4-48
small book, portrait, 4-11
column layouts, 4-24—25

cover, 4-75, 4-76, 4-78
 double text column, 4-25
 headers and footers, 2-15–21, 4-47
 single text column, 4-24
software reference manual, A-4, A-39
spacing, 4-5
 editorial, 4-56
 fixed (mono), GL-20
 fixed patterns, 4-55–56
 heading, 4-49, 4-50, 4-57
 line, 4-32, GL-32–33
 proportional, GL-47
 special problems, 4-57–58
special information page, 2-12, 2-24
spellcheck program, 3-47
spelling, 3-47–49
 American versus British, 3-48–49
split infinitives, 3-46, GL-28
standards, see publishing standards
statistics, 3-37
step-by-step techniques, 3-38
storage, 1-3, 1-35
structure, document, 2-5–8
style, xv, xviii, 3-5–6
 abbreviations, 3-63
 capitalization, 3-59–61
 conventions, 3-5
 design versus, 3-6
 grammar, 3-45–46
 numerals, 3-65–67
 punctuation, 3-51–58
 spelling, 3-47–49
subject
 verb and, 3-29–30, 3-45
 placement, 3-30
subject matter
 annotation in, 2-28–31
 defined, 2-8
 numbering, 2-11, 2-12, 2-13
 organization, 2-27
subtitle page, 2-12, 2-27, 4-60, see also part
summary, 2-12, 2-33
support plans, A-3, A-13–14
Swift, Jonathan, 3-39
system requirements specification, A-3, A-9
systems analysis training documents, A-4, A-44
systems management training document, A-4, A-45
systems support training document, A-4, A-44–45

T
tab, 2-13, 4-63–64
table
 design, 4-39–43
 list, 2-12, 2-24
 notes, 2-28
 numbering, 2-13
 placement, 4-40
 rules, 4-39
 spacing, 4-55–56
 text, 4-41–43
 text reference to, 4-42
 title, 4-41
table of contents, 2-12, 2-24, 4-60

technical service training document, A-4, A-44–45
technical writers, 1-15
tense, 3-24, 3-45, GL-56
terminology, document, 2-8
text, 2-8, 4-31–37, GL-57
 column layouts, 4-15–28
 downstyle capitalization, 4-34
 emphasis, 4-33
 in graphics, 4-41–43
 justification, 4-32
 leading, 4-32
 line length, 4-31, see also column layouts
 list, 4-34–36
 paper, 4-69
 type, 4-29, 4-31
 visual conventions, 4-36–37
title, document, 2-9–10, 2-21
title page, 2-12, 2-21, 4-59
trademark, 2-41–42
 list, 2-23
 use of, 3-44
training documents, A-4, A-5, A-41–47
 customer, A-46–47
 sales personnel, A-42–44
 technical service, A-44–45
triple text column, 4-15
 big book, portrait, 4-20–21
Twain, Mark, 3-39
type
 condensed, GL-12
 face, 4-5, 4-29, GL-59
 font, GL-21
 size, 4-31, 4-50, 4-51, GL-59
 terminology, GL-4

U
underlining, 4-33, 4-37
underscoring, 4-33, 4-37
updating, 1-3, 1-12, 1-29, 1-35, see also revision
 document

V
value analysis questionnaire, A-3, A-29
van den Velde, Jan, 3-2
verb, GL-61
 active, 3-31–32, GL-61
 object and, 3-30
 subject and, 3-29–30, 3-45
 tense, 3-24, 3-45, GL-56
verso, 2-8
Vinci, Leonardo da, 4-2
Vitruvius, 4-2

W
warning, 2-28
warranty, 2-42
Wire-O binding, 4-65, 4-66
 covers, 4-76–77
 footprint, GL-22
 specifications, 4-68
word
 choice, 3-39–44
 cliché, 3-41
 contextual clues, 3-42–43

jargon, 3-40—41
order, 3-45
position, 3-45
precision, 3-41
redundant, 3-43
simple, 3-39—40
transitional, 3-42
word list, B-1—9
writing, xv, xviii, 1-3, 1-15—23, 3-5—6
 actual, 1-16, 1-20—21
 analogy in, 3-36
 bias-free, 3-9—11
 blocks in, 1-20
 clarity, 1-11—12
 classification in, 3-36
 comparison in, 3-37
 content, 3-7—8
 definition, 3-35

electronic tools and, 1-4
 examples in, 3-37
 expository, 3-35—38
 grammar and, 3-45—46
 identification in, 3-35
 paragraphs, 3-19—25
 principles, 3-3
 purpose, 1-18
 readability, 1-13, 3-15—18
 sentences, 3-27—33
 stages of, 1-16—23
 statistics in, 3-37
 technical, 1-15
 techniques, 3-35—38
 time budget, 1-17
 word choice, 3-39—44
 see also style

Production notes

The artwork that appears in this book was developed using a variety of technologies. Artwork scanning was done on both the Xerox 150 Graphic Input Station and Xerox 7650 Pro Imager. Some artwork creation and enhancements were done using the Intran METAFORM workstation. Artwork was then printed on a Xerox 9790 Laser Printing System Model V. We have used the Optima typeface, lovingly created by Herman Zapf over a six-year period.